The Indian Peoples of Eastern America

182-83

The Indian Peoples
of Eastern America

A Documentary History of the Sexes

Edited by

James Axtell

THE COLLEGE OF WILLIAM AND MARY

New York · Oxford
OXFORD UNIVERSITY PRESS
1981

Copyright © 1981 by Oxford University Press, Inc.

Library of Congress Cataloging in Publication Data

Main entry under title:
The Indian peoples of Eastern America.

 Bibliography: p.
 1. Woodland Indians—Social life and customs—
Sources. 2. Indians of North America—Social
life and customs—Sources. 3. Woodland Indians—
Women—Sources. 4. Indians of North America—
Women—Sources. I. Axtell, James L.
E78.E2I52 970.004'97 79–28370
ISBN 0–19–502740–X
ISBN 0–19–502471–8 pbk.

Printed in the United States of America

For Susan

Mine own familiar friend

Preface

The idea for this collection came to me as I was seeking ways to make American history more engaging for students who knew only the antiseptic paraphrase and unsupported generalities of textbooks. Since professional and amateur historians obviously take great pleasure in what they do, I sought to give students some of the same pleasure by encouraging them to become practicing historians, at least temporarily while they interrogated the past in their classes. What historians find most enjoyable about their craft is research, the labyrinthine quest in primary sources for answers to their questions about the past. While most historians look upon writing as hard work, they, like Barbara Tuchman, find research "endlessly seductive." When given an opportunity to do their own research, students feel the same way, if my classes over the past thirteen years are at all typical.

The fascination of primary sources lies in their personal perspective and the immediacy of experience they convey. However lacking in objectivity or insight they may be, they were written by people at or close to the scene of the events they describe. This gives them not only primary authority as evidence but compelling interest as human artifacts, as various as the personalities that created them. It is these qualities that seduce historians of all ages.

Unfortunately, the constraints of classroom time and library holdings often make it difficult (though by no means impossible) for the student to be fairly exposed to the joys and problems of primary research. One way to surmount these difficulties is to put in the student's hands a collection of primary sources small enough to be affordable in time and cost, yet large enough to offer a field for purposeful rummaging. Completeness of coverage, of course, is probably impossible. Any event capable of fitting within the covers of such a book must be either poorly documented or relatively insignificant. For the only other requirement of such a collection is that while it must necessarily treat a microcosmic aspect of American history, it should be capable of shedding strong light on the larger whole.

Within these general guidelines I then searched my interests for a subject that would present the student with as many fruitful methodological

challenges as opportunities to approach American history from new perspectives. It took very little time to choose the present topic: the life cycle of the Indians of eastern North America. My reasoning went something like this: Despite woeful neglect by our traditional histories, no people determined the course of America's formative history more than the native Americans. However, the behavior and actions of the Indians cannot be understood without knowing something about their culture—how they thought and felt and what they believed and valued. But it is impossible to understand Indian culture without knowing how Indian people were socialized and enculturated, how they became full and functioning members of their societies and came to share the values of those societies. Since native culture shaped and was shaped by all members of native society, the lives of women as well as men must be examined. And the best way to view the lives of all Indians is through the human life cycle as the individual celebrates the various rites of passage that mark his or her transition to new stages of social maturity. By viewing the lives of native men and women in tandem as they moved from birth to death, we can distinguish the workings of culture from those of biology in the formation of their distinctive personalities and social roles.

In working out the implications and contours of the subject I had chosen, I was fortunate to have Dave and Susan Allmendinger as resonant soundingboards and fertile sources of ideas. Their experience in nineteenth-century social history saved me from colonial parochialism and ethnic myopia in the theoretical stages, while their friendship heightened the pleasures of collegiality. The favorable reception given my ideas by Dave Oliphant and Barbara O'Brien at an early stage was both heartening and helpful in defining the best approach to the proper audience. More recently, Nancy Lane of Oxford University Press has assumed their good offices by offering genial criticism, strong suggestions, and boundless encouragement in the right proportions át the right times.

I am also grateful to Nancy Lurie for her critical reading of the manuscript from an ethnological point of view. While a text such as this, aimed primarily at students of history, can never meet her high standards of cultural discrimination, her frank and friendly suggestions have saved me from a number of small and not-so-small errors of fact and interpretation.

To my wife, Susan, I owe somewhat more. With her infinite love of words, uncanny ear for rhythm, and puckish sense of humor, she has placed me and my incessant scribbling deeply in her debt, not by red pencillings and scholastic commentary but by applying to it the truest power of all—

acute intelligence graced by gentleness. And not least, she has taught almost daily lessons how Adam must have felt about the gift of E education that no historian of aboriginal man and woman shou without.

Williamsburg
June 1980

Contents

xi

Contents

Introduction

Few of America's many peoples are as misunderstood—if not ignored—by historians and their readers as its original inhabitants. Despite constant and considerable exposure in the national mythology and popular media (most of it demeaning), the American Indians are conspicuously untreated or mistreated by our academic histories, especially the textbooks which carry so much responsibility for our historical socialization. Even the best textbooks pay almost no attention to the eastern Indians in the colonial period and only slightly more to the western tribes in the nineteenth century. With the battle of Wounded Knee and Frederick Jackson Turner's famous closing of the frontier in 1890, the Indians vanish from the pages of history. In every period, they appear—if at all—chiefly as colorful obstacles to the inevitable and inexorable "civilization" of the "untamed continent" (what used to be called "Manifest Destiny"), whether the texts are traditionally or liberally slanted. Even sympathetic authors who have been urged by their consciences or their publishers to expose the injustices suffered by America's oppressed minorities still cast the Indians in bit parts as hapless victims who could react to the white juggernaut only defensively, with martial courage and pathetic eloquence. Never are they given leading roles as *determinants* of American history, as people who helped shape, both positively and negatively, the historical contours of the multi-ethnic society we have inherited.

This pattern of neglect is doubly unfortunate because it pays the Indians least attention in the period when they were most important, and the most attention (however small) when they were least capable of altering the course of national events. In the colonial period of North America's history, which stretched nearly 250 years from Cartier's first winter on the St. Lawrence to the Peace of Paris ending the American Revolution, the Indians were the colonists' single greatest problem and, for much of that time, their greatest opportunity. For the natives lived everywhere the colonists chose to settle. Their presence simply could not be ignored, and it was not. European merchants needed them to harvest the continent's furs as only they could and to consume trade goods. Missionaries sought to convert

them to their various brands of Christianity and thereby to enlist them in the earthly warfare between the Catholic and reformed churches. Similarly, the military leaders of the various colonies needed them as allies against hostile or recalcitrant neighbors, native and colonial, while empire-builders at home sought to manipulate them on the giant chessboard of international competition for territory, wealth, and souls. Only to the vast majority of agricultural settlers were the Indians dispensable. When the fertility of the New World soil and Old World women came together in a salubrious climate, the native inhabitants quickly became numerical inferiors and social liabilities who needed to be removed from the plowed paths of progress. But not before many struggling settlements gratefully interposed Indian corn and know-how between themselves and the "starving time." So essential were the natives to the exploration, colonization, and national origins of America that their absence from its history is, quite simply, inconceivable. Without the Indians, America would not be America as we know it.

While the Indians can no longer be ignored without serious distortion to our true past, they have another claim on our historical attention and national awareness: they were here first. We may deny them their rightful place in our history books and try to prevent them from jogging our corporate memory by caching them on remote reservations, but we can never alter the ineluctable fact that Indian peoples lived in America for tens of thousands of years before anyone else and, in many instances, for hundreds of years in the same places where the first European invaders found them. This historical priority, reflected so aptly in the bumper sticker often seen in Indian country—"Americans Discovered Columbus"—should guarantee them moral priority in our national consciousness. We need not and should not feel guilty for the wrongs committed by our ancestors—unless by our actions or inaction we perpetuate them. But we do owe the Indians and ourselves the fundamental obligations of remembering the past, understanding its participants in their own cultural contexts, and being sensitive to the burdens entailed on its heirs, obligations which the study of history can help us discharge.

The Indians of greatest relevance to the formative history of America and therefore to this volume are the tribal peoples of the East, particularly the northeastern triangle between the Carolinas, the western Great Lakes, and the Maritime provinces of Canada. They were the tribes who met the European explorers and colonists as they probed the Atlantic coast and then pushed their barks and newly acquired canoes into the lakes and rivers of the interior. The most formidable groups were the Creeks of the deep South, the recently consolidated Powhatan confederacy in Virginia, and the

linguistically related but deadly hostile neighbors of New York and lower Ontario, the Iroquois and the Hurons. Of all the eastern tribes, the Iroquois enjoyed preeminence by virtue of an effective league of peace between the five member nations, a military reputation incommensurate with their numbers, and a fortuitous location astride the best waterlevel route through the Appalachians. For more than a century and a half, the Iroquois were the native force to be reckoned with, by natives and colonists alike. Yet from one perspective they were little different culturally from the other eastern tribes who took their living from the region's mixed coniferous-deciduous forests, abundant lakes, rivers, and bays, and fertile meadows and bottom lands.

Contrary to the stereotype of the Indian as a nomadic carnivore, the eastern tribes were predominantly horticulturalists who supplemented their vegetable diet with seasonally available game, fish, and wild nuts and berries. The mainstay of native nutrition was maize or Indian corn, the tough-kernelled Northern Flint variety that required a relatively short growing season and could tolerate acidic soils and cool, moist climates. Only in northern New England and north of the St. Lawrence was big game hunting the dominant economic activity.

The zone separating predominantly farming from hunting tribes also roughly marked a division between kinship systems. The basic unit of social membership in all the tribes was the exogamous clan, a lineal descent group determined through only one parent. The farming tribes, from the Hurons of southern Ontario to the Creeks of Alabama, were largely—though not invariably—matrilineal because farming was done by the women, who owned the fields and houses, and served as the guardians of tradition and stability in the frequent absence of the men for hunting, trading, diplomacy, and war. (Prominent exceptions were the patrilineal Central Algonquians of Michigan and Ohio: Shawnee, Miami, Sauk, Fox, and Potawatomi.) Among the hunting tribes of the northern Great Lakes and Canada, on the other hand, descent tended to be reckoned through the father because he owned the hunting and trapping territories upon which the family depended for survival. Whether matrilineal or patrilineal, the kinship systems were functionally equivalent in that everyone belonged to a lineage and acquired relations and obligations not only to that primary group but to the lineage of the other parent as well. Then, as now, an Indian's identity was shaped more by social kinship than by language, religion, or political allegiance.

The eastern tribes were divided by language as well, but this division corresponded to no other major social, cultural, or ecological differences. The tribes of the Southeast were predominantly Muskogean-speakers while

the natives of the eastern Great Lakes and St. Lawrence valley as well as the Cherokees and Tuscaroras of the upper South spoke Iroquoian dialects. The other eastern tribes, except for a sprinkling of Siouans in the upper South, spoke Algonquian tongues. Though the four language groups were mutually unintelligible, the tribes who spoke them had much in common. In addition to functionally similar subsistence and kinship systems, they shared a tendency to live in bark or mat-covered houses, in summer villages of a few hundred people, and in winter hunting camps of only a few families. Politically, they seldom recognized an authority greater than the band, a group of villages who shared goals, people, and resources, though the threat posed by the European invaders pushed many peoples toward tribal and intertribal consolidation. Their manual technologies of bone, stone, and wood were similarly (and superbly) adapted to the woodland environment they shared. Every band and tribe knew precisely the boundaries of its land and authority, demanding tribute or retribution from those who trespassed. War, therefore, was common to all the tribes at various times as was the more persistent quest for peace. And while their mythological heroes and deities might differ slightly in name and deed, the eastern tribes shared a belief in living "spirits" or souls, a divine creator, the essential continuity of the natural and supernatural, the efficacy of prayer and ritual, and the necessity of thanksgiving.

The Indian peoples of the East were not without their social and cultural differences, and these we must not minimize or forget. But their shared activities, beliefs, and values formed such a recognizable pattern that ethnographers speak with justice of an Eastern Woodland culture area. It is this general pattern that the documents below are intended to reveal. For without an understanding of the persistent characteristics of a culture, we cannot accurately measure the effects of historical change.

Although the reality of Indian life was a "seamless web," there are many approaches to analysis and interpretation. Archaeologists take to the soil in search of the material manifestations of social arrangements and cultural values. Linguists look for similar clues among the phonetic bricks and syntactical mortar of living and dead languages. Historical ethnologists comb the documentary record for ways to construct synchronic models of the structures and functions of whole societies. And more recently, ethnological historians have joined the Indian enterprise in search of explanations for cultural change among the native groups and for the impact that the native and Euro-American societies had upon each other over time.

Each of these broad disciplines is also capable of taking a wide or narrow perspective on the subject. It is possible—and somewhat easier—to focus on one of the many aspects of culture—subsistence, kinship, religion—or on

a particular segment of the society—men, women, young, old, leaders, followers, traditionalists, deviants. But when each of these various facets has been explored and understood, we should always try to reconstruct the full web of Indian life leaving no discernible scars from our disciplinary scalpels. Otherwise we run the scholarly risk of mistaking our favorite microcosm for the whole world.

In this collection I have tried to cast a wide net over the native cultures of the East, hoping thereby to allow the reader to capture the fullest possible understanding of what it meant to be an Indian in early America. I have also sought to cast a strong light on the native people of all ages and both sexes, not just the adult men who are most visible in the public colonial records. Despite a long-standing assumption in historical circles, a society is not made by men alone. The best way, in my opinion, to do justice to the full range and richness of people, activities, and values that constitute a society and its culture is to focus on the life cycle of those people as they move from birth to death. In the "rites of passage" which every society celebrates to mark the social transitions in its members' lives, we have a sensitive barometer of cultural values and social significance. The life cycle also forces us to recognize the historical ubiquity and complementarity of men and women, children and adults, peace and war, stability and change. The essential aim of this collection is to restore some measure of this complexity and fullness to our historical image of native life.

The documentary sources chosen for this task pose a number of obstacles—none of them insurmountable—to a clear understanding of the eastern Indians. The first problem is that, in the absence of Indian writing systems, nearly all of our sources were written by Europeans. They are all, with two notable exceptions, the products of outsiders, members of alien and often antagonistic societies who viewed the world of the Indians through the refracting lenses of their own cultural norms. The problem is not the color but the cultures of the observers. We would seriously and unnecessarily handicap our search and commit the "genetic fallacy" if we depreciated the value of our sources simply because they were written by non-Indians. As anthropologists have ably demonstrated, outsiders are often better qualified to perceive the patterns and meanings of a culture than those who are surrounded and shaped by it. Moreover, although these observers shared a Western European background, they were divided by national origins, religion, social class, and New World goals. Not infrequently, these differences cancel each other out, leaving native reality largely accessible. Since the colonial sources are filled with native information, speeches, and viewpoints, the measure of native reality is not small.

An obstacle akin to the first is that, since the discipline of anthropology

was not developed until the second half of the nineteenth century, none of our sources was written by a trained ethnographer. We must therefore attempt to form a composite picture of each stage of native life from shards and snapshots of description by observers variously qualified, perceptive, and interested. I have tried to minimize this problem by selecting the best descriptions by the most objective, most discerning, and most experienced observers. For not unlike modern anthropologists, some were better than others.

Another obstacle to our understanding of the lives of Indian men and especially women is that nearly all of the early observers were adult men. While this should be borne in mind as we read, it does not necessarily accuse those men of sexual bias and automatically depreciate the value of their observations. For the very limitations of their male perspective work to our advantage in at least two ways. First, their perspective was one largely common to Western European men of the day. Thus, while they may have *misinterpreted* the evidence of their eyes in the glare of their own cultural values, they accurately observed that Indian women often performed roles and enjoyed statuses quite different from those of European women. And second, because they *were* men, they showed an understandable curiosity about the dark-skinned women who sometimes sold the fur coats off their backs and often wore skimpier clothing than European men had ever seen at home. Among people who honored the kinship of the female processes and the rhythms of the natural world, European observers had little difficulty and less reticence uncovering aspects of women's lives that would have been taboo in their own cultures. Menstruation and childbearing are among the most striking. And in the process of implicitly and explicitly comparing the women of two cultures, they threw light on the customs of European women and the (predominantly male) attitudes that surrounded them.

In some ways the Christian bias of the sources is more problematical than their male perspective for the simple reason that the observers' religion was essentially a value system that judged every action at the bar of Scripture. Consequently, these men often found it difficult to observe and record without placing value judgements on what they saw. This only means that we should be *aware* of their particular cultural biases, not that we must abandon their observations as hopelessly prejudiced. For if we did, we might exclude some of our most objective and most reliable evidence, that of the early Jesuit and Recollect missionaries. While they were Christians to the soul, and therefore dramatically at odds with much in Indian life and religion, they were also trained in accurate and subtle observation, wanting to understand as fully as possible Indian thoughts and emotions,

fears, and hopes so that they might better insinuate themselves into the natives' confidence and thereby begin their conversion. It is our task as historians to separate their Christian and European cultural interpretations from their perceptive insights. If we do it well, we will be amply rewarded by a richer understanding of the Indian peoples of eastern America and the historical origins of the peoples who supplanted them.

The Indian Peoples of Eastern America

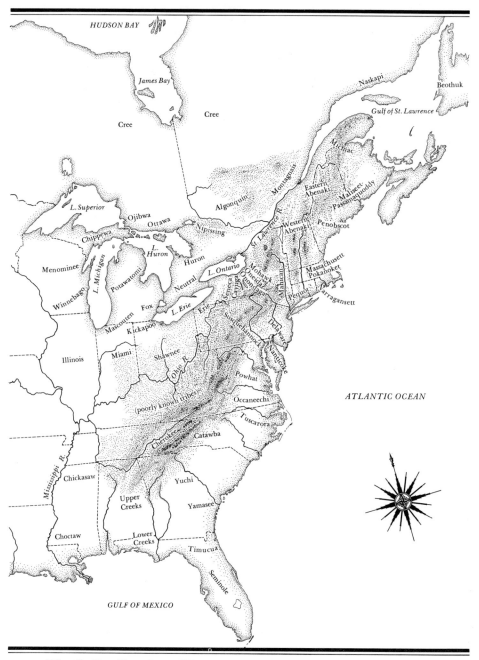

The Indian Peoples of Eastern America

(At the earliest stages of European contact with each tribe)

ONE:

Birth

Physiologically, the human process of giving birth is much the same the world over, especially in societies that are unfamiliar with cesarean surgery. But socially and culturally the event varies widely. Each culture attaches different meaning and importance to childbirth as it pertains both to the mother, particularly a new mother, and to the child. These cultural meanings receive social recognition in one or more rites of passage. As the following documents show, the Indian societies of eastern North America were not exempt from the universal desire to mark the first transition in a person's life—from unborn to born.

Pregnancy itself was surrounded by a number of taboos, some of which sought to protect the unborn child and others to shield the community, particularly its male half, from the heightened powers of the woman's condition. In pregnancy as in menstruation, Indian women were thought to possess an abundance of spiritual power, which, like all such power, had the double-edged capacity to harm or heal. Thus a pregnant woman was at once revered and feared for her intimate connection with the mysterious forces of nature, and regarded as a socially different person. This gradual process of separation was completed in most eastern tribes as delivery neared and the woman put down her daily tasks to withdraw to a special hut in the woods. There, either alone or with the help of relatives, priests, and midwives, she participated in the child's abrupt translation to the society of the born, an event marked by special attention to the cutting and care of the umbilical cord. Many observers—all of them men—thought that her role was painless and easy. She, herself, knew the universal pains of labor, but sublimated them for her cultural ideals, which demanded that mother and child display a stoic courage in the face of all adversity.

The newborn child began its initiation into native life with a healthy swig of animal oil, a quick dip in a cold stream, and a warmer acquaintance with its mother's breast, at which it would continue to feed for two, three, or more years. For a year it would nestle against a fur-clad, bone-straightening cradleboard, toes in to give it a distinctive Indian walk for narrow trails and snowshoes. Meanwhile, after the new mother had remained for a cer-

tain time in her birthing hut, she and the baby returned to the family lodge with some ceremony of incorporation. There she assumed the prestigious status of a mother, no longer just a woman, and abstained from sexual relations with her husband until the infant was weaned, thereby safeguarding the "purity" of her milk and postponing any sibling rivalry over it.

In most tribes, the infant's full entrance into the community came a few months after birth when the village elders and priests officiated at a formal initiation rite. There, surrounded by the members of its maternal or paternal clan, the child received its public name, usually from a special clan repertoire, and sometimes had its ears and nose pierced. The first rite of passage was thus complete, infancy was left behind, and the culturally formative years of childhood lay ahead.

1. Infancy in Huronia

The first missionaries in New France were the Jesuits, who from 1611 to 1614 came in small numbers to Acadia (now Nova Scotia and New Brunswick). But from the founding of Quebec in 1608, Samuel de Champlain had wanted to send a religious mission to the tribes of the Great Lakes, particularly the Hurons, upon whom the French depended for their trade in furs. On his eighth voyage to France, Champlain enlisted the enthusiastic support of four Recollects, members of a strict Franciscan order that sought to carry poverty, plainness of dress, and self-abnegation to perfection. From 1615 to 1632, before they were excluded by Cardinal Richelieu (for reasons more political than religious), the Recollects had the Canadian missions to themselves.

Gabriel Sagard was serving as the private secretary to the provincial of the Recollects of Saint-Denis in Paris when he was sent to Canada in 1623 to minister to the Huron Indians at the foot of Georgian Bay in Lake Huron. With another priest, the grey-frocked brother spent about a year

Source: Father Gabriel Sagard, *The Long Journey to the Country of the Hurons,* ed. George M. Wrong, trans. H. H. Langton (Toronto: The Champlain Society, 1939), pp. 127–31.

with the natives in two villages, preaching, praying, visiting families, and learning their language. When he was recalled the following year, he had completed a Huron dictionary to help later missionaries, and had obviously taken notes for his classic *Long Journey to the Country of the Hurons,* which he published in 1632.

Sagard's observations were perceptive, but his interpretations were sometimes skewed. For instance, he exaggerated the extent to which Huron parents loved their children out of need for their support in old age. His correct observation that Huron women were not as prolific as French women has a cultural, not a biological, explanation: nursing provided a considerable degree of contraception and the mothers often abstained from sexual relations while they were nursing. His worry that making newborns swallow grease or oil as a mockery of baptism was misplaced. Almost all northeastern tribes did it to flush the infant's digestive system and perhaps, as Calvin Martin has suggested, to "feed" the child's future "guardian spirit" ("The European Impact on the Culture of a Northeastern Algonquian Tribe: An Ecological Interpretation," *William & Mary Quarterly,* 3d ser. 31 [1974], 15). That children did not inherit their father's property (or name) was due not to marital promiscuity but to the Hurons's matrilineal kinship system, in which a child belonged to its mother's clan. And Sagard stood in a long line of European observers who felt that the Indians "spared the rod and spoiled the child," without realizing that corporal punishment was not the only way to promote discipline, especially self-discipline.

It is a fact that they [Huron parents] all are very fond of their children, in obedience to that law of caring for them which Nature has implanted in the hearts of all animals. Now what makes them love their children, however vicious and wanting in respect, more than is the case here is that they are the support of their parents in old age, either helping them to a living or else defending them from their enemies, and Nature preserves unimpaired its authority over them in this respect. Wherefore what they most desire is to have many children, to be so much the stronger and assured of support in the time of their old age. And yet the women are not so prolific as they are here [France], perhaps as much on account of their lubricity [lewdness] as from choosing so many men.

When the woman bears a child the custom of the country [of the Hurons] is that she pierces the ears of the child with an awl or a fish-bone and puts in the quill of a feather or something else to keep the hole open, and afterwards suspends to it wampum beads or other trifles, and also hangs them round the child's neck however small it may be. There are some also who even make them swallow grease or oil as soon as they are born; I do not know the purpose or reason, unless it is that the devil, who apes the work of God, has chosen to devise and impose upon

them this practice, in order to mimic in certain respects holy baptism or some other sacrament of the Church.

In giving names they follow tradition, that is to say they have a great supply of names [in each clan] from which they choose in order to bestow them on their children. Some names have no meaning; others have, such as *Yocoisse,* the wind, *Ongyata,* the neck, *Tochingo,* crane, *Sondaqua,* eagle, *Scouta,* the head, *Tonra,* the belly, *Taihy,* a tree, etc. I saw one man who was called Joseph, but I was not able to learn who had given him that name, and perhaps among such a number of names as they have there may be found some resembling our own.[1]

The ancient German women were praised by Tacitus because each fed her children at her own breast and would have been unwilling that any other than herself should give them milk. Our savage women also nourish their children with milk from their own breasts, and since they do not know the use or suitability of pap [a soupy mixture of bread and milk, common in Europe] they give them the very same meat that they take themselves, after chewing it well, and so by degrees they bring them up. If the mother happens to die before the child is weaned the father takes water in which Indian corn has been thoroughly boiled and fills his mouth with it, then putting the child's mouth against his own makes it take and swallow the liquid, and this is to make up for the lack of the breast and of pap; just so I saw it done by the husband of the woman savage whom we baptized. The women use the same method in feed-

ing the puppies of their bitches, but I found this very displeasing and nasty, to put their mouth in this way to the puppies' muzzles, which are often not too clean.

During the day they swathe [swaddle] their children upon a little wooden board, on which sometimes there is a rest or small bit of wood bent into a semi-circle under the feet, and they stand it up on the floor of the lodge, unless they carry the child with them when they go out, with this board on their back fastened to a belt [a burden strap or tumpline], which is supported on the forehead; or they take them out of their swaddling clothes and carry them wrapped up in their dress above the girdle in front, or behind their back almost straight up, the child's head outside, looking from side to side over the shoulders of the woman who carries it.

When the child is swaddled on this board, which is usually decked out with little paintings and strings of wampum beads, they leave an opening in front of its private parts through which it makes water, and if the child is a girl they arrange a leaf of Indian corn upside down which serves to carry the water outside without the child being soiled with its water; and instead of napkins [diapers], for they have none, they put under it the beautifully soft down of a kind of reed [cattail fluff] on which it lies quite comfortably, and they clean it with the same down. At night they put it to bed quite naked between the father and the mother, without any accident happening, or very seldom. In other tribes I have seen them, in order to

1. Joseph had obviously been named either by a visiting Frenchman or during a trip to Quebec.

put the child to sleep, lay it in its wrappings on a skin which is hung up, tied by the four corners to the wooden supports and poles of the lodge, like the reed hammocks of sailors under the ship's deck, and when they want to rock the child they have only from time to time to give a push to the skin thus suspended.

The Cimbri [an ancient German tribe] used to put their new-born children into the snow to harden them to suffering, and our savages do no less; for not only do they leave them naked in the lodge, but the children, even when rather big, roll, run about, and play in the snow and during the greatest heat of summer [naked], without receiving any harm, as I have seen in many instances, wondering that these tender little bodies could endure such great cold and such great heat, according to the weather and the season, without being disordered by them. And hence it is that they become so inured to pain and toil that when they have grown up and are old and white-haired they remain always strong and vigorous, and feel hardly any discomfort or indisposition. Even the women with child are so strong that they give birth by themselves, and for the most part do not lie up [recuperate in bed]. I have seen some of them come in from the woods, laden with a big bundle of wood, and give birth to a child as soon as they arrive; then immediately they are on their feet at their ordinary employment.

Since the children of such marriages cannot be vouched for as legitimate [see chap. 3], this custom prevails among them, as well as in many other parts of the West Indies, that the children do not succeed to [inherit] their father's property; but the fathers constitute the children of their own sisters their successors and heirs, since they are sure that these are of their blood and parentage. Nevertheless they love their children dearly, in spite of the doubt that they are really their own, and of the fact that they are for the most part very naughty children, paying them little respect, and hardly more obedience; for unhappily in these lands the young have no respect for the old, nor are children obedient to their parents, and moreover there is no [corporal] punishment for any fault. For this reason everybody lives in complete freedom and does what he thinks fit; and parents, for failure to punish their children, are often compelled to suffer wrong-doing at their hands, sometimes being beaten and flouted to their face. This is conduct too shocking and smacks of nothing less than the brute beast. Bad example, and bad bringing up, without punishment or correction, are the causes of all this lack of decency.

2. The Powers of Pregnancy

The Jesuits returned to Canada in 1625 at the request of the Recollects, who felt themselves undermanned for the enormous task of converting the tribes of North America. After the Recollects withdrew from the field in 1632, the Jesuits assumed the lion's share of the work and glory—only the Sulpicians around Montreal and in Acadia and the Recollects who returned in 1670 offered any competition—during the remainder of the French colonial period. One of the early Jesuits, François du Peron, came to Canada in 1638 after teaching at two Jesuit colleges. He worked among the Hurons in lower Ontario until they were routed and dispersed by the Iroquois in 1649. Later he was part of the short-lived mission to the Iroquois (or Five Nations) at Onondaga. His brief description of Huron taboos surrounding pregnant women, which closely resembled those pertaining to menstruating women (see below, Docs. 24, 26–28), were included in a letter to his brother Joseph, a Jesuit priest in France, in 1639.

Pregnant women among them cause, they say, many misfortunes; for they cause the husband not to take anything in the hunt; if one of them enters a cabin where there is a sick person, he grows worse; if she looks at the animal that is being pursued, it can no longer be captured; if people eat with her, those who eat thus fall sick. A pregnant woman, by her presence and the application of a certain root, extracts an arrow from a man's body. Moreover, they rejoice more in the birth of a daughter than of a son, for the sake of the multiplication of the country's inhabitants.

Source: Reuben Gold Thwaites, ed., *The Jesuit Relations and Allied Documents,* 73 vols. (Cleveland, 1896–1901), 15:181, 183.

3. Micmac Mothering

Nicolas Denys (1598–1688) was one of the founders of Acadia (the present Maritime provinces of Canada). A man of great energy but flawed vision and small means, he tried his hand at lumbering, trading, farming, and cod-fishing before admitting defeat in 1669 by fire, war, heavy costs, and ruinous rivalries. But he had come to know well the Micmac Indians with whom he had lived and traded along the Atlantic coast for forty years, knowledge which he put to good use when he retired to write *The Description and Natural History of the Coasts of North America*, first published in 1672.

Denys's description of the sanitary limitations of the cradleboard, which was widely used throughout native America, adds a sour note to Sagard's more benign version, while his notice of abortion and long nursing helps to explain why Indian women spaced their children farther apart than their European counterparts.

There was formerly a much larger number of Indians than at present. They lived without care, and never ate either salt or spice. They drank only good soup, very fat. It was this which made them live long and multiply much. They would have multiplied still more were it not that the women, as soon as they are delivered, wash the infant, no matter how cold it may be. Then they swaddle them in the skins of Marten or Beaver upon a [cradle]board, to which they bind them. If it is a boy, they pass his penis through a hole, from which issues the urine; if a girl, they place a little gutter of bark between the legs, which carries the urine outside. Under their backsides they place dry rotten wood reduced to powder, to receive the other excrements, so that they only unswathe them each twenty-four hours. But since they leave in the air during freezing weather the most sensitive part of the body, this part freezes, which causes much mortality among them, principally among the boys, who are more exposed to the air in that part than the girls. To this board there is attached at the top, by the two corners, a strap, so arranged that when it is placed on the forehead the board hangs behind the shoulders; thus the mother has not her arms encumbered and is not prevented either from working or going to the woods, whilst the

Source: Nicolas Denys, *The Description and Natural History of the Coasts of North America (Acadia)*, ed. and trans. William F. Ganong (Toronto: The Champlain Society, 1908), pp. 403–4.

child cannot be hurt by the branches along the paths. They have three or four wives, and sometimes more. If one of them turns out to be sterile they can divorce her if they see fit, and take another. Thus they are able to have plenty of children. But if a woman becomes pregnant whilst she is still suckling a child, she produces an abortion. A thing which is also ruinous to them is that they have a certain drug which they use for this purpose, and which they keep secret among themselves. The reason why they produce the abortion is, they say, because they cannot nourish two children at the same time, forasmuch as it is necessary that the child shall cease suckling of itself, and it sucks for two or three years. It is not that they do not give them to eat of that which they have, for in chewing a piece of anything they place it in their mouths and the infant swallows it.

4. Giving Birth on the Gaspé

When Governor Frontenac invited the Recollects to return to Canada in 1670, the order left the Great Lakes tribes to the powerful Jesuits and concentrated largely on the Micmacs between the Gulf of St. Lawrence and Cape Breton. There Chrestien Le Clercq, a French priest from Artois, was sent in 1675. In his eleven years of intermittent service on the Gaspé peninsula, he devised a hieroglyphic system for writing Micmac (which is the basis for that used today), composed a Micmac dictionary, and took notes for his *New Relation of Gaspesia,* which was published in 1691 after his return to France.

In describing the occasional trials of childbirth, including the necessity for the ministrations of a native priest, Le Clerq gives us a welcome amendment to the idealized picture of the stoic Indian woman who delivered her baby with scarcely a missed step or stroke. His praise of native breast-feeding carried a thinly veiled criticism of the European upperclasses, as did many subsequent observations of the American Indians. If the natives were not always noble savages in these comparisons, neither were the Europeans cultural paragons.

Source: Father Chrestien Le Clercq, *New Relation of Gaspesia With the Customs and Religion of the Gaspesian Indians,* ed. and trans. William F. Ganong (Toronto: The Champlain Society, 1910), pp. 88–92.

The Indians wash their children in the river as soon as they are born, and then they make them swallow some bear's, or seal, oil. In place of a cradle, they make the children rest upon a little board, which they cover with skins of beaver, or with some other furs. The women adorn this little cradle carefully with certain bits of bead-work, with wampum, porcupine quills, and certain figures which they form with their paints. This is in order to beautify it, and to render it just so much the finer in proportion as they love their children. For these they make little garments of skins, which are all painted and adorned with the prettiest and most curious things they possess. They are accouched [delivered] with very great ease, and carry very heavy burdens during their pregnancy. Some indeed, finding themselves overtaken by this illness in going to fetch wood, retire a little apart in order to bring the child into the world; and they carry the wood to the wigwam upon their backs, with the new born babe in their arms, as if nothing at all had happened. An Indian woman, when in a canoe one day, feeling herself pressed by the pains of childbirth, asked those of her company to put her on shore, and to wait for her a moment. She entered alone into the woods, where she was delivered of a boy; she brought him to the canoe, which she helped to paddle all the rest of the journey. They never give birth to a child in the wigwam, for the men never give it up to them. The men remain therein whilst the wife is delivered in the woods at the foot of a tree. If she suffers pains, her arms are attached above to some pole, her nose, ears, and mouth being stopped up. After this she is pressed strongly on the sides, in order to force the child to issue from the belly of its mother. If she feels it a little too severely, she calls on the jugglers [Indian shamans], who come with joy, in order to extort some smoking tobacco, or other things of which they have need. They say that this is a present which they ask for their Ouahiche, that is to say, their demon, in order that he may chase and remove the germ which hinders the accouchement. . . .

Our Gaspesians are not so ridiculous as the Indians of South America, who at the same moment that their wives are accouched, betake themselves to bed, as if they had themselves suffered the pains and the cramps of childbirth, whilst their wives, with all their relatives and their friends, endeavour to console this imaginary invalid, to whom they give a thousand kindnesses and the best of everything that they have. The Indians have too much spirit to be willing to pass for women newly accouched, although they comfort their consorts with much charity. They go hunting for the purpose of providing the wherewithal for supporting their wives, in order that these may suckle their babes. For it is a thing unheard of, that they should give them out to be nursed, since they cannot persuade themselves to yield to others the fruits of their own bowels. By this conduct they reproach the lack of feeling of those [French] mothers who abandon these little innocents to the care of nurses, from whom very often they suck corruption with the milk. . . . Our poor Indian women have so much affection for their children that they do not rate the quality

of nurse any lower than that of mother. They even suckle the children up to the age of four or five years, and, when these begin to eat, the mothers chew the meat in order to induce the children to swallow it. One cannot express the tenderness and affection which the fathers and mothers have for their children. I have seen considerable presents offered to the parents in order that these might give the children to certain Frenchmen who would have taken them to France. But this would have torn their hearts, and millions would not induce them to abandon their children for a moment.

5. The End of Infancy on the Great Lakes

Nicolas Perrot's deep acquaintance with the Canadian Indians began in 1660 when he came to New France as a *donné*—a lay servant—to the Jesuits. After five years with the missionaries, he launched a long career as a fur trader, interpreter, and emissary for the French government to the Great Lakes tribes. On more than one occasion he was the first Frenchman to visit the various Wisconsin tribes and to win their affection. Even after marrying in 1671 and raising a large family, he continued to make trips into the West for peace missions and trade, which earned him the Indian nickname Metaminens (The Man with Iron Legs). After he finally settled down on his estate at Bécancour, he wrote the unusually accurate *Memoir on the Manners, Customs, and Religion of the Savages of North America* for Claude Michel Bégon, the Intendant of Canada from 1712 to 1726.

Perrot describes an important rite of passage for the Indian child that marked its entrance into the tribe. The pervasiveness of religion in native culture is underlined by the operations of the village priests, who oversaw the child's "circumcision" (piercing) and perhaps the bestowal of its initial name as well (see below, Doc. 6). He also notes the attenuation of the ceremony among the tribes in close contact with the French, and the early education for the sexual division of labor.

Source: Emma Helen Blair, ed. and trans., *The Indian Tribes of the Upper Mississippi Valley and Region of the Great Lakes*, 2 vols. (Cleveland: The Arthur H. Clark Co., 1911), 1:76–78. Reprinted by permission of The Arthur H. Clark Co.

When a child, either boy or girl, has reached the age of five or six months, the father and mother make a feast with the best provisions that they have, to which they invite a juggler [shaman] with five or six of his disciples. This juggler is one of those who formerly offered sacrifices [to their divinities]. . . . The father of the family addresses him, and tells him that he is invited in order to pierce the nose and ears of his child; and that he is offering this feast to the sun, or to some other pretended divinity whose name he mentions, entreating that divinity to take pity on his child and preserve its life. The juggler then replies, according to custom, and makes his invocation to the spirit whom the father has chosen. Food is presented to this man and his disciples, and if any is left they are permitted to carry it away with them. When they have finished their meal, the mother of the child places before the guests some peltries, kettles, or other wares, and places her child in the arms of the juggler, who gives it to one of his disciples to hold. After he has ended his song in honor of the spirit invoked, he takes from his pouch a flat bodkin [needle] made of a bone, and a stout awl, and with the former pierces both ears of the child, and with the awl its nose. He fills the wounds in the ears with little rolls of bark, and in the nose he places the end of a small quill,

and leaves it there until the wound is healed by a certain ointment with which he dresses it. When it has healed, he places in the aperture some down of the swan or the wild goose.

This child has for a cradle a very light piece of board, which is ornamented at the head with glass beads or bells, or with porcelain beads either round or long. If the father is a good hunter, he has all his adornments placed on the cradle; when the child is a boy, a bow is attached to it; but if it is a girl, only the mere ornaments are on it. When the child cries, its mother quiets it by singing a song that describes the duties of a man, for her boy; and those of a woman, for her daughter. As soon as the child begins to walk, a little bow with stiff straws is given to a boy, so that he may amuse himself by shooting them. When he has grown a little larger, they give him little arrows of very light weight; but when he has once attained the age of eight or ten years he occupies himself with hunting squirrels and small birds. Thus he is trained and rendered capable of becoming some day skilful in hunting. Such is the method pursued by the upper [Great Lakes] tribes; those down here [near Quebec] no longer use this sort of circumcisions, and do not call in jugglers to make them; the father, or some friend of the family, performs this ceremony without any further formality.

6. The Importance of Being Named

Pierre de Charlevoix, a son of the lesser French nobility, was ordained a Jesuit priest in 1713. As part of his training he was sent to teach the humanities at the Jesuit college in Quebec from 1705 to 1709. He returned to France for further study leading to his ordination, but in 1720 the king sent him to Canada again, ostensibly to inspect the Jesuit missions in North America but actually to search for a route to the elusive Western Sea. For two years Charlevoix and eight companions paddled the waters from the St. Lawrence to the Gulf of Mexico, an experience that the scholarly traveller turned to good advantage by interviewing many makers of Canada's history. This oral testimony was combined with an exhaustive study of the published and manuscript sources in French archives to produce the three-volume *History and General Description of New France* in 1744. The third volume of that work was entitled *Journal of a Voyage to North-America* and was separately translated and published in London in 1761.

Charlevoix provides an excellent description of the naming ceremony that marked the end of infancy (at what age he does not say, but probably at less than a year). Because the logic of classificatory kinship was not understood until Lewis Henry Morgan began to unravel it in the nineteenth century, Charlevoix did not realize that in Indian societies each person was "related" to, and therefore obligated to behave toward, every other member by virtue of their classification in a unilateral clan (i.e., membership defined by only one parental lineage; modern American kinship is bilateral in that one is related to and behaves in the same way toward persons, such as an "aunt," in either parent's lineage). Thus a young child of one clan might logically be classified as a "grandfather" by even an elderly member of another clan because all members of an affinal descent group were grouped together, regardless of generation. The Jesuit also drew the native connection between childbearing and menstruation, both of which were expressions of female power and the woman's close relation to the mysterious forces of nature. The ceremony of new fires can be seen as a minor rite of passage for the women who were usually so honored on fewer occasions than their native brothers.

The "Flatheads," primarily tribes in the Southeast (Choctaw and Catawba) and Pacific Northwest (Salish and Chinook), artificially molded their

Source: P[ierre] de Charlevoix, *Journal of a Voyage to North-America.* 2 vols. (London, 1761), 2:54–57, 109–10.

heads not only with clay but with wood, which pressed against the infant's head as it lay in a cradleboard (see John Lawson below, Doc. 11).

The Indian women are generally delivered without pain, and without any assistance; there are some however who are a long time in labour and suffer severely; when this happens they acquaint the young people of it, who when the sick person is least thinking of it, come shouting in a prodigious manner to the door of her cabbin, when the surprize occasions a sudden fright, which procures her an immediate delivery; the women always lie in their own cabbins; several of them are surprized and bring forth at work or on the road; for others as soon as they perceive themselves near their time, a small hut is built without the village, where they remain till forty days after they are brought to bed [delivered]; I think I remember however to have heard it said, that this is never done except at their first lying-in only.

This term being expired they put out all the fires in the cabbin, to which she is to return; they shake all the cloaths in it, and at her return light a new fire; the same formalities nearly are observed with regard to the sex in general during the time of their courses [menstruation]; and not only while these last, but while a woman is with child, or giving suck [nursing], which they commonly do for three years running, their husbands never come near them; nothing would be more commendable than this custom, provided both parties observed the fidelity they ought all the while, but both sides often fail in this respect; such is the corruption of the heart of man, that the wisest regulations are often productive of the greatest disorders. It is even pretended that the use of certain simples [medicine], which have the virtue of keeping back in women the natural consequences of their infidelity, is familiar enough in this country.

Nothing can exceed the care which mothers take of their children whilst in the cradle; but from the moment they have weaned them, they abandon them entirely to themselves; not out of hard heartedness or indifference, for they never lose but with their life the affection they have for them; but from a persuasion that nature ought to be suffered to act upon them, and that they ought not to be confined in any thing. The act which terminates their state of infancy is the imposition of the name, which amongst the Indians is a matter of great importance.

This ceremony is performed at a feast, at which are present none but persons of the same sex with the child that is to be named; during the repast the child remains on the knees of its father or mother, who are incessantly recommending it to the genii [spirits], and above all to him who is to be his guardian, for each person has one but not from the time of birth; they never invent new names, each family [clan] preserves a certain number of them, which they make use of by turns; they even sometimes change them as they grow older, and there are some which cannot be used after a certain age, but I do not believe this practice to be universal; and as it is the custom amongst some nations on assuming a name, to

put themselves in the place of the person who last bore it, it sometimes happens that a child is called grand-father by a person, who might well enough be his own.

They never call a man by his own name when they speak to him in a familiar manner; this would be a piece of great unpoliteness, they always name him by the relation he bears to the person that speaks to him; but when there is neither affinity nor consanguinity between them; they call one another brother, uncle, nephew or cousin, according to the age of either, or in proportion to the esteem in which they hold the person to whom they address themselves.

Farther, it is not so much with a view of perpetuating names that they renew them, as with a view to incite the person on whom they are bestowed, either to imitate the great actions of the persons that bore them, or to revenge them in case they have been either killed or burned; or lastly to comfort their families: thus a woman who has lost her husband or her son, and finds her herself thus void of all support makes all the haste in her power, to give the name of the person she mourns for, to some one who may stand her in his stead; lastly, they likewise change their names on several other occasions, which it would take up too much time to mention minutely. In order to do this there wants only a dream, or the prescription of some physician, or some other reason equally frivolous.

The care which the mothers take of their children, whilst they are still in the cradle is beyond all expression, and proves in a very sensible manner, that we often spoil all, by the reflec-

tions which we add to the dictates of simple nature. They never leave them, they carry them every where about with them; and even when they are ready to sink under the burthen with which they load themselves, the cradle of the child is held for nothing: and one would even think, that this additional weight were an ease to them and rendered them more agile.

Nothing can be neater than these cradles in which the child lies as commodiously and softly as possible. But the infant is only made fast from the middle downwards: so that when the cradle is upright, the little creatures have their head and the half of the body hanging down; we Europeans would imagine, that a child left in this condition would become entirely decrepid; but quite the contrary happens, this posture rendering the body supple; and they are in fact of a port and stature, which the handsomest among us might look upon with envy. What can we oppose to so general an experience? But what I am going to tell to you is not so easily justified.

There are nations in this continent called flatheads, and which have, in fact, their fore-head very flat, and the crown of their head somewhat raised. This conformation is not the work of nature but of their mothers, who give it to their children gradually from their birth. In order to [do] this, they apply upon the forehead and back part of the head, two masses of clay or of some other heavy matter, which they press together by degrees, till the cranium has taken the form they have a mind to give it. It appears that this operation causes the children to suffer a great deal, as there is a thick and whitish matter which proceeds from

their nostrils: but neither this circumstance nor the cries of the little innocents alarm the mothers, who are above all things desirous of procuring them this point of beauty which they conceive indispensably necessary. Quite the contrary happens among certain Algonquins, whom we have thought fit to call *Tetes de Boule*, or Roundheads, . . . they making their chief beauty to consist in having heads perfectly round, and the mothers likewise begin very early to give them this form.

7. Laboring under Illusions

John Long, an Englishman, came to Canada in 1768 as an indentured clerk to a merchant in Montreal, the center of the Indian trade at that time. "Being at once prepossessed in favor of the savages," he was sent to live with a Mohawk chief at Caughnawaga, an Indian village near Montreal, to learn the Iroquois dialects before returning to his employer to master French. When his seven-year apprenticeship expired in 1775, he joined a party of British-Indian rangers sent to stop American advances into Canada. For the next thirteen years he served as an army scout, interpreter, and fur trader around the Great Lakes, where he was adopted by an Ojibwa (or Chippewa) chief. In 1788 he returned to England, as penniless as he had come, where his *Voyages and Travels of an Indian Interpreter and Trader* was published three years later.

Long is one of the few colonial observers who did not subscribe to the myth of painless Indian childbirth. He saw that native culture suppressed the expression of labor pains in hopes of imparting the mother's stoic courage to her offspring. He also realized that the absence of corporal punishment and compulsion in Indian education was designed to foster independence of mind and action in adulthood, the supreme qualities of most native societies. Observers from large, urban European societies, where social hierarchy and structured dependence prevailed, usually felt that native educational methods bred license and anarchy.

Source: John Long's Voyages and Travels in the Years 1768–1788, ed. Milo Milton Quaife (Chicago: R. R. Donnelley & Sons Co., The Lakeside Press, 1922), pp. 77–80.

About an hour before sunset on the fourth day we stopped at a small creek, which was too deep to be forded, and whilst the Indian was assisting me in making a raft to cross over, rather than swim through in such cold weather against a strong current, I looked round, and missed his wife. I was rather displeased, as the sun was near setting and I was anxious to gain the opposite shore, to encamp before dark. I asked the Indian where she was gone; he smiled, and told me he supposed into the woods to set a collar [snare] for a partridge. In about an hour she returned with a newborn infant in her arms, and coming up to me, said in Chippewa, *"Oway Saggonash Payshik Shomagonish,"* or, "Here, Englishman, is a young warrior." It is said that the Indian women bring forth children with very little pain, but I believe it is merely an opinion. It is true they are strong and hardy, and will support fatigue to the moment of their delivery; but this does not prove they are exempt from the common feelings of the sex on such trying occasions. A young woman of the Rat nation has been known to be in labor a day and a night without a groan. The force of example, acting upon their pride, will not allow these poor creatures to betray a weakness or express the pain they feel, probably lest the husband should think her unworthy of his future attention, and despise both mother and child. At any rate he would tell her the infant, if a boy, would never be a warrior: and if a girl, would have a dastardly spirit, and of course neither of them be fit for a savage life.

I believe it will not be disputed that the Indian women love their children with as much affection as parents in the most civilized states can boast. Many proofs might be adduced to support this assertion. A mother suckles her child till it attains the age of four or five years, and sometimes till it is six or seven. From their infant state they endeavor to promote an independent spirit. They are never known either to beat or scold them, lest the martial disposition which is to adorn their future life and character should be weakened; on all occasions they avoid everything compulsive, that the freedom with which they wish them to think and act may not be controlled. If they die, they lament their death with unfeigned tears, and even for months after their decease will weep at the graves of their departed children. The nation of savages called *Biscatonges,* or by the French, *Pleureurs* [*Criers*], are said to weep more bitterly at the birth of a child than at its decease, because they look upon death only as a journey from whence he will return, but with regard to his birth, they consider it an entrance into a life of perils and misfortunes.

As soon as a child is born, if in summer, the mother goes into the water and immerses the infant. As soon as this is done, it is wrapped up in a small blanket and tied to a flat board, covered with dry moss, in the form of the bottom of a coffin, with a hoop over the top where the head lies, to preserve it from injury. In winter it is clad in skins as well as blankets. In the heat of summer gauze is thrown over the young savage to keep off the mosquitoes, which are very troublesome in the woods. The board on which the child is placed is slung to the mother's forehead with a broad worsted belt

[tumpline], and rests against her back.

When the French took possession of Canada the women had neither linen nor swaddling clothes. All their child-bed furniture consisted of a kind of trough, filled with dry rotten wood dust, which is as soft as the finest down and well calculated to imbibe the moisture of the infant. On this the child was placed, covered with rich furs, and tied down with strong leather strings. The dust was changed as often as necessary till the child was weaned.

Among the Indians who are in any degree civilized, the women feed their children with pap made of Indian corn and milk, if it can be obtained, but in the parts more northern and re-mote from Europeans, wild rice and oats are substituted, which being cleansed from the husk and pounded between two stones, are boiled in water with maple sugar. This food is reckoned very nourishing, and with broth made from the flesh of animals and fish, which they are frequently able to procure, cannot fail of supporting and strengthening the infant. Among several of the tribes of Indians pap is made of sagavite [sagamité, a porridge of boiled corn], from a root they call toquo, of the bramble kind. This is washed and dried, afterward ground or pounded and made into a paste, which being baked is pleasant to the taste, but of a very astringent quality. It is their common bread.

8. The Pains of Sin in New England

When Roger Williams was banished from Massachusetts in 1635, he moved his family to Narragansett Bay, where he purchased land from the Indians and the following year founded Providence, Rhode Island. There he continued his ministerial calling and cultivated the friendship of the powerful Narragansett Indians who lived around the bay. He lived with them, preached to them, and learned their language as few white men have since. In 1643, when he went to London to obtain a royal charter for his new colony, he published the first extensive Indian vocabulary in the English language. *A Key into the Language of America* consisted of Indian vocabulary and English translations followed by commentaries upon various aspects of native culture.

Source: Roger Williams, *A Key into the Language of America* (London, 1643), pp. 148–50.

In speaking of God's "curse" upon women, Williams referred to 1 Timothy 2:14–15 (King James Version): "And Adam was not deceived, but the woman [Eve] being deceived was in transgression. Notwithstanding she shall be saved in childbearing, if they continue in faith and charity and holiness with sobriety." In other words, labor pains were woman's reward for Eve's original sin. The addition of America to the known European geography of the world, coupled with the apparent painless deliveries of Indian babies, led some observers to ask whether Indian women were not exempt from the divine curse and therefore somehow outside the course of Christian history (see the next selection from Adriaen Van der Donck, Doc. 9).

Nummíttamus.	*My Wife.*
Nullógana.	
Waumaûsu.	*Loving.*
Wunnêkesu.	*Proper.*
Maânsu.	*Sober and chast[e].*
Muchickéhea.	*Fruitfull.*
Cutchashekeâmis?	*How many children have you had?*
Nquittékea.	*I have had one.*
Neesékea.	*Two, &c.*

Obs[ervation]. They commonly abound with Children, and increase mightily; except the plague fall amongst them or other lesser sicknesses, and then having no meanes of recovery, they perish wonderfully [surprisingly].

Katoû eneéchaw.	*She is falling into Travell [labor].*
Néechaw.	*She is in Travell.*
Paugcótche nechaúwaw.	*She is already delivered.*
Kitummâyi-mes-néchaw.	*She was just now delivered.*

Obs. It hath pleased God in wonderfull manner to moderate that curse of the sorrowes of Child-bearing to these poore Indian Women: So that ordinarily they have a wonderfull more speedy and easie Travell, and delivery then the Women of *Europe:* not that I think God is more gracious to them above other Women, but that it followes, First from the hardnesse of their constitution, in which respect they beare their sorrowes the easier.

Secondly from their extraordinary great labour (even above the labour of men) as in the Field, they sustaine the labour of it, in carrying of mighty Burthens, in digging clammes and getting other Shelfish from the Sea, in beating all their corne in Morters: &c. Most of them count it a shame for a Woman in Travell to make complaint, and many of them are scarcely heard to groane. I have often

knowne in one Quarter of an houre a Woman merry in the House, and delivered and merry againe: and within two dayes abroad, and after foure or five dayes at worke, &c.

Noosâwwaw.	*A Nurse.*
Noònsu Nonánnis.	*A sucking Child.*
Wunnunògan.	*A Breast.*
Wunnunnóganash.	*Breasts.*
Munnúnnug.	*Milke.*
Aumáúnemun.	*To take from the breast, or Weane.*

9. Easing Birth along the Hudson

The best evidence for the belief that the Indians might have been exempt from Eve's curse comes from Adriaen Van der Donck. After earning doctorates in both civil and canon law from the University of Leyden, he came to New Netherland in 1641, still in his early twenties, as the resident legal officer for the huge Van Rensselaer patroonship along the Hudson River. During the next eight years he gained a deep knowledge of the land and its native inhabitants, which served him well in 1645 when he helped end the bloody war that Governor Willem Kieft had started against the river Indians. For his services he was allowed to purchase from the Indians some 24,000 acres where Yonkers, New York, now stands.

When Peter Stuyvesant became governor in 1647, Van der Donck soon became the leader of Stuyvesant's thorniest opponents, the Board of Nine Men. In 1649 he returned to Holland to protest the governor's mismanagement before the States General. Five years of unraveling bureaucratic red tape provided Van der Donck with the time to write his *A Description of the New Netherlands* (1655).

Van der Donck also documents the native practice of sexual abstinence by nursing mothers, an untypically short period of breast-feeding (if he is correct), and the use of medicines to ease childbirth, which were still being

Source: Adriaen Van der Donck, *A Description of the New Netherlands,* 2nd ed. (Amsterdam, 1656), trans. Jeremiah Johnson, *Collections of the New-York Historical Society,* 2d ser. 1 (1841), 200–201.

used by the Iroquois in the following century. In 1769 Dr. Benjamin Gale of Killingworth, Connecticut, requested Samuel Kirkland, a Protestant missionary among the Oneidas, to "make Enquiry, what Medicines the Indian Parturient Women take antecedent to Delivery which occasions so easy a Travail—they have given some of our [English] Captives Medicines which have had very Extraordinary Effects to Ease their Travail Pains" (Gale to Eleazar Wheelock, 21 July 1769, Wheelock Papers, Dartmouth College Library, Hanover, N.H.).

Whenever a native female is pregnant, in wedlock or otherwise, they take care that they do no act that would injure the offspring. During pregnancy they are generally healthy, and they experience little or no sickness or painful days, and when the time of their delivery is near (which they calculate closely), and they fear a severe accouchement [delivery], or if it be their first time, then they prepare a drink made of a decoction of roots that grow in the woods, which are known by them, and they depart alone to a secluded place near a brook, or stream of water, where they can be protected from the winds, and prepare a shelter for themselves with mats and covering, where, provided with provisions necessary for them, they await their delivery without the company or aid of any person. After their children are born, and if they are males, although the weather be ever so cold and freezing, they immerse them some time in the water, which, they say, makes them strong brave men and hardy hunters. After the immersion they wrap their children in warm clothing and pay them great attention from fear of accidents, and after they have remained several days in their secluded places, again return to their homes and friends. They rarely are sick from childbirth, suffer no inconveniences from the same, nor do any of them die on such occasions. Upon this subject some persons assign, as a reason and cause for their extraordinary deliveries, that the knowledge of good and evil is not given to them, as unto us; that therefore they do not suffer the pains of sin in bringing forth their children; that such pains are really not natural, but the punishment which follows the knowledge of sin, as committed by our first mother [Eve], and is attached to those only; others ascribe the cause of the difference to the salubrity of the climate, their well-formed bodies, and their manner of living.

The native Indian women of every grade always nurse their own children, nor do we know of any who have trusted that parental duty to others. About New Amsterdam, and for many miles and days' journey into the interior, I have never heard of but a few instances of native women, who did not take good care of their children, or who trusted them to the nursing and care of others; when they suckle or are pregnant, they in those cases practice the strictest [sexual] abstinence, because, as they say, it is beneficial to their offspring, and to nursing children. In the meantime, their women are not precise or offended, if

their husbands have foreign associa-
tions [extra-marital sex], but they ob-
serve the former custom so religiously,
that they hold it to be disgraceful for
a woman to recede from it before her
child is weaned, which they usually do
when their children are a year old,
and those who wean their children be-
fore that period are despised. During

a certain season [menstruation], their
women seclude themselves, and do not
appear abroad or permit themselves to
be seen of men; if they are at one of
their great feasts or public assemblies,
and the fountain springs, they retire
immediately if possible, and do not
appear abroad again until the season
is over.

10. Moravian Indian Mothers

David Zeisberger, a Moravian missionary, came to America with his family
from Saxony at the age of sixteen (1737). In Pennsylvania and New York he
learned the Delaware and Iroquois languages while attempting to convert
the natives to Christianity. He was so trusted by the Iroquois that their
record keepers entrusted the league records (wampum belts) to Zeisberger's
house. From the close of frontier hostilities in 1763, he spent the rest of his
life trying—unsuccessfully—to preserve his villages of converted Indians,
largely Delawares and Mahicans, from white vices and frontier vigilantes,
to whom "the only good Indian was a dead Indian." During the American
Revolution he was forced to take his flock into British Canada, but he re-
turned in 1798 to Fairfield, the site of his first and most promising village in
Ohio. The *History of the Northern American Indians* was written in 1780
for the use of George Henry Loskiel, a Moravian bishop who was writing a
history of his denomination's missions.

 Written late in the colonial period, Zeisberger's account describes several
persistent features of native culture as well as a number of changes wrought
during, but not always by, prolonged contact with European colonists. Sex-
ual abstinence during nursing seems to have persisted, as did the occasional
use of formal ceremonies to confer names (though Zeisberger was wrong in

Source: David Zeisberger's History of the Northern American Indians, ed. Archer Butler
Hulbert and William Nathaniel Schwarze (Columbus: Ohio State Archaeological and His-
torical Society, 1910), pp. 80–81, 85.

23

thinking that Indian people were "ashamed" of their own names; calling a person by his kinship classification, such as "grandfather," was considered more respectful). One important change—among Zeisberger's converts, at least—was the gradual disuse of cradleboards, brought about by the altered economic role of the convert women, who abandoned the fields to their husbands for more solitary housework in English-style cabins with large, open fireplaces.

The Indian women are in general of a very strong bodily constitution. There are generally clever and experienced women enough who are able to give assistance and advice in time of labor; generally, women will remain in the house at this time. Some go into the woods by themselves and bring their children to the house when they have seen the light of day. Most mothers nurse their children until they are two or more years old. During this time many husbands have concubines, though not in the house.

If it is left to the mother to give the child a name, she uses little ceremony and calls it after some peculiar mark or character in it, for instance the Beautiful, the Good Child, the Great-Eye, sometimes giving it a name of unsavory meaning. If the father gives the child a name he pretends that it has been suggested to him in a dream. The name is given at a sacrifice [feast], on which occasion the Indian brings to some aged person, who performs the offering, a string of wampum, and tells him that he wishes his child's name to be named thus and so. During the sacrifice some other person sings a song in Indian fashion at a public gathering and makes known the child's name. This is called praying over the child. The same ceremony is performed when an adult person re-

ceives a name, even although he may already have been named. It is not common to call an adult by his name, for they are ashamed of their own names. If the attention of any one is to be attracted it is done in some other fashion than by the use of the name. In case of children, the names are used. In assemblies and in discourses they do not use the name of any one who is present, though absent persons are referred to by their names.

The children have entirely their own will and never do anything by compulsion. Told to do something they do not care about, the children let it go by default and are not reprimanded for it. Yet many wellbred children are found among them who pay great attention and respect to parents and do things to please them. They are courteous, even to strangers. They respond to mild treatment. The contrary [i.e., harsh treatment] generally produces bitterness, hatred and contempt. The women are frequently guilty of thus raising their children to anger, for the women are often ill-tempered. By way of punishment, they will pour water on the children or thrust them into the water. The parents are careful not to beat their children, lest the children might remember it and revenge themselves on some future occasion. Instances are not

wanting where children when grown have reproached their parents for corporal punishment received in youth and have threatened to return the indignity.

Families have from four to six children. More than this number is unusual. Birth of twins is rarely heard of. In many cases children who have become motherless after birth have been reared by careful old women. Sometimes children are given to such women. Then they spare no pains in rearing them. Soup made of Indian corn, pounded very fine, is given by them to infants of tender age, that may have come into their possession. Ordinarily, orphans, even if they have lost but the mother, meet with hard experience and often suffer want. Children who have been given or bequeathed, on the contrary, are almost without exception well cared for.

Mothers carry the children on their backs under the blanket. They do this even when the children are five years old and over, for they love their children. In former days it was the custom to bind the child upon a board which was carried by means of a band fastened round the head in such a way that the child was suspended on the back in an upright position. This practice gets more and more out of fashion, for the reason that it has been the cause of miserable death of the children. It was customary that children thus fastened were placed against a bench or elsewhere, the mother going to fetch water or on some other errand. The children by pushing and kicking not infrequently tumbled themselves into the fire or other danger and thus miserably perished, or were severely burned. For this reason the custom is in disfavor.

ii. The Uses of a Carolina Cradleboard

Indian childbearing practices in the upper South differed little from those in the North, according to the observations of a well-travelled English gentleman and man of science, John Lawson. Lawson came to North Carolina in 1700, where he helped to found Bath Town, the colony's first town, and New Berne, the site of his home on what is still known as Lawson's Creek. Active in colonization and surveying for eight years, during which time he travelled more than a thousand miles through Indian country, he

Source: John Lawson, *A New Voyage to Carolina* (London, 1709), pp. 189-90.

returned to London in 1709 to attend the publication of his book *A New Voyage to Carolina.* He was killed by Tuscarora Indians in 1711 while exploring the Neuse River.

Lawson provides reliable evidence of the use of native medicines to ease labor pains, and reveals the interesting detail that Indian fathers crafted the cradleboards, upon which some children in the South had their heads flattened into culturally desirable shapes. He may have been on shakier ground when he asserted that Indian women were strangers to severe postpartum pains. In the face of traditional Indian stoicism, he probably lacked reliable (female) sources of information.

The Savage Women of *America,* have very easy Travail with their Children; sometimes they bring Twins, and are brought to bed [delivered] by themselves, when took at a Disadvantage; not but that they have Midwives amongst them, as well as Doctors, who make it their Profession (for Gain) to assist and deliver Women, and some of these Midwives are very knowing in several Medicines that *Carolina* affords, which certainly expedite, and make easy Births. Besides, they are unacquainted with those severe Pains which follow the Birth in our *European* Women. Their Remedies are a great Cause of this Easiness in that State; for the *Indian* Women will run up and down the Plantation, the same day, very briskly, and without any sign of Pain or Sickness; yet they look very meager and thin. Not but that we must allow a great deal owing to the Climate, and the natural Constitution of these Women, whose Course of Nature [menstrual period] never visits them in such Quantities, as the *European* Women have. And tho' they never want Plenty of Milk, yet I never saw an *Indian* Woman with very large Breasts; neither does the youngest Wife ever fail of proving so good a

Nurse, as to bring her Child up free from the Rickets and Disasters that proceed from the Teeth, with many other Distempers which attack our Infants in *England,* and other Parts of *Europe.* They let their Children suck till they are well grown, unless they prove big with Child [pregnant] sooner. They always nurse their own Children themselves, unless Sickness or Death prevents. I once saw a Nurse hired to give Suck to an *Indian* Woman's Child. . . . After Delivery, they absent the Company of a Man for forty days. As soon as the Child is born, they wash it in cold Water at the next Stream, and then bedawb it [with "Bears Oil, and a Colour like burnt Cork"]. After which, the Husband takes care to provide a Cradle, which is soon made, consisting of a Piece of flat Wood, which they hew with their Hatchets to the Likeness of a Board; it is about two Foot long, and a Foot broad; to this they brace and tie the Child down very close, having, near the middle, a Stick fasten'd about two Inches from the Board. which is for the Child's Breech to rest on, under which they put a Wad of Moss, that receives the Child's Excrements, by which means they can shift the Moss,

and keep all clean and sweet. Some Nations have very flat Heads . . . which is made whilst tied on this Cradle. . . . These Cradles are apt to make the Body flat; yet they are the most portable things that can be invented; for there is a String which goes from one Corner of the Board to the other, whereby the Mother slings her Child on her Back; so the Infant's Back is towards hers, and its Face looks up towards the Sky. If it rains, she throws her Leather or Woollen Match-coat, over her Head, which covers the Child all over, and secures her and it from the Injuries of rainy Weather. The Savage Women quit all Company, and dress not their own Victuals, during their Purgations [menstruation].

After they have had several children, they grow strangely out of Shape in their Bodies; As for Barrenness, I never knew any of their Women, that have not Children when marry'd.

12. From an Indian Mother's Mouth

As valuable as they often are, the second-hand observations of European men cannot fully fathom the female experience of giving birth to an Indian baby. For that we must rely on the testimony of an Indian woman, such as the Fox woman who in 1918 related her life's story to anthropologist Truman Michelson. Born in the late nineteenth century, she lived in Indian communities throughout the Midwest, many of whose ways had not changed since the seventeenth century when Nicolas Perrot met her ancestors in Wisconsin. So "naïve and frank" was her autobiography that even the anthropologist felt compelled to delete a "few sentences" for the sake of "European taste." The excisions must have been small because what remains wears no false modesty or "civilized" trappings. The following excerpt vividly describes: the real pains of childbirth; one of many Indian reasons for eschewing corporal punishment; the helpers present at a woman's first delivery; the continued use of the cradleboard to mold straight, undeformed bodies; and the rich variety of taboos surrounding pregnancy, which

Source: "The Autobiography of a Fox Indian Woman," ed. and trans. Truman Michelson, U.S. Bureau of American Ethnology, *Annual Report,* no. 40 (Washington, D.C., 1925), pp. 315–21.

differed little from the learned advice of seventeenth-century European physicians, who also wished to avoid "marking" the fetus in utero.

And when I had been living with him [her husband] for half a year, soon I ceased having catamenial flows. Thereupon I was given instructions again, "Well, this is what has happened: probably you are to have a child. When anything is cooked and it is burned, it must not be eaten so that children's afterbirths will not adhere. And nuts are not to be eaten, so that the babies will be able to break through the caul [amniotic membrane]. And in winter, one is not to warm their feet, so that the babies will not adhere (to the caul). And (women) are not to join their feet to those of their husbands, so that (the babies) will not be born feet-first. And the feet of no (animals) are to be eaten. And one must be careful not to touch crawfish. Also, if these are touched when one is enceinte [pregnant], the babies will be born feet-first. It is said that (women) have a hard time when they are born that way. That is why one believes and fears (what one has been told), so that one will not suffer a long time at childbirth. It is better to do what we are told. And no corpse is to be touched. If it is touched the babies would die after they are born, by inheriting it. And if the dead are looked at, they are to be looked at with straight eyes. Also it is said that if they are looked at slantingly, the babies will be cross-eyed. And if cranes are touched, the babies will always look upward. The children will not be able to look upon the ground. And when any one drowns, if he is touched, the babies would die. These are the number of things one is forbidden to do. And it is told that one should carry wood always on one's back so that the babies will be loosened (i.e., born easily). Again, after (a woman) knows that she is pregnant, she is to cease to have anything to do [sexually] with her husband. (Otherwise) the babies will be filthy when they are born. When their parents do not observe this, (the babies) begin to move around. That is the rule when that happens. For we women have a hard time at childbirth. We suffer. Some are killed by the babies. But we are not afraid of it, as we have been made to be that way. That is probably the reason why we are not afraid of it. Oh, if we were all afraid of it, when we all became old, that is as far as we could go. We should not be able to branch out (to a new generation). So at childbirth we should do only what we are told. The ones who do not do as they are told are the ones who are injured by their children."

I have now told you all how it is, though I did not know about this, namely, how hard childbirth is. Even at this time I was not able to know about it. Only after I had given birth (to a child) would I know how hard it is. Soon surely my abdomen grew large. I was ashamed. When there was a dance I did not go there as I was ashamed.

Soon after eight months were by, my mother-in-law came. She came to talk with my mother. "Now is the time when she is on the point of giving birth (to a child). We should build

(a little wickiup [a brush shelter]) beforehand for her so that she may be delivered there. That is why I took my time coming, (thinking) she might be sick [go into labor] at night," she said to my mother. They built it. After they built it, she said to my mother, "Well, you may summon me whenever she is sick."

Soon I became sick in the evening when lying alone. I did not tell of it. Soon I was told, "You might be sick?" "Yes," I answered, "I am sick and have a little pain in the small of my back," I said to my mother. "Oh ho," she said, "very likely now is the time when you are to have a child. I shall summon her. For she said, 'you will summon me.'" In a little after she came, she said to me, "Come, go to the little wickiup." (Blankets) were spread for me. When I sat down comfortably a strap was fastened from above. "You are to hold on to this when you begin to feel intense pain," I was told. I then felt more intense pain. After a while I was told, "Lie down. When you begin to suffer acute pain you are to try to sit up. You are to sit on your knees and you are to sit erect." I did so. I would hold on to the strap. (The child) could not be born.

After midnight I was nearly unable to get up. The women who were attending me became frightened. Then they said among themselves, "We shall pray (for help)." My mother-in-law took Indian tobacco and went to a woman skilled in obstetrics for help. And when that woman came, she at once boiled some medicine. After she had boiled it, she said: "Let her in any case sit up for a while. You must hold her so that she will not fall over." After I was made to sit up, she spat

upon my head; and she gave me (the medicine) to drink. After she had given me (the medicine) to drink, she began singing. She started to go out singing and went around the little wickiup singing. When she danced by where I was, she knocked on the side. "Come out if you are a boy," she would say. And she would again begin singing. When she danced by she again knocked the side. "Come out if you are a girl," she would say again. After she sang four times in a circle, she entered (the wickiup). And she gave me (medicine) to drink. "Now it will be born. She may lie down. Only lay her down carefully. You must hold her knees straight up," she said. Lo, sure enough, a little boy was born.

Then I knew how painful childbirth was. After I had borne (the child) I was not in pain in any spot. I was well. They cut off the baby's navel with one inch of the cord on it. A brand-new pair of scissors was used. They tied up the place where he was cut. His belly was washed. The next day he was placed in a cradle [board]. And they tied a little piece of meat on his navel with a cloth going around (his body), tying it on his abdomen. "You must moisten him once in a while so that his umbilical cord will drop off soon," I was told. I did so to him. I did not wash him myself. My mother attended to him for me. In three days his umbilical cord dropped off. He could not draw the milk out for two days when I nursed him.

Then, "You must always keep him in a cradle: (otherwise) he might have a long head, (or) he might be humpbacked, (or) he might be bow-legged. That is why they are placed carefully, so they will (not) be that way. When

they are tied that way they will be straight. They are kept in cradles for nearly one year. Again, they are not to be held all the time. They are placed in a swing after they suckle so that they will not be a nuisance. They become trained to be left alone when one goes some place, if they are not cry-babies. And when they are constantly held some cry when they are laid down. (People) are bothered by them when they get them used to being constantly held," I was told.

I lived outside [of her home] for thirty-three days.

Then soon my husband began to act differently. He did not treat me at all the way he had done when he was acting nicely. The fact of the matter is that the young woman with whom I used to go around before I was married had been telling him something. "You are treating her so well, but your wife formerly was the same as married to another man. (That is) what I know about her. 'We shall never stop talking to each other even if we marry other (persons),' they said to each other," she kept on telling him. Finally he apparently really believed her. From that time on he began to treat me badly. That young woman was made jealous because he treated me well. That was why she kept on telling him stories. As

for her, the men would not marry her as she was immoral. Finally (my husband) began to beat me.

"That is why I formerly forbade you to talk to any men. That is why I said to you, 'You must talk only to the one whom you are to marry,'" my mother said to me. "Finally you will make your son angry if you are always having trouble with each other. Babies die when they become angry," I was told.

Soon, when our little boy nearly knew how to talk, he became ill. I felt very sorrowful. Later on, indeed, he died. It is surely very hard to have death (in the family). One can not help feeling badly. "That is why I told you about it when you were both unfortunately frightening him," I was told. "That is why children are not struck. One would feel worse if one had beaten (the child)," I was told. I felt worse after he was buried. The fourth day we fed those who buried him in the evening. We began to make every kind of new finery. After we had made it, I began to think over the one whom we should adopt. I thought of all the babies. I found one as if this way: "This one perhaps is loved as much as I loved my baby," I thought. Then we adopted him, so that we in a way had a son.

TWO:
Coming of Age

The Indian child in eastern America moved from the cradleboard into a relatively uninhibited world of individual initiative and freedom. Its bones having been set straight by swaddling in the first months of life, the child was now expected to learn to walk the narrow paths of culture by following its own developing sense of reason. In contemporary European societies, physical compulsion and parental coercion were deemed the best ways to mold the cultureless child into a social adult. But the Indian societies of the East feared that such methods would produce timorous slaves rather than the courageous and proud individualists their societies required and desired. Therefore they relied less upon negative sanctions, such as corporal punishment, than upon positive inducements, such as the example of elders, frequent praise, and enhanced public reputation. When a wayward child needed correction, public shame and ridicule were usually effective in the small, face-to-face communities in which they lived. Withdrawal of maternal affection was especially useful in matrilineal groups, where fathers participated in the education of their children less than mothers and maternal aunts and uncles, and where men were absent much of the year on hunting, trading, and warring expeditions. Even the southeastern tribes who "dry-scratched" their youthful offenders with sharp fish teeth did so less with the intent of hurting the child than with having the visible scratches serve as public badges of shame.

Almost as soon as children could toddle, they were introduced to the economic roles appropriate to their sex. Boys hunted small game and birds with miniature bows and arrows, set traps, and stalked each other in war games. Girls worked beside their female relatives in the fields and house, learning by imitation to make clothes and moccasins for dolls, plant and weed corn, and weave mats, baskets, and burden straps. Indian adults knew well what many modern parents have forgotten—that play is serious business to a child and that the best way to learn is through playful emulation. Social relations were probably learned in a more serious spirit. Age brought increased awareness of and responsibility toward one's clansmen, especially the "grandmothers" and "grandfathers" to whom one owed the greatest

respect, not least for the care they bestowed on their "grandchild's" moral education.

As children grew physiologically older, they also approached social puberty, which was marked in all the eastern tribes by special rites of passage. Boys began to form lifelong "particular friendships" with male contemporaries, perhaps partly as an answer to the closer sodalities of women in their largely horticultural and matrilineal communities. When a boy killed his first big game, and again when he performed some deed of bravery on the warpath, he was feted and given a new name to replace his childhood nickname. A more solemn occasion was a successful vision quest, in which a young man—less frequently a young woman—dreamed of a spiritual guardian who would guide his actions and give him confidence for the rest of his life. These visions normally followed a period of fasting and other sensory deprivation alone in the woods. Other forms of social initiation required longer and more arduous communal trials. In most tribes, potential religious and political leaders were selected by rituals in which the child candidates were ritually "killed" to be "resurrected" as adults who had literally forgotten the things of childhood. All these occasions involved separation from the world of women and children, strict dietary and other taboos, and public rites of incorporation into the company of men.

Both men and women were isolated from the community during the occurrence of those events associated with being either male or female. While boys required considerable public ceremony (in lieu of obvious physical change) to become men, girls experienced a sudden and discernible physiological transition to womanhood. With the onset of menstrual discharge came the community's attribution of heightened supernatural power, which made her an object of fear and reverence. Dreams occurring during her period were hearkened to as specially significant, but otherwise her touch and look were avoided like the plague to which she was likened. While European male observers interpreted her seclusion as onerous and shameful, she herself may have looked forward to a monthly respite from the work routines and close personal demands of village life (except in cold weather) and taken secret pleasure in her novel power. Considering the perceptible mood changes in most menstruating women (whether physiologically or socially caused), segregation may have helped preserve the delicate balance of feelings in her face-to-face society.

13. Childrearing on the Great Lakes

According to the Jesuit priest Pierre de Charlevoix, the childrearing techniques of the Miami and Potawatomi Indians he met in Michigan in 1721 closely resembled those of the other Algonquian tribes he had met in Canada. Emphasizing the personal search for "glory" and "honor," they employed emulation and precept rather than compulsion, threats, or corporal punishment. Only natives who had chosen to emulate their French trading partners, allies, and priests learned to wield the unsubtle European rod. In an aboriginal setting, Charlevoix also noted, Indian children threatened suicide if they were reprimanded in a way that seemed to compromise their growing sense of personal dignity. That the threats were sometimes carried out added weight to the children's grasp for independence. For all his approval of the native *mode* of inculcating virtue, Charlevoix's culture-bound Christian inheritance led him to denigrate the *content* of Indian virtue. By "virtue," of course, he meant the cultural values of Western Europe, which were often incompatible with native values. Missionaries such as Charlevoix, therefore, sought to plant their own values in Indian children. But as they quickly discovered, European messages could not be transmitted with Indian media.

The children of the Indians after leaving off the use of the cradle, are under no sort of confinement, and as soon as they are able to crawl about on hands and feet, are suffered to go stark naked whereever they have a mind, through woods, water, mire and snow; which gives them strength and agility, and fortifies them against the injuries of the air and weather; but this conduct . . . occasions weaknesses in the stomach and breast, which destroy their constitution very early. In the summer time they run the moment they get up to the next river or lake, where they remain a great part of the day playing, in the same manner we see fishes do in good weather, near the surface of the water. Nothing is more proper than this exercise to render the body active.

They take care likewise to put the bow and arrow into their [sons'] hands betimes; and in order to excite in them that emulation which is the best mistress of the arts, there is no necessity of placing their breakfast on the top of a tree, as was formerly done to the Lacedemonian youth; they are all born with so strong a passion for

Source: P[ierre] de Charlevoix, *Journal of a Voyage to North-America,* 2 vols. (London, 1761), 2:113–16.

glory, as to have no need of a spur; thus they shoot their arrows with wonderful exactness, and it scarce costs them any trouble to arrive at a like dexterity in the use of our firearms. They also cause them [to] wrestle together, and so keen are they in this exercise, that they would often kill one another, were they not separated in time; those who come off with the worst, are so mortified at it that they can never be at rest till they have had their revenge.

We may in general say, that fathers and mothers neglect nothing, in order to inspire their children with certain principles of honour which they preserve their whole lives, but which are often ill enough applied; and in this consists all the education that is given them. They take care always to communicate their instructions on this head, in an indirect manner. The most common way is by rehearsing to them the famous exploits of their ancestors or countrymen: the youth take fire at these recitals, and sigh for an opportunity of imitating what they have thus been made to admire. Sometimes in order to correct their faults they employ tears and entreaties, but never threats; these would make no manner of impression on minds which have imbibed this prejudice, that no one whatever has a right to force them to any thing.

A mother on seeing her daughter behave ill bursts into tears; and upon the other's asking her the cause of it, all the answer she makes is, Thou dishonourest me. It seldom happens that this sort of reproof fails of being efficacious. Notwithstanding, since they have had a more frequent commerce with the French, some of them begin to chastise their children, but this happens only among those that are Christians, or such as are settled in the colony. Generally the greatest punishment which the Indians make use of in chastising their children, is by throwing a little water in their face; the children are very sensible of this, and in general of every thing that looks like reproof, which is owing to this, that pride is the strongest passion at this age.

Young girls have been known to strangle themselves for a slight reprimand from their mothers, or for having a few drops of water thrown in their face, warning them of what was going to happen in such words as these, *You shall not have a daughter long to use so.* The greatest evil in this sort of education, is that what they exhort young people to is not always virtue, or that what comes nearly to the same thing, that the ideas they give them of it are not just. In fact, nothing is so much instilled into them, whether by precept or example, as an implacable desire of revenge.

It would seem . . . that a childhood so ill instructed, should be followed by a very dissolute and turbulent state of youth; but on one hand the Indians are naturally quiet and betimes masters of themselves, and are likewise more under the guidance of reason than other men; and on the other hand, their natural disposition, especially in the northern nations, does not incline them to debauchery. They however have some usages in which no sort of regard is paid to modesty; but it appears that in this, superstition has a much greater share than a depravation of heart.

14. Huron Mischief

Gabriel Sagard's year-long stay among the Hurons from 1623 to 1624 gave him some knowledge of how their children from an early age were prepared for different adult sex roles. But his own cultural background—formally learned, celibate, French, and Christian—led him to condemn several native practices whose values he did not share. Frustrated by his inability to impose "correction," he silently suffered the mischief of Huron boys who treated the priests—as did many adults—as troublesome outsiders, played games that were educational for their culture, and resisted the sedentary acquisition of literary skills whose only utility lay in some promised future. Sagard's disapproval of the sexual "evil" learned early by Huron girls must have been heightened by "their continual importunity and requests to marry us, or at least make a family alliance with us," a necessity for other strangers in that kin-oriented society (*Long Journey*, p. 125). By the same token, he did not appreciate the unfeigned hospitality in a Huron man's offer of his wife or daughter to a stranger for the duration of his stay. Blinded by his focus on the act's contravention of his standards of sexual propriety, he failed to recognize that no stranger could long survive in Huronia without a woman to provide food and a matrilocal residence to provide shelter, fire, and the cooperation of her male relatives. His remarks about the girls' "improper language" should not be misinterpreted either. While the eastern Indians were free with the language of bodily parts and functions, about which they felt no "civilized" shame, they did not learn to swear until taught by Europeans.

The usual and daily practice of the young boys is none other than drawing the bow and shooting the arrow, making it rise and glide in a straight line a little higher than the ground. They play a game with curved sticks [snowsnakes], making them slide over the snow and hit a ball of light wood, just as is done in our parts; they learn to throw the prong with which they spear fish, and practise other little sports and exercises, and then they put in an appearance at the lodge at mealtimes, or else when they feel hungry. But if a mother asks her son to go for water or wood or do some similar

Source: Father Gabriel Sagard, *The Long Journey to the Country of the Hurons,* ed. George M. Wrong, trans. H. H. Langton (Toronto: The Champlain Society, 1939), pp. 132–34.

household service, he will reply to her that this is a girl's work and will do none of it. If sometimes we [the Recollect missionaries] got them to perform similar services it was on condition that they should always have access to our lodge, or for some pin, feather, or other little thing for adorning themselves, and this satisfied them very well, and us also, as a return for the small and petty services rendered us.

There were, however, some mischievous boys who delighted in cutting the cord that held up our door after the manner of the country, so as to make it fall when one opened it, and then afterwards they would deny it absolutely or take to flight. Moreover they never admit their faults or tricks, being great liars, except when they have no fear of being blamed or reproached for them, for though they are savages and incapable of receiving correction they are at the same time very proud and covetous of honour, and do not like to be thought mischievous or naughty, although they may be so.

We had made a beginning of teaching them their [alphabetical] letters, but as they are all for freedom and only want to play and give themselves a good time, as I said, they forgot in three days what we had taken four to teach, for lack of perseverance and for neglect of coming back to us at the hours appointed them; and if they told us that they had been prevented because of a game, they were clear [exonerated]. Besides, it was not yet advisable to be severe with them or reprove them otherwise than gently, and we could only in a complaisant manner urge them to be thorough in

gaining knowledge which would be such an advantage to them and bring them satisfaction in time to come.

Just as the little boys have their special training and teach one another to shoot with the bow as soon as they begin to walk, so also the little girls, whenever they begin to put one foot in front of the other, have a little stick put into their hands to train them and teach them early to pound corn, and when they are grown somewhat they also play various little games with their companions, and in the course of these small frolics they are trained quietly to perform trifling and petty household duties, sometimes also to do the evil that they see going on before their eyes, and this makes them worthless for the most part when grown up, and with few exceptions worse even than the boys, boasting often of the wickedness which should make them blush. They vie with one another as to which shall have the most lovers, and if the mother finds none for herself she freely offers her daughter and the daughter offers herself, and the husband also sometimes offers his wife, if she be willing, for some small and trifling present; and there are procurers and wicked people in the towns and villages who apply themselves to no other occupation than that of offering and bringing some of these creatures to the men who desire them. I give praises to our Lord that the women received our reproofs in quite good part, and finally began to practise modesty and show some shame at their dissoluteness, no longer venturing, except very rarely, to make use of improper language in our presence; and they were full of admiration and approval of the propriety of the girls

in France of whom we told them. This gave us hopes of great amendment and alteration of their mode of living in a short time, if the Frenchmen [fur traders] who came up with us, most of them, had not told them the contrary, in order always to be able, like beasts, to enjoy their sensual pleasures to the full, in which they wallowed, even keeping together groups of these bad girls in several places, so that those who should have seconded us in teaching and being a good example to these people were the very ones who went about destroying and obstructing the good that we were building up for the salvation of the tribes and for the advancement of the glory of God. There were, however, some good men, virtuous and of good life, with whom we were well content and from whom we received spiritual encouragement, just as, on the contrary, we were scandalized by those other brutal, godless, and sensual men who hindered the conversion and amendment of these poor folk.

15. Particular Iroquois Friends

Another missionary who tried to alter the direction of Indian childrearing—but gave us an invaluable description of some of its features as he did so—was Joseph François Lafitau. Born in the busy port city of Bordeaux, he joined the Jesuit order at the age of fifteen (1696) and began his climb up the rungs of the order's educational ladder. After studying and teaching grammar, rhetoric, and the humanities at various colleges, he was granted a request to join the Canadian missions. In 1712 he reached Sault St. Louis (later Caughnawaga), the Iroquois mission village (predominantly Mohawk) on the south shore of the St. Lawrence opposite Montreal, where he remained for six years. In 1717 he returned to France to petition the government to move the village to more fertile and wooded ground and to prevent the sale of liquor to the natives. His request to return to Canada was not granted, however, because he was to be groomed as the procurator (fundraiser and supply officer) for the Canadian missions and was encouraged to write what became his important book, *Customs of the American Indians*

Source: Father Joseph François Lafitau, *Customs of the American Indians Compared with the Customs of Primitive Times,* ed. and trans. William N. Fenton and Elizabeth L. Moore, 2 vols. (Toronto: The Champlain Society, 1974–1977), 1:358, 360–61, 364–65.

Compared with the Customs of Primitive Times (1724), which required access to the learned libraries of the capital. In three years he completed his 1100-page treatise, which greatly advanced the science of anthropology by systematically comparing the practices and beliefs of ancient and modern "primitive" cultures. In 1727 he finally returned to the Sault as superior of the mission, but remained only two years before being recalled to Paris.

Lafitau was the keenest observer of Iroquois life in the colonial period. His flexible union of field work and theory gave him numerous insights into Iroquois culture, such as the importance of women, residence patterns and their relation to the classificatory kinship system, age-grading, and the generational tensions in village politics. In the following excerpt he observes—almost laments—the loss of Spartan elements in Iroquois education as a result of contact with the French. As the economy and social polity of native life was converted to a European model, Iroquois adults could no longer offer their children precepts and examples of ancient values, creating cultural dissonance between generations. One of the strongest bonds of native society to suffer corrosive change in Lafitau's day was "particular friendship" between young men, who were, not surprisingly, suspected by the sensitive priests of "unnatural" (homosexual) attachments.

On leaving the cradle, the children begin to roll rather than to walk. The parents usually leave them naked in the lodge during their first years, in the belief that the body forms itself better or else to harden them early to the effects of fresh air. As soon as they have grown a little larger, they follow their mothers and work for the family. For this, they are trained to go fetch water from the river, to bring in little loads of wood as heavy as they can carry, and which they can regard as playthings rather than a burden. Little by little, they are thus trained to render services as far as their ability permits. For the rest, their persons are neglected and they are badly clothed until they reach the age of adolescence and are incorporated in the body of the young people, when they are allowed to dress up. . . . Although to-day, they have not that consistent and regulated education [reminiscent of ancient Greece], especially in the neighbourhood of the Europeans and in the missions where all their former usages have been abolished as much as possible, the same idea and spirit of austerity is seen in their training. All the instructions given the Indian children by their parents consist in things fitted to stimulate their courage by the examples of their ancestors, to inspire them to follow in the latter's footsteps, to instruct them in the early customs and usages, and to inculcate in them [the idea of] the glory to be gained by skill and courage. To this end, the bow and arrow are put in their hands; for a long time, they keep them as playthings; but, as their strength increases with age, they make a necessary exercise out of an amuse-

ment and a game, and, in a short time, make themselves very skilful.

Since their life in itself is hard, and lacks many things necessary for nourishment, clothing and other things, it contributes no little to hardening them, making them capable of enduring hunger, thirst, the rigours of the seasons and other hardships, under which we [the French] are seen to succumb, because we have had too weak and too sensual an education.

The little Indians exercise continually together, as do the adolescents; one sees them jostling each other with kicks and punches, an exercise ordered by Lycurgus [the ninth-century B.C. Spartan law-giver] for his young people. If two antagonists come to blows in a way that goes beyond play, the admirable calmness of the others has struck me. They form a ring around the two combatants and as simple onlookers, they let them fight and "play," as they say, as they wish; no one takes sides, not even their own brothers; no one separates them unless the play is carried too far or the match too unequal; [in that case] they satisfy themselves with laughing at the expense of the one at a disadvantage.

But, as they no longer have those public and continual exercises which may contribute a great deal to regularizing their customs, they have relaxed much of that exact discipline which made them virtuous, as it were, in spite of themselves. The parents do what they can to give them good principles, but, since they do not always preach to them by their examples, they are not always able to turn them away from vice by their words. The mothers who are in charge of them, have not the strength to punish and

correct them when they fail in their duties; they let them do everything that they like when they are very young, under the pretext that they are not yet at the age of reason and that, when they reach those years, they will follow the light [of reason] and correct themselves, a bad principle which favours vicious habits which they cannot shake off. The worst punishment given them when they are still little is to throw water in their faces [a traditional Iroquois reproof used well into the nineteenth century] or to threaten them with it: when they grow older, the mothers satisfy themselves with pointing out to them their duties, which they are not always of a mind to obey. No one, moreover, would dare strike and punish them. In spite of that, the children are docile enough, they have sufficient deference for the members of their lodge, and respect for the elders from whom one scarcely ever sees them emancipated; a thing which indicates that in methods of bringing up children, gentleness is often more efficacious than punishments, especially violent ones. The Indians in general are, besides, so sensitive, that, for a little too bitter a reproach, it is not unusual to see them poison themselves with water hemlock and do away with themselves.

The *Athenrosera,* or particular friendships between young people . . . prevail almost in the same way from one end of America to the other. . . .

Among the North American Indians, these relationships of friendship carry no suspicion of apparent vice, although there is or may be much real vice. They are very ancient in their origin, very clear in their constant us-

age, sacred, if I dare say so, in the union which they form, the knots of which are as closely tied as those of blood and nature and can be broken only if one of them, making himself unworthy by cowardly acts which would dishonour his friend, [should] force him to renounce his alliance. Some missionaries have told me that they have seen examples of this. The parents are the first to encourage these friendships and to respect their rights; they [the friends] are chosen in such a way as to be worthy of respect, being founded on mutual merit as they [the Indians] reckon it, on congeniality of manners and qualities fitted to arouse emulation. Thus everyone wants to be the friend of the most highly esteemed men and those who most deserve admiration.

These friendships are purchased by gifts made by the friend to his selected friend; they are kept up by mutual marks of affection; the two become companions in hunting, warfare, and good or bad fortune; they are entitled to food and shelter in each other's lodging. The most affectionate compliment which a friend can make his friend, is to give him this name of friend: finally, these friendships grow old with them and are so well cemented that often there is heroism in them. . . .

Father Garnier[1] told me that he had learned from an Indian that this statement had often been made by the Indians among themselves on the subject of these friendships that, when a captive was burned, it could be regarded as certain that the one named (by the captive) in his death song would soon be taken himself and have the same fate. This father then made this reflection. Even if the omen should be followed by the event, there would be nothing extraordinary in it; for, he said, that captive threatening his torturers as was customary, calls to his help his closest friend to avenge him: and the latter, grieving over the loss of his friend of whose fate he soon learns, is not slow, in the hope of getting vengeance, in rushing into the same perils in which he is almost always the victim of the temerity inspired in him by regret for the loss of his friend and his grief at losing him.

I have also read in our [Jesuit] Relations,[2] that, among some prisoners taken at Onnontagué [Onondaga], there were two so closely bound by the ties of friendship, that the one being condemned to be burned and the other allowed to live, the latter was so much distressed that the same pardon had not been given his companion that he could not dissimulate his grief and carried his complaints and threats

1. Julien Garnier (1643–1730), the first Jesuit to be ordained in New France (1666), worked among the Oneida and Onondaga Iroquois from 1668 to 1685 and at Sault St. Louis until 1728, where he advised Lafitau. For three years (1717–1719) he served as superior of all the Canadian missions. He was a master of the Huron and five Iroquois languages.

2. The *Jesuit Relations* were reports from the Jesuit superiors in Canada printed in France to win financial and spiritual support for the missions. Published annually from 1632 to 1673 and irregularly throughout the remainder of the seventeenth and eighteenth centuries, they are the single best source for North American Indian culture. Reuben Gold Thwaites edited and translated them in 73 volumes as *The Jesuit Relations and Allied Documents* (Cleveland, 1896–1901).

so far that he forced his adopters to abandon him to punishment: they were then both put to death and the missionary who told the tale says that he was fortunate enough to administer baptism to them and to see them die in the great sentiment of piety which charmed the Iroquois no less than the missionary's zeal.

In one of our missions, where the missionaries have suppressed these ties of friendship, because of the abuses which they might fear from them, but without saying that this was their motive, the Indians were not at all angry about it because these friendships were too costly and became, for that reason, too burdensome.

16. Growing Up Delaware

David Zeisberger's many years among the Iroquois and Delawares at the end of the colonial period allowed him to see both change and persistence in native culture. Some of the changes had been wrought by his own Moravian mission, such as the wedge driven into "particular friendships" by the conversion of one partner. It is more difficult to determine whether the intrusion of patriarchal missionaries into the native social structure, often in the place of native priests and wise men, led to a real or imagined decline in the Indians's respect for their own "white heads." Perhaps Zeisberger misinterpreted the long-standing conflict between young warriors and old peace chiefs as a serious generational split of recent vintage. At the same time, he accurately noted: that differential education for adult sex roles began early in childhood, as it does in most nonindustrial societies; that fear of revenge was one reason Indian parents gave their white interrogators for not using corporal punishment on their children; and that young men still celebrated their first game kill and went on vision quests for personal guardian spirits.

Children, especially boys, are not held to work; the latter are to become hunters. They are allowed their own way, their elders saying: "We did not work ourselves in the days of our youth." They follow their own inclina-

Source: David Zeisberger's History of the Northern American Indians, ed. Archer Butler Hulbert and William Nathaniel Schwarze (Columbus: Ohio Archaeological and Historical Society, 1910), pp. 16–17, 75–76, 119, 127.

tions, do what they like and no one prevents them, except it be that they do harm to others; but even in that case they are not punished, being only reproved with gentle words. Parents had rather make good the damage than punish the children, for the reason that they think the children might remember it against them and avenge themselves when they have attained to maturity. Girls are rather more accustomed to work by their mothers, for as the women must pound all the corn in a stamping trough or mortar, they train their daughters in this and also in such other work as will be expected of them, as cooking, breadmaking, planting, making of carrying-girdles [tumplines] and bags, the former used to carry provisions and utensils on their backs while journeying and the latter to hold the provisions. . . .

Boys and girls sleep apart. As soon as girls walk[,] a little frock is fastened about them in order that they may accustom themselves to wear their clothing in a modest manner, the garments of the women being short, for the reason that long gowns would seriously inconvenience them in their movements through the forests. In this particular the boys are neglected, wearing little or nothing until at the age of five or six years, when a flap of cloth is fastened to a leathern band or girdle that has been worn [around the waist] from early in infancy in order that they might become accustomed to it. . . .

The boys exercise by shooting at a mark with bow and arrow. They may throw something into the air and shoot at it, the one hitting the object being regarded as a good marksman. As soon as they are able to run about they learn to use the bow and arrow. When they grow older they shoot pigeons, squirrels, birds and even raccoon with their bows and arrows.

Two comrades who have been reared together or have become attached to one another will be very close and constant companions. If one goes on a journey or to hunt the other will, if possible, accompany him. It seems almost impossible for either of them to live without the other, and for one to give up his companion, as may be necessary when one becomes a Christian, is very hard. Often such friends will make a covenant with one another to remain together and share alike possessions and knowledge. If they go to war together and one perishes the other will fight desperately to avenge him, accounting his own life as nothing. . . .

The first deer a boy shoots proves the occasion of a great solemnity. If it happens to be a buck it is given to some old man; if a doe, to some old woman. These [young hunters] bring in the whole animal, skinned, if it is possible to do so. If the animal is too heavy, they bring the skin and as much of the flesh as they can carry, fetching the rest later. When they reach the village, they turn to the east, having the whole or part of the animal on the back, always with the skin, before entering the house and give vent to a prolonged call, which is the old man's or old woman's prayer to the Deity in behalf of the boy, that he may always be a fortunate hunter. During the repast they repeat their petitions and give counsel to the boy (who, with his companions, is a mere spectator) regarding the chase and all the circumstances of his future life, exhorting him above all things to revere

old age and gray hairs and to be obedient to their words, because experience has given them wisdom. Such counsel was heeded in time past, and though the ceremonies are still kept up, the young no longer revere the aged as was the case at one time.

Formerly, the young revered the old, especially if they had gray or white heads. They believed that these must be very wise and prudent, because they were of such an age and seemed to be favored of the gods. Therefore, they treated the aged well, brought them, it may be, a deer, in the hope that they might be instructed of them how to attain to equal age. They presented the old, also, with wampum or belts, with the same hope. While nothing was said, the aged understood and gave the desired instruction on another occasion. . . .

Most extraordinary experiences have been met with by boys from twelve to fourteen years of age, when they have been alone in the forest in apprehension and in need. An old man in a gray beard may have appeared and said in soothing tone, "Do not fear, I am a rock and thou shalt call me by this name. I am the Lord of the whole earth and of every living creature therein, of the air and of wind and weather. No one dare oppose me and I will give thee the same power. No one shall do thee harm and thou needest not to fear any man." Such and similar prophecies he makes. Such a boy ruminates upon what he has heard and is confirmed in the opinion as he grows up that a peculiar power has been imparted to him to perform extraordinary exploits, and he imagines that no one can do him injury. As he can receive no further instruction from any one, he must learn from experience how far he can go, his imagination inspiring him to make every effort. Such boys give themselves to the practice of the dark arts [magic], having abundance of time for investigation and practice, because in their youth they are not required to work unless they choose to do so. Such a boy is feared above others, but of these there are very few.

17. The Search for Leaders in New England

As in contemporary English or French society, with their courts, universities, schools, and apprenticeships, not all Indian children were educated in the same way for the same adult roles. While most eastern tribal societies

Source: Alexander Young, ed., *Chronicles of the Pilgrim Fathers of the Colony of Plymouth from 1602 to 1625,* 2d ed. (Boston, 1844), p. 360.

were excessively egalitarian in European eyes, a small number of specialized offices had to be filled in each generation. Edward Winslow, one of the founders of the Plymouth Colony, briefly described the training of future sachems and *pnieses* (chief warriors and counsellors) among the Pokanokets (or Wampanoags), Massachusetts, and Narragansetts of southern New England. The vomit initiation was also described by a colonial physician "who hath conversed [associated] much with the Indians." Dr. Caleb Arnold of Portsmouth, Rhode Island, told a friend that "powwawes [shamans] use the bark of a tree to vomit persons 7 daies before they are admitted into that order" (George L. Kittredge, ed., "Letters of Samuel Lee and Samuel Sewall Relating to New England and the Indians," *Publications of the Colonial Society of Massachusetts* 14 [1911–1913], 151).

Winslow was the son of a Worcestershire salt victualer. After an English public school education, he joined the Pilgrim elder William Brewster in the printing business in Leyden, from whence he departed in 1620 on the *Mayflower*. His consummate diplomacy was used by the colony in missions to the neighboring Indians, especially Massasoit of the Pokanokets, and to England to defend the colony against the accusations of its enemies. He served as Governor Bradford's assistant from 1624 to 1647, except for three years when he served as governor himself. In 1643 he was appointed a commissioner of the United Colonies, the body responsible for Indian policy in New England. In 1624, while in London on a diplomatic mission, he published an account of the colony and its native inhabitants entitled *Good Newes from New England*, from which the following excerpt is taken.

And to the end they may have store of these [sachems and *pnieses*], they train up the most forward and likeliest boys, from their childhood, in great hardness, and make them abstain from dainty meat, observing divers orders prescribed, to the end that when they are of age, the devil [manitou] may appear to them; causing to drink the juice of sentry [centaury] and other bitter herbs, till they cast [vomit], which they must disgorge into the platter, and drink again and again, till at length through extraordinary oppressing of nature, it will seem to be all blood; and this the boys will do with eagerness at the first, and so continue till by reason of faintness, they can scarce stand on their legs, and then must go forth into the cold. Also they beat their shins with sticks, and cause them to run through bushes, stumps and brambles, to make them hardy and acceptable to the devil, that in time he may appear unto them.

18. A Dutch View of New England Leaders

Edward Winslow's description of an Indian boy's initiation was substantiated by Isaack de Rasieres, who came to New Netherland in 1626 as the chief commercial officer of the Dutch East India Company and provincial secretary. In a letter written in about 1628, he compared the New England and New Netherland Indians for one of the company directors, having visited Governor Bradford at Plymouth the previous October.

The savages [in New England] utilize their youth in labor better than the savages round about us [in New Netherland]: the young girls in sowing maize, the young men in hunting. They teach them to endure privation in the field in a singular manner, to wit:

When there is a youth who begins to approach manhood, he is taken by his father, uncle, or nearest [male] friend, and is conducted blindfolded into a wilderness, in order that he may not know the way, and is left there by night or otherwise, with a bow and arrows, and a hatchet and a knife. He must support himself there a whole winter with what the scanty earth furnishes at this season, and by hunting. Towards the spring they come again, and fetch him out of it, take him home and feed him up again until May. He must then go out again every morning with the person who is ordered to take him in hand; he must go into the forest to seek wild herbs and roots, which they know to be the most poisonous and bitter; these they bruise in water and press the juice out of them, which he must drink, and immediately have ready such herbs as will preserve him from death or vomiting; and if he cannot retain it, he must repeat the dose until he can support it, and until his constitution becomes accustomed to it so that he can retain it.

Then he comes home, and is brought by the men and women, all singing and dancing, before the Sackima [sachem]; and if he has been able to stand it all well, and if he is fat and sleek, a wife is given to him.

Source: J. Franklin Jameson, ed., *Narratives of New Netherland, 1609–1664,* Original Narratives of Early American History (New York, 1909, 1937), pp. 113–14. Reprinted by permission of Barnes & Noble Books, a division of Harper & Row, Publishers, Inc.

19. The Virginia Huskanaw

The southern tribes also had special tests for their future leaders. In tidewater Virginia and Carolina the *huskanaw* was used to select candidates for the offices of priest, sachem, and *cockarouse* (a counsellor similar to the *pniese* in New England), and served as a rite of passage for those who survived its rigors. Captain John Smith's early description (1610) of the ceremony gave the impression that only priests were being selected, that several of the boys were killed as sacrifices to their "Okee" or devil, and that the rest were treated "as dead" by the community. In 1705 Robert Beverley had the opportunity to observe the facts more carefully and to correct several of Smith's misunderstandings. He discovered that all tribal officers had to undergo the rite before assuming office, and that hallucinatory drugs were used to deprive the boys of all memory of childhood in order to give them perfect freedom from kinship, custom, and education when they were charged with the administration of justice. When the candidates "commence[d] Men, by forgetting that they ever have been Boys," they celebrated an archetypal rite of passage.

Despite his aristocratic English heritage, Beverley, the author of the following observations on huskanawing, was, if anything, partial to Virginia's Indians. One of nine children of a prominent Virginia planter and politician, he was sent to school in England until the age of nineteen. He returned to Virginia to a series of clerkships in various colonial offices, the last being the General Assembly. In 1697 he married Ursula, the daughter of William Byrd I, probably the richest girl in the colony, which added considerable landholdings to his already ample inheritance. When she died in childbirth the following year, he never remarried, content to raise the son who survived. In 1705, while in London to plead a land case before the Privy Council, he published *The History and Present State of Virginia*, which contained a sympathetic description of the Indians. In the preface Beverley asked his readers to excuse his plain style because "I am an Indian," by which he meant a colonial American; but he might well have referred to more than his words. Although he enjoyed boundless wealth for the rest of his life, he lived simply on one of his estates after his retirement from politics, importing nothing that could be made from the land, eschewing English "fopperies" for American utility and plainness, and hunting,

Source: [Robert Beverley,] *The History and Present State of Virginia* (London, 1705), bk. 3, pp. 37–42.

fishing, and exploring. In a sense, he was trying to preserve for himself the Edenic existence he felt the Indians once had but had lost through the acquisition of infinite "artificial wants" and other civilized vices.

The *Indians* [of Virginia] have their Altars and places of Sacrifice. Some say they now and then sacrifice young Children: but they deny it, and assure us, that when they withdraw these Children, it is not to Sacrifice them, but to Consecrate them to the service of their God. [Capt. John] *Smith* tells of one of these Sacrifices in his time, from the Testimony of some people, who had been Eye-witnesses. His words are these.

"Fifteen of the properest young Boys between ten and fifteen years of Age they painted white, having brought them forth, the people spent the Forenoon in Dancing and Singing about them with Rattles. In the Afternoon they put these Children to the Root of a Tree. By them all the Men stood in a Guard, every one having a *Bastinado* [club, switch] in his Hand, made of Reeds bound together; they made a Lane between them all along, through which there were appointed five Young Men to fetch these Children: So every one of the five went through the Guard, to fetch a Child each after other by turns; the Guard fiercely beating them with their *Bastinadoes*, and they patiently enduring and receiving all, defending the Children with their naked Bodies from the unmerciful blows, that pay them soundly, though the Children escape. All this while the Women weep and cry out very passionately, providing Mats, Skins, Moss, and dry Wood, as things fitting for their Childrens Funeral. After the Children were thus

past the Guard, the Guards tore down the Tree, Branches and Bows with such violence, that they rent the Body, made Wreaths for their Heads, and bedeck'd their Hair with the Leaves.

"What else was done with the Children was not seen, but they were all cast on a heap in a Valley as dead, where they made a great Feast for all the Company.

"The *Werowance* [war chief] being demanded the meaning of this Sacrifice, answer'd, that the Children were not dead, but that the *Okee* or Devil did suck the Blood from the Left Breast of those, who chanc'd to be his by lot, till they were dead, but the rest were kept in the Wilderness by the young men, till nine months were expired, during which time they must not converse with any; and of these were made their Priests and Conjurers."

How far Captain *Smith* might be misinform'd in this account, I can't say, or whether their *Okee*'s sucking the Breast, be only a delusion or pretence of the Physician, (or Priest, who is always a Physician) to prevent all reflection on his skill, when any happen'd to dye under his discipline. This I choose rather to believe, than those Religious Romances concerning their *Okee*. For I take this story of *Smith*'s to be only an example of *Huskanawing*, which being a Ceremony then altogether unknown to him, he might easily mistake some of the circumstances of it.

The Solemnity of *Huskanawing* is

commonly practis'd once every fourteen or sixteen years, or oftener, as their young men happen to grow up. It is an Institution or Discipline which all young men must pass, before they can be admitted to be of the number of the Great men, or *Cockarouses* [counsellors] of the Nation; whereas by Captain *Smith's* Relation, they were only set apart to supply the Priesthood. The whole Ceremony is performed after the following manner.

The Choicest and briskest young men of the Town, and such only as have acquired some Treasure by their Travels and Hunting, are chosen out by the Rulers to be *Huskanawed;* and whoever refuses to undergo this Process, dare not remain among them. Several of those odd preparatory Fopperies are premis'd in the beginning, which have been before related; but the principal part of the business is to carry them into the Woods, and there keep them under confinement, and destitute of all Society, for several months; giving them no other sustenance, but the Infusion, or Decoction of some Poisonous Intoxicating Roots; by virtue of which Physick, and by the severity of the discipline, which they undergo, they become stark staring Mad: In which raving condition they are kept eighteen or twenty days. During these extremities, they are shut up, night and day, in a strong Inclosure made on purpose; one of which I saw, belonging to the *Paumaunkie Indians,* in the year 1694. It was in shape like a Sugar-loaf, and every way open like a Lattice, for the Air to pass through. . . . In this Cage thirteen young Men had been *Huskanaw'd,* and had not been a month set at liberty, when I saw it. Upon this occasion it is pretended, that these poor Creatures drink so much of that Water of *Lethe* [Hades's river of oblivion], that they perfectly lose the remembrance of all former things, even of their Parents, their Treasure, and their Language. When the Doctors [priests] find that they have drank sufficiently of the *Wysoccan,* (so they call this mad Potion) they gradually restore them to their Sences again, by lessening the Intoxication of their Diet; but before they are perfectly well, they bring them back into their Towns, while they are still wild and crazy, through the Violence of the Medicine. After this they are very fearful of discovering any thing of their former remembrance; for if such a thing should happen to any of them, they must immediately be *Huskanaw'd* again; and the second time the usage is so severe, that seldom any one escapes with Life. Thus they must pretend to have forgot the very use of their Tongues, so as not to be able to speak, nor understand any thing that is spoken, till they learn it again. Now whether this be real or counterfeit, I don't know; but certain it is, that they will not for some time take notice of any body, nor any thing, with which they were before acquainted, being still under the guard of their Keepers, who constantly wait upon them every where, till they have learnt all things perfectly over again. Thus they unlive their former lives, and commence Men, by forgetting that they ever have been Boys. If under this Exercise any one should dye, I suppose the Story of *Okee,* mention'd by *Smith,* is the Salvo [excuse] for it: For (says he) *Okee* was to have such as were his by lot; and such were said to be Sacrificed.

Now this Conjecture is the more probable, because we know that *Okee* has not a share in every *Huskanawing;* for tho two young men happen'd to come short home, in that of the *Pamaunkie Indians,* which was perform'd in the year 1694, yet the *Appamattucks,* formerly a great Nation, tho now an inconsiderable people, made an *Huskanaw* in the year 1690, and brought home the same number they carried out.

I can account no other way for the great pains and secrecy of the Keepers, during the whole process of this discipline, but by assuring you, that it is the most meritorious thing in the World, to discharge that trust well, in order to their preferment to the greatest posts in the Nation, which they claim as their undoubted right, in the next promotion. On the other hand, they are sure of a speedy Passport into the other World, if they should by their Levity or Neglect, show themselves in the least unfaithful.

Those which I ever observ'd to have been *Huskanawed,* were lively handsome well timber'd young men, from fifteen to twenty years of age or upward, and such as were generally reputed rich.

I confess, I judged it at first sight to be only an Invention of the Seniors, to engross the young mens Riches to themselves; for, after suffering this operation, they never pretended to call to mind any thing of their former property: But their Goods were either shared among the old men, or brought to some publick use; and so those Younkers [Dutch: *jonkheers,* young gentlemen] were oblig'd to begin the World again.

But the *Indians* detest this opinion, and pretend that this violent method of taking away the Memory, is to release the Youth from all their Childish impressions, and from that strong Partiality to persons and things, which is contracted before Reason comes to take place. They hope by this proceeding, to root out all the prepossessions and unreasonable prejudices which are fixt in the minds of Children. So that, when the Young men come to themselves again, their Reason may act freely, without being byass'd by the Cheats of Custom and Education. Thus also they become discharg'd from the remembrance of any tyes by Blood, and are establisht in a state of equality and perfect freedom, to order their actions, and dispose of their persons, as they think fit, without any other Controul, than that of the Law of Nature. By this means also they become qualify'd, when they have any Publick Office, equally and impartially to administer Justice, without having respect either to Friend or Relation.

20. Carolina Variations

Apparently, the huskanaw ceremony was not uniform—or perhaps more to the point, not unchanging—throughout the South. John Lawson's description of the native Carolina version, published only four years after Beverley's, reveals a number of significant contrasts between the huskanawing of contiguous native groups. The first contrast was its function. The Powhatans employed it to test their future leaders, the Carolinians to subject their youth to discipline and to inure them to hardship. Other contrasts are no less sharp. Only in Carolina were girls huskanawed along with the boys; the Carolinians held the ceremony every one or two years as a disciplinary function, while the Virginians could wait 14 to 16 years to prepare a new generation of leaders; and the Carolina initiates were incarcerated for 5 to 6 weeks, compared to 18 to 20 days for the Virginians. Difficult to reconcile with the well-documented Indian love of children is the seemingly cold-blooded defence of the huskanaw as an instrument of natural selection for ridding the community of the weak and infirm. Carolina in 1710, where Lawson said that due to smallpox and rum "there is not the sixth Savage living within two hundred Miles of all our Settlements, as there were fifty Years ago" (*New Voyage*, p. 232), would seem a strange place for the Indians to be exercising any kind of population control.

There is one most abominable Custom amongst them, which they call *Husquenawing* their young Men. . . . You must know, that most commonly, once a Year, or, at farthest, once in two Years, these People take up so many of their young Men, as they think are able to undergo it, and *husquenaugh* them, which is to make them obedient and respective to their Superiors, and (as they say) is the same to them, as it is to us to send our Children to School, to be taught good Breeding and Letters. This House of Correction is a large strong Cabin, made on purpose for the Reception of the young Men and Boys, that have not passed this Graduation already; and it is always at *Christmas* that they *husquenaugh* their Youth, which is by bringing them into this House, and keeping them dark all the time, where they more than half-starve them. Besides, they give them Pellitory-Bark, and several intoxicating Plants, that make them go raving mad as ever were any People in the World; and you may hear them make the most dismal and hellish Cries, and Howlings, that ever humane Creatures express'd; all which continues about five

Source: John Lawson, *A New Voyage to Carolina* (London, 1709), pp. 232–34.

or six Weeks, and the little Meat they eat, is the nastiest, loathsome stuff, and mixt with all manner of Filth it's possible to get. After the Time is expired, they are brought out of the Cabin, which never is in the Town, but always a distance off, and guarded by a Jaylor [jailer] or two, who watch by Turns. Now, when they first come out, they are as poor as ever any Creatures were; for you must know several die under this diabolical Purgation. Moreover, they either really are, or pretend to be dumb, and do not speak for several Days; I think, twenty or thirty; and look so g[h]astly, and are so chang'd, that it's next to an Impossibility to know them again, although you was never so well acquainted with them before. I would fain have gone into the mad House, and have seen them in their time of Purgatory, but the King would not suffer it, because, he told me, they would do me, or any other white Man, an Injury, that ventured in amongst them; so I desisted. They play this Prank with Girls as well as Boys, and I believe it a miserable Life they endure, because I have known several of them run away, at that time, to avoid it. Now, the Savages say, if it was not for this, they could never keep their Youth in Subjection, besides that it hardens them ever after to the Fatigues of War, Hunting, and all manner of Hardship, which their way of living exposes them to. Besides, they add, that it carries off those infirm weak Bodies, that would have been only a Burden and Disgrace to their Nation, and saves the Victuals and Cloathing for better People, that would have been expended on such useless Creatures.

21. The Quest for a Guardian Spirit

In most northeastern Algonquian and Iroquoian cultures a young man's acquisition of a guardian spirit through a vision or dream quest, rather than an initiation like the huskanaw, marked his departure from the world of children. Through fasting, medicines, sleeplessness, and other sensory deprivation he hoped to experience the release of his soul into the spirit world, where an important *manitou* would give him advice about the future

Source: Rev. John Heckewelder, *History, Manners, and Customs of the Indian Nations Who Once Inhabited Pennsylvania and the Neighbouring States,* rev. ed. by Rev. William C. Reichel (Philadelphia: Historical Society of Pennsylvania, 1876), pp. 245–48.

conduct of his life. An Ojibwa boy in the nineteenth century had the following experience as he lay alone on an island:

> For several nights I dreamed of an *ógīmä* (chief, superior person). Finally he said to me, "Grandson, I think you are now ready to go with me." Then *ógīmä* began dancing around me as I sat there on a rock and when I happened to glance down at my body I noticed that I had grown feathers. Soon I felt just like a bird, a golden eagle (kīnīu). *Ogīmä* had turned into an eagle also and off he flew towards the south. I spread my wings and flew after him in the same direction. After a while we arrived at a place where there were lots of tents and lots of "people." It was the home of the Summer Birds. . . . [After returning north again the boy was left at their starting point after his guardian spirit had promised help whenever he wanted it.] (Quoted in A. Irving Hallowell, *Culture and Experience* [Philadelphia, 1955], p. 178.)

Not long before this boy's experience in the western Great Lakes, John Heckewelder, a Moravian missionary with impeccable credentials as an authority on Indian culture, described the signal importance of this rite of passage in the native East. Beneath the missionary's disdain for the Indian's adherence to a non-Christian spiritual world lies a clear description of the cultural values of a successful vision quest—a new name, formidable confidence and courage, and supernatural guidance in any of several walks of life, not just war. As Heckewelder's colleague, David Zeisberger, put it, "If an Indian has no Manitto to be his friend he considers himself forsaken, has nothing upon which he may lean, has no hope of any assistance and is small in his own eyes. On the other hand those who have been thus favored possess a high and proud spirit" (*Zeisberger's History of the Northern American Indians,* ed. A. B. Hulbert and W. N. Schwarze [Columbus, 1910], pp. 132–33).

Heckewelder (1743–1823), the English-born son of a Moravian minister, came to America in 1754. In 1762 he began to assist Moravian missionaries in their work with the Indians of Pennsylvania and Ohio, and for fifteen years (1771–1786) had his own mission in Ohio. After many years of study and life among the natives, particularly the Delawares, he was invited by the American Philosophical Society to publish his *Account of the History, Manners, and Customs of the Indian Nations who once inhabited Pennsylvania and the Neighbouring States* in the first volume of their *Transactions* (1819).

I do not know how to give a better name [than "initiation"] to a superstitious practice which is very common among the Indians, and, indeed, is universal among those nations that I have become acquainted with. By cer-

tain methods which I shall presently describe, they put the mind of a boy in a state of perturbation, so as to excite dreams and visions; by means of which they pretend that the boy receives instructions from certain spirits or unknown agents as to his conduct in life, that he is informed of his future destination and of the wonders he is to perform in his future career through the world.

When a boy is to be thus *initiated*, he is put under an alternate course of physic [medicine] and fasting, either taking no food whatever, or swallowing the most powerful and nauseous medicines, and occasionally he is made to drink decoctions of an intoxicating nature, until his mind becomes sufficiently bewildered, so that he sees or fancies that he sees visions, and has extraordinary dreams, for which, of course, he has been prepared beforehand. He will fancy himself flying through the air, walking under ground, stepping from one ridge or hill to the other across the valley beneath, fighting and conquering giants and monsters, and defeating whole hosts by his single arm. Then he has interviews with the Mannitto or with spirits, who inform him of what he was before he was born and what he will be after his death. His fate in this life is laid entirely open before him, the spirit tells him what is to be his future employment, whether he will be a valiant warrior, a mighty hunter, a doctor, a conjurer, or a prophet. There are even those who learn or pretend to learn in this way the time and manner of their death.

When a boy has been thus initiated, a name is given to him analogous to the visions that he has seen, and to the destiny that is supposed to be prepared for him. The boy, imagining all that happened to him while under perturbation, to have been real, sets out in the world with lofty notions of himself, and animated with courage for the most desperate undertakings.

The belief in the truth of those visions is universal among the Indians. I have spoken with several of their old men, who had been highly distinguished for their valour, and asked them whether they ascribed their achievements to natural or supernatural causes, and they uniformly answered, that as they knew beforehand what they could do, they did it of course. When I carried my questions farther, and asked them how they knew what they could do? they never failed to refer to the dreams and visions which they had while under perturbation, in the manner I have above mentioned.

I always found it vain to attempt to undeceive them on this subject. They never were at a loss for examples to sh[o]w that the dreams they had had were not the work of a heated imagination, but that they came to them through the agency of a mannitto. They could always cite numerous instances of valiant men, who, in former times, in consequence of such dreams, had boldly attacked their enemy with nothing but the *Tamahican* [tomahawk] in their hand, had not looked about to survey the number of their opponents, but had gone straight forward, striking all down before them; some, they said, in the French wars, had entered houses of the English filled with people, who, before they had time to look about, were all killed and laid in a heap. Such was the

strength, the power and the courage conveyed to them in their supernatural dreams, and which nothing could resist.

If they stopped here in their relations, I might, perhaps, consider this practice of putting boys under perturbation, as a kind of military school or exercise, intended to create in them a more than ordinary courage, and make them undaunted warriors. It certainly has this effect on some, who fancying themselves under the immediate protection of the celestial powers, despise all dangers, and really perform acts of astonishing bravery. But it must be observed, that all that are thus initiated are not designed for a military life, and that several learn by their dreams that they are to be physicians, sorcerers, or that their lives are to be devoted to some other civil employment. And it is astonishing what a number of superstitious notions are infused into the minds of the unsuspecting youth, by means of those dreams, which are useless, at least, for making good warriors or hunters. There are even some who by that means are taught to believe in the transmigration of souls.

I once took great pains to dissuade from these notions a very sensible Indian, much esteemed by all who knew him, even among the whites. All that I could say or urge was not able to convince him that at the time of his *initiation* (as I call it) his mind was in a state of temporary derangement. He declared that he had a clear recollection of the dreams and visions that had occurred to him at the time, and was sure that they came from the agency of celestial spirits. He asserted very strange things, of his own supernatural knowledge, which he had obtained not only at the time of his initiation, but at other times, even before he was born. He said he knew he had lived through two generations; that he had died twice and was born a third time, to live out the then present race, after which he was to die and never more to come to this country again. He well remembered what the women had predicted while he was yet in his mother's womb; some had foretold that he would be a boy, and others a girl; he had distinctly overheard their discourses, and could repeat correctly every thing that they had said. It would be too long to relate all the wild stories of the same kind which this otherwise intelligent Indian said of himself, with a tone and manner which indicated the most intimate conviction, and left no doubt in my mind that he did not mean to deceive others, but was himself deceived.

I have known several other Indians who firmly believed that they knew, by means of these visions, what was to become of them when they should die, how their souls were to retire from their bodies and take their abodes into those of infants yet unborn; in short, there is nothing so wild and so extraordinary that they will not imagine and to which, when once it has taken hold of their imagination, they will not give full credit.

22. The Mythical Origins of Menominee Menstruation

While Indian boys had their huskanaws, vision quests, and other initiations, the society of women also celebrated the passage of their daughters into adulthood. The most dramatic moment in any young girl's life was her first menstruation, which signalled her eligibility for marriage, motherhood, and (sometimes) religious experiences normally reserved for her brothers. But in most eastern tribes she first had to undergo a ritual of separation, perhaps as frightening as the physiological changes affecting her body. Only when she had completed her period in the forest and been cleansed physically and spiritually was she accepted as a woman.

Like most tribal cultures, the Indians regarded menstruation as ritually contaminating and avoided contact, especially sexual relations, with menstruating women. The regular onset of menstruation, tied so closely to nature's cycles and forces, and the appearance of blood, the sign of both life and death, combined to endow, in the Indian mind, the menstruating woman with extraordinary powers, capable of good and evil. She was revered as she was feared, which explains the variety of taboos that surrounded her and the social—not physical—need to separate her from the community for a time. It also explains her less publicized curative powers.

So obviously natural and powerful was menstruation that the Indians had to account for it in their religious cosmology. The Menominees of Wisconsin described its origins in a story featuring the mythical Manabozho (Manabush) or trickster, who, under various names, personified for many northeastern Algonquian tribes the creative forces of life in all their human and physical manifestations. The following version was recorded by Walter Hoffmann in the last decade of the nineteenth century.

One day Manabush went away into the woods to hunt for something to eat, but being unsuccessful he returned to his wigwam. When he entered he saw his grandmother seated upon a mat with her hair nicely combed, as he had never seen it before. So he said to her:

"Grandmother, I see you have combed your hair very nicely and put on clean clothes; have you had a visitor, or why have you done so?"

His grandmother made no satisfactory reply, and he asked nothing further regarding the circumstance; but he suspected that someone had been

Source: Walter James Hoffman, "The Menomini Indians," Bureau of American Ethnology, *Annual Report*, no. 14, pt. 1 (Washington, D.C., 1896), 174–75.

there and that she did not want him to know it.

On the following day Manabush again went away into the woods to hunt, and when he returned he again found his grandmother seated upon a mat, her hair nicely arranged, and her best skirt and leggings on. He said nothing, but his suspicions became stronger that someone had been to the wigwam during his absence.

On the following morning Manabush again went away into the woods to hunt, and when he returned to the wigwam he found his grandmother just as he had found her twice before.

The next morning Manabush pretended to go into the woods to hunt as before, but he soon came back near to his wigwam to discover who visited his grandmother. He suspected that it was the Bear, but he wanted to be certain. He had not long to wait before he heard the Bear coming along a trail leading to the wigwam, snorting and grunting, so he kept very quiet. Presently the Bear came into view, waddling from side to side and making directly for the wigwam, which he entered. Then Manabush got a piece of dry birchbark and lit one end of it, making a fierce blaze; he then went quietly up to the doorway of the wigwam, and, pulling aside the cover, saw the Bear with his grandmother. He threw the burning bark at the Bear, striking him on the back just above the loin. The Bear, frantic with pain, rushed out of the opposite door of the wigwam, and sped away through the woods and down the hill toward a

stream. Before reaching the water, however, the flames had burnt the hair from the Bear's back, because the bark was still adhering to his body, and he fell dead.

After Manabush had thrown the blazing bark at the Bear, he ran away from the wigwam to hide in the brush, but when he saw the Bear running away through the woods, he followed him, and ere he came up to where the Bear was, the latter was already dead. Taking up the carcass, Manabush carried it back to his wigwam, which he entered and threw the body down on the floor before his grandmother, saying, "There, grandmother, I have killed a bear; now we shall have something to eat."

"How did you kill him, my grandson?" said the grandmother.

"I killed him," replied Manabush, not wishing to admit that he had burnt him to death.

Manabush cut up the Bear and offered a piece to his grandmother; but she cried out excitedly, "No, my grandson, that was my husband; I can not eat it."

Manabush then took up a clot of the Bear's blood and threw it at his grandmother, hitting her upon the abdomen, saying, "There, take that!" Then she replied, "For that act your aunts will always have trouble every moon, and will give birth to just such clots as this."

Manabush then ate all he wanted of the meat and put the rest aside for another time.

23. Female Visions among the Illinois

In most native societies, a girl's first menstruation was socially the most significant because it marked so abruptly her transition to physiological adulthood. Among the Illinois nations, as Pierre Liette noted, she was moved out of the village a distance commensurate with her new power and encouraged to fast to induce a vision, just as her brothers did on their dream quests.

Liette was a French trader, diplomat, and army officer in the Mississippi Valley for over forty years. Arriving in Illinois in 1687 as the protégé of his cousin Henry Tonty, the Italian-born youth spent four years among the Miami Indians at Chicago and many more as commander of Fort Saint-Louis among the Illinois on the Wabash and Illinois rivers. When he died he was one of the most knowledgeable sources in New France on the customs of the western Indians. In 1702 he had penned a memoir of his experiences in Illinois, but it remained in manuscript until 1934. In 1947 Milo Milton Quaife made a new translation, from which the following excerpt is taken.

They fear the women and girls when they have the malady to which they are all subject [menstruation]. Because of this, opposite every cabin there is another just large enough to hold two persons, to which they retire with a kettle, a spoon, and a dish during all the time they are in this condition. No one enters save those who are in the same condition. When they need anything they come to the door to ask for it. When it is their first time, they make themselves cabins in the wilderness at a distance of more than ten arpents [c. one-half mile] from the village, and all their relatives advise them to abstain from eating and drinking as long as they are in this condition, telling them that they see the Devil [manitou], and that when he has spoken to them they are everlastingly fortunate and achieve the gift of great power for the future.

I saw a young girl of sixteen who was foolish enough to remain six days without eating or drinking and whom it was necessary to carry back to her cabin, after thoroughly washing her of course, because she was not able to stand up. She made all her relatives believe that she had seen a buffalo, which had spoken to her, and that her

Source: Milo Milton Quaife, ed., *The Western Country in the 17th Century: The Memoirs of Lamothe Cadillac and Pierre Liette* (Chicago: R. R. Donnelley & Sons Co., The Lakeside Press, 1947), pp. 132–33.

two brothers who were leading a war party against the Iroquois would make a successful attack without losing anyone. They did indeed make a successful attack, as she had said, but one of the two brothers was killed. All the medicine men said she had been right, because the attack had succeeded, but that apparently she had not fasted long enough, which was the reason the Devil had lied in a part of what he had said to her, since she had performed only a part of what she ought to have done.

24. Huron Stay-at-Homes

The customs regarding menstruation were not uniform even in the Northeast, as the Recollect priest Gabriel Sagard related in 1632 after his year-long stay with the Hurons. His observation about the differential use of menstrual huts seems to suggest that in predominantly horticultural tribes, which tended to be matrilineal and matrilocal and to accord women some authority in war-making, government, and religion, menstruating women were not required by custom to separate themselves from their families, as women in patrilineal, male-dominated hunting societies, like the Ottawa, usually were. This hypothesis gains some credence from Bernard Romans, a soldier of some experience in the largely horticultural-matrilineal Southeast, who wrote in 1775 that the Chickasaws were "the only ones i ever heard of who make their females observe a separation at the time of their *Menses* (some ancient almost extirpated tribes to the northward only excepted, and these used to avoid their own dwelling houses) [when] the women then retire into a small hut set apart for that purpose, of which there are from two to six round each habitation [village?], and by them called moon houses" (Capt. Bernard Romans, *A Concise Natural History of East and West Florida* [New York, 1775], 1:64). Romans, however, was simply ill-informed. James Adair, an educated trader among the southeastern tribes for thirty-three years, knew of no exceptions to the rule of menstrual separation, a rule so important that its breach was counted among "the most

Source: Father Gabriel Sagard, *The Long Journey to the Country of the Hurons,* ed. George M. Wrong, trans. H. H. Langton (Toronto: The Champlain Society, 1939), p. 67.

capital crimes" (*Adair's History of the American Indians* [London, 1775], ed. Samuel Cole Williams [New York, 1966], p. 130). Roger Williams also noted that among the Narragansetts of Rhode Island, a horticultural and matrilineal society, menstruating women withdrew to a *Wetuomémese,* a "little house," in the time of their "monethly sicknesse" (Roger Williams, *A Key into the Language of America* [London, 1643], pp. 31–32).

The [Ottawa] women live very comfortably with their husbands, and they have this custom, like all other women of wandering peoples, that when they have their monthly sickness [menstruation] they leave their husbands, and the girl leaves her parents and other relatives, and they go to certain isolated huts away from their village; there they live and remain all the time of their sickness without any men in their company. The men bring them food and what they need until their return, if they have not themselves taken provisions enough as they usually do. Among the Hurons and other settled tribes the women and girls do not leave their house or village for such occasions, but they cook their food separately in little pots during that period and do not allow anyone to eat their meats and soups; so that they seem to copy the [Biblical] Jewish women who considered themselves unclean during these periods. I have not been able to find out whence they derive this custom of separating themselves in such a manner, although I think it a very proper one.

25. Seclusion among the Delawares

David Zeisberger, the Moravian missionary to the Delawares, also confirms the eastern pattern of menstrual seclusion. For the Delawares were as horticultural and matrilineal as the Mingo-Iroquois, and in both groups menstruating women were separated from their families all or part of the time. Zeisberger also noted—late in the eighteenth century—that the age of first

Source: David Zeisberger's History of the Northern American Indians, ed. Archer Butler Hulbert and William Nathaniel Schwarze (Columbus: Ohio State Archaeological and Historical Society, 1910), pp. 77–78.

menstruation was "generally between the twelfth and sixteenth year." Whether this age range constituted a decline from an aboriginal average is impossible to tell from the available evidence. Historically, the age of menarche has fallen in the white American and European populations. If a Rhode Island physician's estimate is also correct, and applicable to the distant Delawares, the natives may have experienced a similar decline. In 1690 Dr. Caleb Arnold testified from close knowledge that Narragansett girls did not menstruate until the age of eighteen or nineteen, which in his experience was "late" (George L. Kittredge, ed., "Letters of Samuel Lee and Samuel Sewall Relating to New England and the Indians," *Publications of the Colonial Society of Massachusetts* 14 [1911–1913], 148).

When, in a young female, the first menstrual discharge occurs, generally between the twelfth and sixteenth year, the Delawares generally separate such daughters from all companionship, the Monsies [Munsees, a linguistic sub-group of the Delawares] being more strict and having more ceremonies in the observance of the custom than the Miamis. They build for such a girl, [a] separate hut, apart from the rest, where her mother or some old female acquaintance cares for her and guards her so that none may see her. Wherefore, she is also kept within the hut the whole of the menstrual period, with the blanket over her head. She is given little to eat, but regularly dosed with emetics. She is not allowed to do any work during the whole time, which generally lasts twelve days. At the end of the time, they bring her into her home, looking black, grimy and dishevelled, because she has been lying about in dust and ashes the whole time. Washed and dressed in new garments, she is allowed to be in the home, but required to wear a cap with a long shield, so that she can neither see any one readily, nor be seen. Such a covering she must wear for two months, at the end of which time she is informed that she may marry.

The Shavanose [Shawnee] and Mingoes [an Ohio branch of the Iroquois], however, who observe much the same custom, follow a different course in this matter. The young woman in question is allowed to remain in the house. She prepares food for those in the house, of the corn and fruits she has raised. Of such food she does not, however, herself partake, but goes to her hut, apart from the others, and there prepares and eats her food.

Every month, during her menstrual period, a Delaware woman lives by herself in a separate hut, which is usually very poorly built, and remains there two or three days, food being taken to her. When the time is over they bathe and wash their clothes and are allowed to return to their husbands. During the menstrual period, they are not permitted to do any cooking or domestic work. None will eat what a woman in this condition prepares, for food prepared under such circumstances is said to be unwholesome and to cause pain in the abdomen. The women do not go into com-

pany, but keep to their huts until their time is over. Hence, it occasionally happens that a woman engaged in baking will leave everything and go to her hut. This custom does not obtain among the Mingoes; their women continue their usual work and remain in the house.

26. Micmac Menstrual Power

The native reason for segregating a menstruating woman was that she was at once a source of pollution and of heightened supernatural power. Her touch or even glance could cause illness or bad luck. So to avoid having to blame a kinswoman for misfortune, as well as to protect the group, she was urged to separate herself for the duration of her period. Chrestien Le Clercq, the Recollect missionary in the Gaspé region of Canada, noted the importance of ritual purity in the beaver-fur economy of the Micmacs.

A matter which is yet more surprising is this—they observe still to this day certain ceremonies of which they do not know the origin, giving no other reasons than that their ancestors have always practised the same thing. The first is this, that the women and girls, when they suffer the inconveniences usual to their sex, are accounted unclean. At that time they are not permitted to eat with the others, but they must have their separate kettle, and live by themselves. The girls are not allowed, during that time, to eat any beaver, and those who eat of it are reputed bad; for the Indians are convinced, they say, that the beaver, which has sense, would no longer allow itself to be taken by the Indians if it had been eaten by their unclean daughters.

Source: Father Chrestien Le Clercq, *New Relation of Gaspesia With the Customs and Religion of the Gaspesian Indians,* ed. and trans. William F. Ganong (Toronto: The Champlain Society, 1910), pp. 227–28.

27. More Micmac Menstrual Power

In 1699, a few years after Le Clercq left the Micmacs, a young French surgeon from Pont-l'Evêque arrived in Port Royal (in what is now Nova Scotia) to dispose of a trade consignment and to collect specimens for the Royal Botanical Gardens in Paris. Although he lost most of his trade goods at sea, Sieur de Dièreville managed in his year's stay in Acadia to gather several botanical species and to observe the Micmacs of the area. A well-educated man who had studied at the Hôtel Dieu in Paris (where he had witnessed the postmortem flaying of a tattooed American Indian and the dressing of his skin), Dièreville probed native customs with keen curiosity and frequent indulgence, though he was not above exposing what he called their "stupid superstitions." Understandably, he was most interested in matters medical, but loath to meddle in magic and religion.

When he returned to France in 1700, he was requested to publish his observations by Michel Bégon, the intendant successively of La Rochelle and Rochefort and the father of an intendant (for whom Nicolas Perrot wrote) and father-in-law of a governor of New France. Originally the work was composed entirely in verse—Dièreville had published poetry in French periodicals—but the criticism of friends made him put more than half of it in prose, in which form it was published in 1708. His observations on Micmac menstrual taboos incorporate a sly criticism of French morals, a propensity shared by other Canadian visitors.

Should a Maiden, when she is in a certain condition brought about by the Moon in accordance with a law common enough, come into contact with a Youth with whom she is sharing a Wigwam, he would believe himself deprived of the use of his limbs, & be so convinced of their impotence, that he would not attempt to take a step, remaining in bed until the im-aginary cause of his malady, which is itself no less imaginary, has passed away. If she were to touch his musket during that period, he would believe that it was bewitched, & that he would be unable to kill anything with it; so strongly is he possessed by this idea, that he fears less the most malign spells of the Magicians. When a married Woman is in this condition, she

Source: Sieur de Dièreville, *Relation of the Voyage to Port Royal in Acadia or New France* [Rouen, 1708], ed. John Clarence Webster, trans. Mrs. Clarence Webster (Toronto: The Champlain Society, 1933), pp. 161–62.

must withdraw apart, & warn her Husband lest, without knowing it, he be seized by the desire for contact with her.

> *He will avoid her all that*
> *time;*
> *What vexing hindrance to her*
> *soul's desire!*
> *There is in France more than*
> *one Woman who*

> *Would maintain silence in a*
> *case like this.*

There are, however, many among the Indian Women, who, although they are very amorous, deprive themselves for long periods of the pleasures they enjoy with their Husbands, regarding as Concubines those who have numerous Children.

28. Cause to Fear in Canada

In another part of New France, Paul Le Jeune, the superior of the Jesuits in Canada, noticed in his *Relation* of 1636 the power of menstruating women to cause relapses as well as the initial illness in men.

One of our people, visiting a sick Savage and finding him very disconsolate, asked him what new thing had happened to him. "Alas," said he, "I was beginning to get better; I went out of my Cabin, a girl in her courses looked at me, and my disease attacked me as severely as ever." I have already said that these girls withdraw from the Cabin when they are subject to this infirmity, and that the Savages dread even to meet them. The Father consoled him, and made him understand that this glance was incapable of injuring him.

Source: Reuben Gold Thwaites, ed., *The Jesuit Relations and Allied Documents*, 73 vols. (Cleveland, 1896–1901), 9:123.

29. Becoming a Woman in the Midwest

One of the fullest and frankest descriptions of an Indian girl's coming of age in eastern America is that of the anonymous Fox woman who came to maturity at the end of the last century in the Midwest. Her autobiography underlines a number of continuities in Indian education, such as the importance of play in molding adult sex-role skills and the special role of clan grandmothers and aunts as moral instructors. Like children in most societies, Indian girls learned to be women by playing with dolls in miniature wigwams and wickiups, tending their own crops in child-sized fields, and gathering firewood with miniature burden straps and hatchets. In their early teens the onset of menstruation would thrust them out of childhood forever. The Fox woman's experience at 13½ years was like that of her ancestors: seclusion in a distant hut to prevent her maleficent glance from harming a passing tribesman; food and other taboos to preserve the girl from her own power; ritual segregation for a period longer than the actual menstrual flow; water purification; and the replacement of the child's clothes with new adult dress. In her grandmother's generation, fasting for a vision was usual, but the onslaughts of time and Christianity had weakened the practice.

Well, I shall now tell what happened to me. From the time when I was six years old is perhaps when I begin to recollect it. Of course (I do) not (recollect it) fully; I forget once in a great while (some days) each year back.

Well, I played with dolls when I made them. (And) when I played with them I would make one large doll. Now they would be supposed to be many children. And that large doll, I would pretend, would do the cooking. Of course I would do the cooking in my play. And many of us would eat together when we ate, I pretended. And then I made little wickiups [mat-covered houses] for the dolls to live in.

When I was perhaps seven years old I began to practice sewing for my dolls. But I sewed poorly. I used to cry because I did not know how to sew. Nor could I persuade my mother to (do it) when I said to her, "Make it for me." "You will know how to sew later on; that is why I shall not make them for you. That is how one learns to sew, by practicing sewing for one's dolls. That is why one has dolls,

Source: "The Autobiography of a Fox Indian Woman," ed. and trans. Truman Michelson, U.S. Bureau of American Ethnology, *Annual Report,* no. 40 (Washington, D.C., 1925), pp. 297–307.

namely, to make everything for them— their clothing and moccasins." And so I would always practice sewing for my dolls.

When I was perhaps eight years old I began to like to swim. If we were living near where a river flowed by, we girls always would swim. There were many of us. Although we were scolded, yet when we could do so secretly we would go swimming. Some would be whipped because they did not mind. As for me, I was never whipped as I was the only girl (my parents) had. I would only be severely scolded when I did not mind when I was forbidden (anything). And I was made to fast when I did not pay attention. And I was forbidden to go with the other little girls, that is, the very naughty ones. "They might get you (into their habits), as they will not know how to make anything when they grow up in the future if they do not try to make anything. That is the way you will be if you do not try to make anything, if you merely loaf around," I would be told when I was made to fast. I was fed at noon. But soon, within several days, I had forgotten what I was forbidden. Again I was told, "Do not sleep anywhere (in the wickiups) of the little girls with whom you play. Come back to where we live while it is still daylight. Do not be out some place in the night. Play with them now and then."

Well, when I was nine years old I was able to help my mother. It was in spring when planting was begun that I was told, "Plant something to be your own." Sure enough I did some planting. When they began to hoe weeds where it was planted, I was told "Say! You weed in your field." My hoe

was a little hoe. And soon the hoeing would cease. I was glad.

When (we) ceased bothering where it was planted, I was unwilling to do anything. But when I would be told, "When you finish this, then you may go and play with the little girls," I was willing. I then surely played violently with the children. We played tag as we enjoyed it.

And at the time when what we planted was mature, I was told, "Say! You must try to cook what you have raised." Surely then I tried to cook. After I cooked it, my parents tasted it. "What she has raised tastes very well," they said to me. "And she has cooked it very carefully," I would be told. I was proud when they said that to me. As a matter of fact I was just told so that I might be encouraged to cook. And I thought, "It's probably true."

And when I was ten years old I ceased caring for dolls. But I still liked to swim. But when I said to my mother, "May I go swimming?" she said to me, "Yes. You may wash your grandmother's [dress] for her, and you may wash mine also," I was told. I was made to wash (anything) little. Surely I would not feel like asking, "May I go swimming," as I was afraid of the washing. Now as a matter of fact the reason why I was treated so was to encourage me to learn how to wash.

"That is why I treat you like that, so that you will learn how to wash," my mother told me. "No one continues to be taken care of forever. The time soon comes when we lose sight of the one who takes care of us. I never got to know how my mother looked. My father's sister brought me up. Today I treat you just as she treated me. She did not permit me to be just fool-

ing around. Why, even when I was eight years old I knew how to cook very well. When my father's sister was busy with something, I did the cooking," she said to me. I did not believe her when she said that, for I was then ten years old and was just beginning to cook well, and I knew how to sew but I was poor at it. At that time when my mother woke up, she said to me, "Wake up, you may fetch some water. And go get some little dry sticks so we may start the fire," she said to me. When I was unwilling I was nevertheless compelled. That is the way I was always treated.

Soon, moreover, I was told, "This is your little ax," when a little ax was brought. I was glad. "This is your wood-strap," I was told. My mother and I would go out to cut wood; and I carried the little wood that I had cut on my back. She would strap them for me. She instructed me how to tie them up. Soon I began to go a little ways off by myself to cut wood.

And when I was eleven years old I likewise continually watched her as she would make bags. "Well, you try to make one," she said to me. She braided up one little bag for me. She instructed me how to make it. Sure enough, I nearly learned how to make it, but I made it very badly. I was again told, "You make another." It was somewhat larger. And soon I knew how to make it very well. Then surely I was unwilling to make them. At first I was willing to make them as I did not know how to make them very well. But I was constrained to keep on making them. During the winters I kept on making them. Moreover, at that time a little rush mat was woven for me. "Make this," I was told. I tried

to make it. Later on I finished it. I made it extremely poorly. Soon I began to help my mother after I knew how to make rush mats.

She would be very proud after I had learned to make anything. "There, you will make things for yourself after you take care of yourself. That is why I constrain you to make anything, not to treat you meanly. I let you do things so that you may make something. If you happen to know how to make everything when you no longer see me, you will not have a hard time in any way. You will make your own possessions. My father's sister, the one who took care of me, treated me so. That is why I know how to make any little thing. 'She is in the habit of treating me meanly,' I thought, when she ordered me to make something all the time. Now as a matter of fact she treated me well. When I knew about it, I would think, 'why she must have treated me very well.' And that is why I treat you so to-day. So very likely when you think of me, you think, 'she treats me meanly.' It is because I am fond of you and wish you to know how to make things. If I were not fond of you, I would not order you around (to do things). (If I were not fond of you) I would think, 'I don't care what she does.' If you are intelligent when you are grown and recollect how I treated you, you will think, 'I declare! My mother treated me well.' Or if you are bad you will not remember me when I am gone. And this. Though you know how to make things you will not make anything. That is what you will do if you are bad. I do not wish you to be that way. I desire that you take care of yourself quietly," my mother told me.

And again, when I was twelve years old, I was told, "Come, try to make these." (They were) my own moccasins. "You may start to make them for yourself after you know how to make them. For you already know how to make them for your dolls. That is the way you are to make them," I was told. She only cut them out for me. And when I made a mistake she ripped it out for me. "This is the way you are to make it," I was told. Finally I really knew how to make them.

And then a small belt of yarn was put on the sticks for me. A little was started for me. "Try to make this one," I was told. I began to try to make it. Later on I surely knew how to make it. Then I kept on making belts of yarn. My mother was pleased when I learned how to make anything.

At that time I knew how to cook well. When my mother went any place, she said to me, "You may cook the meal." Moreover, when she made mats I cooked the meals. "You may get accustomed to cooking, for it is almost time for you to live outside. You will cook for yourself when you live outside," I would be told.

Soon I was told, "Well, begin to try to weave; you may wish to make these mats." Then I began to try to weave. Later I knew how to weave very well. Then I began to help my mother all the time. She was proud when I continued to learn how to make anything.

And then I was thirteen years old. "Now is the time when you must watch yourself; at last you are nearly a young woman. Do not forget this which I tell you. You might ruin your brothers if you are not careful. The state of being a young woman is evil.

The manitous [spirits] hate it. If any one is blessed by a manitou [in a vision quest], if he eats with a young woman he is then hated by the one who blessed him and the (manitou) ceases to think of him. That is why it is told us, 'be careful' and why we are told about it beforehand. At the time when you are a young woman, whenever you become a young woman, you are to hide yourself. Do not come into your wickiup. That is what you are to do." She frightened me when she told me.

Lo, sure enough when I was thirteen and a half years old, I was told, "Go get some wood and carry it on your back." It was nearly noon when I started out. When I was walking along somewhere, I noticed something strange about myself. I was terribly frightened at being in that condition. I did not know how I became that way. "This must be the thing about which I was cautioned when I was told," I thought.

I went and laid down in the middle of the thick forest there. I was crying, as I was frightened. It was almost the middle of summer after we had done our hoeing. After a while my mother got tired of waiting for me. She came to seek me. Soon she found me. I was then crying hard.

"Come, stop crying. It's just the way with us women. We have been made to be that way. Nothing will happen to you. You will have gotten over this now in the warm weather. Had it happened to you in winter you would have had a hard time. You would be cold when you bathed as you would have to jump into the water four times. That is the way it is when we first have it. Now, to-day, as it is

warm weather, you may swim as slowly as you like when you swim," I was told. "Lie covered up. Do not try to look around. I shall go and make (a wickiup) for you," I was told.

I was suffering very much there in the midst of the brush. And it was very hot.

It was in the evening when I was told, "At last I have come for you. I have built (a place) for you to live in. Cover your face. Do not think of looking any place." I was brought there to the small wickiup. And I was shut off by twigs all around. There was brush piled up so that I could not see through it. There was only a little space where I lived to cook outside. My grandmother must have made it a size so that there was only room for us to lie down in.

"I shall fetch your grandmother to be here with you," my mother told me. It was another old woman. As a matter of fact the reason she was brought there was for to give me instructions. I did not eat all day long. The next day I was told, "We shall fetch things for you to use in cooking." I was not hungry as I was frightened. The next day my grandmother went to eat. It was only as long as she (took) when she went to eat that I was alone, but I was afraid. In the evening I was brought little buckets to cook with, any little thing to eat, water and wood. Then for the first time I cooked.

And my grandmother would keep on giving me instructions there, telling me how to lead a good life. She really was a very old woman. Surely she must have spoken the truth in what she had been saying to me. "My grandchild," she would say to me, "soon I shall tell you how to live an upright life. To-day you see how old I am. I did exactly what I was told. I tried and thought how to live an upright life. Surely I have reached an old age," she told me. "That is the way you should do, if you listen to me as I instruct you. Now as for your mother, I began giving her instructions before she was grown up, every time I saw her. Because she was my relative is why I gave her instructions, although she was well treated by her father's sister by whom she was reared. That is why she knows how to make things which belong to the work of us women. If you observe the way your mother makes anything, you would do well, my grandchild. And this. As many of us as entered young womanhood, fasted. It was very many days: some fasted ten days, some four, five, every kind of way. To-day, to be sure, things are changing. When I was a young woman I fasted eight days. We always fasted until we were grown up," my grandmother told me.

My mother only came to fetch me water and little sticks of wood so that I might kindle a fire when I cooked. And we made strings. That is what we did.

"Do not touch your hair: it might all come off. And do not eat sweet things. And if what tastes sour is eaten, one's teeth will come out. It is owing to that saying that we are afraid to eat sweet things," my grandmother told me. She always gave me good advice from time to time. "Well, there is another thing. Now the men will think you are mature as you have become a young woman, and they will be desirous of courting you. If you do not go around bashfully, for a long time they will not have the audacity

to court you. When there is a dance, when there are many boys saying all sorts of funny things, if you do not notice it, they will be afraid of you for a very long time. If you laugh over their words, they will consider you as naught. They will begin bothering you right away. If you are immoral your brothers will be ashamed, and your mother's brothers. If you live quietly they will be proud. They will love you. If you are only always making something in the same place where you live, they will always give you something whenever they get it. And your brothers will believe you when you say anything to them. When one lives quietly the men folks love one. And there is another thing. Some of the girls of our generation are immoral. If one goes around all the time with those who are immoral, they would get one in the habit of being so, as long as one has not much intelligence. Do not go around with the immoral ones, my grandchild," my grandmother told me. "And this. You are to treat any aged person well. He (she) is thought of by the manitou: because he (she) has conducted his (her) life carefully is why he (she) reached an old age. Do not talk about anyone. Do not lie. Do not steal. If you practice stealing, you will be wretched. Do not (be stingy) with a possession of which you are fond. (If you are stingy) you will not get anything. If you are generous you will (always) get something. Moreover, do not go around and speak crossly toward anyone. You must be equally kind to (every) old person. That, my

grandchild, is a good way to do," my grandmother said to me. She was indeed always instructing me what to do.

Soon I had lived there ten days. "Well, at last you may go and take a bath," my mother said to me. We started to the river. "Take off your [dress]," I was told. After I had taken if off I leaped into the water. Then, "I am going to peck you with something sharp," I was told. I was pecked all over. "And now on your lower part," I was told. "Only use your skirt as a breechcloth," is what I was told. I was also pecked on my thighs. "It will be that you will not menstruate much if the blood flows plentifully," I was told. I was made to suffer very much. I put on other garments. I threw away those which I had formerly been wearing around. And then for the first time I looked around to see. And again I had to cook alone for myself outside for ten days. After ten days I again went to bathe. And then for the first time I began to eat indoors with (the others).

I told my mother, "My grandmother has always been instructing me what I should do," I said to her. She laughed. "That is why I went after her, so she would instruct you thoroughly in what is right. 'She might listen to her,' is what I thought of you."

And I began to be told to make something more than ever. Moreover, when she made a basket, she said to me, "You (make one)." I would make a tiny basket. Later on the ones which I made were large ones. And then I was fifteen years old.

THREE:
Love and Marriage

In the native societies of eastern America, marriage was one of the classic rites of passage because one spouse made a distinct and publicly recognized transition to the other spouse's family and often household. Moreover, it ascribed a new adult status to both partners, demanding new responsibilities and decorum, and brought the young woman in a socially acceptable way to the threshold of motherhood, another important step in female status. Unlike childbirth and religion, for example, Indian marriage has the advantage for the historian of having been highly popular, common to both sexes, and publicly discussed and celebrated, which made it widely accessible to foreign observers. Only the role of kinship, which few outsiders understood fully until the second half of the nineteenth century, complicated the relatively neat patterns traced by the European colonists and missionaries.

Before serious courtship leading to marriage, the young people of most eastern tribes indulged in sexual exploration with the tacit approval of their parents, sometimes even before puberty. But there were no public displays of adolescent affection. Kissing was largely unknown until imported from Europe, and social mores frowned on any kind of overt emotionalism. The young lovers commonly met at night or clandestinely in cornfields and strawberry patches to carry on their ageless rites of wooing.

When a young man set his heart on a particular girl, he sent intermediaries—a brother, an uncle, or his parents, depending on the custom of the tribe—to ask her parents' consent to the match. Frequently, the girl's close clansmen and even the village sachem were consulted because a marriage represented a union of two clans as well as two individuals, with expanded responsibilities for all. But a girl was seldom forced to marry against her will, though her parents might veto her first choice and urge her to look further.

When both families were satisfied that the match was suitable, a two-part wedding ceremony was performed. The first part consisted of a private exchange of gifts between the espoused and their families, symbolizing the reciprocal nature of native marriage and later making it easy for either spouse to initiate divorce. Since Indian women did not bring expensive and

legally entangling dowries to their husbands, as European women of all but the lowest classes did, the men were as free to divorce and remarry as their wives. The second part of the wedding was a public feast, for the whole village or at least the two clans involved, to announce the union and to signal the couple's new status. In some patrilineal hunting tribes, such as the Micmac, no women, except perhaps the two mothers, attended the wedding feast.

Rather than establishing their own independent households, most young couples went to live with the girl's parents for a specified period, usually a year, while the husband demonstrated his ability to provide for a family and to get along with his in-laws. In some tribes the couple abstained from sexual relations for much or all of that time in order to knit their affections as "brother and sister," the closest relationship the natives knew. The lack of children also allowed the couple to work out the inevitable early problems of marriage or to freely divorce if they could not be resolved. Once a couple had children, they tended to stay together on their account.

At the completion of the trial period, the couple could move into their own lodge or, more frequently, remain with or near the wife's relatives (in matrilocal societies) or move near the husband's relatives (in patrilocal societies). Wherever they lived, the woman assumed complete control over her immediate household, distributing the fish and game her husband caught and her own horticultural crops to family and friends with a free hand. As long as children came along and the couple treated each other well, without flagrant or socially proscribed resort to other lovers, the monogamous marriage endured, perhaps a full lifetime. (In some tribes a husband was allowed sexual relations outside the marriage bed during his wife's pregnancy and nursing period.) Only if the man was obliged by tribal custom to marry a brother's widow or his wife's sister, or by social success and position to acquire another wife to help provide hospitality, would his first wife have any competition for his affections. Even then she would be "first among equals."

Understandably, the European Christians who viewed the Indian cultures of the East through their own cultural lenses disapproved of premarital sex, "adultery," easy divorce, and polygamy. But those observers who looked more deeply into these customs often discovered socially compelling reasons for their existence, reasons that made eminently good sense for cultures in that place at that time. Like their technology and religion, their marriage customs were finely tuned adaptations to the social environment in which they lived before the European invasion.

30. Huron Unions

After only one year with the Hurons of lower Ontario, Gabriel Sagard gathered a number of accurate observations about their marriage and sexual customs. These were marred only by some obvious Christian moralizing about premarital sex and the mistaken belief that the children of divorced parents usually went with the father, which was highly unlikely in that matrilineal society where children belonged to their mother's clan alone. His ignorance of the kinship system also led him to underestimate the number of restrictions on the choice of marriage partners. The Catholic priest found the absence of public display of affection refreshing, but could not countenance young couples living together without the benefit of sacramental marriage, the sexual freedom that amounted to adultery by his standards, or the easy divorces instigated by either partner, which in the Catholic Church were anathema. As a Frenchman, though celibate, he appreciated that Huron men were as economically free to divorce as the women since no dowries had to be repaid, as they had to be in France. His observations on the two parts of the marriage ceremony (one private between families, the other public), the presents of firewood to the bride (whose job it was to keep the lodge fires burning), and the importance of parental (actually clan) consent if not arrangement are relatively value-free and therefore the more readily usable.

We read that Caesar praised the Germans highly for having in their ancient savage life such continence as to consider it a very vile thing for a young man to have the company of a woman or girl before he was twenty years old. It is the reverse with the boys and young men of Canada, and especially with those of the Huron country, who are at liberty to give themselves over to this wickedness as soon as they can, and the young girls to prostitute themselves as soon as they are capable of doing so. Nay even the parents are often procurers of their own daughters; although I can truthfully say that I have never seen a single kiss given, or any immodest gesture or look, and for this reason I venture to assert that they are less prone to this vice than people here [in France]. This may be attributed partly to their lack of clothing, especially about the head, partly to the absence of spices and wine, and partly to their habitual use of tobacco, the smoke of which

Source: Father Gabriel Sagard, *The Long Journey to the Country of the Hurons,* ed. George M. Wrong, trans. H. H. Langton (Toronto: The Champlain Society, 1939), pp. 121–25.

deadens the senses and ascends to the brain.

Many young men, instead of marrying, often keep and possess girls on terms of supplying food and fire, and they call them, not wives, *Aténonha,* because the ceremony of marriage has not been performed, but *Asqua,* that is to say, companion, or rather concubine; and they live together for as long as it suits them, without that hindering the young man or the girl from going freely at times to see their other friends, male or female, and without fear of reproach or of blame, such being the custom of the country.

But their preliminary marriage ceremony is this: when a young man wishes to have a girl in marriage he must ask her parents for her, without whose consent the girl cannot be his (although most frequently the girl does not accept their consent and advice, only the best and most sensible doing so). The lover who would make love to his mistress and obtain her good graces will paint his face and wear the finest adornments he can get, so as to appear more handsome; then he will make a present to the girl of some necklace, bracelet, or ear-ring made of wampum. If the girl likes this suitor she accepts the present, whereupon the lover will come and sleep with her for three or four nights, and so far there is still no complete marriage nor promise of one made, because after they have slept together it happens quite often that the kindness is not maintained, and that the girl, who in obedience to her father has allowed this unauthorized favour, has in spite of it no affection for this suitor, and he must then withdraw without further steps. This happened in our time

to a savage in regard to the second daughter of the great chief of Quieunonascaran, as the father of the girl himself complained to us, in view of the girl's obstinacy in not wishing to go on to the last marriage ceremony, because she did not like the suitor.

When the parties are agreed, and the consent of the parents given, they proceed to the second marriage ceremony in the following manner. A feast is served of dog, bear, moose, fish, or other meat prepared for them, to which all the relations and friends of the espoused couple are invited. When all are assembled and seated, each according to his rank, all round the lodge, the father of the girl, or the master of ceremonies deputed to the office, announces before the whole gathering, pronouncing his words aloud and clearly, that such and such are being married and that it is for that reason the company is assembled and this feast of bear, dog, fish, etc., prepared for the enjoyment of all and to complete so worthy a proceeding. All meeting with approval, and the kettle cleaned out, everyone withdraws. Then all the women and girls bring the newly married wife a load of wood each for her store, if she is married at the season when she cannot do it easily herself.

Now it must be noted that they observe three degrees of consanguinity within which it is not their custom to marry, namely those of a son and his mother or a father and his daughter, brother and sister, and cousins. This I found out clearly one day when I pointed out a girl to a savage and asked him if that was his wife or his concubine, and he replied No, and said that she was his cousin and that

it was not their custom to sleep with their cousins. Apart from this, everything is permissible. There is no question of dowry, so when a divorce takes place the husband is liable for nothing.

The excellence and wealth that the parents mainly look for in him who seeks their daughter in marriage are, not only that he should have a good address and be well painted and adorned, but in addition that he must show himself bold in hunting, war, and fishing, and be able to do something, as is shown by the following instance. A savage made love to a girl, but she could not secure the agreement and consent of her father; he carried her off, and took her for his wife. Thereupon there was a great quarrel, and in the end the girl was taken from him and went back to her father. The reason why the father did not wish the savage to have his daughter was that he was not willing to give her to a man who had no occupation capable of supporting her and the children who should issue from the marriage. But the man did not consider that he was incapable of doing anything, though he amused himself with cooking in the French way and did not make a practice of hunting. In order to prove what he was actually capable of, since otherwise he could not have the girl again, the lad went fishing and caught a number of fish, and after this act of valour the girl was given up to him and he took her back to his lodge, and they lived happily together as they had done in the past.

If in course of time husband and wife like to separate for any reason whatever, or have no children, they are free to part, it being sufficient for the husband to say to the wife's relations and to herself that she is no good and may provide elsewhere for herself, and after that she lives in common with the rest until some other man seeks her out; and not only the men procure this divorce when their wives have given them some cause for doing so, but the wives also leave their husbands with ease when the latter do not please them. Hence it often happens that some woman spends her youth in this fashion, having had more than a dozen or fifteen husbands, all of whom nevertheless are not the only men to enjoy the woman, however much married they be; for after nightfall the young women and girls run about from one lodge to another, as do the young men for their part on the same quest, possessing them wherever it seems good to them, yet without any violence, leaving all to the wishes of the woman. The husband will do the like to his neighbour's wife and the wife to her neighbour, no jealousy intervening on that account, and no shame, disgrace, or dishonour being incurred.

But when they have children begotten from the marriage they rarely separate and leave one another except for some important reason, and when that does happen they are not long without being married again to someone else, notwithstanding their children, as to the possession of whom they come to an agreement. Usually these remain with the father, as I have seen in some instances, except in that of one young woman with whom the husband left a little son in swaddling clothes, and I do not know whether even so he would not have reclaimed it for himself when it had been weaned, if

their marriage had not been patched up. We [Recollect priests] were the intermediaries to bring them together again and compose their quarrel, and in the end they did what we advised them, which was to forgive one another and continue to live happily together for the future, as they did.

31. Marital Fidelity on the Great Lakes

Nicolas Perrot's close familiarity with the Great Lakes Algonquian tribes in the second half of the seventeenth century allowed him to generalize accurately about native courtship and marriage. He is especially helpful about the tribal variations in marriage duration (though his language seems to confuse intentions with results), the disposal of children upon divorce (normally to the mother), and the role of intermediaries in courtship. Because two patrilineal clans were being joined as well as two people, the girl's brother and the boy's father or paternal uncle were party to the process. Although Perrot seems to imply that the wife was "bought," he certainly knew that the exchange of gifts between families did not constitute "purchase," as his vivid description of the permissible recourse of aggrieved spouses indicates. However, very few tribes, the Ottawas and Illinois among them, permitted a husband to actually kill an unfaithful wife. More frequently her nose was cut off. In light of the native enjoyment—and Christian abhorrence—of premarital sex, the custom in many eastern tribes of sexual continence during the first several months of marriage came as a pleasant surprise to most European observers.

There are some savage peoples among whom persons marry in order to live together until death; and there are others among whom married persons separate whenever it pleases them to do so. Those who observe this latter maxim are the Irroquois, the Loups [Mahicans], and some others. But the Outaoüas [Ottawas] marry their wives in order to remain with them through-

Source: Emma Helen Blair, ed. and trans., *The Indian Tribes of the Upper Mississippi Valley and Region of the Great Lakes,* 2 vols. (Cleveland: The Arthur H. Clark Co., 1911), 1:64–70. Reprinted by permission of The Arthur H. Clark Co.

out life, unless some very forcible reason gives the husband occasion to put away [divorce] his wife. For without such a reason the man would expose himself to be plundered and to a thousand humiliations, since she whom he had wrongfully quitted, in order to take another wife, would go at the head of her relatives and take from him whatever he had on his person and in his cabin; she would tear out his hair and disfigure his face. In a word, there is no indignity or insult which she would not heap upon him, and which she may not lawfully inflict on him, without his being able to oppose her therein if he does not wish to become the butt of ignominy in the village. When the husband does not take another wife, the one whom he has deserted may strip him when he comes back from hunting or trading, leaving to him only his weapons; and she takes away [even] these if he positively refuses to return with her. But when the man can prove on his side that she has been unfaithful to him, either before or since he has left her, he can take another wife without any one being able to raise objection. The woman cannot at her own whim abandon her husband, since he is her master, who has bought and paid for her; even her relatives cannot take her away from him; and if she leaves him custom authorizes him to kill her, without any one blaming him for it. This has often brought on war between families, when [relatives] undertook to maintain the husband's right when the woman would not consent to return to him.

The Irroquois, the Loups, and some other tribes do not act toward their women as the Outaoüas do; there are among them, however, some men who never leave their wives and love no other woman during life. But the greater number, especially the young men, marry in order to leave their wives whenever they please. The man and wife take each other for a hunting or trading voyage, and share equally the profit they have made therein. The husband can even agree with the wife regarding what he will give her for such time as he desires to keep her with him, under condition that she remain faithful to him; she also, after having ended the voyage, can separate from him. There are some of them, however, who feel a mutual love, and always live together; these are the couples who have had children; and the latter, according to the rule of the savages, belong to the mother, since they always live with her—the boys, until they are ready to be married; and the girls, until the death of the mother. If the father should leave his wife, the children whom he has had by her would not fail, when they grew up, to treat him with contempt, and to overwhelm him with reproaches for having abandoned them in their childhood and left to their mother all the care and hardship of rearing them.

Those peoples [Algonquian-speakers] make love secretly, during a rather long time. The youth makes the first beginning, by declaring his purpose to some one of his friends whose discretion and fidelity he knows; the girl does as much, on her side, and chooses as confidant one of her companions, to whom she discloses her secret. The youth, having with him the comrade whom alone he has informed of his love, approaches at an unseasonable

[late] hour the place where the girl is sleeping, and informs her that he wishes to visit her. If she consents to this, he sits down close to her, and makes known to her, in the most decorous manner, the affection that he feels toward her, and his intention of making her his wife. If the girl does not give a favorable reply on an occasion of this sort, after he has made his declaration, he then withdraws; but he returns on the next day, in the same manner as before. He continues to visit her every night, until he has gained her consent, given by her telling him that her mother is mistress of her person.

The young man then goes to his mother, and announces to her the name of the girl whom he is seeking in marriage, with the consent which the latter has given him. The mother then tells his father, or, if he has none, the [maternal] uncle or nearest cousin; and the two go to visit the girl's family, in order to propose to them the alliance with their son. Sometimes it is sufficient to make this proposal to the brother of the girl, who will then discuss it with their mother; and, after having gained her consent, the relatives meet together in order to settle what amount, whether in furs or in other goods, they will give to provide for the young people. The mother of the young man carries to the girl's home the half of what shall be given her in marriage, and returns thither two or three times to carry something in order, as she says, to pay for the body of her future daughter-in-law. During that time all the goods are distributed among the relatives of the girl, who reimburse the mother-in-law for part of them with provisions, such as Indian corn and other kinds of grain; for it is the woman who takes care to furnish her husband with grain. The new bride is dressed as handsomely as possible, and is accompanied by her mother-in-law, who points out to the girl the place near herself which she must occupy with her husband, who is then strolling in the village. When the bride is seated, the mother-in-law takes from her all the garments which she has on her person, and gives her others, also some goods which she carries to the girl. The latter then returns to her mother, who again strips her of all her finery, and receives from her all the goods that she has; then having dressed the girl for the last time, the mother sends her back to her husband's house, making her a present of some sacks of grain. Repeated visits of this sort are sometimes made very often; but when it is desired to end them the girl is dressed in ragged garments, and it is by this means that the marriage ceremonies are terminated; for after that she lives with her mother-in-law, who has charge of her.

Although the savages have not, at bottom, much esteem for modesty they nevertheless surpass the Europeans in external propriety; for in all their love-affairs they never utter in conversation a word which can wound chaste feelings. There are among them some who, after being married, have remained six months or even a year without intercourse, and others the same for more or less time. The reason which they give for this is, that they marry not because of lust, but purely through affection.

When the marriage has been consummated, the newly wedded go to-

gether to hunt and fish; and thence they return to the village, to the cabin of the girl's mother, and give her whatever they have brought. This mother takes a part of it to give to the mother of the youth, who is obliged to live with his mother-in-law and work for her during two years, for it is his duty to do so. During all that time, she alone is under obligation to feed and support him; and if he must give any feast she pays the expense of it.

After he has served his two years with his mother-in-law, he returns with his wife to his own mother; and when he comes back from hunting or fishing he gives his mother-in-law a part of what he has brought back for his mother. Similarly, when he returns from trading it is always the wishes of his mother-in-law to which he must pay regard; and his wife is obliged to do whatever work is suitable for women, the same as if she were the servant of the house.

32. Polygamy in Canada

While Nicolas Perrot learned about native marriage customs from personal experience, Pierre de Charlevoix relied mostly on the experiences of others, particularly his fellow Jesuits in Canadian missions. His early eighteenth-century overview of eastern Canadian customs corroborates Perrot on a number of points, such as the norm of long-term monogamy, parental match-making, trial marriages, children belonging to their mother's clan, strict incest taboos extending to several degrees of consanguinity, and adulteresses who lost their noses.

He also sheds light on several other aspects of Great Lakes marriage. Among the most interesting is the sororate, in which a widower married his wife's sisters in turn. There were two reasons for this practice: the rigors of warfare and hunting sometimes created a surplus of women who needed to be cared for, and in classificatory kinship systems a woman and her sisters, being of the same mother, were considered logically equivalent. Of equal value are Charlevoix's notice of polyandry (two or more husbands for one woman) among the Senecas—only Lafitau mentioned it thereafter (*Customs*

Source: P[ierre] de Charlevoix, *Journal of a Voyage to North-America.* 2 vols. (London, 1761), 2:48–54.

of the American Indians, ed. and trans. William N. Fenton and Elizabeth L. Moore, 2 vols. [Toronto: The Champlain Society, 1974–1977], 1:377)—and recognition that after and sometimes before marriage a young man had to provide fish and game for his in-laws for a certain period to demonstrate his prowess as a provider for their daughter. Less reliable is the priest's European male perception of the woman's household "slavery" (see below, chap. 4).

A plurality of wives is allowed of, amongst several of the nations of the Algonqui[a]n language, and it is common enough to marry all the sisters; this custom is founded on a persuasion, that sisters must agree better together than strangers. In this case all the women are upon an equal footing; but amongst the true Algonquins there are two orders of wives, those of the second order being the slaves of the first. Some nations have wives in every quarter where they have occasion to sojourn for a while in hunting time; and I have been assured, that this abuse has crept in some time since, amongst the nations of the Huron language, who were always before satisfied with one wife. But there prevails in the Iroquois canton of Tsonnonthouan [Seneca] a much greater disorder still, namely a plurality of husbands.

With respect to degrees of parentage in marriage, the Hurons and Iroquois are very scrupulous; the parties amongst them must have no manner of consanguinity, and even adoption itself is included in this law. But the husband when the wife happens to die first is obliged to marry her sister, or in default of her, such person as the family of the deceased shall chuse for him. The wife on her part is under the same obligation with respect to the brothers or relations of her husband,

provided he dies without leaving any children by her, and that she is still capable of having any. The reasons they alledge for this, are the same expressed in the 25th chapter of Deuteronomy. The husband who should refuse to marry the sister or relation of his departed wife, would thereby expose himself to all the outrages which the person he rejects shall think fit to offer him; and which he is obliged to suffer without murmuring: when for want of such person a widow is permitted to provide herself in a husband elsewhere, they are obliged to make her presents, as a testimony rendered to her virtuous behaviour; and which she has a right to exact, provided she have really observed a prudent deportment during the time of her first marriage.

Amongst all the Indian nations, there are certain considerable families, who can only contract alliances with each other, and chiefly amongst the Algonquins. Generally speaking, the perpetuity of marriages is sacred in this country, and most look upon those agreements to live together as long as they shall see fit, and to separate when they become weary of each other, as being contrary to good order. A husband who should abandon his wife without lawful cause, must lay his account with many insults from her relations; and a woman who should

leave her husband without being forced to it by his ill conduct, must pass her time still worse.

Amongst the Miamis, a husband has a right to cut off the nose of the wife who elopes from him: but amongst the Iroquois and Hurons they may part by mutual consent; this is done without any noise, and the parties thus separated are at liberty to enter into new engagements. These Indians cannot so much as conceive how men should make any difficulty about it: "My wife and I, (said one of them to a missionary, who endeavoured to bring him to a sense of the indecency of this sort of separations,) cannot live in peace together; my neighbour is exactly in the same situation, we have agreed to exchange wives and are all four perfectly well satisfied: now what can be more reasonable than to render one another mutually happy when it can be so easily brought about, and without hurting anybody." This custom however as I have already remarked, is looked upon as an abuse, and is of no great antiquity, at least among the Iroquois.

What most commonly destroys the peace of families amongst the Canadian nations is jealousy, to which both sexes are equally subject. The Iroquois boast of being free from this evil; but those who have been most conversant among them assure us, that they are jealous to an extravagant height. When a woman has discovered that her husband likes another, her rival must take care to keep well upon her guard, and the more so as the unfaithful husband can neither defend her, nor side with her in any manner; a man who should maltreat his wife on this account would be disgraced for ever.

The parents are the only matchmakers in this country; the parties concerned never appear in it, but abandon themselves blindly to the will of those on whom they depend; but behold the caprice of these barbarians, who suffer themselves to be dependant on their parents in no case, except in the very thing in which they ought least of all to depend on them: nothing however is concluded without their consent, but this is only a mere piece of formality. The first steps are taken by the [clan] matrons, but it is not common for the relations of the young woman to make any advances; not but that in case a girl should happen to remain too long in the market, her family would act underhand in order to get her disposed of, but in this a great deal of caution is used. In some places the girls are in no hurry to get themselves married, as they are at full liberty to make trial of that state beforehand, and as the ceremony of marriage makes no change in their condition except to render it harder.

They remark a great deal of modesty in the behaviour of young people whilst the match is making, though we are told the thing was quite different in ancient times; but what is almost incredible, and which is nevertheless attested by good authors is, that in several places the new married couple live together for a whole year in perfect continence; this is done say they, to shew that they married out of friendship and not to gratify their passions; a young woman would even be pointed at who should prove with child the first year of her marriage.

After what has been said we ought to have less difficulty in believing what is related of the manner in which young people behave during the courtship in those places, in which they are permitted to be alone. For though

custom allows them great familiarities, they nevertheless pretend that in the most extreme danger to which modesty can be exposed, and even under the veil of night, there passes nothing which trangresses the rules of the most rigid decorum, and that not a word is uttered which can offend the chastest ear. . . .

I find many different relations with regard to the preliminaries and ceremonies of marriage amongst these nations; whether this proceeds from the different customs of different nations, or from the want of care in those authors to inform themselves exactly in those points. . . . It is the bridegroom who is to make the presents, in which, as indeed in every thing else, nothing can exceed the respect and decorum he shews his intended spouse; in some places the young man goes and seats himself by the side of the girl in her own cabbin, which if she suffers without stirring from her place, she is held as consenting and the marriage is concluded; but through all this difference and respect he lets it plainly be seen, that he is soon to be the master.

In effect amongst the presents she receives, there are some which ought less to be understood as testimonies of friendship, than as so many symbols and admonitions of the slavery, to which she is going to be reduced; such are the collar or straps [tumplines] for carrying burthens, the kettle and a faggot, which are carried into her cabbin; this is done in order to give her to understand, that it is to be her office to carry burdens, to dress the victuals, and to make the provision of wood.

It is even customary in some places for the bride to stock the cabbin, in which she is to make her abode after marriage, with wood sufficient to serve the following winter; and it may be remarked that in all the circumstances I have been mentioning, there is no manner of difference between the nations, in which the women have all the authority, and those in which they have nothing to do with publick business; even those very women who are in some sort mistresses of the state, at least in outward appearance, and who make the principal body of the nation after arriving at a certain age, and when their children are in a condition to cause them to be respected are of no account before this, and in houshold affairs are no more than the slaves of their husbands.

Generally speaking there is perhaps no nation in the world where the sex is more despised; to call an Indian a woman is the highest affront that can be offered him. Notwithstanding what is odd enough, children belong only to the mother, and acknowledge no authority but hers; the father is always held as a stranger with respect to them, in such manner however that if he is not looked upon as the father, he is at least always respected as the master of the cabbin. I do not know however if this is universal in every point, among all the nations we know in Canada, any more than what I have found in good memoirs, that the young wives, besides the right which their husbands have over them, with respect to the service of the cabbin, are also obliged to provide for all the necessities of their own parents, which probably is to be understood of those, who have no-body left to render them these services, and who by reason of their

age or infirmities are incapable of serving themselves.

Be this as it will, the bridegroom has also his own peculiar functions; besides hunting and fishing, to which he is obliged during the whole course of his life, he is first of all to make a mattress for his wife, build her a cabbin, or repair that in which they are to live, and whilst he remains with his father and mother-in-law, he is obliged to carry the product of his hunting home to them. Amongst the Iroquois the woman never leaves her cabbin, she being deemed the mistress, or least the heiress of it; in other nations she goes at the expiration of a year or two after her marriage, to live with her mother-in-law.

33. Micmac Modesty

While the northeastern tribes shared many marriage customs, each tribe contributed some individual richness to the general pattern. The Micmacs of the Canadian Maritime provinces were noted for the modesty of their women and the sexual purity of their first year of marriage, during which the young suitor, as in other Canadian tribes, hunted for his father-in-law to establish his credentials as a skilled woodsman and amiable companion. These were essential qualities in the small, patrilocal hunting camps that pursued big game during much of the northern year. The Recollect missionary Chrestien Le Clercq spoke for several other observers of the Micmacs, including lawyer Marc Lescarbot, the Jesuit missionary Pierre Biard, and trader Nicolas Denys, when he testified to the proverbial purity of Micmac girls (who relaxed their guard only under the influence of traders' brandy) and to the equal devotion of monogamous spouses. In the following passage, Le Clercq also notes how the objects of a proposed match had the final say (no matter how adroitly their families had engineered the espousal); describes the public wedding feast (at which the only woman present was the groom's mother, and the groom's genealogy and personal history were laboriously recited); and shows how easily childless couples divorced, and

Source: Father Chrestien Le Clercq, *New Relation of Gaspesia With the Customs and Religion of the Gaspesian Indians,* ed. and trans. William F. Ganong (Toronto: The Champlain Society, 1910), pp. 250–51, 259–64.

what complete authority the woman had over the running of the household. In the midst of often censorious descriptions of "savage" behavior it is well to be reminded that Indian husbands could openly cry at the loss of their loved ones, despite the strongest cultural sanctions against emotional expression.

It can be said, to the praise and the glory of our Gaspesian [Micmac] women, that they are very modest, chaste, and continent, beyond what could be supposed; and I can say with truth that I have specially devoted myself to the mission of Gaspesia because of the natural inclination the Gaspesians have for virtue. One never hears in their wigwams any impure words, not even any of those conversations which have a double meaning. Never do they in public take any liberty—I do not say criminal alone, but even the most trifling; no kissing, no badinage between young persons of different sexes; in a word, everything is said and is done in their wigwams with much modesty and reserve.

There are among our Indian women none of those who, as in the case of the girls of some nations of this new world, take pride in prostituting themselves to the first comer, and whom their fathers and mothers themselves present to the most famous and prominent hunters and warriors. All of these shameful prostitutions are held in horror and abomination among our Gaspesians, and one sees without wonder young Indian women so chaste and modest as to serve as an example, and to teach those of their sex the love and esteem which they ought to have for modesty and chastity. I have seen one of them, who, being solicited strongly to submit to the pursuit and the importunities of a young warrior, whom

she could not love without the loss of her honour, which was as dear to her as life, and who, wishing to escape his insolent pursuit, fled from the wigwam of her father and betook herself more than fifty leagues away, travelling with one of her companions upon the ice and in the snow, where she preferred to pass the nights in mid-winter upon some branches of fir, rather than to expose herself to committing a crime which she detested infinitely in her heart. The young Indian sought her in vain in the company of the other Indian women, who, not being able to imagine what had become of their companion, feared lest she had fallen over some precipice, or had made an attempt on her life in the displeasure and the annoyance which she felt in seeing herself persecuted by the brutality of her lover. All the Indians, however, were agreeably surprised when this girl appeared some time after in the wigwam of her father, to whom she gave an account of the matter and of the cause of her absence. . . .

The boys, according to the usual custom of the country, never leave the wigwams of their fathers except to go and live with some of their friends, where they hope to find girls whom they may marry. A boy has no sooner formed the design to espouse a girl than he makes for himself a proposal about it to her father, because he well knows that the girl will never approve

the suit, unless it be agreeable to her father. The boy asks the father if he thinks it suitable for him to enter into his wigwam, that is to say, into relationship with him through marrying his daughter, for whom he professes to have much inclination. If the father does not like the suit of the young Indian, he tells him so without other ceremony than saying it cannot be; and this lover, however enamoured he may be, receives this reply with equanimity as the decisive decree of his fate and of his courtship, and seeks elsewhere some other sweetheart. It is not the same if the father finds that the suitor who presents himself is acceptable for his daughter; for then, after having given his consent to this lover, he tells him to speak to his sweetheart, in order to learn her wish about an affair which concerns herself alone. For they do not wish, say these barbarians, to force the inclinations of their children in the matter of marriage, or to induce them, whether by use of force, obedience, or affection, to marry men whom they cannot bring themselves to like. Hence it is that the fathers and mothers of our Gaspesians leave to their children the entire liberty of choosing the person whom they think most adaptable to their dispositions, and most conformable to their affections, although the parents, nevertheless, always keep the right to indicate to them the one whom they think most likely to be most suitable for them. But in the end this matter turns out only as those wish who are to be married; and they can very well say that they do not marry for the sake of others, but for themselves alone.

The boy, then, after obtaining the consent of the father, addresses himself to the girl, in order to ascertain her sentiments. He makes her a present from whatever important things he possesses; and the custom is such that if she is agreeable to his suit, she receives and accepts it with pleasure, and offers him in return some of her most beautiful workmanship. She takes care, say they, not to receive the least thing from those who seek her in marriage, in order not to contract any engagement with a young man whom she has not the intention of marrying.

The presents having been received and accepted by both parties, the Indian returns to his home, takes leave of his parents, and comes to live for an entire year in the wigwam of his sweetheart's father, whom, according to the laws of the country, he is to serve, and to whom he is to give all the furs which he secures in hunting. . . . It is necessary then that he show himself a good hunter, capable of supporting a large family: that he make himself pleasant, obedient, and prompt to do everything which is connected with the welfare and the comfort of the wigwam: and that he be skilled in the usual exercises of the nation; this he does in order to merit the esteem of his mistress and to make her believe that she will be perfectly happy with him. The girl, for her part, also does her best with that which concerns the housekeeping, and devotes herself wholly, during this year, if the suit of the boy be pleasing to her, to making snowshoes, sewing canoes, preparing barks, dressing skins of moose or of beaver, drawing the sled [toboggan]— in a word, to doing everything which can give her the reputation of being a good housewife.

As they are all equally poor and rich, self-interest never determines their marriages. Also there is never a question of dowry, of property, of inheritance, of a contract, or of a notary who arranges the property of the two parties in case of divorce. If they possess a blanket, or some beaver robe, it is sufficient for setting up housekeeping, and all that even the richest can hope for is a kettle, a gun, a fire-steel, a knife, an axe, a canoe, and some other trifles. These are all the riches of the newly-married couples, who do not fail, nevertheless, to live content when this little is wanting, because they hope to find in hunting that with which to supply in plenty their needs and necessities.

Many persons are persuaded but too easily that the young man abuses his future spouse during this year which he is obliged to spend in the wigwam of his sweetheart. But aside from the fact that it is a custom and an invariable law among our Gaspesians, which it is not permissible to transgress without exposing the entire nation to some considerable evil, it is truth to say that these two lovers live together like brother and sister with much circumspection. I have never heard, during all the time that I have lived in Gaspesia, that any disorder occurred between them, considering likewise that the women and the girls, as we have said, are themselves so modest as not to permit in this matter any liberty which would be contrary to their duty.

When, then, the two parties concur in disposition and tastes, at the end of the year the oldest men of the nation, and the parents and friends of the future married couple, are brought together to the feast which is to be made for the public celebration of their marriage. The young man is obliged to go for the provision, and the entertainment is more or less magnificent according as he makes a hunt or a fishery more or less successful. The usual speeches are made, they sing, they dance, they amuse themselves; and in the presence of the whole assembly the girl is given to the boy as his wife, without any other ceremony. If it turns out then that the disposition of one is incompatible with the nature of the other, the boy or the girl retires without fuss, and everybody is as content and satisfied as if the marriage had been accomplished, because, say they, one ought not to marry only to be unhappy the remainder of one's days.

There is nevertheless much instability in these sorts of alliances, and the young married folks change their inclinations very easily when several years go by without their having children. "For in fact," say they to their wives, "I have only married thee in the hope of seeing in my wigwam a numerous family, and since I cannot have children with thee, let us separate, and seek elsewhere each his own advantage." It is such that if any stability is found in the marriages of our Gaspesians, it is only when the wife gives to her husband evidence of her fecundity; and it can be said with truth that the children are then the indissoluble bonds, and the confirmation, of the marriage of their father and mother, who keep faithful company without ever separating, and who live in so great a union with one another, that they seem not to have more than a single heart and a single will.

They are very fond of one another, and they agree remarkably well. You never see quarrels, hatred, or reproaches among them. The men leave the arrangements of the housekeeping to the women, and do not interfere with them. The women cut up, slice off, and give away the meat as they please, but the husband does not get angry; and I can say that I have never seen the head of the wigwam where I was living ask of his wife what had become of the meat of moose and of beaver, although all that he had laid in had diminished very quickly. No more have I ever heard the women complain because they were not invited to the feasts or the councils: because the men amused themselves and ate the best morsels: because they themselves worked incessantly going to fetch wood for the fires, building the wigwams, dressing the skins, and occupying themselves with other severe labours, which are done only by the women. Each does her little duty quietly, peaceably, and without debate. The multiplication of children does not embarrass them; the more they have, the more they are content and satisfied.

One cannot express the grief of a Gaspesian when he loses his wife. It is true that outwardly he dissimulates as much as he can the bitterness which he has in his heart, because these people consider it a mark of weakness unworthy of a man, be he ever so little brave and noble, to lament in public. If, then, the husband sometimes sheds tears, it is only to show that he is not insensible to the death of his wife, whom he loved tenderly; although it can truly be said that in his own privacy he abandons himself entirely to melancholy, which very often kills him, or which takes him to the most distant nations, there to make war and to drown in the blood of his enemies the sorrow and grief which overwhelm him.

34. Wampum for Wives in New England

According to Roger Williams, the marriage customs of the Narragansetts of Rhode Island resembled those of the other eastern tribes, but with two interesting differences. The punishment of female adultery fell upon the wife's lover rather than upon the wife, and part of the groom's gift to the

Source: Roger Williams, *A Key into the Language of America* (London, 1643), pp. 146–48, 150.

bride's family consisted of wampum, the bead "money" of drilled quahog shells made by only a few tribes on Long Island Sound until the middle of the seventeenth century. Williams also relates two native reasons for the (infrequent) resort to polygamy: the horticultural wealth of women and the long periods of sexual abstinence required by custom during pregnancy and breast-feeding.

Wuskéne.	*A young man.*
Keegsquaw.	*A Virgin or Maide.*
Segaûo.	*A Widdower.*
Segoúsquaw.	*A Widdow.*
Wussénetam.	*He goes a wooing.*
Nosénemuck.	*He is my sonne in Law.*
Wussenetûock,	*They make a match.*
Awetawátuock.	

Obs[ervation]. Single fornication they count no sin, but after Mariage (which they solemnize by consent of Parents and publique approbation publiquely) then they count it h[e]inous for either of them to be false.

Mammaûsu.	*An adulterer.*
Nummam mógwunewò.	*He hath wronged my bed.*
Pallè nochisquaûaw.	*He or She hath committed adultery.*

Obs. In this case the wronged party may put away [divorce] or keepe the party offending: commonly, if the Woman be false, the offended Husband will be solemnely revenged upon the offendor, before many witnesses, by many blowes and wounds, and if it be to Death, yet the guilty resists not, nor is his Death revenged.

Nquittócaw.	*He hath one Wife.*
Neesócaw.	*He hath two Wives.*
Sshócowaw.	*He hath three.*
Yócowaw.	*Foure Wives, &c.*

Their number is not stinted, yet the chief Nation in the Country, the Narrigansets (generally) have but one Wife.

Two causes they generally alledge for their many Wives.

First desire of Riches, because the Women bring in all the increase of the Field, &c. the Husband onely fisheth, hunteth, &c.

Secondly, their long sequestring themselves from their wives after conception, untill the child be weaned, which with some is long after a yeare old, generally they keep their children long at the breast:

Commíttamus.	*Your Wife.*
Cowéewo.	
Tahanawátu? ta shin-commaugemus.	*How much gave you for her?*

Napannetashom paûgatash *Five fathome of their*
 Money.
Qutta, énada shoásúck ta *Six, or seven, or eight*
 shompaúgatash. *Fathome.*

If some great mans Daughter *Piuckquompaúgatash*, ten fathome.

Obs. Generally the Husband gives these payments for a Dowrie, (as it was in *Israell*) to the Father or Mother, or guardian of the Maide. To this purpose if the man be poore, his Friends and neighbours doe *pummanùmminteàuguash*, that is contribute Money toward the Dowrie. . . .

Obs. They put away [divorce] (as in Israell) frequently for other occasions besides Adultery, yet I know many Couples that have lived twenty, thirty, forty yeares together.

Npakétam. *I will put her away.*
Npakénaqun. *I am put away.*
Aquiepakétash. *Doe not put away.*
Aquiepokesháttous *Doe not break the knot*
Awetawátuonck. *of Marriage.*
Tackquiûwock. *Twins.*
Towiû-ûwock. *Orphans.*
Ntouwiú. *I am an Orphane.*
Wáuchaũnat. *A Guardian.*
Wauchaúamachick. *Guardians.*
Nullóquaso. *My charge or Pupill,*
 or Ward.

Peewaúqun. *Looke well to him &c.*

35. Love Charms and Venality among the Delawares

Like all aspects of culture, marriage customs were destined to change with time, especially under the pressure of contact with the European colonists and missionaries. David Zeisberger, the Moravian missionary who worked Pennsylvania and Ohio in the second half of the eighteenth century, de-

Source: David Zeisberger's History of the Northern American Indians, ed. Archer Butler Hulbert and William Nathaniel Schwarze (Columbus: Ohio State Historical and Archaeological Society, 1910), pp. 20–21, 78–79, 81–83, 85.

tected what he felt were deleterious changes among the Iroquois, Mahicans, and Delawares he knew well. Besides a general increase in sexual and moral "vice," which any Christian missionary was likely to find, Zeisberger documents a growing venality on the part of young women who contracted serial marriages only for the gifts they brought. When Indian girls married at between fourteen and sixteen years, it is perhaps not surprising that divorce was common until maturity and the responsibility of children diminished their unfocused longings.

Zeisberger's other observations merely confirm age-old patterns: the use of intermediaries in courtship, the necessity of parental approval but the children's ultimate choice of spouse, and female authority over the household. The seriousness of unfaithfulness and the corresponding value of firm marriages is underlined by the resort to suicide and to love charms, which were common throughout the native East.

In studying the Indians, their mode of life and deportment toward each other, particularly the relations between the sexes, it is safe to say that one does not learn to know them well until they become concerned about the well-being of their souls and confess the evils that weigh on their consciences. One may be among them for several years and, not knowing them intimately, as stated, regard them as a virtuous people. Far from it. Impurity and immorality, even gross sensuality and unnatural vice flourish among them, according to the testimony of the Indians themselves, more than was the case formerly. As they marry early in life, the men in the eighteenth or nineteenth year, the women in the fifteenth or sixteenth or even earlier, one would imagine that the Indians should increase rapidly and have many children. Yet an Indian may become old and have but few or no children, for family ties are only too frequently and easily broken on slight provocation, even when there are children. Only as the parties ad-vance in age and cannot so readily form other connections, are matrimonial relations apt to be permanent. Owing to instability of family relationship, children are often neglected. This does not argue that the Indians do not love their children. As every creature loves its young, so the Indians do love their children, are indeed, very fond of them, especially as they mature and return the affection. But sin and lust bring about unnatural conditions. It seems as if a curse rested upon them and that they were destined to become extinct. There is another clan of Indians who live with their wives because they love their children, and at the same time have concubines, who do not live in the house, because the rightful wife will not suffer this. The latter will generally be content to remain with her husband. I have known cases where an Indian would have two wives in his house, but this is rare.

Yet there are Indians, even among the savages, who maintain peaceable

and orderly family life. Among them larger families are the rule, there being often from eight to twelve children. The difference between these Indians and their fellows may be easily appreciated. . . .

In the wooing of a bride, custom demands that if an Indian would proceed honorably and at the same time have assurance that his wife when married will remain with him, he first sends a present of blankets, strouds, linen and whatever else the Indians commonly use for clothing and perhaps a few belts or fathoms of wampum. If he has no cloth, wampum alone will do. These things he gives to an Indian to whom he has declared his purpose and who hands them to a friend of the person fixed upon, speaks for him and presses his suit. Thereupon, the friends assemble, examine the present, propose the matter to the girl, who generally decides agreeably to the wish of her parents and relations. The suitor is then informed that his proposal has been accepted. If it is decided to decline the proposal, the present is simply returned and understood to be a friendly negative. In case the match is agreeable, the girl is led to the dwelling of the groom, without further ceremony. After the bride has joined her husband, the things constituting the present are divided among the friends and the belts of wampum cut and a piece given to each. The friends return the civility by a present of Indian corn, beans, kettles, dishes, spoons, sieves, baskets, hatchets, brought in solemn procession into the hut of the newly married couple. Commonly, the latter lodge in a friend's house until they can erect a dwelling of their own.

This custom still obtains among the Indians. Within the last years, however, disorderly living and evil have become so common that faith is not kept and many of the usages, that were good and preserved a certain decency, have fallen into disuse. At the present time [c. 1780], even if the Indian would take a wife in honorable fashion and proceed in accordance with the above described custom, the parties concerned will not deny his suit in view of the presents, even though the friends and the girl are not willing to accept him. The friends will urge the girl to live with the man a short time, and tell her that if she is not pleased, to leave him again. Thus it happens that women will go from one to another for the sake of the gifts. Yet there are many cases where husband and wife are faithful to one another throughout life.

Occasionally, parents who have a son will agree with parents who have a daughter that in due time their children shall marry. As, however, they can neither persuade nor compel their children against their wishes, it in the end depends upon the children whether the match shall be consummated.

Among the Mingoes [Ohio Iroquois] it is not unusual to fix upon children of four or five years of age, with a view to future marriage. In this case the mother of the girl is obliged to bring a basket of bread every week into the house of the boy and to furnish him with firewood. The parents of the boy must supply the girl with meat and clothes, till they are both of a proper age. Their marriage, however, solely depends upon their own free will, for there is never any compulsion. If either man or woman is

unwilling to follow up the engagement entered into by parents, no marriage results.

Although there are many Indians who live peaceably with their wives, especially if they have children for whom they care (for if a man has several children he will try to get along with his wife) the younger Indians at the present time generally live together only a very short time after a marriage. Hence, fornication is very common among them. Satan's influence in this respect being very strong. . . .

In the management of household affairs the husband leaves everything to his wife and never interferes in things committed to her. She cooks victuals regularly twice a day. If she neglects to do it in proper time, or even altogether, the husband never says a word but goes to a friend, being assured that he will find something to eat, for when a stranger comes into the house the first attention shown is to put food before him, if there is anything in the house. The husband never offers to put wood on the fire, except it be that he has guests or some other extraordinary call to do it, for the woman cuts the wood and brings it to the house and is, therefore, the proper person to take care of the fire.

If his wife longs for meat, and gives him a hint of it, the husband goes out early in the morning without victuals and seldom returns without some game, should he even be obliged to stay out till late in the evening. When he returns with a deer, he throws it down before the door of the hut and walks in, saying nothing. But his wife, who has heard him lay down his burden, gives him something to eat, dries his clothes and then goes out to bring

in the game. She may then do what she pleases with it. He says nothing, if she even gives the greatest part of it to her friends, which is a very common custom. A woman generally remembers her friends when meat has been secured, or when her husband has brought flour from the whites.

If the husband intends to take a journey or go hunting, he gives his wife notice, and then she knows that it is her business to furnish him with proper provisions. If any dissatisfaction arises between them, the husband commonly takes his gun and walks off into the woods, without telling his wife whither he is going. Sometimes he does not return for some days, when both parties have generally forgotten their quarrels and live again in peace.

Young people who marry rarely remain faithful to each other, but join themselves to others and again separate, continuing such disorderly living until they are older and more sensible. Then it not infrequently happens that they find one another again, or the husband may join himself permanently to some other woman and settle down to housekeeping. Marriages are contracted early in life, when men are from eighteen to twenty years of age and women fourteen or fifteen. There is in general no very strong tie between married people, not even between the older. A mere trifle furnishes ground for separation. Not every Indian, however, is indifferent to the light behavior of his wife. Many a one takes her unfaithfulness so to heart that in the height of his despair he swallows a poisonous root, which generally causes death in two hours, unless an antidote be administered in good

time; this is often done, the Indians knowing that the properties of certain herbs counteract each other and being able to judge from the effects, what poison has been taken. Women, also, have been known to destroy themselves on account of a husband's unfaithfulness. To prevent such a calamity, they make use of a Beson, a love-charm, prepared by the old people and sold at a good price. This is constantly carried about by one or the other of the parties and is believed to keep man or woman faithful. Such a charm is even declared to have had the effect of making a woman run always and everywhere after her husband, until weary of life she has destroyed herself, or of similarly affecting a man. For this Beson, also, the Indians have their antidote. All this converted [Christian] Indians have related to me.

It occurs to me to add that when a man and his wife have no children, they generally separate before long, each believing the other to be the guilty cause, and attributing it to the other. There are also women who never have children. Such a one goes from one man to another until some man who has children already takes her. There are men also who never have children. In both sexes, however, these cases are rare.

36. Married Continence in the Carolinas

The native peoples encountered by surveyor and town-founder John Lawson in his 550-mile swing through the Carolinas in 1700 apparently regarded courtship and marriage much as their northern cousins did. The Tuscaroras, Catawbas, Santees, and other small tribes from the coast to the Piedmont believed in clan approval of a match, sexual continence during the early months of marriage, at least until the full "brideprice" of gifts had been paid to the girl's family, an incest taboo, the appropriateness of a man's marrying two sisters or his brother's widow, and the primary responsibility of the male lover for a wife's infidelity. Lawson also documents the serious inroads made on the native populations by disease, alcohol, and European-induced warfare in his observation that various tribes were forced to choose marriage partners outside their own tribal communities. It is also interesting that the girls who married European traders and resorted to

Source: John Lawson, *A New Voyage to Carolina* (London, 1709), pp. 185–88.

means to abort children were later accepted by their tribesmen without apparent discredit, perhaps because they brought to their native husbands wealth in trade goods and the prestige of special alliance with the now indispensable traders. Whether these girls and their sisters discerned any real difference in the sexual prowess of Indian and European men is difficult to judge. An Englishman may be forgiven for thinking that the "daughters of the country" valued his skill in bed when they actually preferred his pots and pans.

As for the *Indian* Marriages, I have read and heard of a great deal of Form and Ceremony used, which I never saw, nor yet could learn in the Time I have been amongst them, any otherwise than I shall here give you an Account of; which is as follows.

When any young *Indian* has a Mind for such a Girl to his Wife, he, or some one for him, goes to the young Woman's Parents, if living; if not, to her nearest Relations; where they make Offers of the Match betwixt the Couple. The Relations reply, they will consider of it, which serves for a sufficient Answer, till there be a second Meeting about the Marriage, which is generally brought into Debate before all the Relations (that are old People) on both Sides; and sometimes the King [sachem], with all his great Men, give their Opinions therein. If it be agreed on, and the young Woman approve thereof, (for these Savages never give their Children in Marriage, without their own Consent) the Man pays so much for his Wife; and the handsomer she is, the greater Price she bears. Now, it often happens, that the Man has not so much of their Money [roanoke, a form of shell bead] ready, as he is to pay for his Wife; but if they know him to be a good Hunter, and that he can raise the Sum agreed for,

in some few Moons [months], or any little time, they agree, she shall go along with him, as betroth'd, but he is not to have any [sexual] Knowledge of her, till the utmost Payment is discharg'd; all which is punctually observ'd. Thus, they lie together under one Covering for several Months, and the Woman remains the same as she was when she first came to him. I doubt, our *Europeans* would be apt to break this Custom, but the *Indian* Men are not so vigorous and impatient in their Love as we are. Yet the Women are quite contrary, and those *Indian* Girls that have convers'd with the *English* and other *Europeans*, never care for the Conversation [sexual company] of their own Countrymen afterwards.

They never marry so near as a first Cousin; and although there is nothing more coveted amongst them, than to marry a Woman of their own Nation, yet when the Nation consists of a very few People (as now adays it often happens) so that they are all of them related to one another, then they look out for Husbands and Wives amongst Strangers. For if an *Indian* lies with his Sister, or any very near Relation, his Body is burnt, and his Ashes thrown into the River, as unworthy to remain on Earth; yet an *Indian* is

allow'd to marry two Sisters, or his Brothers Wife. Although these People are call'd Savages, yet Sodomy is never heard of amongst them, and they are so far from the Practice of that beastly and loathsome Sin, that they have no Name for it in all their Language.

The Marriages of these *Indians* are no farther binding, than the Man and Woman agree together. Either of them has Liberty to leave the other, upon any frivolous Excuse they can make; yet whosoever takes the Woman that was another Man's before, and bought by him, as they all are, must certainly pay to her former Husband, whatsoever he gave for her. Nay, if she be a Widow, and her Husband died in Debt, whosoever takes her to Wife, pays all her Husband's Obligations, though never so many; yet the Woman is not required to pay any thing (unless she is willing) that was owing from her Husband, so long as she keeps Single. But if a Man courts her for a Nights Lodging, and obtains it, the Creditors will make him pay her Husband's Debts, and he may, if he will, take her for his Money, or sell her to another for his Wife. I have seen several of these Bargains driven in a day; for you may see Men selling their Wives as Men do Horses in a Fair, a Man being allow'd not only to change as often as he pleases, but likewise to have as many Wives as he is able to maintain. I have often seen, that very old *Indian* Men (that have been Grandees in their own Nation) have had three or four very likely young *Indian* Wives, which I have much wondered at, because to me they seem'd incapacitated to make good Use of one of them.

The young Men will go in the Night from one House to another, to visit the young Women, in which sort of Rambles they will spend the whole Night. In their Addresses they find no Delays, for if she is willing to entertain the Man, she gives him Encouragement and grants him Admittance; otherwise she withdraws her Face from him, and says, I cannot see you, either you or I must leave this Cabin, and sleep somewhere else this Night.

They are never to boast of their Intrigues with the Women. If they do, none of the Girls value them ever after, or admit of their Company in their Beds. This proceeds not on the score of Reputation, for there is no such thing (on that account) known amongst them; and although we may reckon them the greatest Libertines and most extravagant in their Embraces, yet they retain and possess a Modesty that requires those Passions never to be divulged.

The Trading Girls [Indian women who lived with European traders], after they have led that Course of Life, for several Years, in which time they scarce ever have a Child; (for they have an Art to destroy the Conception, and she that brings a Child in this Station, is accounted a Fool, and her Reputation is lessen'd thereby) at last they grow weary of so many, and betake themselves to a married State, or to the Company of one Man; neither does their having been common to so many any wise lessen their Fortunes, but rather augment them.

The Woman is not punish'd for Adultery, but 'tis the Man that makes the injur'd Person Satisfaction, which is the Law of Nations practis'd amongst them all; and he that strives to evade such Satisfaction as the Husband de-

mands, lives daily in Danger of his Life; yet when discharg'd, all Animosity is laid aside, and the Cuckold is very well pleased with his Bargain, whilst the Rival is laugh'd at by the whole Nation, for carrying on his Intrigue with no better Conduct, than to be discover'd and pay so dear for his Pleasure.

The *Indians* say, that the Woman is a weak Creature, and easily drawn away by the Man's Persuasion; for which Reason, they lay no Blame upon her, but the Man (that ought to be Master of his Passion) for persuading her to it.

They are of a very hale Constitution; their Breaths are as sweet as the Air they breathe in, and the Woman seems to be of that tender Composition, as if they were design'd rather for the Bed then Bondage. Yet their Love is never of that Force and Continuance, that any of them ever runs Mad, or makes away with themselves on that score. They never love beyond Retrieving their first Indifferency, and when slighted, are as ready to untie the Knot at one end, as you are at the other.

Yet I knew an *European* Man that had a Child or two by one of these *Indian* Women, and afterwards married a Christian, after which he came to pass away a Night with his *Indian* Mistress; but she made Answer that she then had forgot she ever knew him, and that she never lay with another Woman's Husband, so fell a crying, and took up the Child she had by him, and went out of the Cabin (away from him) in great Disorder.

37. A Fox Woman Finds True Love

At the end of the nineteenth century Fox marriage customs had changed very little from their aboriginal form. Girls were instructed by their mothers and clan relations in moral etiquette, parents voiced strong preferences for their daughter's husband, wedding ceremonies consisted largely of formalized gift exchanges between the spouses' families, and the ease of divorce served to maintain family harmony.

When the Fox woman narrating this story was treated meanly by the husband chosen for her by her now deceased mother, she simply "chase[d] him

Source: "The Autobiography of a Fox Indian Woman," ed. and trans. Truman Michelson, U.S. Bureau of American Ethnology, *Annual Report*, no. 40 (Washington, D.C., 1925), pp. 309–15, 321–29.

away." After a suitable period of chaste behavior recommended by her maternal uncle, she married her first love, who confounded her mother's predictions by becoming a good provider, faithful lover, and gentle husband. Because she easily miscarried, the Fox woman was given a native sterility drug to prevent conception, demonstrating once again that the eastern Indians were adept in controlling the natural female processes.

Now when I was more than seventeen, while living outside somewhere, after two days, late at night while I was still sleeping, (some one) said to me, "Wake up." (The person) was holding a match, and lit it. Lo, it was a man when I looked at him. I was as frightened as possible. I trembled as I was frightened. When I ordered him away, (my voice) did not (sound) natural when I spoke. I was barely able to speak to him. And from then on, now and then men tried to come to me. I always had been instructed what was proper. When it was known (what kind of a person) I (was), they began to try to court me.

Then I was instructed, "Well, when you are twenty, then you may desire to take a husband. Whoever is the one whom you are going to take as your husband, he alone is the one with whom you are to talk when you begin to talk with (a man). Do not talk to many. It is not right for women to have many [male] friends. Their husband(s) will not treat them well as they are jealous when they know what (their wives) have been doing. That indeed is why (women) are forbidden to have many friends." That is what I was told.

Then soon when I was eighteen, in the spring at the time when (people) begin to pick strawberries, I accompanied a young woman when we were strawberrying. "We will see one," she would say to me. Then she would say to me, "I am just joshing you." As a matter of fact she and one young man had made arrangements to see each other over there.

Soon he came over there. They were well acquainted with each other and treated each other kindly. She was helped by him when she was picking strawberries. She kept coming to me to get me to go with her some place. Soon he came with another young man. Then this young woman got me to talk to his fellow young man. "He will not do anything: you may talk together quietly," that woman told me. As often as we went anywhere those men came. Finally I surely began to talk to that young man. And then we four went around (together) a great deal. It surely was enjoyable (to hear them) say funny things. Then it was that I always wished to see him right away when I went anywhere, that is after I had seen him.

Of course many men tried to get me to talk with them. Soon it was known (what kind of a person I was). My, but they scolded me severely. Another young man had been selected for me to take as husband. (The other one) and I were already well acquainted.

"You had better take a husband right away," I was told. " 'When you are twenty, you shall take a husband,'

I told you formerly when I was instructing you. And I forbade you to go around with immoral (girls). Surely you are already not doing right. I desired to see you well-married while I was still living. But now I do not expect you to be well-married to one (man). The father of the one with whom you talk is evil. He (your lover) might beat you. That is the way his father is. He is always beating his wife. And when anything is taking place, he will not allow his wife to go there. Moreover, that man is extremely lazy. That is why I think the son will be like that. He is always merely walking around. I have never known him to do any work. If you took him as your husband, you would probably then be taking care of him. He would cheat you, for you already know how to do all the work that belongs to us women. You really must not take him for your husband. You must take the other one as your husband, the one with whom I think it proper for you to live. You must stop talking with the one you are trying to love. If, however, I learn that you talk again with him, you will cease to have control over any of our things. I shall not believe anything you say to me. Now I know in the past that you listened to what I told you. That is why I believed you when you said anything to me. And this. As many things as you have learned to make, I am very proud of (them). That is why I would forbid you to go around with immoral (girls). Surely as soon as you began to go around with them we found it out. You are no longer afraid of men. You formerly were afraid to go anywhere because of them. But now you always desire to go somewhere. You will be

thought of as naught if you are immoral. The ones who are moral are those whom men want to live with (i. e., marry). And they will only make sport of the immoral ones. That is why they bother them, to have a good time with them, not to marry them. You might as well quickly take as your husband the one whom I permit you," I was told.

I was nineteen years old. Then I made up my mind to begin talking with the one I was permitted. I did not like him very well. I thought more of the other one. Always I would think, "Would that I might talk (with him)." I really couldn't stop talking with him. I worried about him. And I again went around with the one I was permitted, when I went anywhere. Later on I became acquainted with him. But I always thought more of the other one, the one they hated on my account.

Soon the one I was permitted began to try to have me accompany him to his home. He always asked me to go with him whenever I saw him. Then I said to him, "I am very much afraid of your parents." "Well, I will go with you to your home," he said to me, "we do not speak a different language, so it is not right for us to be afraid of each other. As for me, I am not afraid of your parents. For I have done nothing evil to you. As long as we have been talking together, I have been quiet with you. You know it too. I intend that we shall live quietly with each other. I always think, 'Oh that she were willing.' You are the only one with whom I wish to live. I shall treat you very nicely. Whatever you tell me, I shall do. And I shall always work. And I shall not hate your par-

ents. I am not fooling you. What I say to you this day, I shall surely do," he said to me. Soon I consented. At night we departed. When it was daylight, I was (rather) ashamed to go where we lived with him. The next day when he was seen, he surely was treated very nicely, for I had taken for a husband the one they had wished me to.

Then he gave me his horse, and the clothing which he used at dances, his finery. And I gave that horse to my brothers. Soon my mother-in-law came to summon me. "Go over there," my mother said to me. I departed. When I arrived there, "Right here," I was told. "Sit down," I was told. I sat down comfortably. Well, they began to clothe me in finery. I was clad all over in finery. Then, "You may also take this kettle (home)," I was told. There were also some dry goods in it, and a bridle was in the kettle. I had a very large bundle on my back when I departed. I arrived where we lived clad in finery. My mother looked at (the bundle). When she saw the bridle (she said), "Now you have two horses. If you had taken the other (man) as your husband, you wouldn't have been given anything." Soon I likewise was told, "I say, you take this (to them)." Food was placed in a sack, mattings (were to go), and several belts of yarn were tied around them. Then we were through (with the wedding ceremonies). And then only the relatives of my husband gave me each something, usually dry goods. And I would take a sack or basket full of food, beans, pumpkins (to his people), and mattings and corn.

Surely my husband for a long time treated me nicely. And my mother strongly forbade me to keep on talking with the other one. She watched me closely. But I couldn't stop thinking of him, for he was the one I loved. I did not love my husband. That is why I always thought of the other one. When anything was going on, I went around with my mother as she was watching me so that I should not talk with the other one again. And she forbade me to go any place by myself. "Go with your husband when you go any place. They might say something about you. Some one might say of you, 'she goes around with another man.' Those who desire to make trouble for married couples are smart," I would be told. . . .

And then later on (my husband) became meaner. He was lazy. But my mother forbade me to be divorced. And soon my mother died. I was twenty-five years old. I felt terribly. I remembered everything she told me from time to time.

And from that time I really began taking care of myself. It was very hard. Work never ended. (A person) could not just stay around (and do nothing). "Surely my mother treated me well in teaching me how to make things. What would have happened to me if I had not known work suitable for women? I should have been even poorer, if my mother had not instructed me," I thought all the while. Whenever I made anything I surely was given clothing to wear in exchange. And when I made something, I gave it away. In the spring when I planted anything I attended to it carefully. Surely I cooked it when it grew. In winter I did not lack things to cook.

And my husband did nothing but act meanly. When there was a dance he would not allow me to go and see

it. Soon I thought, "Well, now that my mother has gone, this fellow treats me meanly. It was because my mother forbade me to become a divorcée that (I allowed) this fellow to ill-treat me. Besides I do not love him. Now no one would scold me. And I love the other one. I hate this one." I began to see dances in spite (of what he had said). He was fearfully angry. "It's because you may see that man is why you are perverse in going there," he said to me. "I want to see him," I would say to him. I began to chase him away.

[I told him] "You may marry other (women) who are quiet (i. e., moral). We shall never be able to live nicely together. While I was living quietly (i. e., morally) with you, you began to act badly. And it was not my idea to live with you. It was because I was told. I suppose I was permitted so that you would treat me well and not abuse me. So now we will be divorced. You must go. You could have behaved nicely if you had wished us to live together always. You might have been working quietly so that we should not be poor. You know how I have been doing. I have been working quietly. And you without reason began to be jealous. I have not talked to any one as long as we have been living together. But now we must surely be divorced," I said to him.

"Truly from now on I shall stop acting that way. I shall begin to treat you nicely. And I shall work diligently. I shall not be able to refuse what you ask me. From now on you shall have control of what we shall continue to do," he said to me. "No. I shall not believe you though you may do your best to speak nicely. You have ill-

treated me too long," I said to him. I was not able to chase him away. As I was leaving he came and seized me. "Believe me," he said to me. "No, indeed," I said to him. He held me there. "You are not going off any place," he said to me. I cried bitterly and he let me go.

I went where my uncle (mother's brother) lived and slept there. The next day my uncle said to me, "It is strange that you came and slept with us. Something has happened to you." "My husband treats me very badly. That is why I was unwilling (to keep on living with him)," I said to him. "It is known broadcast that he abuses you. No one will reproach you if you think of being divorced. I myself will not scold you. It is a rule that a married couple should alike treat each other well. As for me, I treat the one with whom I live (i. e., wife) well and she treats me well. She always cooks for me when I am working. And if I were suddenly to treat her badly while she was still treating me well and while she was still living morally, were I to become jealous over something without reason, her relatives would not like it. For I surely would be doing wrong. If she cast me off none of her relatives would scold her. Every one, all over, would be glad of what happened to me. Certainly I should not find one (woman) who behaved as well. Surely I should always want back the one who behaved well. (But) I might have angered her. I alone should be thinking of her. Surely she would not think of me. She would hate me as much as possible," my uncle said to me. "Well, my niece (sister's daughter), now you are of sufficient age to listen attentively," he said to me. "You prob-

ably still think of what your mother told you. You may foolishly begin to be immoral. You should look at men quietly (i. e., without an immoral purpose). Whomever you think will treat you well is the one whom you should take for your husband. If he happens to treat you well, you should live quietly with him. Do not again desire another (husband). For it also is not right for you women to have many husbands. A woman who does that is gossiped about a good deal. It is the same as if she goes from man to man. That, my niece, is what I want you to do. Because your mother is gone is why I tell you as I understand it. And if you are now divorced you should stay (single) for at least one or two years. You should just be working diligently. Then you might marry that one," my uncle said to me.

And so I became divorced. Of course (my former husband) was always trying to get me, but I could not be kind again to him. I hated him tremendously.

And the wife of the (man) with whom I talked when I was still a virgin died. After I had been divorced for one year and he had become a widower free from death-customs, he again began to (court) me. Of course others courted me but I did not talk to them. And soon I began talking with him, for we were already acquainted with each other while we were young. And soon he asked me why I became divorced. I told him exactly how it was that I became divorced.

"Well! He was entirely wrong in what he thought of us. I ceased seeing you when you were married. Even if I had seen you I should not have been able to screw up my courage to say anything to you. You surely would have reported me. You acted that way when you were married. If I had persuaded you (to marry me) at the time, I should not have beaten you. Now you must be willing for us to do that," he said to me. "I suppose you too will beat me, that is why you are courting me," I said to him. "Why, how often have you heard of me striking the one with whom I was living? I never struck her even once. Nor did I scold her. She danced vigorously at dances also before she became ill. That is how I should treat you too. You might dance vigorously if you felt like dancing vigorously. To dance vigorously is natural. I do not know of any one being married (at the dances). How, pray, could any one act in a courting way as there would be many people? No one would fail to be seen if he courted there. I should think that way myself. If you are willing we shall do that. I want you to consent very much. I have always thought, 'I wish I might live with her,'" he said to me. "Well, I might consent in a year, but not now," I said to him. For a long time we were merely talking with each other.

The one with whom I formerly lived never gave up. He always tried to court me. But I could not think kindly of him again. For he had angered me as he already had treated me badly. I hated him thoroughly.

Soon the time came which I had set for us to live together. When we saw each other, he said to me, "Well, at last it is the time you set for your consent. To-night at night do not latch your door firmly. I shall come to you." That is what I did. He came. And sometimes he would sleep far off in a wickiup where his relatives lived. And

at any time I went and visited my relatives. He never spoke crossly to me. So I loved him dearly. The other one, the one with whom I first lived, was sensual. That is why I hated him.

And after I married the other one I was so well. When there was a dance, he said to me, "Go and dance. I should be made ashamed by their talk if you were not seen when something is going on. 'He is probably jealous,' is what they would say of me. I am ashamed to have that said of me," he would say to me. "Clothe yourself in fine apparel," he would also say to me.

And soon when we were talking together, he said to me, "I wish I had been able to persuade you long ago, for we first talked with each other." "Well," I said to him, "I was not master of my own person while my mother was yet living. They soon found out that I was talking with you. I was scolded and I was told, 'you must marry the other fellow.' It was that good-for-nothing. The fact is that had I been master of myself, I couldn't have married him. Perhaps you might have persuaded me, for I had already become acquainted with you. For I was always thinking of you, especially at first. When I first stopped talking to you I was lonely," I said to him. "Well, let it be, for we have each other nicely at last," he said to me. My, but he talked so nicely. I had been living with him for two years. I continued to love him more and more as he treated me well.

Soon we had another child, a little girl, but it died after it was four months old. Then they had me drink medicine so that I would not have a

child again as they died when I had them.

I never heard my husband speak crossly. Even when there were Shawnee dances at night, he said to me, "Have a fine time dancing." "Well, I have surely found a man," I thought. "If this (man) were to cast me off to-day, I should tag after him anyhow," I thought. When he went to any place for a long time, I yearned for him. And I thought, "He has made me happy by treating me well. Then I began to make things for him, his finery, his moccasins, his leggings, his shirt, his garters, his cross-belt. After I had made finery of every kind for him, (I said), "These are what I have made for you as you have made me happy as long as I have lived with you, (and) because you have never made me angry in any way. 'You must dance vigorously,' I thought. That is why I made them for you." "You please me very much. That is how I was told when given instructions. 'If you live with a woman, if she likes the way you act and you treat her well, she will also care for you if she is intelligent. If she is immoral, you will not please her; she will only think of treating you meanly,' I was told. Now I see what I was told," he said to me.

I had more and more charge over everything. It seems as if he was a good hunter, for he brought in much game when he went hunting. So we never were in want of meat, as he knew how to hunt. I was rightly married to him. I was married to him a good many years. . . . I did not even think of divorce as I liked his ways so much.

FOUR:

Working

In some societies, particularly Western technological societies with their myriad specialties and professions, the choice of one's life-work is almost as important as the rite of becoming an adult itself. Indeed, the work a person does establishes his or her adult identity more clearly than any other activity. But in the Indian societies of eastern America, young people did not exercise a conscious choice. Instead they assumed the work patterns and skills of their parents of like sex at an early age. The division of labor in Indian society was sharply drawn, as it is in most tribal societies. Men and women were conceived of as "two radically different forms of humanity," who were consequently assigned contrasting though complementary roles in subsistence activities (Charles Hudson, *The Southeastern Indians* [Knoxville, 1978], 259).

In all but the most northern tribes, the eastern Indians were able to make their living by a seasonal combination of hunting, fishing, gathering of wild food, and the cultivation of domesticated crops. The men were primarily responsible for providing meat and fish, while the women's primary responsibility was to provide cultivated vegetables, and wild berries, fruits, and nuts. Three other contrasts resulted from this basic division of labor. First, the men tended to work hardest and most continuously during the cold seasons of the year. Hunting was best on snow in which small animals left prints and large ones were slowed down, and fishing was best in early spring when freshwater fish swam upstream in large numbers to spawn. Most of the women's activities, however, occurred in the warm season when the planting, weeding, and harvesting of corn, beans, squash—the "three sisters" of the Iroquois—and other crops were possible.

A second contrast was that the men's activities took them away from the village for substantial periods, while the women's fields were contiguous. These absences, combined with longer ones for trade, war, and diplomacy, lay the burden for the education of the young and the essential continuity of village life upon the women, who, in the majority of eastern tribes, owned the houses and perhaps the fields. Consequently, native women tended to be more conservative than the men, especially when the colonial

invaders threw their forces for change against native culture in the form of technology, disease, fur traders, and missionaries.

The final contrast between the labor patterns of Indian men and women was the quality and quantity of work done by each. The work of Indian men was virtually constant and largely demanding of strength, endurance, courage, and the ability to tolerate physical discomfort. Many European observers saw the Indian men as incurably idle, largely because they encountered them at home when they were recouping their energies after an exhausting chase or during the summer when their tasks were lightest. But their hunting, fishing, and warring cannot be reduced to "sport" merely because they were the pastimes of Europe's gentlemen.

Native women worked only infrequently at physically demanding or dangerous tasks. Most of their daily chores—cooking simple dishes, roasting game, baking bread in the ashes, dressing skins, making clothes and moccasins, webbing snowshoes and lacing bark canoes (in the North), weaving mats and baskets, making pottery, fetching firewood, and caring for children—were reasonably light and performed around the household. Only summer cultivation was particularly strenuous, but this was mitigated by the company of other women, the use of hills rather than long furrows, which reduced planting and weeding time, and the relatively short growing season. The greatest danger came from an enemy's surprise attack while working in the fields or while taking a turn as a human scarecrow. Perhaps the women of the northern hunting tribes suffered the hardest lot. Not only were they deprived for most of the year of much female company and relegated to secondary status in all facets of their patrilineal and patrilocal societies, but they probably worked harder than any of their southern sisters when they packed virtually the whole camp on their backs in their frequent removes to new hunting grounds. But even they were unknown to bemoan their lot because they knew that their role was no harder than the men's and that both were essential for survival. The economic roles of Indian men and women were indeed different, but each was demanding in its own way.

38. The Making of the Myth

During Canada's first century, Catholic missionaries, especially the Jesuits, were closest to the numerous northern tribes and wrote the fullest and usually earliest descriptions of their sexual divisions of labor. For the first few decades after their arrival, the French missionaries, like their Protestant counterparts in the English colonies, sought to "civilize" the natives by turning them from their semi-nomadic hunting life to sedentary farming, which was tantamount to destroying the economic and domestic relations between the sexes that had evolved over centuries. Although they did not succeed, their early perceptions of Indian work patterns were conditioned by their conversion goals and their jarring discovery that native women's work differed greatly in quality, if not quantity, from that of European women, especially the middle-to-upperclass women the priests had known in France. The following excerpts from the *Jesuit Relations* bear the marks of these attitudes, but also of some of the Jesuits's great sensitivity to cultural nuances, which has made them excellent ethnographers the world over.

The first excerpt comes from a short Latin book published in 1710 on the customs of the Canadian Indians. Its author was Joseph Jouvency, who was not a missionary himself but a writer and former professor of rhetoric, brought to Rome to work on the official history of the Jesuit order. His brief chapter entitled "Homes and Household Economy" was based on the cumulative record of Jesuit reports from Canada, which did not paint a happy picture of the female lot. It not only minimizes the man's role as a hunter and warrior but grossly exaggerates the rate of infant mortality that allegedly resulted from the woman's role as "slave, laborer and beast of burden."

Pierre Biard, one of two Jesuit missionaries sent to Acadia in 1611, retraces the picture of the squaw "slave" in the second excerpt. After eight months among the Micmacs around Port Royal, Biard was convinced that Indian men were indolent except when hunting and warring and that their wives—often plural—had all the work of the camp "imposed" upon them.

The last two passages come from the annual reports for 1633 and 1634 of Paul Le Jeune, the Superior of the Canadian missions, who had spent six months with the Montagnais and Algonquins on the northern shore of the St. Lawrence. With the advantage of considerable experience, both his own and

Source: Reuben Gold Thwaites, ed., *The Jesuit Relations and Allied Documents*, 73 vols. (Cleveland, 1896–1901), 1:257, 259; 2:77, 79; 5:133; 6:233, 235.

that of the growing number of other priests in the Canadian field, Le Jeune was able to recognize that the accepted picture of the Indian woman was partly caricature, and that the family work load was sharply divided, neatly balanced, and quietly accepted.

Now, if you inquire concerning the customs and character of this people [Canadian Indians in general], I will reply that a part of them are nomads, wandering during the winter in the woods, whither the hope of better hunting calls them—in the summer, on the shores of the rivers, where they easily obtain their food by fishing; while others inhabit villages. They construct their huts by fixing poles in the ground; they cover the sides with bark, the roofs with hides, moss and branches. In the middle of the hut is the hearth, from which the smoke escapes through an opening at the peak of the roof. As the smoke passes out with difficulty, it usually fills the whole hut, so that strangers compelled to live in these cabins suffer injury and weakening of the eyes; the savages, a coarse race, and accustomed to these discomforts, ridicule this. The care of household affairs, and whatever work there may be in the family, are placed upon the women. They build and repair the wigwams, carry water and wood, and prepare the food; their duties and position are those of slaves, laborers and beasts of burden. The pursuits of hunting and war belong to the men. Thence arise the isolation and numerical weakness of the race. For the women, although naturally prolific, cannot, on account of their occupation in these labors, either bring forth fully-developed offspring, or properly nourish them after they have been brought forth; therefore they either suffer abortion, or forsake their newborn children, while engaged in carrying water, procuring wood and other tasks, so that scarcely one infant in thirty survives until youth. To this there is added their ignorance of medicine, because of which they seldom recover from illnesses which are at all severe.

To obtain the necessaries of life they [the Indians of Acadia] endure cold and hunger in an extraordinary manner. During eight or ten days, if the necessity is imposed on them, they will follow the chase in fasting, and they hunt with the greatest ardor when the snow is deepest and the cold most severe. And yet these same Savages, the offspring, so to speak, of Boreas [The North Wind] and the ice, when once they have returned with their booty and installed themselves in their tents, become indolent and unwilling to perform any labor whatever, imposing this entirely upon the women. The latter, besides the onerous rôle of bearing and rearing the children, also transport the game from the place where it has fallen; they are the hewers of wood and drawers of water; they make and repair the household utensils; they prepare food; they skin the game and prepare the hides like fullers; they sew garments; they catch fish and gather shellfish for food; often they even hunt; they make the canoes, that

is, skiffs of marvelous rapidity, out of bark; they set up the tents wherever and whenever they stop for the night— in short, the men concern themselves with nothing but the more laborious hunting and the waging of war. For this reason almost every one has several wives, and especially the Saga-mores, since they cannot maintain their power and keep up the number of their dependents unless they have not only many children to inspire fear or conciliate favor, but also many slaves to perform patiently the menial tasks of every sort that are necessary. For their wives are regarded and treated as slaves.

It is true that the [Montagnais] Savages are very patient, but the order which they maintain in their occupations aids them in preserving peace in their households. The women know what they are to do, and the men also; and one never meddles with the work of the other. The men make the frames of their canoes, and the women sew the bark with willow withes or similar small wood. The men shape the wood of the raquettes [snowshoes], and the women do the sewing on them. Men go hunting, and kill the animals; and the women go after them, skin them, and clean the hides. It is they who go in search of the wood that is burned. In fact, they would make fun of a man who, except in some great necessity, would do any-thing that should be done by a woman. Our [converted] Savage, seeing Father de Nouë carrying wood, began to

laugh, saying: "He's really a woman;" meaning that he was doing a woman's work. But a short time afterward, his wife falling sick, and having no one in his cabin who could assist him, he was compelled to go out himself in search of supplies; but in truth he went only at night, when no one could see him.

They are very much attached to each other, and agree admirably. You do not see any disputes, quarrels, en-mities, or reproaches among them. Men leave the arrangement of the household to the women, without in-terfering with them; they cut, and de-cide, and give away as they please, without making the husband angry. I have never seen my host ask a giddy young woman that he had with him what became of the provisions, al-though they were disappearing very fast. I have never heard the women complain because they were not in-vited to the feasts, because the men ate the good pieces, or because they had to work continually,—going in search of the wood for the fire, making the Houses, dressing the skins, and busying themselves in other very la-borious work. Each one does her own little tasks, gently and peacefully, with-out any disputes. It is true, however, that they have neither gentleness nor courtesy in their utterance; and a Frenchman could not assume the ac-cent, the tone, and the sharpness of their voices without becoming angry, yet they do not.

39. Native Noblemen in Huronia

After a year with the Hurons in southern Ontario, Gabriel Sagard realized that native men worked at more than hunting, fishing, and fighting, but still characterized them as Frenchlike "noblemen" for their abundant leisure and disdain of "woman's work". What he could not accurately gauge from his stationary post in Huronia was the energy they expended on long trading trips through the lakes and rivers of northern Ontario and Quebec. Sagard describes how the year's routes were allocated by the tribal councils and how each route was controlled by one of the headmen, who had the right to collect tolls from those using it. He also observes the seasonal periodicity of the economy, alternating between hunting, fishing, and farming, the last of which was the women's province (save for the heavy clearing of the fields). Most important is his early recognition that the women were not *forced* to work more than their husbands, if indeed they did so. Sagard describes the women's tasks as "little," but he would have been closer to the truth if he had said "lighter," for they were no less important to the economy than the men's periodic but more strenuous activities. Moreover, the women provided the essential continuity of family and village life by working at home while their husbands spent long periods—often several months—away from home engaged in trade, hunting, diplomacy, and war.

The occupations of the [male] savages are fishing, hunting, and war; going off to trade, making lodges and canoes, or contriving the proper tools for doing so. The rest of the time they pass in idleness, gambling, sleeping, singing, dancing, smoking, or going to feasts, and they are reluctant to undertake any other work that forms part of the women's duty except under strong necessity. . . .

During winter with the twine twisted by the women and girls they make nets and snares for fishing and catching fish in summer, and even in winter under the ice by means of lines or the seine-net, through holes cut in several places. They make also arrows with the knife, very straight and long, and when they have no knives they use sharp-edged stones; they fledge them with feathers from the tails and wings of eagles, because these are strong and carry well in the air, and at the point with strong fish-glue they attach sharp-pointed stones or bones, or iron heads obtained in trade from the French. They make also wooden

Source: Father Gabriel Sagard, *The Long Journey to the Country of the Hurons*, ed. George M. Wrong, trans. H. H. Langton (Toronto: The Champlain Society, 1939), pp. 96, 98–104.

clubs for warfare, and shields which cover almost the whole body, and with animals' guts they make bow-strings and rackets [snowshoes] for walking on the snow when they go for wood and to hunt.

They make journeys overland too, as well as by sea and river, and they will undertake (an incredible thing) to go for ten, twenty, thirty, and forty leagues through the woods where they find neither paths nor houses, and without carrying any provisions, but only tobacco and steel [for fire-making], with their bow in their hand and quiver at their back. If they have an urgent thirst and no water they know how to suck it from the trees, and in particular from beech-trees, out of which distils a sweet and very pleasant liquid at the time when the trees are in sap, as we also did. But when they undertake journeys to distant countries they do not usually make them except after due consideration nor without having received permission from the chiefs. These in a special council are in the habit of determining every year the number of men who may go out from each town or village, so as not to leave them unprovided with warriors, and anyone who wishes to go away without this authorization may do so to be sure, but he will be blamed and thought foolish and imprudent. I have seen several savages from neighbouring villages come to Quieunonascaran [St. Joseph, to the French] to ask leave of absence from Onorotandi, brother of the great chief Auoindaon, in order that they might have permission to go to the Saguenay [River]. For he is called the Master and Overlord of the roads and rivers that lead there, that is, up to the lim-its of the Huron country. Similarly it was necessary to get permission from Auoindaon to go to Quebec, and since each means to be master in his own country, they allow no one of another tribe of savages to pass through their country to go to the trading unless they are recognized as master and their favour secured by a present. No difficulty is made of this by the others; without it they might be hindered or an injury done to them.

In winter when the fish feel the cold and withdraw [to deep water] the nomad savages, such as the Canadians, Algonquins, and others, leave the shores of the sea and the rivers, and encamp in the woods, wherever they know there is game. As to our Hurons, the Honqueronons, and [other] sedentary peoples, they do not quit their lodges nor move their towns and villages. . . . When the nomad tribes are hungry they consult the oracle, and then go off, bow in hand and quiver at their back, in the direction that their Oki [conjurer] has pointed out to them, or elsewhere where they think they will not be wasting their time. They have dogs which follow them, and although these do not bark, yet they understand quite well how to discover the lair of the animal they are looking for. When it is found the men pursue it courageously and never leave it until they have brought it down; finally, having wearied it to death they get their dogs to worry it so that it must fall. Then they cut open the belly, give the quarry to the dogs, have a feast, and carry off the remainder. If the animal, too hard pressed, comes to a river, the sea, or a lake, it leaps into it boldly; but the savages, active and ready, are immediately after it in their

canoes, if there are any at hand, and then give it the death-stroke. . . .

Just as the men have their special occupation and understand wherein a man's duty consists, so also the women and girls keep their place and perform quietly their little tasks and functions of service. They usually do more work than the men, although they are not forced or compelled to do so. They have the care of the cooking and the household, of sowing and gathering corn, grinding flour, preparing hemp and tree-bark, and providing the necessary wood. And because there still remains plenty of time to waste, they employ it in gaming, going to dances and feasts, chatting and killing time, and doing just what they like with their leisure; this is no trifle, since their whole household arrangements amount to but little, in view furthermore of the fact that among our Hurons they are not admitted to many of the men's feasts nor to any of their councils, nor allowed to put up lodges and make canoes. They have discovered how to twist hemp thread on the thigh, not using distaff and spindle, and with this thread the men twine their nets and snares as I have said. They also pound corn for cooking and roast it in hot ashes. Again, they extract the meal [from the corn] for their husbands when these go in summer to trade with other nations far away.

They make pottery, especially round pots without handles or feet, in which they cook their food, meat or fish. When winter comes they make mats of reeds, which they hang in the doors of their lodges, and they make others to sit upon, all very neatly. The women of the High Hairs [Missisaugas], moreover, colour the reeds and make divisions in the weaving in such apt proportion that no fault can be found with it. They dress and soften the skins of beaver and moose and others, as well as we could do it here [in France], and of these they make their cloaks and coverings; and they paint them in patterns and a mixture of colours with very good effect. Likewise they make reed baskets, and others out of birchbark, to hold beans, corn, and peas (which they call *Acointa*), meat, fish, and other small provender. They also make a kind of leather game-bag or tobacco-pouch, which they work in a manner worthy of admiration with porcupine quills, coloured red, black, white, and blue, and these colours they make so bright that ours do not seem to come near them in that respect. They employ themselves also in making bowls of bark for drinking and eating out of, and for holding their meats and soups. Moreover the sashes, collars, and bracelets that they and the men wear are of their workmanship; and in spite of the fact that they are more occupied than the men, who play the noblemen among them and think only of hunting, fishing, or fighting, still they usually love their husbands better than the women here. If they were Christians these would be families among whom God would take pleasure to dwell.

It is their custom for every family to live on its fishing, hunting, and planting, since they have as much land as they need; for all the forests, meadows, and uncleared land are common property, and anyone is allowed to clear and sow as much as he will and can, and according to his needs; and this cleared land remains in his possession for as many years as he con-

tinues to cultivate and make use of it. After it is altogether abandoned by its owner, then anyone who wishes uses it, but not otherwise. Clearing is very troublesome for them, since they have no proper tools. They cut down the trees at the height of two or three feet from the ground, then they strip off all the branches, which they burn at the stump of the same trees in order to kill them, and in course of time they remove the roots. Then the women clean up the ground between the trees thoroughly, and at distances a pace apart dig round holes or pits. In each of these they sow nine or ten grains of maize, which they have first picked out, sorted, and soaked in water for a few days, and so they keep on until they have sown enough to provide food for two or three years, either for fear that some bad season may visit them or else in order to trade it to other nations for furs and other things they need; and every year they sow their corn thus in the same holes and spots, which they freshen with their little wooden spade, shaped like an ear with a handle at the end. The rest of the land is not tilled, but only cleansed of noxious weeds, so that it seems as if it were all paths, so careful are they to keep it quite clean; and this made me, as I went alone sometimes from one village to another, lose my way usually in these corn-fields more than in the meadows and forests.

40. Bringing Home the Bear on the Great Lakes

Nicolas Perrot adds some fine detail to the generally accurate picture of the Great Lakes economies drawn by Sagard. He notes that a western Great Lakes hunter brought the game he had killed to the door of his cabin, rather than leaving his wife to haul it home from the woods where it had fallen. Although Perrot was probably correct about some tribes, or about small winter hunting camps, the hunters of many tribes, both then and later, left their kills in the woods to avoid the cultural demands of generosity. John Tanner, an American captive who lived with the Ojibwas for thirty years, described the custom in 1830 (Edwin James, ed., *A Narrative of the Captivity and Adventures of John Tanner* [Minneapolis, 1956], 362):

Source: **Emma Helen Blair**, ed. and trans., *The Indian Tribes of the Upper Mississippi Valley and Region of the Great Lakes*, 2 vols. (Cleveland: The Arthur H. Clark Co., 1911), 1:64–70. Reprinted by permission of The Arthur H. Clark Co.

The custom is, that if any man, in returning from his hunt, no matter how long and laborious it may have been, or how great may be the necessities of his own family, meet another just starting out to hunt, or even a little boy walking from the camp or village, he is bound to throw down at his feet, and give him whatever he may have brought. It is partly to avoid the effect of this custom, that the men oftentimes leave their game on the spot where they killed it, and the women are sent to bring in the meat. In other instances the hunter carries the animal on his back as far as he thinks he can without the risk of meeting men, then conceals it, and goes home.

Perrot also notes that the men were required by custom to build the larger wigwams in the summer villages while their wives generally erected the smaller hunting lodges from bent saplings and the rolls of birchbark or rush matting they carried with them. What Perrot describes is an economy of labor divided largely according to physical strength. While women fashioned articles that required artistry and finesse, such as quill-decorated bark baskets, a man's strength was needed to carve wooden bowls. Similarly, without need for the deep-cutting plow pulled by large draft animals or fertilizer of any kind, Indian women could easily hand-plant, hoe-weed, and harvest (often with male help) the vegetable crops for the village. But only the men were capable of paddling and portaging heavily-laden canoes over hundreds of miles of dangerous waterways to trade with foreign tribes and later European colonies.

Among the savages the men are obliged to hunt and fish. They usually live along the shores of the lake otherwise called "the fresh-water sea" [Lake Superior], and they repair to it in the evening to stretch their nets, and then in the morning to lift these out. They are obliged to bring their venison to the door of the cabin, and their fish to the landing-place, where they leave it in the canoe. It is their duty to go to find the wood and poles suitable for building the cabin, and roofing for the cabin which stands in the regular village, not out in the fields; also to make the canoes, if they are skilful enough, and to chop all the wood which they need, as it is taken for granted that this is somewhat rough work. When they are on the road, it is for the man to carry the load if the woman finds herself too heavily burdened, or the child if it is unable to follow them; when these difficulties do not occur, he marches at his ease, carrying only his weapons.

The obligations of the women are to carry into the cabin (of which she is the mistress) the meat which the husband leaves at the door, and to dry it; to take charge of the cooking; to go to get the fish at the landing, and clean it; to make twine, in order to provide nets for the men; to furnish firewood; to raise and harvest the grain; not to fail in supplying shoes for the entire family, and to dry those of her husband and give them to him

when he needs them. The women also are obliged to go to bring water, if they have no servants in the house; to make bags for holding the grain, and mats of rushes (either flat, or round, or long) to serve as roofing for the cabins or as mattresses. Finally, it is for them to dress the skins of the animals which the husband kills in hunting, and to make robes of those which have fur. When they are traveling, the women carry the roofing for the cabin, if there is no canoe. They apply themselves to fashioning dishes of bark, and their husbands make the wooden dishes. They fabricate many curious little articles which are much in demand by our French people, and which they even send to France as rarities.

41. In a Micmac Hunting Camp

In 1672 Nicolas Denys described the work of Micmac men and women in their shifting hunting camps. Since the Micmacs lived too far north to raise corn in large summer villages, they subsisted largely on game and fish and dwelt in small hunting camps consisting of one or two families. When the camp had to be moved, the women and girls did most of the breaking and carrying, to free the men's arms for trail-breaking and defense against enemy and animal attacks. But Denys's description of the methods of hunting and fishing leaves no doubt that the man's function in the Micmac economy involved more danger and exertion for longer periods than did the woman's, which was generally steadier, safer, and lighter. On balance, the tasks of life were equally divided.

After they have lived for some time in one place, which they have beaten [for game] all around their camp, they go and camp fifteen or twenty leagues away. Then the women and girls must carry the wigwam, their dishes, their bags, their skins, their robes, and everything they can take, for the men and the boys carry nothing, a practice they follow still at the present time [1672].

Having arrived at the place where

Source: Nicolas Denys, *The Description and Natural History of the Coasts of North America (Acadia)*, ed. and trans. William F. Ganong (Toronto: The Champlain Society, 1908), pp. 405–6, 419–20, 422–24, 426–33.

they wish to remain, the women must build the camp. Each one does that which is her duty. One goes to find poles in the woods; another goes to break off branches of Fir, which the little girls carry. The woman who is mistress, that is, she who has borne the first boy, takes command, and does not go to the woods for anything. Everything is brought to her. She fits the poles to make the wigwam, and arranges the Fir to make the place on which each one disposes himself. This is their carpet and the feathers of their bed. If the family is a large one they make it [the wigwam] long enough for two fires; otherwise they make it round, just like military tents, with only this difference that in place of canvas they are of barks of Birch. These are so well fitted that it never rains into their wigwams. The round kind holds ten to twelve persons, the long twice as many. The fires are made in the middle of the round kind, and at the two ends of the long sort. . . .

As to the work of the men, it consisted in making their bows, which were of Maple, an unsplit piece. In fashioning them, they made use of their axes and knives; for polishing them, they used shells of Oysters or other shells, with which they polished as can be done with glass. Their arrows were of Cedar, which splits straight; they were nearly half a fathom in length. They feathered them with Eagles' quills. In place of iron they tipped them with bone. The frames of their snow-shoes were of Beech, of the thickness of those used in playing tennis, but longer and thicker and of the same form without a handle. . . . They were corded with Moose skin, dressed to parchment; this was cut into very long cords [which were] both thick and thin. . . . It was usually the women who did the cording.

Their lances were also of Beech, at the end of which they fixed a large pointed bone. They used them to spear animals when there was deep snow. . . . They made also the boards on which the women placed their children, and all other articles of wood.

They made also their pipes for holding their tobacco. They made them of wood, with a claw of Lobster, which is properly a Sea-crayfish. They made them also of a certain green stone, and of another which is red, with the stem, the whole in one piece. . . .

The hunting by the Indians in old times was easy for them. They killed animals only in proportion as they had need of them. When they were tired of eating one sort, they killed some of another. If they did not wish longer to eat meat, they caught some fish. They never made an accumulation of skins of Moose, Beaver, Otter, or others, but only so far as they needed them for personal use. They left the remainder where the animals had been killed, not taking the trouble to bring them to their camps.

The hunting of the Moose in summer took place by surprising them. The Indians knew approximately the places where they could be found. In those localities they beat the woods, going from one part to another to find their tracks. Having found one they followed it, and they knew by the track, and even from the dung, whether it was male or female, and whether it was old or young. By its track they knew also whether they were near the beast; then they consid-

ered whether there was any thicket or meadow near by where the beast would be likely to be, judging from the direction it was taking. They were rarely mistaken. They made a circle around the place where it was, in order to get below the wind so as not to be discovered by the Moose. They approached it very softly, fearful of making noise enough to reveal themselves to it. Having discovered it, if they were not near enough they approached closer until within arrow-shot, which is from forty-five to fifty paces. Then they launched their blow against the beast, which rarely fell to a single arrow. Then it was necessary to follow its track. Sometimes the beast would stop, hearing no more noise. Knowing this from its pace, they went slowly and tried to approach it yet again, and gave it still another arrow-shot. If this did not make it drop, they had again to follow it, even to evening, when they camped near the beast, and in the morning went again to take up the track. The animal being sluggish in rising because of the blood it had lost, they gave it a third shot, and made it drop, [thus] accomplishing the killing. They then broke off some branches to mark the place, in order to send their wives to find it.

But after having delivered the two first blows, they endeavoured to get in front of it to make it turn towards the camp, following it and making it approach until it fell dead from lack of strength. Often they worked it up very close to the camp. They always found several together, but in summer they can never follow more than one.

In the spring the hunting was still made thus, as it was except when the females enter on the rutting-time. At that time the hunting was done at night upon the rivers in a canoe. Counterfeiting the cry of the female, the Indians with a dish of bark would take up some water, and let it fall into the water from a height. The noise brought the male, who thought it was a female making water. For this object they let themselves go softly along the stream; if they were ascending, they paddled very softly, and from time to time they made water fall, counterfeiting always the female. They went all along the border of the river, and if there was any male in the woods who heard the sound of this water, he came there. Those who were in the canoe would hear him coming, because of the noise the beast made in the woods, and they kept on constantly imitating the cry of the female, which made him come close up to them. They were all ready to draw upon him and never missed him. The darkest night was best for this hunting, and also the most calm, [since] the wind prevented the noise made by the fall of the water from being heard.

In winter the hunting was different. Because of the snow, snow-shoes were used, by means of which one marches over the snow without sinking in, especially in the morning, because of the freezing in the night. At that time it bears the Dogs, but the Moose does not find good going, because he sinks into the snow, which fatigues him greatly in travelling.

To find the Moose, the Indians ran about from one place to another, seeking wood that was bitten. For at this time of year they eat only the twigs of wood of the year's growth. Where they found the wood eaten, they met straightway with the animals, which

were not far distant, and approached them easily, they being unable to travel swiftly. They then speared them with the lance, which is the large shaft of which I have spoken; at its end is fixed that large pointed bone which pierces like a sword. But if there were several Moose in the band, they made them flee. At that season the Moose arranged themselves one after another, and made a large ring of a league and a half, or two leagues, and sometimes of more, and beat down the snow so well by virtue of moving around, that they no longer sank into it. The one in front becoming weary, dropped to the rear. But the Indians, who were more clever than they, placed themselves in ambush, and waited for them to pass, and there they speared them. There was always one person chasing them; at each circuit always one of them fell; but in the end they scattered into the woods, some in one direction and some in another. There fell always five or six, and, when the snow would carry, the Dogs followed whatever ones were left. Not a single one could escape. But in those times they killed only their provision, and they only went hunting in proportion as they had need of meat. All their hunting and fishing were done only as they had need for food.

The hunting of the Beaver took place in summer with arrows, when they were taken in the woods, or else in the lakes or ponds, where the Indians placed themselves in canoes at a proper spot to watch until they came to the surface of the water to take air. But the commonest and most certain way was to break their dam, and make them lose the water. Then the Beavers found themselves without water, and did not know any more where to go; their houses showed everywhere. The Indians took them with blows of arrows and of spears; and, having a sufficiency, they left all the rest.

The Beavers, hearing no more noise, reassembled and set about repairing their dam. . . . I do not consider that the work of making their dams entirely anew is so difficult as to repair them when broken in the middle.

In winter the hunting of them was done differently, the dams and the lakes being all frozen. Then the Indians have their Dogs, which are a kind of Mastiff, but more lightly built. They have the head of a Fox, but do not yelp, having only a howl which is not of great sound. As for their teeth, these are longer and sharper than those of Mastiffs. These Dogs serve for hunting the Moose, as I have related, in the spring, summer, and autumn, and in the winter when the snows will bear them. There is no hunter who has not from seven to eight of them. They cherish them greatly. If they have little ones which the mother cannot nourish, the women suckle them; when they are large they are given soup. When they are in condition to be serviceable, they are given nothing but the offal of the beasts which are killed. If eight days pass without any animals being killed, they are just so long without eating. As to the bones, they are not given any, for fear of damaging their teeth, not even those of the Beaver. If they should eat of that, it would keep the Indians from killing any, and the same if one were to burn them. For it is well to remark here that the Indians had many superstitions about such things, of which it

has been much trouble to disabuse them. If they had roasted an Eel, they also believed that this would prevent them from catching one another time. They had in old times many beliefs of this kind, which they have no more at the present time, and of which we have disabused them. . . .

As for that [hunting] of the Beavers, it also was done in winter with Dogs, but they were only used to find the houses in which they smelled the Beavers through the ice. Having found them, the Indians cut through the ice and made a hole large enough to let through a Beaver. Then they made another hole twenty-five or thirty paces away, on the open surface of the lake. In this place an Indian or two took their stand with a bow and an arrow which has a harpoon of bone at the end, made like a barbed rod, like that which was used in fishing the Sturgeon, but smaller. It has also a cord to which it is attached at one end, and the Indian took hold of the other. Everything being ready, another Indian went to the other hole near the house of the Beavers. Lying down on his belly upon the ice, he placed his arm through the hole to find the Beavers' opening, that by which they place their tail in the water. There they are all arranged one against the other, that is to say, all those of one Beaver family. Having found them, the Indian passed his hand very gently along the back of one several times, and, approaching little by little to the tail, tried to seize it.

I have heard it said by the Indians that they have kept the arm so long in the water that the ice froze all around the arm. When they once seized the tail they drew the Beaver all at one swoop out from the water upon the ice, and at the same time gave it the axe upon the head. They killed it for fear lest the Beaver bite them, for wherever these set their teeth they take out the piece. Having thus drawn one out they tried to obtain another, which they did in the same way, rubbing them gently. That does not put them to flight, for they imagine they are touching one another. But nevertheless three or four of them having been removed, the remainder take to flight and throw themselves into the water. Not being able to remain long without breathing, the daylight which shows over the hole out on the surface leads them to go there to get the air. The other Indians who are there in ambush, so soon as they appear, give them an arrow shot; the harpoon, which has teeth, holds in some part of the Beaver from which it cannot be drawn out. The cord is then pulled and the Beaver is drawn out through the hole; then they raise it upon the ice and kill it. Some time after there comes another which is taken in the same way. Few in a house are saved; they would take all. The disposition of the Indians is not to spare the little ones any more than the big ones. They killed all of each kind of animal that there was when they could capture it. It is well to remark here that they were more fond of the young than of the grown of various species of animals, whatever these might be, to such a degree that often when they were chasing two Elks, male and female, they quitted the male if they perceived that the female was pregnant, in order to obtain the young ones, for ordinarily they carry two, and it is for them a great dainty.

The work of the women was to go fetch the animal after it was killed, to skin it, and cut it into pieces for cooking. To accomplish this they made the rocks red hot, placed them in and took them out of the kettle, collected all the bones of the Moose, pounded them with rocks upon another of larger size, [and] reduced them to a powder; then they placed them in their kettle, and made them boil well. This brought out a grease which rose to the top of the water, and they collected it with a wooden spoon. They kept the bones boiling until they yielded nothing more, and with such success that from the bones of one Moose, without counting the marrow, they obtained five to six pounds of grease as white as snow, and firm as wax. It was this which they used as their entire provision for living when they went hunting. We call it Moose butter; and they *Cacamo*.

They made their dishes, large and small, of bark. They sewed them with the Fir [black spruce] roots so well that they held water. They ornamented some of them with quills of Porcupine. They made bags of flattened rushes, which they plaited one within another. They went to the woods to fetch dry fuel, which did not smoke, for warming and for burning in the wigwam. Any other kind of wood was good for the kettle, since that was always outside the wigwam. They fetched the water, dressed the skins, made the robes, the sleeves, the stockings, and the moccasins, corded the snowshoes, put up and took down the wigwams.

42. Squaw Drudges and Lazy Gourmands in New England

In colonial eyes, Indian women suffered a hard lot. But on occasion it was painted all the darker by the male colonists' need to defend themselves from European accusations of using their own women hard. William Wood's sprightly portrait of the native women of southern New England is overdrawn in places to present a sharper contrast with their colonial sisters, who it was rumored were not being treated with all due English respect and gentleness. Wood's defense, entitled *New Englands Prospect,* was based upon "some few yeares travels and experience" of the author, who said he

Source: *William Wood's New England's Prospect,* Publications of the Prince Society, vol. 1 (Boston, 1865), pp. 105–110.

had lived in New England "these foure yeares, and intend God willing to returne shortly againe." Little is known of the author save the popularity of his honest book, which was published in London in 1634 and reached a third edition by 1639 and a fourth as late as 1764. The following excerpt seriously exaggerates the Indian man's "lazy gourmandizing" and the woman's oppressed condition, especially in suggesting that her ordinary household work amounted to "drudgerie." The description more nearly fits a colonial farmwoman's chores—her endless round of washing, sweeping, weaving, darning, milking, cooking, and baking. An Algonquian wigwam required little housekeeping, and leather clothes were easier to make and more durable among the briars and snags of the American forests. Furthermore, the fairness of Wood's characterization is belied by his admission that the native women "rest[ed] themselves content" with their "womans portion"—until they could make unfavorable comparisons with the pampered women newly arrived from England. For all their "oppression," the Indian women are seen as superior farmers to English husbandmen, a view that other English observers shared with as much chagrin as admiration.

To satisfie the curious eye of women-readers, who otherwise might thinke their sex forgotten, or not worthy a record, let them peruse these few lines, wherein they may see their owne happinesse, if weighed in the womans ballance of these ruder *Indians,* who scorne the tuterings of their wives, or to admit them as their equals, though their qualities and industrious deservings may justly claime the pre[-]eminence, and command better usage and more conjugall esteeme, their persons and features being every way correspondent, their qualifications more excellent, being more loving, pittifull, and modest, milde, provident, and laborious than their lazie husbands. Their employments be many: First their building of houses, whose frames are formed like our garden-arbours, something more round, very strong and handsome, covered with close-wrought mats of their owne weaving, which deny entrance to any drop of raine, though it come both fierce and long, neither can the piercing North winde finde a crannie, through which he can conveigh his cooling breath, they be warmer than our *English* houses; at the top is a square hole for the smoakes evacuation, which in rainy weather is covered with a pluver [rain flap]; these bee such smoakie dwellings, that when there is good fires, they are not able to stand upright, but lie all along under the smoake, never using any stooles or chaires, it being as rare to see an *Indian* sit on a stoole at home, as it is strange to see an *English* man sit on his heeles abroad. Their houses are smaller in the Summer, when their families be dispersed, by reason of heate and occasions. In Winter they make some fiftie or three-score foote long, fortie or fiftie men being inmates under one roofe; and as is their husbands occasion these poor

tectonists [architects or builders] are often troubled like snailes, to carrie their houses on their backs sometime to fishing-places, other times to hunting-places, after that to a planting place, where it abides the longest: an other work is their planting of corne, wherein they exceed our *English* husband-men, keeping it so cleare with their Clamme shell-hooes, as if it were a garden rather than a corne-field, not suffering a choaking weede to advance his audacious head above their infant corne, or an undermining worme to spoile his spurnes [roots]. Their corne being ripe, they gather it, and drying it hard in the Sunne, conveigh it to their barnes, which be great holes digged in the ground in forme of a brass pot, seeled with rinds [bark] of trees, wherein they put their corne, covering it from the inquisitive search of their gurmandizing husbands, who would eate up both their allowed portion, and reserved feede, if they knew where to finde it. But our hogges having found a way to unhindge their barne doors, and robbe their garners, they are glad to implore their husbands helpe to roule the bodies of trees over their holes, to prevent those pioners, whose theeverie they as much hate as their flesh. An other of their employments is their Summer processions to get Lobsters for their husbands, wherewith they baite their hookes when they goe a fishing for Basse or Codfish. This is an every dayes walke, be the weather cold or hot, the waters rough or calme, they must dive sometimes over head and eares for a Lobster, which often shakes them by their hands with a churlish nippe, and bids them adiew. The tide being spent, they trudge home two or three miles, with a hundred weight of Lobsters at their backs, and if none, a hundred scoules [scolds] meete them at home, and a hungry belly for two dayes after. Their husbands having caught any fish, they bring it in their boates as farre as they can by water, and there leave it; as it was their care to catch it, so it must be their wives paines to fetch it home, or fast: which done, they must dresse it and cooke it, dish it, and present it, see it eaten over their shoulders; and their loggerships having filled their paunches, their sweete lullabies scramble for their scrappes. In the Summer these *Indian* women when Lobsters be in their plenty and prime, they drie them to keepe for Winter, erecting scaffolds in the hot sun-shine, making fires likewise underneath them, by whose smoake the flies are expelled, till the substance remain hard and drie. In this manner they drie Basse and other fishes without salt, cutting them very thinne to dry suddainely, before the flies spoile them, or the raine moist them, having a speciall care to hang them in their smoakie houses, in the night and dankish weather.

In Summer they gather flagges [long, sword-shaped water grass], of which they make Matts for houses, and Hempe and Rushes, with dying stuffe of which they make curious baskets with intermixed colours and protractures of antique Imagerie: these baskets be of all sizes from a quart to a quarter, in which they carry their luggage. In winter time they are their husbands Caterers, trudging to the Clamm bankes for their belly timber [food], and their Porters to lugge home their Venison which their lazinesse exposes to the Woolves till they im-

pose it upon their wives shoulders. They likewise sew their husbands shooes, and weave coates of Turkie feathers, besides all their ordinary household drudgerie which daily lies upon them, so that a bigge bellie [pregnancy] hinders no business, nor a childebirth takes much time, but the young Infant being greased and sooted, wrapt in a Beaver skin, bound to his good behaviour with his feete up to his bumme, upon a board two foote long and one foot broade, his face exposed to all nipping weather; this little *Pappouse* travells about with his bare footed mother to paddle in the Icie Clammbankes after three or foure dayes of age have sealed his passeboard [navel] and his mothers recoverie. For their carriage it is very civill, smiles being the greatest grace of their mirth; their musick is lullabies to quiet their children, who generally are as quiet as if they had neither spleene or lungs. To heare one of these *Indians* unseene, a good eare might easily mistake their untaught voyce for the warbling of a well tuned instrument. Such command have they of their voices. These womens modesty drives them to weare more cloathes than their men, having alwayes a coate of cloath or skinnes wrapt like a blanket about their loynes, reaching downe to their hammes [thighs] which they never put off in company. If a husband have a minde to sell his wives Beaver petticote, as sometimes he doth, shee will not put it off untill shee have another to put on: commendable is their milde carriage and obedience to their husbands, notwithstanding all this their customarie churlishnesse and salvage inhumanitie, not seeming to delight in frownes or offering to word

it with their lords, not presuming to proclaime their female superiority to the usurping of the least title of their husbands charter, but rest themselves content under their helplesse condition, counting it the womans portion: since the *English* arrivall comparison hath made them miserable, for seeing the kind usage of the *English* to their wives, they doe as much condemne their husbands for unkindnesse, and commend the *English* for their love. As their husbands commending themselves for their wit in keeping their wives industrious, doe condemne the *English* for their folly in spoyling good working creatures. These women resort often to the *English* houses, where *pares cum paribus congregatæ* [*equals meet with equals*], in Sex I meane, they do somewhat ease their miserie by complaining and seldome part without a releese: If her husband come to seeke for his *Squaw* and beginne to bluster, the *English* woman betakes her to her armes which are the warlike Ladle, and the scalding liquors, threatning blistering to the naked runnaway, who is soone expelled by such liquid comminations. In a word to conclude this womans historie, their love to the *English* hath deserved no small esteeme, ever presenting them some thing that is either rare or desired, as Strawberries, Hurtleberries, Rasberries, Gooseberries, Cherries, Plummes, Fish, and other such gifts as their poore treasury yeelds them. But now it may be, that this relation of the churlish and inhumane behaviour of these ruder *Indians* towards their patient wives, may confirme some in the beliefe of an aspersion, which I have often heard men cast upon the *English* there, as if they should learne of

the *Indians* to use their wives in the like manner, and to bring them to the same subjection, as to sit on the lower hand, and to carrie water, and the like drudgerie: but if my owne experience may out-ballance an ill-grounded scandalous rumor, I doe assure you, upon my credit and reputation, that there is no such matter, but the women finde there as much love, respect, and ease, as here in old *England.* I will not deny, but that some poore people may carrie their owne water, and doe not the poorer sort in *England* doe the same, witnesse your *London* Tankerd-bearers, and your countrie-cottagers? But this may well be knowne to be nothing, but the rancorous venome of some that beare no good will to the plantation. For what neede they carrie water, seeing every one hath a Spring at his doore, or the Sea by his house? Thus much for the satisfaction of women, touching this entrenchment upon their prerogative, as also concerning the relation of these *Indian* Squawes.

43. Helpful Husbands among the Narragansetts

According to Roger Williams's trustworthy account, the Narragansetts of Rhode Island did not fit Wood's somewhat satirical picture of the sexual division of labor in New England. Narragansett men and women worked side-by-side on numerous occasions, including the hoeing of the fields for planting and the harvesting of the corn.

Aukeeteaûmen.	*To plant Corne.*
Quttáunemun.	*To plant Corne.*
Anakáusu.	*A Labourer.*
Anakáusichick.	*Labourers.*
Aukeeteaûmitch.	*Planting time.*
Aukeeteáhettit.	*When they set Corne.*
Nummautaukeeteaûmen.	*I have done planting.*
Anaskhómmin.	*To how* [hoe] *or break up.*

 Obs. The Women set or plant, weede, and hill, and gather and barne all the corne, and Fruites of the field: Yet

Source: Roger Williams, *A Key into the Language of America* (London, 1643), pp. 98–100.

sometimes the man himselfe, (either out of love to his Wife, or care for his Children, or being an old man) will help the Woman which (by the custome of the Countrey) they are not bound to [do].

When a field is to be broken up [hoed], they have a very loving sociable speedy way to dispatch it: All the neighbours men and Women forty, fifty, a hundred &c, joyne, and come in to help freely.

With friendly joyning they breake up their fields, build their Forts, hunt the Woods, stop and kill fish in the Rivers, it being true with them as in all the World in the Affaires of Earth or Heaven: By concord little things grow great, by discord the greatest come to nothing.

Anáskhig-anash.	*How, Howes.* [hoe, hoes]
Anaskhómwock.	*They how.*
Anaskhommonteâmin.	*They break for me.*
Anaskhomwáutowwin.	*A breaking up How.*

The *Indian* Women to this day (notwithstanding our Howes, doe use their naturall Howes of shells and Wood.

Monaskúnnemun.	*To weede.*
Monaskunnummaûtowwin.	*A weeding or broad How.*
Petascúnnemun,	*To hill the Corne.*
Kepenúmmin &	*To gather Corne.*
Wuttúnnemun.	
Núnnowwa.	*Harvest time.*
Anoûant.	*At harvest.*
Wuttúnnemitch-	*When harvest is in.*
Ewáchim.	
Pausinnummin.	*To dry the corne.*

Which they doe carefully upon heapes and Mats many dayes, before they barne it up, covering it up with Mats at night, and opening when the Sun is hot.

Sókenug.	*A heap of corne.*

Obs. The woman of the family will commonly raise two or three heaps of twelve, fifteene, or twentie bushells a heape, which they drie in round broad heaps; and if she have helpe of her children or friends, much more.

44. The Iroquois Work Bee

Iroquois men, too, helped clear the fields and husk and braid the harvested corn. Joseph Lafitau, the Jesuit missionary to the converted Iroquois near Montreal, was the first to describe not only the men's role (however small) in agriculture but the institution of the women's work bee or mutual aid society, which survived in Cherokee and Iroquois society until the present century. His succinct description of Iroquois maize culture recognizes the cooperative nature of the women's work and the pride they took in it. The planting of nitrogen-fixing beans among the corn, whose stalks served as poles to support them, prolonged and increased the yield of Indian fields without the use of fertilizer. When a field "wore out," the village simply moved to another. With his keen eye for ancient and modern ethnographic comparisons, Lafitau also reminded his readers that women in the fields were not as anomalous as the European colonists liked to believe.

The Indian women as well as the Amazons, the Thracian, Scythian and Spanish women and those of the other barbarian races of antiquity, work the fields as women do today in Gascony, Béarn and Bresse [in France] where we often see them running the plough while their husbands ply the distaff. The grain which they sow is maize, otherwise known as Indian or Turkish or Spanish wheat. It is the basis of the food of almost all the sedentary nations from one end of America to the other. . . . In Canada, the moment that the snows are melted the Indian women begin their work. . . . The first work done in the fields is gathering and burning the stubble. Then the ground is ploughed to make it ready to receive the grain which they are [going] to throw there. They do not use the plough (for this), any more than they do a number of other farming implements whose use is unknown to them and unnecessary for them. All that they need is a piece of bent wood three fingers wide, attached to a long handle which serves them to hoe the earth and stir it lightly.

The fields which they are to sow are not arranged in headlands and furrows as they are in Europe, but in little round hillocks three feet in diameter. They make nine holes in each of these mounds. They cast into each hole a grain of Indian corn which they cover over carefully.

All the women of the village join together for the heavy work. They make numerous different bands ac-

Source: Father Joseph François Lafitau, *Customs of the American Indians Compared with the Customs of Primitive Times,* ed. and trans. William N. Fenton and Elizabeth L. Moore, 2 vols. (Toronto: The Champlain Society, 1974–1977), 2:47, 54–55.

cording to the different quarters where they have their fields and pass from one field to the other helping each other. This can be done with less difficulty and the more quickly in that the fields are not separated by hedges and ditches. All together these [fields] give the appearance of only a single farm where there are no disputes over boundaries because every one knows how to recognize them clearly.

The mistress of the field where they are working distributes to each one of the workers the grain or seed for sowing which they receive in little *mannes* or baskets four or five fingers high and as wide, so that they can calculate the number of grains given out.

Beside maize, they sow horse beans or little lima beans, pumpkins of a species different from those of France, watermelons and great sunflowers. They sow the lima beans next to the grains of their Indian corn, the cane or stalk of which serves them [the lima bean plants] as support as the elm does to the vine. They prepare special fields for their pumpkins and melons, but before sowing them in these fields, they plant the seeds in a preparation of black, light soil between two sheets of bark and place them above their hearths where they germinate.

They keep their fields very clean. They are careful to pull up the grass in them until harvest time. There is also a set time for this [task] when they work all in common. Then each one carried with her a bundle of little sticks a foot or a foot and a half long, with her individual mark and gaily decorated with vermilion. They use these to mark their accomplishments and to make their work show up.

When harvest time has come, they gather Indian corn which they pull off with the leaves around the ears so that they form the husk. These husks, strongly attached as they are serve for braiding them in bunches or in strings as is done with onions.

The festival of binding together corn shocks is doubtless one of those which the ancients called *Cereales* which they celebrated in honour of Ceres. It takes place at night in the fields and is the only occasion when the men, who do no work either in the fields or with the harvest, are called upon by the women to help.

45. Sugaring with the Delawares

One of the favorite female activities in the seasonal work cycle of the Northeast was the gathering and boiling of sap from the sugar maple tree. In February or March, as David Zeisberger relates in the following passage, the winter hunting camps moved to favorite or family maple groves to allow the women to produce the sugar needed to sweeten various vegetable dishes and breads. The men continued their hunting.

The Moravian missionary also describes the differences in male and female conversation among the Delawares. Not surprisingly, men tended to talk about politics (and their successes in war and hunting, no doubt) while the women spoke of domestic affairs and their children. Whether the female "manufacture" of gossip rendered their word unreliable requires more proof than the word of one male observer, however reliable he might be on other subjects.

Sugar trees are usually found in low, rich soil, sometimes, also, on higher land and in more northerly regions even on hills, where, however, the soil is very moist. The Delawares call this tree the *Achsunnamunschi,* that is, the stone-tree, on account of the hardness of the wood. The [Iroquois] Mingoes give it a name signifying the sugar tree, as do the Europeans. From the sap of the tree sugar is boiled. This is done by the Indians in the early part of the year, beginning in February and continuing to the end of March or beginning of April, according as spring is early or late. In this region it is possible to boil sugar even in fall after there has been frost and in winter, if the season is mild. For as soon as the trees thaw a little the sap begins to run and then the trees are tapped. As, however, at that time of the year the weather is very uncertain and it is possible that there should be a cold wave at any time, it is hardly worth the effort to make the necessary arrangements and is hardly ever done, unless some one be driven of necessity to provide sugar for the household. . . .

Spring is the proper season for boiling sugar. The following preparations are made. A number of small troughs are made for receiving the sap. Usually, the Indians make them of wood, cutting them out roughly with a hatchet. Some Indians are able to make twenty or thirty of them in a day. Some do not go to so much trouble, but make dishes of the bark or bast of a tree, which serve quite as

Source: *David Zeisberger's History of the Northern American Indians,* ed. Archer Butler Hulbert and William Nathaniel Schwarze (Columbus: Ohio State Archaeological and Historical Society, 1910), pp. 48–51, 116.

well, but are good for no more than one season. According as they have large or numerous kettles and troughs they can make much sugar, for there is no lack of trees. Besides the smaller troughs and dishes, there must be several of larger size in which the sap is collected. If one is well supplied with utensils, there is this advantage, that on days when the sap flows freely much may be collected, which will enable one to keep on boiling when the sap does not flow plentifully. The sap flows most plentifully when it freezes at night and the sun shines during the day. At night it commonly ceases to run. The same is true in case of warm or rainy weather. As soon as there has been frost the sap runs again. There is a time in the boiling season when sap once or twice begins to flow in considerable quantities, both day and night. When this occurs the height of the sugar season is on. The sap which flows after this is not so good and yields less sugar. The last sugar secured in the spring is always of inferior quality. Hence, toward the end of the season no sugar, but only molasses is in most cases boiled.

The length of the season is determined by the weather conditions. If spring is late and night frosts continue for a considerable time, the flowing season is the longer. With the early advent of warm weather the season terminates very quickly. The shortest season lasts about a month, the longest nearly two months.

The thickest of the trees are two feet, sometimes more, in diameter. Those of middle size, which are still young, have many branches and are growing, yield the most sap. Experience has shown that such a tree will yield about sixty gallons of sap while sugar is being boiled, and thereafter another sixty for molasses. Seven to eight gallons of sap are regarded as necessary for a pound of sugar. Such a tree may, therefore, yield more than seven pounds of sugar and seven quarts of molasses. It has also been found that a tree which one year has yielded very freely, gives but little the next, and on the other hand, a tree that has yielded but little one season, gives largely the next. The sap, which is of a brownish color and becomes darker the longer it boils, is boiled until it gets to be of the consistency of molasses, is then poured off and kept. When a sufficient quantity of this consistency has been secured, it is boiled over a slow fire until it becomes sugar. It is important to boil this over a slow fire, for the sap readily boils over and is easily burned. If the boiled sap is stirred until cold, the sugar becomes granulated and is as fine as the West Indian sugar. As the Indians lack the dishes and do not care to take the time to prepare it in this way, they usually form it into cakes, put it in a kettle or dish, or in default of these, on a stone and let it cool, when it becomes hard and may be easily preserved in baskets. If the troughs and kettles used for collecting the sap are made of wood that does not give color, the sugar becomes the finer, but if it gives color, as does the white walnut, the sugar becomes black the first year; thereafter, this is not the case.

When everything is prepared, an oblique incision is made in the tree and at the lower end of the same a thin wedge, three or four inches broad, is forced in, whence the sap runs down into the vessel placed below. Accord-

ing as the sap runs freely or contrary-wise, the dishes must be emptied at given intervals, day and night. According to the manner of making the incision one may determine whether a tree shall be good for many or few years. If large openings are made the tree is soon spoiled and nothing is gained, for the sap runs no faster. In this matter, however, the Indians are very careless, for trees are numerous and after they have used one place for three or four years, they seek out another. There is, strange to say, no tree among all the rest so hardy as the sugar-tree, for even if the stem is cut all around, so that it can no longer be used, it does not die. Hence, the Indians very reluctantly make their fields where there are sugar-trees, as these are not to be exterminated, except they be cut down. This, however, is true that when trees have been used for eight or nine years they give less sap than formerly, as they are full of incisions and scars. An incision having been made in a tree in the spring of the year and the sap having flowed for some time, the incision needs to be enlarged, though only a little. This may be done two or three times in a season.

As the Indians have trees in abundance, their labors are richly rewarded. For if a man owns a kettle of ten or twelve gallons and has a few smaller ones with which to keep the large one filled, it will be possible for him to make several hundred pounds of sugar in a season and a quantity of molasses, besides.

Sugar boiling is chiefly the employment of women. Even widows are able to earn enough by it to secure clothing and whatever else they may need. While the women are thus engaged, the men hunt and supply meat. As the deer skins are of little value at that season of the year, they generally hunt bear, which they seek in the rocks, hollow trees or thickets in their winter quarters. Bears are at this time generally fat.

Their [men's] common conversation turns upon hunting or the news of the day. Matter that has no foundation in fact may be drawn into conversation, and even though all may be aware of this, the narration continues uninterrupted. They may laugh now and again but they will listen attentively. No one interrupts another. When one has finished another begins. They never put any one publicly to blush; they are polite to each other and enjoy being politely treated. They like to be regarded as worthy people even though they may be the opposite. They are pleased to know that they are liked. When a guest comes into a house, food is placed before him; that comes before anything else. If the guests are from a distance and very good friends, the whole kettle of food is set before them, they are given dishes and spoons and allowed to help themselves first to as much as they wish. The guests having partaken of the food, pass the kettle back to the people of the house. They live very simply. Meat, corn, gruel, corn-bread, are the principal articles of diet. In lieu of meat, various dishes are prepared with corn, or Sopan, milk and butter are used. They like to discuss affairs of state and communicate their opinions. In fact they are more ready to discuss such matters in course of visits than in the Council House, for there they prefer to let the older peo-

ple speak. Occasionally visits are made with the purpose of discovering the opinions of others; in a chief's home all manner of reports, true and false, furnish material for discussion. The women speak of their work, their plantations, the pouches, bags, baskets, carrying bands they have made, many of them though not all smoking tobacco. Stories are carried by women from house to house; they are so often manufactured that if men, having listened attentively to some tale, hear that it originated with a woman they will give it no credit until confirmed by some more reliable authority.

46. Fishing Frolics and Communal Corn in the Southeast

The patterns of southern subsistence and labor did not differ radically from those in the North—with one exception. Among the southern tribes well known to James Adair, an educated Carolina trader who spent thirty-three years among them, the village men participated in all phases of the planting and harvesting of the communal cornfields, while the women also tended separate kitchen gardens of pumpkins and melons. In the following excerpt from Adair's *History of the American Indians,* which was completed by 1768 but not published until 1775, several details of native work are brought to light. Adair recognized that Indian hunting was much too arduous to qualify as "sport," as many English observers, especially gentlemen, dismissed it. But even the trader who lived with the Cherokees, Catawbas, and Chickasaws for the better part of his life saw their fishing as a "diversion," a description belied by his detailed account of their various methods of catching fish. The kind of swimming required by some of those methods was no less strenuous or dangerous than hunting and certainly more so than farming. Equally laborious was the aboriginal method of clearing trees from village sites and fields and for making dug-out canoes with stone axes and fire. While virtually all tribes saw the inherent superiority of steel axes, it was characteristic of most that they preferred to work with a few hand-held tools rather than encumber themselves with heavy farm equipment, which would increase their dependence on the colonists and reduce their mobility.

Source: James Adair, *The History of the American Indians* (London, 1775), pp. 402-9.

Likewise, unfenced fields aptly symbolized the Indian desire to cooperate with nature and to retain one's personal freedom in the process.

Their manner of rambling through the woods to kill deer, is a very laborious exercise, as they frequently walk twenty-five or thirty miles through rough and smooth grounds, and fasting, before they return back to camp, loaded. Their method of fishing may be placed among their diversions, but this is of the profitable kind. When they see large fish near the surface of the water, they fire directly upon them, sometimes only with powder, which noise and surprize however so stupifies them, that they instantly turn up their bellies and float a top, when the fisherman secures them. If they shoot at fish not deep in the water, either with an arrow or bullet, they aim at the lower part of the belly, if they are near; and lower, in like manner, according to the distance, which seldom fails of killing. In a dry summer season, they gather horse chestnuts, and different sorts of roots, which having pounded pretty fine, and steeped a while in a trough, they scatter this mixture over the surface of a middle-sized pond, and stir it about with poles, till the water is sufficiently impregnated with the intoxicating bittern. The fish are soon inebriated, and make to the surface of the water, with their bellies uppermost. The fishers gather them in baskets, and barbicue the largest, covering them carefully over at night to preserve them from the supposed putrifying influence of the moon. It seems, that fish catched in this manner, are not poisoned, but only stupified; for they prove very wholesome food to us, who frequently use them. By experiments, when they are speedily moved into good water, they revive in a few minutes.

The Indians have the art of catching fish in long crails, made with canes and hiccory splinters, tapering to a point. They lay these at a fall of water, where stones are placed in two sloping lines from each bank, till they meet together in the middle of the rapid stream, where the intangled fish are soon drowned. Above such a place, I have known them to fasten a wreath of long grape vines together, to reach across the river, with stones fastened at proper distances to rake the bottom; they will swim a mile with it whooping, and plunging all the way, driving the fish before them into their large cane pots. With this draught, which is a very heavy one, they make a town feast, or feast of love, of which every one partakes in the most social manner, and afterward they dance together, singing *Halelu-yah,* and the rest of their usual praises to the divine essence, for his bountiful gifts to the beloved people. Those Indians who are unacquainted with the use of barbed irons, are very expert in striking large fish out of their canoes, with long sharp pointed green canes, which are well bearded, and hardened in the fire. In Savanah river, I have often accompanied them in killing sturgeons with those green swamp harpoons, and which they did with much pleasure and ease; for, when we discovered the fish, we soon thrust into their bodies one of the harpoons. As the fish would immediately strike deep, and rush

away to the bottom very rapidly, their strength was soon expended, by their violent struggles against the buoyant force of the green darts: as soon as the top end of them appeared again on the surface of the water, we made up to them, renewed the attack, and in like manner continued it, till we secured our game.

They have a surprising method of fishing under the edges of rocks, that stand over deep places of a river. There, they pull off their red breeches, or their long slip of Stroud cloth, and wrapping it round their arm, so as to reach to the lower part of the palm of their right hand, they dive under the rock where the large cat-fish lie to shelter themselves from the scorching beams of the sun, and to watch for prey: as soon as those fierce aquatic animals see that tempting bait, they immediately seize it with the greatest violence, in order to swallow it. Then is the time for the diver to improve the favourable opportunity: he accordingly opens his hand, seizes the voracious fish by his tender parts, hath a sharp struggle with it against the crevices of the rock, and at last brings it safe ashore. Except the Choktah [Choctaw], all our Indians, both male and female, above the state of infancy, are in the watery element nearly equal to amphibious animals, by practice: and from the experiments necessity has forced them to, it seems as if few were endued with such strong natural abilities,—very few can equal them in their wild situation of life.

There is a favourite method among them of fishing with handnets. The nets are about three feet deep, and of the same diameter at the opening, made of hemp, and knotted after the usual manner of our nets. On each side of the mouth, they tie very securely a strong elastic green cane, to which the ends are fastened. Prepared with these, the warriors a-breast, jump in at the end of a long pond, swimming under water, with their net stretched open with both hands, and the canes in a horizontal position. In this manner, they will continue, either till their breath is expended by the want of respiration, or till the net is so ponderous as to force them to exonerate it ashore, or in a basket, fixt in a proper place for that purpose—by removing one hand, the canes instantly spring together. . . .

The Indians formerly had stone axes, which in form commonly resembled a smith's chisel. Each weighed from one to two, or three pounds weight—They were made of a flinty kind of stone: I have seen several, which chanced to escape being buried with their owners, and were carefully preserved by the old people, as respectable remains of antiquity. They twisted two or three tough hiccory slips, of about two feet long, round the notched head of the axe; and by means of this simple and obvious invention, they deadened the trees by cutting through the bark, and burned them, when they either fell by decay, or became thoroughly dry. . . .

By the aforesaid difficult method of deadening the trees, and clearing the woods, the contented natives got convenient fields in process of time. And their tradition says they did not live straggling in the American woods, as do the Arabians, and rambling Tartars; for they made houses with the branches and bark of trees, for the summer-season; and warm mud-walls,

mixt with soft dry grass, against the bleak winter, according to their present plan of building, which I shall presently describe. Now, in the first clearing of their plantations, they only bark the large timber, cut down the saplings and underwood, and burn them in heaps; as the suckers shoot up, they chop them off close by the stump, of which they make fires to deaden the roots, till in time they decay. Though to a stranger, this may seem to be a lazy method of clearing the woodlands; yet it is the most expeditious method they could have pitched upon, under their circumstances, as a common hoe and a small hatchet are all their implements for clearing and planting.

Every dwelling-house has a small field pretty close to it: and, as soon as the spring of the year admits, there they plant a variety of large and small beans, peas, and the smaller sort of Indian corn, which usually ripens in two months, from the time it is planted; though it is called by the English, the six weeks corn. Around this small farm, they fasten stakes in the ground, and tie a couple of long split hiccory, or white oak-saplings, at proper distances to keep off the horses: though they cannot leap fences, yet many of the old horses will creep through these enclosures, almost as readily as swine, to the great regret of the women, who scold and give them ill names, calling them ugly mad horses, and bidding them "go along, and be sure to keep away, otherwise their hearts will hang sharp within them, and set them on to spoil them, if envy and covetousness lead them back." Thus they argue with them, and they are usually as good as their

word, by striking a tomohawk into the horse, if he does not observe the friendly caution they gave him at the last parting. Their large fields lie quite open with regard to fencing, and they believe it to be agreeable to the best rules of œconomy; because, as they say, they can cultivate the best of their land here and there, as it suits their conveniency, without wasting their time in fences and childishly confining their improvements, as if the crop would eat itself. The women however tether the horses with tough young bark-ropes, and confine the swine in convenient penns, from the time the provisions are planted, till they are gathered in—the men improve this time, either in killing plenty of wild game, or coursing against the common enemy, and thereby secure the women and girls, and get their own temples surrounded with the swan-feathered cap. In this manner, the Indians have to me, excused their long-contracted habit and practice.

The chief part of the Indians begin to plant their out-fields, when the wild fruit is so ripe, as to draw off the birds from picking up the grain. This is their general rule, which is in the beginning of May, about the time the traders set off for the English settlements. Among several nations of Indians, each town usually works together. Previous thereto, an old beloved man warns the inhabitants to be ready to plant on a prefixed day. At the dawn of it, one by order goes aloft, and whoops to them with shrill calls, "that the new year is far advanced,—that he who expects to eat, must work,—and that he who will not work, must expect to pay the fine according to old custom, or leave the town, as they will

not sweat themselves for an healthy idle waster." At such times, may be seen many war-chieftains working in common with the people. . . . About an hour after sun-rise, they enter the field agreed on by lot, and fall to work with great cheerfulness; sometimes one of their orators cheers them with jests and humorous old tales, and sings several of their most agreeable wild tunes, beating also with a stick in his right hand, on the top of an earthern pot covered with a wet and well-stretched deer-skin: thus they proceed from field to field, till their seed is sown.

Corn is their chief produce, and main dependance. Of this they have three sorts; one of which hath been already mentioned. The second sort is yellow and flinty, which they call "hommony-corn." The third is the largest, of a very white and soft grain, termed "bread-corn." . . .

The French of West-Florida, and the English colonists, got from the Indians different sorts of beans and peas, with which they were before entirely unacquainted. And they plant a sort of small tobacco, which the French and English have not. All the Indian nations we have any acquaintance with, frequently use it on the most religious occasions. The women plant also pompions, and different sorts of melons, in separate fields, at a considerable distance from the town, where each owner raises an high scaffold, to over-look this favourite part of their vegetable possessions: and though the enemy sometimes kills them in this their strict watch duty, yet it is a very rare thing to pass by those fields, without seeing them there at watch. This usually is the duty of the old women, who fret at the very shadow of a crow,

when he chances to pass on his wide survey of the fields; but if pinching hunger should excite him to descend, they soon frighten him away with their screeches. When the pompions are ripe, they cut them into long circling slices, which they barbacue, or dry with a slow heat. And when they have half boiled the larger sort of potatoes, they likewise dry them over a moderate fire, and chiefly use them in the spring-season, mixt with their favourite bear's oil. As soon as the larger sort of corn is full-eared, they half-boil it too, and dry it either by the sun, or over a slow fire; which might be done, as well, in a moderately hot oven, if the heat was renewed as occasion required. This they boil with venison, or any other unsalted flesh. They commonly have pretty good crops, which is owing to the richness of the soil; for they often let the weeds outgrow the corn, before they begin to be in earnest with their work, owing to their laziness and unskilfulness in planting: and this method is general through all those nations that work separately in their own fields, which in a great measure checks the growth of their crops. Besides, they are so desirous of having *multum in parvo* [much in little], without much sweating, that they plant the corn-hills so close, as to thereby choak up the field.—They plant their corn in straight rows, putting five or six grains into one hole, about two inches distant—They cover them with clay in the form of a small hill. Each row is a yard asunder, and in the vacant ground they plant pumpkins, water-melons, marsh-mallows, sunflowers, and sundry sorts of beans and peas, the last two of which yield a large increase.

47. Putting Down the Myth: A Male View

John Heckewelder's long experience with the Delawares put him in a strong position to contradict the prevailing European opinion that Indian women were no better off than slaves. He sensibly points out that Indian men did not impose duties on the women, who were free to divorce anyone who treated them harshly, but that the women performed their fair share of the work cheerfully and usually in the happy company of other women. He also demonstrates, using the women's own testimony, that the men worked harder and more continuously throughout the year, to keep their families in fish and meat, than the women, whose exertions in the fields were relatively short and far from debilitating. And if Heckewelder is correct, among the Indians of at least the Middle Atlantic colonies, the products of each spouse's labors were given to the other, to whom they could then be said to "belong," perhaps to avoid crushing demands on their generosity by the poor and shiftless.

There are many persons who believe, from the labour that they see the Indian women perform, that they are in a manner treated as slaves. These labours, indeed, are hard, compared with the tasks that are imposed upon females in civilised society; but they are no more than their fair share, under every consideration and due allowance, of the hardships attendant on savage life. Therefore they are not only voluntarily, but cheerfully submitted to; and as women are not obliged to live with their husbands any longer than suits their pleasure or convenience, it cannot be supposed that they would submit to be loaded with unjust or unequal burdens.

Marriages among the Indians are not, as with us, contracted for life; it is understood on both sides that the parties are not to live together any longer than they shall be pleased with each other. The husband may put away [divorce] his wife whenever he pleases, and the woman may in like manner abandon her husband. Therefore the connexion is not attended with any vows, promises, or ceremonies of any kind. An Indian takes a wife as it were on trial, determined, however, in his own mind not to forsake her if she behaves well, and particularly if he has children by her. The woman, sensible of this, does on her part every thing in her power to please her hus-

Source: Rev. John Heckewelder, *History, Manners, and Customs of the Indian Nations Who Once Inhabited Pennsylvania and the Neighbouring States,* rev. ed. by Rev. William C. Reichel (Philadelphia: Historical Society of Pennsylvania, 1876), pp. 154–58.

band, particularly if he is a good hunter or trapper, capable of maintaining her by his skill and industry, and protecting her by his strength and courage.

When a marriage takes place, the duties and labours incumbent on each party are well known to both. It is understood that the husband is to build a house for them to dwell in, to find the necessary implements of husbandry, as axes, hoes, &c., to provide a canoe, and also dishes, bowls, and other necessary vessels for housekeeping. The woman generally has a kettle or two, and some other articles of kitchen furniture, which she brings with her. The husband, as master of the family, considers himself bound to support it by his bodily exertions, as hunting, trapping, &c.; the woman, as his *help-mate,* takes upon herself the labours of the field, and is far from considering them as more important than those to which her husband is subjected, being well satisfied that with his gun and traps he can maintain a family in any place where game is to be found; nor do they think it any hardship imposed upon them; for they themselves say, that while their field labour employs them at most six weeks in the year, that of the men continues the whole year round.

When a couple is newly married, the husband (without saying a single word upon the subject) takes considerable pains to please his wife, and by repeated proofs of his skill and abilities in the art of hunting, to make her sensible that she can be happy with him, and that she will never want while they live together. At break of day he will be off with his gun, and often by breakfast time return home with a deer, turkey, or some other game. He endeavours to make it appear that it is in his power to bring provisions home whenever he pleases, and his wife, proud of having such a good hunter for her husband, does her utmost to serve and make herself agreeable to him.

The work of the women is not hard or difficult. They are both able and willing to do it, and always perform it with cheerfulness. Mothers teach their daughters those duties which common sense would otherwise point out to them when grown up. Within doors, their labour is very trifling; there is seldom more than one pot or kettle to attend to. There is no scrubbing of the house, and but little to wash, and that not often. Their principal occupations are to cut and fetch in the fire wood, till the ground, sow and reap the grain, and pound the corn in mortars for their pottage, and to make bread which they bake in the ashes. When going on a journey, or to hunting camps with their husbands, if they have no horses, they carry a pack on their backs which often appears heavier than it really is; it generally consists of a blanket, a dressed deer skin for mocksens [moccasins], a few articles of kitchen furniture, as a kettle, bowl, or dish, with spoons, and some bread, corn, salt, &c., for their nourishment. I have never known an Indian woman complain of the hardship of carrying this burden, which serves for their own comfort and support as well as of their husbands.

The tilling of the ground at home, getting of the fire wood, and pounding of corn in mortars, is frequently done by female parties, much in the manner of those husking, quilting, and other *frolics* (as they are called), which are

so common in some parts of the United States [among the whites], particularly to the eastward. The labour is thus quickly and easily performed; when it is over, and sometimes in intervals, they sit down to enjoy themselves by feasting on some good victuals, prepared for them by the person or family for whom they work, and which the man has taken care to provide before hand from the woods; for this is considered a principal part of the business, as there are generally more or less of the females assembled who have not, perhaps for a long time, tasted a morsel of meat, being either widows, or orphans, or otherwise in straitened circumstances. Even the chat which passes during their joint labours is highly diverting to them, and so they seek to be employed in this way as long as they can, by going round to all those in the village who have ground to till.

When the harvest is in, which generally happens by the end of September, the women have little else to do than to prepare the daily victuals, and get fire wood, until the latter end of February or beginning of March, as the season is more or less backward, when they go to their sugar camps, where they extract sugar from the maple tree. The men having built or repaired their temporary cabin, and made all the troughs of various sizes, the women commence making sugar, while the men are looking out for meat, at this time generally fat bears, which are still in their winter quarters. When at home, they will occasionally assist their wives in gathering the sap, and watch the kettles in their absence, that the syrup may not boil over.

A man who wishes his wife to be with him while he is out hunting in the woods, needs only tell her, that on such a day they will go to such a place, where he will hunt for a length of time, and she will be sure to have provisions and every thing else that is necessary in complete readiness, and well packed up to carry to the spot; for the man, as soon as he enters the woods, has to be looking out and about for game, and therefore cannot be encumbered with any burden; after wounding a deer, he may have to pursue it for several miles, often running it fairly down. The woman, therefore, takes charge of the baggage, brings it to the place of encampment, and there, immediately enters on the duties of housekeeping, as if they were at home; she moreover takes pains to dry as much meat as she can, that none may be lost; she carefully puts the tallow up, assists in drying the skins, gathers as much wild hemp as possible for the purpose of making strings, carrying-bands [tumplines], bags and other necessary articles, collects roots for dyeing; in short, does every thing in her power to leave no care to her husband but the important one of providing meat for the family.

After all, the fatigue of the women is by no means to be compared to that of the men. Their hard and difficult employments are periodical and of short duration, while their husband's labours are constant and severe in the extreme. Were a man to take upon himself a part of his wife's duty, in addition to his own, he must necessarily sink under the load, and of course his family must suffer with him. On his exertions as a hunter, their existence depends; in order to be able to follow that rough employment with

success, he must keep his limbs as supple as he can, he must avoid hard labour as much as possible, that his joints may not become stiffened, and that he may preserve the necessary strength and agility of body to enable him to pursue the chase, and bear the unavoidable hardships attendant on it; for the fatigues of hunting wear out the body and constitution far more than manual labour. Neither creeks nor rivers, whether shallow or deep, frozen or free from ice, must be an obstacle to the hunter, when in pursuit of a wounded deer, bear, or other animal, as is often the case. Nor has he then leisure to think on the state of his body, and to consider whether his blood is not too much heated to plunge without danger into the cold stream, since the game he is in pursuit of is running off from him with full speed. Many dangerous accidents often befal him, both as a hunter and a warrior (for he is both), and are seldom unattended with painful consequences, such as rheumatism, or consumption of the lungs, for which the sweat-house, on which they so much depend, and to which they often resort for relief, especially after a fatiguing hunt or war-

like excursion, is not always a sure preservative or an effectual remedy.

The husband generally leaves the skins and peltry which he has procured by hunting to the care of his wife, who sells or barters them away to the best advantage for such necessaries as are wanted in the family; not forgetting to supply her husband with what he stands in need of, who, when he receives it from her hands never fails to return her thanks in the kindest manner. If debts had been previously contracted, either by the woman, or by her and her husband jointly, or if a horse should be wanted, as much is laid aside as will be sufficient to pay the debts or purchase the horse.

When a woman has got in her harvest of corn, it is considered as belonging to her husband, who, if he has suffering friends, may give them as much of it as he pleases, without consulting his wife, or being afraid of her being displeased; for she is in the firm belief that he is able to procure that article whenever it is wanted. The sugar which she makes out of the maple tree is also considered as belonging to her husband.

48. Putting Down the Myth: A Female View

The best person to rectify the myth of the "squaw-drudge" was a woman who had known the life of both Indian and white. Mary Jemison was just such a person. She was born in 1743 aboard the ship that took her parents from Ireland to Philadelphia. In 1758 her family was captured and killed by French-allied Indians and she was adopted into the Seneca Iroquois tribe. She later married a Delaware, bore him several children, and despite several opportunities to return to white society, remained with the Indians the rest of her life like hundreds of other colonists. She told her story to James Seaver, a minister, before she died on her New York reservation farm, and in 1824 he published it as *A Narrative of the Life of Mrs. Mary Jemison*. The following excerpt contrasts the work of Indian and colonial women, suggesting that not only was the former easier than the latter but that, as William Bartram wrote of the southeastern tribes in 1789, "the condition of the women is as happy, compared with that of the men, as the condition of women in any part of the world" ("Observations on the Creek and Cherokee Indians," *Transactions of the American Ethnological Society*, vol. 3, pt. 1 [1853], 31).

I had then been with the Indians four summers and four winters, and had become so far accustomed to their mode of living, habits and dispositions, that my anxiety to get away, to be set at liberty, and leave them, had almost subsided. With them was my home; my family was there, and there I had many friends to whom I was warmly attached in consideration of the favors, affection and friendship with which they had uniformly treated me, from the time of my adoption. Our labor was not severe; and that of one year was exactly similar, in almost every respect, to that of the others, without that endless variety that is to be observed in the common labor of the white people. Notwithstanding the Indian women have all the fuel and bread to procure, and the cooking to perform, their task is probably not harder than that of white women, who have those articles provided for them; and their cares certainly are not half as numerous, nor as great. In the summer season, we planted, tended and harvested our corn, and generally had all our children with us; but had no master to oversee or drive us, so that we could work as leisurely as we pleased. We had no ploughs on the

Source: James E. Seaver, *A Narrative of the Life of Mrs. Mary Jemison* (Canandaigua, N.Y., 1824), pp. 46–47.

Ohio; but performed the whole process of planting and hoeing with a small tool that resembled, in some respects, a hoe with a very short handle.

Our cooking consisted in pounding our corn into samp or hommany, boiling the hommany, making now and then a cake and baking it in the ashes, and in boiling or roasting our venison. As our cooking and eating utensils consisted of a hommany block and pestle, a small kettle, a knife or two, and a few vessels of bark or wood, it required but little time to keep them in order for use.

Spinning, weaving, sewing, stocking knitting, and the like, are arts which have never been practised in the Indian tribes generally. After the revolutionary war, I learned to sew, so that I could make my own clothing after a poor fashion; but the other domestic arts I have been wholly ignorant of the application of, since my captivity. In the season of hunting, it was our business, in addition to our cooking, to bring home the game that was taken by the Indians, dress it, and carefully preserve the eatable meat, and prepare or dress the skins.

FIVE:

Peace and War

Among the adult activities of Indian society, the waging of war and the maintenance of peace were perhaps the most vital to the lives of all its members, male and female. Because the potential costs of war were high in manpower loss (both from casualties and the prolonged absence of the warriors), insecurity, and humiliation, most Indian societies made war selectively and infrequently. The greater part of their years were devoted to the arts of peace—farming, fishing, trading, childrearing, socializing, celebrating, and hunting (an emotionally satisfying surrogate for war). Those men who could regularly stalk and kill a deer to fill their families' kettles were regarded with nearly the short-range respect and probably more than the long-range respect accorded a warrior who had returned after a year or more bearing a single enemy scalp. For the majority of the people at home—the women, children, and elders—were less interested in revenge killings and warpath heroics than they were in the daily pleasures of peace and prosperity. Consequently, the eastern tribes experienced constant tension between the young warriors eager to earn their stripes in war and the councils of elders who desired peace.

In many of these tribes, particularly the matrilineal farming tribes such as the Iroquois and the southeastern tribes, the role of the women was crucial. On the one hand, a clan matron could initiate a warparty by secretly requesting a leading war captain of her husband's or her own clan to capture an enemy to replace a deceased member of her extended family, often the victim of an enemy raid. This he would do by recruiting a small group of warriors to accompany him on the warpath in search of honor and revenge. If they returned with a captive, she (or the woman who had suffered the loss) would then decide his fate. If her grief was recent and deep, she might condemn him to the flames and join her sisters in torturing him, satisfied that his scalp would adequately replace her kinsman. If, however, she needed someone to love, to work, and to support the clan, she would adopt him in the exact place of the deceased and he would henceforth be treated as if he had been born of her body. On the other hand, if the village elders were adamantly opposed to war at this time, they could appeal to the

clan matron to recall her captain. And if the warriors decided to go scalping without the women's sanction, the women could withhold the crushed corn and extra moccasins that were essential to any warparty. So powerful were the Iroquoian women that Father Lafitau in 1724 described the tribal system as a gynecocracy—a government by women.

But the Iroquois were atypical in the degree of formal authority their women enjoyed. Certainly in the patrilineal hunting tribes of the North and even in many of the other matrilineal farming tribes, women did not hold the reins of government with their men, though their collective voice was generally heard—through male speakers—in the councils of the nation. It was with some astonishment that eastern tribes treating with colonial legislatures or councils met with no women. Nevertheless, the village and tribal councils of nearly every eastern tribe were composed solely of men. Only the Cherokees gave a place in their councils to "Beloved Women" who had demonstrated courage and wisdom extraordinary for their sex; only a few New England tribes are known to have had female sachems. The women's power normally operated more covertly, though often no less effectively than the men's, for they were the acknowledged guardians of tradition and peace in societies whose survival depended in large measure on both.

As the nutritive element in native society, the women predictably moved behind the scenes of most public feasts, feeding the fires and the men with cheerful subservience. Only when food was abundant did they share the first course with their husbands. Generally, they were content to wait at home for their spouses to return with the feast's leftovers, which in most cases were no doubt ample, or to mount a separate feast with their village sisters. If they were discontent with their subdued role on public occasions, their complaints were not loud enough to reach the ears of European observers looking for any excuse to denigrate Indian manhood.

49. Of Huron Councils and Montagnais Feasts

The Jesuits in Canada took their missions and descriptive pens to many different tribes, to sedentary farmers with matrilineal kinship systems and matrilocal residence as well as to semi-nomadic hunters who descended patrilineally and lived with or near the husband's kinsmen. In all the groups they encountered, with one prominent exception (the Iroquois), the women played no appreciable role in political affairs and participated in public feasts only infrequently. On July 16, 1636, Jean de Brébeuf completed a long report to Paul Le Jeune, his superior in Quebec, describing some of the customs and institutions of the Hurons among whom he had worked for nearly seven years. From his bark lodge in Ihonatiria, or St. Joseph's as he had renamed it, he spoke of the composition and conduct of Huron national councils (the nation being a league of five related tribes, similar to the more famous league of the linguistically related Iroquois). In the first excerpt below, he notes the absence of women (except to build the fire), the respect for the wisdom of old age, the egalitarian and amiable tone of the proceedings, the special council speech pattern, and the importance of oratorical skill and repetition in that oral culture. He did not mention the significance of the apparent approval of each speaker by the council's gutteral "Haau," but several of his fellow missionaries, English and French, found it one of the greatest obstacles to their conversion efforts. No matter what was said by the proselytizing Black Robes, the counsellors voiced their approving "Haau" out of politeness, and the missionary was no wiser about the efficacy of his words.

Among the matrilineal, farming Hurons, women were accorded considerable respect. Montagnais men, belonging to a patrilineal hunting tribe that grew no crops, felt less need to be chivalrous. In both most of the women were given a back seat or no seat at all at public feasts. At the two parts of the important Montagnais bear feast, Father Le Jeune tells in the second excerpt, the unmarried girls and the young married women who were not yet mothers were visibly absent. Only the older women who had achieved full adult status by virtue of age, experience, and motherhood ate with the select group of hunters at the first meal; the second course was an all-male affair.

In the third passage, also from Le Jeune's 1634 report to his provincial

Source: Reuben Gold Thwaites, ed., *The Jesuit Relations and Allied Documents*, 73 vols. (Cleveland, 1896–1901), 10:251–61; 6:217, 219, 279, 281; 7:89.

in Paris, we learn that widows were usually invited by the hunters to their feasts, which served a redistribution and social welfare function. Le Jeune also notes that although women were seldom invited to public feasts, their husbands often took them morsels from the feasts where the guests were not required to "eat all" that was placed before them. That this bounty was sometimes socially and nutritionally insufficient is indicated by the women's (infrequent) feasts of their own and the wife's hungry plea to Le Jeune in the fourth excerpt.

I shall speak here of the general [Huron] Councils or Assemblies, the special ones being ordered in almost the same way, although with less display. These general Assemblies are, as it were, the States-General [the legislature of the Dutch Republic] of the Country, and consequently they take place only so often as necessity requires. The place of these is usually the Village of the principal Captain of the whole Country. The Council Chamber is sometimes the Cabin of this Captain, adorned with mats, or strewn with Fir branches, with several fires, according to the season of the year. Formerly, each one brought his fagot to put on the fire; this is now no longer the custom, the women of the Cabin take this responsibility; they make the fires, but do not warm themselves thereat, going outside to give place to Messieurs the Councilors. Sometimes the assembly takes place in the midst of the Village, if it is Summer; and sometimes also in the obscurity of the forest, apart, when affairs demand secrecy. The time is oftener night than day, whole nights often being passed in council.

The Head of the Council is the Captain who calls it. Matters are decided by a plurality of votes, in which the authority of the Captains draws over many to their views; in fact, the usual way of coming to a decision is to say to the Old Men, *Do you give advice; you are the Masters.*

The usual wages of these Gentlemen are assigned according to the strength of their arms, to their zeal and good management. If they clear the ground better than the others, hunt better, fish better,—in short, if they are successful in trading, they are also richer than the others; but if not, they are the most necessitous, as experience has shown in the cases of some.

The incidental advantages are, in the first place, the best portions of the feasts, to which they are sure to be invited. 2. When any one makes a present, they get the best part of it. 3. When some one, be he Citizen or Stranger, wishes to obtain something from the Country [tribe], the custom is to grease the palms of the principal Captains, at whose beck and call all the rest move. I am quite sure of what I have just said. The regret that some private individuals have for such irregularities, and the envy of the other Captains who have not been called upon to share the booty, discourage the practice more than they like; they decry one another, and the mere suspicion of these secret presents stirs up sometimes great debates and divi-

sions,—not so much through desire of the public good as from regret at not having a share in them; and this jealousy sometimes hinders good measures. But let us come to the order they keep in their Councils.

In the first place, the Captain, having already consulted in private with the other Captains and Old Men of his Village, and having concluded that the affair warrants a public assembly, sends invitations to the Council, to as many persons of each Village as he desires. The Messengers are young men who volunteer or sometimes an Old Man, in order that the summons may be more efficacious, inasmuch as they do not always put faith in young people. These Messengers address their errand to the principal Captain of the Village, or, in his absence, to the one who is nearest him in authority, stating the day on which they are to assemble. These summons are entreaties, not commands, and accordingly some excuse themselves entirely, others delay setting out; whence it happens that these assemblies are sometimes tedious, for they do not like to set out in bad weather, and certainly they have enough difficulty in sometimes coming ten or twelve leagues on foot, and this in Winter and over the snow.

All having arrived, they take their seats each in his own quarter of the Cabin, those of the same Village or of the same Nation near one another, in order to consult together. If by chance some one is absent, the question is raised whether, notwithstanding this, the assembly would be legitimate; and sometimes, from the absence of one or two persons, the whole gathering is dissolved, and adjourns until another time. But if all are gathered, or if,

notwithstanding, they think it their duty to go on, the Council is opened. It is not always the Leaders of the Council who do this; difficulty in speaking, unwillingness, or even their dignity dispenses them from it.

After salutations, thanks for the trouble taken in coming, thanksgivings rendered, I know not to whom, that every one has arrived without accident, that no one has been surprised by enemies, nor has fallen into any stream or River, nor has been injured, —in brief, that every one has arrived happily, all are exhorted to deliberate maturely. Then the affair to be discussed is brought forward, and Messieurs the Councilors are asked to give their advice.

At this point the Deputies of each Village, or those of one Nation, consult in a low tone as to what they will reply. Then, when they have consulted well together, they give their opinions in order, and decide according to the plurality of opinions, in which course there are some things worthy of remark. The first is in the manner of speaking, which, on account of its unlikeness [to common speech], has a different name and is called *acwentonch;* it is common to all Savages; they raise and quaver the voice, like the tones of a Preacher in olden times, but slowly, decidedly, distinctly, even repeating the same reason several times. The second remarkable thing is, that the persons giving their opinions go summarily over the proposition and all the considerations brought forward, before giving their advice.

I once heard it said by some Interpreter, that these Nations had a private language in their Councils; but I have learned by experience that this is

not so. I know well that they have some private terms, as there are in all kinds of arts and sciences, as in the Palace, the Schools [universities] and elsewhere. It is true that their speeches are at first very difficult to understand, on account of an infinity of Metaphors, of various circumlocutions, and other rhetorical methods: for example, speaking of the Nation of the Bear they will say, "the Bear has said, has done so and so; the Bear is cunning, is bad; the hands of the Bear are dangerous." When they speak of him who conducts the feast of the Dead, they say "he who eats souls;" when they speak of a Nation, they often name only the principal Captain,—thus, speaking of the Montagnets [Montagnais], they will say, *"Atsirond* says:" this is the name of one of their Captains. In short, it is in these places they dignify their style of language, and try to speak well. Almost all their minds are naturally of very good quality; they reason very clearly, and do not stumble in their speeches; and so they make a point of mocking those who trip; some seem to be born orators.

3. After some one has given his opinion the Head of the Council repeats, or causes to be repeated, what he has said; consequently, matters must be clearly understood, so often are they repeated. This was very fortunate for me, at the Council of which I have spoken to you, where I made them a present to encourage them to take the road to Heaven; for one of the Captains felicitously repeated all that I had said, and dilated upon it and amplified it better than I had done, and in better terms; for, in truth, owing to our limited knowledge of the Lan-

guage, we say not what we wish, but what we can.

4. Each one ends his advice in these terms, *Condayauendi Ierhayde cha nonhwicwahachen:* that is to say, "That is my thought on the subject under Discussion:" then the whole Assembly responds with a very strong respiration drawn from the pit of the stomach, *Haau.* I have noticed that when any one has spoken to their liking, this *Haau* is given forth with much more effort.

The fifth remarkable thing is their great prudence and moderation of speech; I would not dare to say they always use this self-restraint, for I know that sometimes they sting each other,—but yet you always remark a singular gentleness and discretion. I have scarcely ever been present at their Councils; but, every time I have been invited, I have come out from them astonished at this feature.

When some one of them [the Montagnais] has taken a Bear, there are extensive ceremonies before it is eaten. One of our people took one, and this is what they did:

First, the Bear having been killed, the man who killed it did not bring it back, but he returned to the Cabin to impart the news, so that some one might go and see the prize, as something very precious; for the Savages prefer the meat of the Bear to all other kinds of food; it seems to me that the young Beaver is in no way inferior to it, but the Bear has more fat, and therefore the Savages like it better.

Second, the Bear being brought, all the marriageable girls and young married women who have not had children, as well as those of the Cabin

where the Bear is to be eaten, and of the neighboring cabins, go outside, and do not return as long as there remains a piece of this animal, which they do not taste. It snowed, and the weather was very severe. It was almost night when this Bear was brought to our Cabin; immediately the women and girls went out and sought Shelter elsewhere, the best they could find. They do this not without much suffering; for they do not always have bark at hand with which to make their house, which in such cases they cover with branches of the Fir tree.

In the third place, the dogs must be sent away, lest they lick the blood, or eat the bones, or even the offal of this beast, so greatly is it prized. The latter are buried under the fireplace, and the former are thrown into the fire. The preceding are the observations which I made during the performance of this superstition. Two banquets are made of this Bear, as it is cooked in two kettles, although all at the same time. The men and older women are invited to the first feast, and, when it is finished, the women go out; then the other kettle is taken down, and of this an eat-all feast is made for the men only. This is done on the evening of the capture; the next day toward nightfall, or the second day, I do not exactly remember, the Bear having been all eaten, the young women and girls return.

Only actual hunters, and those who have been hunters, are usually invited to their feasts, to which widows go also, especially if it is not an eat-all feast. The girls, married women, and children, are nearly always excluded. I say nearly always, for occasionally they

are invited. I have known them to have *Acoumagouchanai*, that is to say, feasts where nothing is to be left, to which every one was invited, men, women, and little children. When they have a great abundance of food, sometimes the women have a feast of their own, where the men are not found.

Their way of inviting is straightforward and without ceremony. When all is cooked and ready to eat (for no one is invited before), some one goes through the Cabins of those who are to be invited; or else they will cry out to them this word, from the place where the feast is given, *khinatonmigaouinaouau*, "You are invited to the banquet." The men to whom this word is addressed, answer, *ho ho*, and straightway taking their own bark dish and wooden spoon, come to the Cabin of the one who is to entertain them. When all the men are not invited, those who are desired are named. The absence of ceremony spares these simple people many words. It seems to me in the golden age they must have done like this, except that then cleanliness was in higher favor than among these people.

In all the feasts, as well as in their ordinary repasts, each one is given his part, from which it happens that only two or three have the best pieces, for they do not divide them. For example, they will give the tongue of a Moose and all the giblets to a single person, the tail and head of a Beaver to another; these are the best pieces, which they call *Mascanou*, "the Captain's part." As to the fat intestines of the Moose, which are their great delicacies, they usually roast them and let every one taste them, as they do another dish, which they hold in high esteem,

—namely, the large intestine of the beast filled with grease, and roasted, fastened to a cord, hanging and turning before the fire.

Also they are very magnificent in these feasts, for they only offer the good meat, separating it expressly, and giving to each one very abundantly, when they have it.

They have two kinds of feasts,— one at which everything is eaten; the other at which the guests eat what they please, carrying away the rest to divide with their families. This last feast seems to me praiseworthy, for there is no excess, each one taking as much as he likes of the portion given to him; indeed, I would venture to say that it is a happy invention to preserve friendship among them, and for each

to help feed the others. For usually the heads of families only eat a part of their share, carrying the rest to their wives and children.

I observed in this place [an island near the southern shore of the St. Lawrence] that the young [Montagnais] women did not eat from the same dish as their husbands. I asked the reason, and the Renegade [a former Montagnais convert] told me that the young unmarried women, and the women who had no children, took no part in the management of affairs, and were treated like children. Thence it came that his own wife said to me one day, "Tell my husband to give me plenty to eat, but do not tell him that I asked you to do so."

50. The Etiquette of Feasting among the Micmacs

According to the Recollect missionary Chrestien Le Clercq, the patrilineal Micmacs of eastern Canada also excluded the women from affairs of government and feasts. But they were not totally chauvinistic because young men who had not yet killed a moose were also excluded. Le Clercq's 1691 account ably describes the social importance and frequency of feasts as occasions for reciprocal sharing in that hunting society so dependent on cooperation. The etiquette of feasts, whereby the host did not eat and the women were called in after their husbands had eaten to secure the probably ample

Source: Father Chrestien Le Clercq, *New Relation of Gaspesia With the Customs and Religion of the Gaspesian Indians,* ed. and trans. William F. Ganong (Toronto: The Champlain Society, 1910), pp. 239, 288, 290–92.

leftovers, is outlined as is the reason for the eat-all feasts, which was to bring good luck in hunting.

The women have no command among the Indians. They must needs obey the orders of their husbands. They have no rights in the councils, nor in the public feasts. It is the same, as to this, with the young men who have not yet killed any moose, the death of which opens the portal to the honours of the Gaspesian nation, and gives to the young men the right to assist at public and private assemblies. One is always a young man, that is to say, one has no more rights than the children, the women, and the girls, as long as he has not killed a moose.

A nation can hardly be found which has feasts more in vogue than have the Indians of New France, and especially our Gaspesians, who take much more account of the affection and sincerity of a truly hearty friendship in the little which they give or receive from their friends than in the quantity or the quality of the viands. Consequently with a bit of tobacco, or something else of little account, they entertain one another just as if they were making the great feasts in the world. Hence it comes about that the most miserable [poorest] of them (if one indeed can say that there are any such in this nation of barbarians which does not admit any, or very little, distinction between rich and poor), find always in even the little they possess the wherewithal to repay their friends in kind, and to give feasts as important as those to which they have been invited. . . .

Nevertheless, although these barbarians are content with a little in their feasts, they do not fail to display sometimes a great profusion of viands, especially in the feasts which they make in spring in order to rejoice together over the happy success of the hunting which they have carried on during the winter. They observe no sort of economy in these kinds of feasts, in order to testify in this way to their friends the joy that they have in their company. The women, the children, the young boys who have not yet killed any moose, and all of those who are not in condition to go to war against the enemy, do not, as a rule, enter into the wigwams where there is feasting. They must await the signal which an Indian gives, by means of two or three different cries; by these the women know that it is time to come for the remains of the portions left by their husbands, upon which they regale themselves with their families and friends.

The manner of giving invitations to the feast is without compliment or ceremony, and nobody is invited until everything which the host wishes to give them is all ready cooked. He who is giving the treat then gives from the door of his wigwam the cry for the feast, speaking these words: *Chigoüidah, ouikbarlno.* "Come ye here into my wigwam, for I wish to entertain you." Those to whom these words are addressed answer him by three or four cries of "ho, ho, ho, ho"; they issue promptly from their own homes with

the ouragan [dish], enter into the wigwam of the feast, take the first place which presents itself, smoke some tobacco from the pipe of the chief, and receive without ceremony the portion which he who is dividing and distributing the meat tosses them, or gives them at the end of a stick.

The Gaspesians never make a feast of two kinds of meat at once. They do not mix, for example, the beaver with moose, nor that with bear, or any other animal. They even make feasts in which grease and oil are drunk quite pure. There are feasts of health, of farewell, of hunting, of peace, of war, of thanks. There are eat-all feasts, which are made expressly for securing good hunting; these are feasts in which it is necessary that everything be eaten before anybody goes out from the wigwam, and in which it is forbidden to give anything, howsoever little, to the dogs under penalty of being exposed to great ills. It is, however, permissible for those who cannot finish their portions to present them to their companions, each one of whom takes whatever he desires thereof. The remainder is thrown upon the fire, whilst eulogies are made of him who at this juncture has captured the glory and the reputation of having eaten more than the others.

All the feasts begin with speeches, which the host makes to those assembled for the purpose of declaring to them the subject on account of which he has wished to entertain the company; and they are finished with dances and songs which are the usual compliments of our Indians. The master of the feast does not as a rule eat with the others, because, says he, he has not invited them in order to diminish the portion of that which he presents to them, the whole being solely for them.

51. The Iroquois Gynecocracy

In a letter of 1721, Father Pierre de Charlevoix, en route to the Mississippi by canoe, described the civil government of the Iroquoian-speaking Hurons and Six Nations of Iroquois (the Tuscaroras, who had been driven out of North Carolina in 1714, were officially admitted as a sixth member in late 1722 or early 1723). Charlevoix had obviously received his information before going to Canada from Father Joseph Lafitau, the Jesuit missionary at

Source: P[ierre] de Charlevoix, *Journal of a Voyage to North-America*, 2 vols. (London, 1761), 2:23–27.

Sault St. Louis who had returned to Paris in 1717, for Charlevoix's account closely follows Lafitau's chapter on political organization published in 1724. The choice of source could not have been more fortunate; Lafitau knew the Iroquois in their heyday better than anyone. As summarized by Charlevoix, he understood the special role of the clan matrons in choosing and deposing the male clan chiefs (who comprised the tribal council), and in serving as *Agoianders,* the chiefs' deputies and overseers of their conduct and the public treasury. He also realized that the women, like the warriors, had their own orator to represent their interests in the village, tribal, and league councils. So prominent were the orators that the land-hungry colonists often tried to deal with them as the legitimate sources of power in Iroquois society, not realizing that they were only mouthpieces. But Charlevoix was sagacious enough to realize that even among the Iroquois the women's authority, while formally supreme, was effectively subordinate to that of the male clan chiefs and the village council of elders, composed of all mature men who had demonstrated wisdom and an understanding of public affairs. The women deliberated separately and first on any important issue and submitted their consensus through the clan chiefs to the council, but their opinion was only one of several to be weighed. Since all action was decided by consensus and not majority vote, the clan matrons alone could not win out against strong popular sentiment. Instead they would feel obligated to swallow their dissent for the peace of the community. Charlevoix also discovered, as did most colonial observers, that Indian chiefs and war captains exercised only suasive authority, not coercive power, and that obedience in civil, religious, and military affairs was strictly voluntary. The democratic nature of native institutions, predicated on small face-to-face communities, at once amazed and dismayed the colonists from highly bureaucratic, legalistic, and aristocratic European states.

In the northern parts, and wherever the Algonquin tongue prevails, the dignity of chief is elective; and the whole ceremony of election and installation consists in some feasts, accompanied with dances and songs: the chief elect likewise never fails to make the panegyrick of his predecessor, and to invoke his genius. Amongst the Hurons, where this dignity is hereditary, the succession is continued through the women, so that at the death of a chief, it is not his own, but his sister's son who succeeds him; or, in default of which, his nearest relation in the female line. When the whole branch happens to be extinct, the noblest matron of the tribe or in the nation chuses the person she approves of most, and declares him chief. The person who is to govern must be come to years of maturity; and when the hereditary chief is not as yet arrived at this period, they appoint a regent, who has

all the authority, but which he holds in name of the minor. These chiefs generally have no great marks of outward respect paid them, and if they are never disobeyed, it is because they know how to set bounds to their authority. It is true that they request or propose, rather than command; and never exceed the boundaries of that small share of authority with which they are vested. Thus it is properly reason which governs, and the government has so much the more influence, as obedience is founded in liberty; and that they are free from any apprehension of its degenerating into tyranny.

Nay more, each family has a right to chuse a counsellor of its own, and an assistant to the chief, who is to watch for their interest; and without whose consent the chief can undertake nothing. These counsellors are, above all things, to have an eye to the public treasury; and it is properly they who determine the uses it is to be put to. They are invested with this character in a general council, but they do not acquaint their allies with it, as they do at the elections and installations of their chief. Amongst the Huron nations, the women name the counsellors, and often chuse persons of their own sex.

This body of counsellors or assistants is the highest of all; the next is that of the elders, consisting of all those who have come to the years of maturity. I have not been able to find exactly what this age is. The last of all is that of the warriors; this comprehends all who are able to bear arms. This body has often at its head, the chief of the nation or town; but he must first have distinguished himself by some signal action of bravery; if

not, he is obliged to serve as a subaltern, that is, as a single centinel; there being no degrees in the militia of the Indians.

In fact, a large body may have several chiefs, this title being given to all who ever commanded; but they are not therefore the less subject to him who leads the party; a kind of general, without character or real authority, who has power neither to reward nor punish, whom his soldiers are at liberty to abandon at pleasure and with impunity, and whose orders notwithstanding are scarce ever disputed: so true it is, that amongst a people who are guided by reason, and inspired with sentiments of honour and love for their country, independance is not destructive of subordination; and, that a free and voluntary obedience is that on which we can always rely with the greatest certainty. Moreover, the qualities requisite are, that he be fortunate, of undoubted courage, and perfectly disinterested. It is no miracle, that a person possessed of such eminent qualities should be obeyed.

The women have the chief authority amongst all the nations of the Huron language; if we except the Iroquois canton of Onneyouth [Oneida], in which it is in both sexes alternately. But if this be their lawful constitution, their practice is seldom agreeable to it. In fact, the men never tell the women any thing they would have to be kept secret; and rarely any affair of consequence is communicated to them, though all is done in their name, and the chiefs are no more than their lieutenants. . . . The real authority of the women is very small: I have been however assured, that they always deliberate first on whatever is

proposed in council; and that they afterwards give the result of their deliberation to the chiefs, who make the report of it to the general council, composed of the elders; but in all probability this is done only for form's sake, and with the restrictions I have already mentioned. The warriors likewise consult together, on what relates to their particular province, but can conclude nothing of importance which concerns the nation or town; all being subject to the examination and controul of the council of elders, who judge in the last resource.

It must be acknowledged, that proceedings are carried on in these assemblies with a wisdom and a coolness, and a knowledge of affairs, and I may add generally with a probity, which would have done honour to the areopagus of Athens, or to the senate of Rome, in the most glorious days of those republics: the reason of this is, that nothing is resolved upon with precipitation; and that those violent passions, which have so much disgraced the politics even of Christians, have never prevailed amongst the Indians over the public good. Interested persons fail not, however, to set many springs in motion, and apply an address in the execution of their designs, we could hardly believe barbarians capable of; they also all of them possess, in the most sovereign degree, the art of concealing their real intentions: but generally speaking, the glory of the nation and motive of honour, are the chief movers in all enterprizes. Wha can never be excused in them is, that they often make honour consist in satiating a revenge which knows no bounds; a fault which Christianity alone is able to correct, and in which all our politeness and religion are often unsuccessful.

Each tribe has an orator in every town, which orators are the only persons who have a liberty to speak in the public councils and general assemblies: they always speak well and to the purpose. Besides this natural eloquence, and which none who are acquainted with them will dispute, they have a perfect knowledge of the interests of their employers, and an address in placing the best side of their own cause in the most advantageous light, which nothing can exceed. On some occasions, the women have an orator, who speaks in their name, or rather acts as their interpreter.

52. Sir William Meets the Matrons

To men long used to conducting the affairs of state amongst themselves, the presence of Indian women at treaty councils was a source of no little uneasiness. Although he was at one time married to a powerful Mohawk clan matron himself, Sir William Johnson, the knowledgeable British superintendent of Indian affairs for the northern department (Virginia to Canada), was obviously eager to deal only with his sexual counterparts at negotiations with the Iroquois at Onondaga, the central "fire" (tribe) of the "Longhouse" confederacy, in May 1758, and at Johnson Hall in the Mohawk Valley in April 1762. In the first council, Johnson complied with the matrons' request not to proceed to the "castle" (head village) of Oneida only after receiving a similar injunction from the Oneida chiefs. As the key person responsible for maintaining the Anglo-Iroquois alliance, Sir William was under some compulsion to obey the wishes of his allies, male or female, for tactical reasons, but he knew the Iroquois well enough to know that the women's boast that they could always prevail upon their men to desist from a "rash enterprise" was largely but not wholly true.

The proceedings of the second council, which was aimed partly at securing the return of white captives before they became thoroughly acculturated to Indian life and refused to return, reveal another English attitude toward the Iroquois women: they were felt to be not only politically unnecessary but also economically burdensome, as their requisite gifts were an added expense to the superintendent's budget. The council minutes also recognize that the Iroquois women could discourage a war party simply by withholding the ground corn and supply of extra moccasins needed by the warriors to undertake it.

May 5th [1758]. Sir William having no further accounts of the enemy's appearance, sent a scout of two Mohawks, two Canajoharies, and a white man, to go as far as Wood Creek and the Oneida Lake, in order to obtain the certainty of the alarm. About noon all the women of the chief men [the clan matrons or the chiefs' female deputies] of this castle [Onondaga] met at Sir William's lodging, and brought with them several of the sachems [clan chiefs], who acquainted Sir William that they had something to say to him in the name of their chief women.

Old Nickus (Brant) being appointed

Source: James Sullivan et al., eds., *The Papers of Sir William Johnson*, 14 vols. (Albany: The University of the State of New York, 1921–1965), 13:111–13; 3:707–12.

speaker, opened his discourse with condoling with Sir William for the losses his people had sustained, and then proceeded:—

Brother, we understand you intend to go to a meeting to Onondaga; we can't help speaking with this belt of wampum to you, and giving out sentiments on your intended journey. In the first place we think it quite contrary to the customs of any Governors or Superintendent of Indian affairs being called to Onondaga upon public business, as the council fire which burns there serves only for private consultations of the confederacy; and when matters are concluded and resolved upon there, the confederacy are to set out for the great fire place which is at your house, and there deliver their conclusion. In the next place we are almost convinced that the invitation is illegal, and not agreed upon or desired by the confederacy, but only the Oneidas—which gives us the more reason to be uneasy about your going, as it looks very suspicious. Did not they tell you, when they invited you, the road of friendship was clear, and every obstacle removed that was in before? They scarce uttered it, and the cruelties were committed at the German Flatts, where the remainder of our poor brethren were butchered by the enemy's Indians [French allies]. Is this a clear road of peace and friendship? Would not you be obliged to wade all the way in the blood of the poor innocent men, women, and children who were murdered after being taken?

Brother, by this belt of wampum, we, the women, surround and hang about you like little children, who are crying at their parents' going from them, for fear of their never returning again to give them suck; and we earnestly beg you will give ear to our request, and desist from your journey. We flatter ourselves you will look upon this our speech, and take the same notice of it as all our men do, who, when they are addressed by the women, and desired to desist from any rash enterprise, they immediately give way, when, before, every body else tried to dissuade them from it, and could not prevail.

Gave the [wampum] Belt.

Canajoharie, May 7th. This afternoon Sir William had a meeting with the chief women of this castle [village], and returned them thanks for their condolence of the 5th instant. At the same time he condoled with them for the loss of one of the tribe [clan] of the Bear, that belonged to the chief of that tribe, with a stroud blanket, a shirt, and stockings.

[Gave] A string of Wampum.

Sir William told them that he would answer their speech concerning his journey, when the messengers who had gone to Oneida came back. He also made private presents to a few of the head women [clan matrons] of each tribe, with a blanket and shirt each.

May 10th. This afternoon Sir William returned his answer to the speech of the chief women of this castle, made to him on the 5th instant, which is as follows:—

Dyattego, your tender and affectionate speech, made some days ago, I have considered, and thereupon have dispatched messengers to Oneida, in order to inquire how things stand there after what happened at the Ger-

man Flatts, and whether my presence at the meeting would be still necessary. These messengers are returned, and I find by them that the sachems of Oneida likewise disapprove my proceeding any farther, for sundry reasons they give in their reply. Wherefore I shall comply with your request to return, and heartily thank you for the great tenderness and love expressed for me in your speech.

<div align="right">Returned their Belt.</div>

25th [April 1762]. The Indians remained in Council together Untill afternoon. At 4 p.m. they sent to Acquaint Sir W^m. Johnson they were prepared to Say Something of Moment, upon Which he went to them.—

<div align="right">Present as before.</div>

The Chenussio Chief *Kanadiohora* Spoke as follows.—Brother Warraghiyagey [Sir William], . . .

You have frequently Required Us to Deliver up all the English Prisoners who were Amongst Us; we have Listened to you Attentively, and are now Resolved to agree to your Desire; and as We, the Chief Warriors, are the Most Active & Ruling People, we shall not fail to see that they are all Delivered up to you immediately, So that not one Shall Remain; all which you May Depend upon; and we hope that those People, who have been at great Expence in Cloathing, and Maintaining them, will not be forgot on their Coming down [to Johnson Hall], but that you will Consider them by giving them Something to Make their hearts easy.—

Then *Conoghquieson* Sachem of Oneida Spoke as follows.—
Brother Warraghiyagey,

I am now Directed to Speak to you

on behalf of all our Confederacy, as all Matters are So Amicably settled between you, & the Senecas, & the Covenant Chain [symbolizing the English-Iroquois alliance] renewed so that it May last for ever; We cannot but Express our great Uneasiness, at the ill treatment we Generally meet with at the Several [English] Garrisons, Such as the being debarred the Liberty of fishing, & our People for the Most frivolous Causes abused, threatned to be fired upon & often Run at with Bayonets; this treatment we look upon as not only Unjust, but very Unbrotherlike; besides if we were Starving with Hunger (which is often Our Case) they will not give Us a Morsel of Any thing; a Usage very different from What we had Reason to Expect, or were promised; and therefore we beg you will take the same into Consideration, & put a Stop to the like for the future, neither can we See that you have any Occasion for the Posts between the *German Flatts*, & *Oswego* (which we had been told were only to Remain for a time) as the French are now entirely Conquered [as of 1760].—

Gave a very long Belt of 14 feet.

Brother,

I am in the next place to Speak to you at the Request of the women of the Six Nations, who on your first Summons were desirous to Come down, & Assist in the good work, which you had in hand, but afterward were Informed you did not Desire their Attendance; however as it was always the Custom for them to be present on Such Occasions (being of Much Estimation Amongst Us, in that we proceed from them, & they provide our Warriors with Provisions when they go abroad)—they were therefore Resolved

to Come down, & hear the good words, which you had to Say, Which hath afforded them great Satisfaction; they now therefore hope you will Consider their fatigue in Coming so far, & that His present Majesty [King George III] will follow the Same good Steps of His Royal Grandfather [King George I], by Considering their wants, agreeable to his Example & Affording them Cloathing & Petticoats to Cover them, as our Warriors for want of Ammunition cannot take Care of them as formerly.—

A Belt 10 Rows.—

Then the Speaker of the Onondagas Spoke as Follows.— . . .

Brother,

I am Directed to Speak to you on the behalf of the Warriors & Women of the Senecas, who beg you will Consider their Wants & Indulge them as formerly with a [black-] smith to mend their Axes, & other working Implements as also to permit a Trader to Carry Indian Goods into their Country (but no Rum) as it is so far for them to go to *Oswego* or *Niagara* for their Necessaries.

Gave 2 Strings.

26th [April]. P.M. Sir William Assembled all the Indians—Present as before.

Being all Seated he Addressed them as follows.—

Brethren of the Chenussios [a Seneca village], . . .

I am glad to find you Seem Determined to Deliver up all the English Prisoners yet Amongst you, & will procure the Discharge of those in the *Mounsies* [Munsee Delawares'] possession, as it will be a proof of your Desire to preserve Peace, & fullfill your Engagements with Us, but at the Same time I cannot but be Surprized you

Should Expect a Gratuity for having Joyned with the Enemy, made our People Prisoners, & detained them so long in your Custody; This is a Request I can by no means agree to, especially after the many murders Some of your People have Committed without having made Us any Satisfaction for the Same; I Expect therefore if you hope for a Continuance of Our Friendship you will, without fail, deliver up all the English Prisoners, Who are in any of your Castles.—

Brethren,

When I Called you to this Meeting I really could not Discover any Necessity there was for the presence of Women & Children, and therefore I Called none but those who were Qualified for, and Authorized to proceed on business; And altho' I am Obliged to your Women for their Zeal & Desire to promote a good work, And know it is their Custom to Come down on Such Occasions, I could heartily wish that no more persons would Attend any meeting than were necessary for the Discharge of the business on Which they were Summoned, I have notwithstanding provided Some Cloathing for the women, with Some Ammunition and other Articles for the Warriors to Enable them to Subsist their Familys as formerly, & hope it will be applied to a proper use.—

A Belt. . . .

Brethren,

The present being now ready, I Desire you will make an Equal and fair Distribution amongst you of this fresh proof of His Majesty's Royal Bounty.—

Then Delivered them the present which they afterwards Divided Amongst One Another.—

53. The Delawares as Women

While men and women performed different roles within Indian society, sometimes a tribe itself played the part of a woman among its neighbors, a practice that has given rise to much misunderstanding among white observers. David Zeisberger, the Moravian missionary to the Delawares, presents an accurate picture of the women's role in northeastern Indian politics, even though his historical perspective is exclusively Delaware. The Iroquois claimed to have defeated the Delawares in 1742 and reduced them to female status, though not enough documentation exists to support either view. Zeisberger also gives a concise description of the native women's dress and implements, which remained largely unchanged in form and style as late as 1780, despite the introduction of cloth and metal through the fur trade.

With the Delawares the Six Nations [Iroquois] carried on long wars before the coming of the white man, and even after the advent of the pale-face, but the former were always too powerful for the Six Nations. The latter were convinced that if they continued the wars, their total extirpation would be inevitable. The Six Nations indeed boast that they had overcome the Delawares but these will not grant it, stating that as the Six Nations recognized the superior strength of the Delawares they thought of a means of saving their honor and making peace so that it might not seem that they had been conquered by the Delawares.

Soon after Pennsylvania had been settled by the whites, the Six Nations sent an embassy to the Delawares, opened negotiations and said: It is not profitable that all the nations should be at war with each other, for this would at length ruin the whole Indian race. They had, therefore, contrived a remedy by which this evil might be prevented while there was yet opportunity to do so. One nation should be the woman. She should be placed in the midst, while the other nations, who make war, should be the man and live around the woman. No one should touch or hurt the woman, and if any one did so, they would immediately say to him, "Why do you beat the woman?" Then all the men should fall upon him who has beaten her. The woman should not go to war but endeavor to keep the peace with all. Therefore, if the men that surround her should beat each other and the war be carried on with violence, the

Source: David Zeisberger's History of the Northern American Indians, ed. Archer Butler Hulbert and William Nathaniel Schwarze (Columbus: Ohio State Archaeological and Historical Society, 1910), pp. 34–36.

woman should have the right of addressing them, "Ye men, what are ye about; why do ye beat each other? We are almost afraid. Consider that your wives and children must perish unless you desist. Do you mean to destroy yourselves from the face of the earth?" The men should then hear and obey the woman. Ever since then the Six Nations have called the Delawares their cousins, i.e., sister's children, and declared them to be the woman, dressed them in a woman's long habit reaching down to the feet, though Indian women wear only short garments that reach but little below the knee, and fastened this about their bodies with a great, large belt of wampum. They adorned them with ear-rings, such as their women were accustomed to wear. Further, they hung a calabash filled with oil and beson [medicine] on their arms, therewith to anoint themselves and other nations. They also gave them a corn-pestle and a hoe. Each of these points was confirmed by delivering a belt of wampum and the whole ceremony observed with the greatest solemnity. One must not, however, think they actually dressed them in women's garments and placed corn-pestle and hoe in their hands. It is to be understood in the same way as when the chiefs among the Indians lay out a trail several hundred miles through the woods, they cut away thorn and thicket, clear trees, rocks and stones out of the way, cut through the hills, level up the track and strew it with white sand, so that they may easily go from one nation to another; but when one goes the way that has thus been cleared it is found to be full of wood and rocks and stones and all overgrown with thorns and thicket.

The woman's garment signified that they should not engage in war, for the Delawares were great and brave warriors, feared by the other nations; the corn-pestle and hoe that they should engage in agriculture. The calabash with oil was to be used to cleanse the ears of the other nations, that they might attend to good and not to evil counsel. With the medicine or beson they were to heal those who were walking in foolish ways that they might come to their senses and incline their hearts to peace.

The Delaware nation is thus looked to for the preservation of peace and entrusted with the charge of the great belt of peace and the chain of friendship which they must take care to preserve inviolate and which they bear on their shoulders at its middle, the other nations and the Europeans holding the ends.

Thus it was brought about that the Delawares should be the cousins of the Six Nations and were made by them to be the women. Such a state of things was preserved until 1755, when a war broke out between the Indians and the white people into which the Delawares were enticed by the Six Nations. The woman's dress of the Delaware nation was shortened so as to reach only to the knees and a hatchet was given into their hands for defense. More than this, on the occasion of a council held during the same war, near Pittsburg, the Six Nations proposed to take the woman's dress away altogether and clothe them with the breech-clout, saying they could well see that the dress was a hindrance, inasmuch as the Delawares did not enter heartily into the war, being well aware that the Six Nations only sought their

ruin. This, therefore, was not approved of by the Delawares, one of their chiefs rising to say to the Six Nations, "Why do you wish to rob the woman of her dress? I tell you that if you do, you will find creatures in it that are ready to bite you."

The Six Nations who had betrayed the Delawares into a war with the white people, at the last fell upon them themselves at the instigation of Sir William Johnson, taking many captives, especially of the Monsy [Munsee] tribe, whom they delivered over to Johnson, destroying and ravaging their towns on the Susquehanna and killing their cattle. The Delawares will not easily forget this piece of treachery and there is and remains a national hostility between these nations. In this present war [the American Revolution] the Delawares have done much to avenge themselves.

54. The Iroquois Call to War

Contrary to the myth of the blood-thirsty, war-mongering savage that has permeated American literature from the very beginning, the Indians of the East were at peace with each other and with the European colonists for the greater part of the colonial period and the greater portion of every year. The vast majority of Indians, like most colonists, were not directly involved in warfare, either as participants or victims. Despite the strong military ethic of the young warriors, the tribal elders and women were powerful forces for peace. However, when the counsels of peace were finally drowned out by the cry for revenge and the call of adventure, individual—less frequently tribal—warparties were summoned, often by clan matrons or other women who had lost children or kinsmen at the hands of their enemies.

As Father Joseph Lafitau describes in the following account of Iroquois war-making in the early eighteenth century, the Iroquois (and many other eastern tribes) went to war not for empire or wealth, as the Europeans did, but primarily to maintain their populations by adopting captives into their

Source: Father Joseph François Lafitau, *Customs of the American Indians Compared with the Customs of Primitive Times,* ed. and trans. William N. Fenton and Elizabeth L. Moore, 2 vols. (Toronto: The Champlain Society, 1974–1977), 2:98–103.

families and clans in the place of deceased relatives. The key figures in this process were the clan matrons, who could call on their husbands' clansmen (*Athonni*) to seek revenge and to bring them enemy captives. That these requests had to be made secretly suggests that peace was a powerful paradigm and that family honor was less valuable than tribal security. Caught in a relentless cycle of revenge whose origins were often lost in the mists of time, the small war parties took to the warpath for months, even years, at a time, sometimes with, more often without, the blessings of the tribal elders. The colonial records are filled with laments from chiefs who could not bridle their young "hot heads" in search of scalps and honor. Only by requesting the clan matrons to call off their warriors or by interrupting their progress with false rumors could the elders maintain the peace. If, on the other hand, the council approved of the war, they deployed a formidable range of diplomatic skills to lull the enemy into a false sense of security and to neutralize his allies. Such past masters of forest diplomacy were the Iroquois that they were able to dominate the native Northeast and to successfully "play off" the English and the French until the middle of the eighteenth century, when the fall of Canada left them prey to Anglo-American land hunger and political domineering.

The men, who are so idle in their villages, make their indolence a mark of honour, giving it to be understood that they are properly born only for great things, especially for warfare. This exercise, which exposes their courage to the rudest tests, furnishes them frequent occasions to put in its brightest light all the nobility of their sentiments and the unshakeable firmness of a truly heroic greatness of mind. They like hunting and fishing which, after warfare, take their attention, only because they are the image of warfare. Perhaps they would leave these occupations as well as that of [getting] subsistence and all others to women if they did not consider hunting and fishing exercises which get them into shape to be a terror to enemies even more formidable than wild beasts. . . .

Whether the Areskoui [Great Spirit] of the Huron and the Iroquois is Ares or the true Thracian Mars [god of war], we must confess also that the Huron and Iroquois are even worthier of belonging to the God of War than the other barbarous nations of America, because of their superiority in valour. They may yield to some in advantages of the mind and body, vivacity in conversation, gentleness of facial expression, skill in different exercises, lightness in running and so on, but they do not yield to any one in courage. They pass incontestably as being the best soldiers and the quality of their courage cannot be disputed.

War is a necessary exercise for the Iroquois and Huron, perhaps also for all the other American Indians for, besides the usual motives which people have in declaring it against trouble-

some neighbours who offend them or furnish them legitimate causes by giving them just reasons for complaint, it is indispensable to them also because of one of their fundamental laws of being.

The families . . . are sustained only by the number of those composing them, whether men or women. It is in their number that their main force and chief wealth consist. The loss of a single person is a great one, but one which must necessarily be repaired by replacing the person lacking by one or many others, according to the importance of him who is to be replaced.

It is not up to the members of the household to repair this loss, but to all those men who have marriage links with that house, or their *Athonni,* as they say; and in that fact, resides the advantage of having many men born in it. For these men, although isolated at home and limited to themselves, marry into different lodges. The children born of these different marriages become obligated to their fathers' lodge, to which they are strangers, and contract the obligation of replacing them [those who are lost] so that the matron, who has the principal authority in this household, can force these children to go to war if it seems best to her, or keep them at home if they have undertaken a war displeasing to her.

When, then, this matron judges it time to raise up the tree again, or to lay again on the mat someone of her family whom death has taken away from her, she addresses herself to some one of those who have their *Athonni* [sire] at her home and who she believes is most capable of executing her

commission. She speaks to him by a wampum belt, explaining her intention of engaging him to form a war party. This is soon done.

There must be some similar custom established among the other tribes. It may vary, according to the rules by which gynecocracy [rule of women] is established among them. At certain times, the women of Florida come all together into the chief's presence and putting themselves in the posture of suppliants before him, they weep for the dead of their tribe, each one representing to him the losses which she has suffered in her own family. They all ask him to give some relief to their grief, urging revenge on the enemies who have caused it. Among the Carib and Brazilians [Timucuans], also, the women are charged with the duty of soliciting the warriors to avenge the injuries done their nation by their common enemies. It is during their feasts that the women weep, each one exaggerating her sufferings, making an effort to stimulate the courage of their youth by their complaints and words, to excite the young people to march boldly to combat and there to give proofs of their valour and love for the fellow countrymen whose deaths they are avenging.

Besides that, there must be some private obligation for families to take up each other's quarrels with laws a little different from those of the Iroquois. This is what I infer from what [André] Thevet [author of *La Cosmographie universelle* (Paris, 1575)] says in the following passage which I am quoting exactly. "As for the before mentioned widows, they do not remarry, except to the brother or male relative of their late husband, who has,

beforehand, to avenge the death of the said defunct if he has been taken and eaten by the enemy. If he died of old age or illness, it is the widow's new husband who has to take a captive to clean up over the dead man's grave, whether he had changed his village or otherwise; also all the feather adornments, belts, bows and arrows of the aforesaid, even his great bed where he slept in his lifetime, are washed by the said captive. Still the said widows [if they] marry [do not choose] any man less strong and valiant than their husbands were, for if they did they would be deposed, and even their children and allies would be angry and dissatisfied, so that, if the peers [of their late husbands] are not found, they prefer to remain widows all the rest of their life, and end their days with their children and, even if they remarry, it is always more than a year after their husband's death or on the accomplishment of the other things [mentioned] above. In this connection, I shall tell you here of a woman, who, after her husband had been taken, put to death, and eaten by his enemies, never being willing to remarry because none of the relatives of said defunct had made the effort to avenge his death, [undertook] to do so herself, and taking a bow and arrows went herself to war with men and was so successful that she took prisoners whom she gave to her children to be killed, saying to them, 'kill, my dear children, avenge your father's death, since none of his relatives has taken other vengeance; it is possibly because I am not young or beautiful enough, but a charge is upon me, it makes me strong, and valiant to avenge the death of your said father, my hus-

band;' and in fact, this woman succeeded so well that she took prisoner many of her enemies, whom she made even the young brothers and nephews of the said defunct put to death so that, putting away all womanly actions, and taking on the masculine and virile ones, she no longer wore her hair long like the other women or as she had been accustomed to doing, but adorned herself in the feathers and other things suitable to men. But to come back to our subject; after feasting well, making flutes of the leg and arm bones of their enemies and other instruments, like tambourines made, in their fashion, they go away, jumping and dancing joyously all around their lodges, where the oldest, however, do not cease all day long to drink without eating, as is customary, and are served by the defunct's widow and relatives and, when I asked them about these ways of doing things, told me that it was to stimulate the courage of the young people and to animate them to march bo[l]dly to war against their enemies, with the hope of such an honour after they have died [in their turn].''

The warriors do not always wait to be summoned. Their duty warns them enough, and the desire of winning glory presses them on still more keenly than duty or custom. He who wants to raise a party or is thus engaged to do so, furnishes a wampum belt or, if he has received it, shows it to those whom he wants to enroll in his expedition as the sign of his engagement and of theirs, without telling them, nevertheless, either who solicited him to go to war or who is the person whom he wishes to replace. If he does go so far as to explain himself to them, it is

[kept] secret among the warriors and the village has no knowledge of it.

War may be regarded either as private when it is made by little parties, some of which are nearly always in the field, or as general, when it is carried on in the name of the tribe.

The old men are not always consulted by the leaders of these little parties but they are not opposed to them when the interest of the tribe is not itself unfavourably affected. They are, on the contrary, very glad to see their young people exercising and enjoying themselves in the warlike spirit which makes their safety more assured by rendering them more formidable. But, if they fear that the number of these parties is weakening their village too much, that they [the parties] are going to insult some tribe with which the tribe wants to remain on good terms, or that their warriors are needed for some secret plan, they [the elders] would undertake underhanded measures to stop the leaders. If their negotiations are not successful enough or if they have some difficulty in succeeding in them, they let the party go away and bring it back by false information which they cause, in an adroit way, to be given its members on their way, but the surest way which they have at hand to break up the enterprise is to reach the matrons of the lodges, where those who are engaged with the leader have their *Athonni* [paternity] for these have only to interpose their authority to turn aside all the best devised plans. This is a sign that they have a prestige somewhat more important than the Council of the Old Men itself. This means is rarely employed, however, because the Indians treat each other with great respect and are

not eager to set in motion these means of prestige and authority to constrain others against their will.

These little parties are usually composed only of seven or eight people of one village. This number is increased rather often by [the addition of] the people of other villages or allied tribes who join them. . . .

The detached parties thus formed in peace times, so as not to involve the nation in hostilities which might have disastrous consequences, go to carry war to the most remote people. They will take possibly two or three years on the road and go two or three thousand leagues, going and coming, to break a head and lift a scalp. This little warfare is a veritable assassination and brigandage which has no semblance of justice either in the motives which cause it to be undertaken or in reference to the peoples against whom it is made. Not only are they unknown to these distant tribes or are known only by the damages which they cause them when they come to club them to death or take them captives almost at the gates of their palisades. The Indians regard this, nevertheless, as a fine action.

Ordinarily intertribal warfare among neighbours is most intense. Jealousy which reigns supreme among all these tribes, causes so much dislike to grow up between them, that it is not long until they have legitimate causes for rupture. However little they may be embittered or think they are right in their dissatisfaction with each other, they do not fail to seize upon any occasions which present themselves to take advantage of those whom they can easily get rid of accidentally when they meet any of them [the enemy

tribe] in their own hunting country, or pass any in a lonely place on their grounds when they are returning from making war in distant countries. The hope of impunity and of being able to keep those interested from learning of assassinations of this sort, emboldens many to commit them. They cannot be [kept] so secret, however, that the mystery is not sooner or later revealed by the guilty ones' imprudence or that they do not leave violent causes for suspicion, thus causing wounds as profound as the most complete and best developed proofs. The tribe at fault tries then to justify itself as best it can. It brings forward the most credible excuses. Then it sends people to cover the deed, and make presents to try to rebind together an understanding on the point of being broken. But even though these presents are accepted, if the omens are not favourable for taking complete vengeance for the assassination just at that time, they should not flatter themselves that the insult is entirely forgotten. The dressing put on this wound only covers, without curing it. It bleeds internally as long as the enemy has not received from it all the punishment inspired by resentment. The Council keeps an exact register of people killed on occasions of this sort and the memory of these events is refreshed until conditions are such that the most magnificent satisfaction can be gotten for them.

The Council decides on war only after considering the plan for a long time and weighing with mature consideration all the factors pro and con. All the assemblies treat this matter. They examine carefully all the consequences of an enterprise of this importance. They submit to deliberation all the means and measures possible for them to take and neglect none of the smallest precautions. They do not omit any particulars to assure themselves of their allies and their neighbours. They send secret embassies and wampum secretly to the homes of every one to engage them [their allies] committed to the same cause or force them, by sowing seeds of distrust, to remain neutral, in order to keep them [their enemies] at odds with each other.

In the Council, peace has its partisans as well as war. Those who have only the loss of fellow citizens to avenge, although they are not indifferent to losses of this sort, feel it, however, much less than those who mourn their brothers or next of kin. They are also in better condition to judge whether it is wiser to declare war or to dissimulate, but they are not always able to convince others that they are right. In cases of division of opinion, those most aroused underhandedly engage a party in warfare and begin hostilities through detached adventurers who turn the scales and hasten the decision in favour of war, which circumstances then render necessary.

The peace being thus broken or all measures brought together to break it, they publicly raise the hatchet. As is customary, they send it to be borne solemnly to the allied nations and sing war in all the villages. The terror of the name Iroquois is so widespread that, at that moment, all their neighbours tremble, each one for himself, and recover from their trepidation only when they see where the blow is going to strike. It is their policy even when they sing war not to hasten to depart but to keep all in suspense, to balance the matter for a long time,

often to put it off from one year to the next, to lull into false security those whom they wish to surprise. It is also an ordinary policy, on the other side, to give free rein to all the rumours of war however false they may be, to foment them, to start them or spread them, themselves, in order to keep their youth on the qui vive so that they will not be caught unaware.

55. Warring with the Illinois

Among the matrilineal Iroquois and Hurons, the clan matrons called on their kinsmen to avenge the losses within their families. In the patrilineal Illinois tribes along the upper and lower reaches of the Illinois River, war parties were aroused by the pleas of male leaders. Pierre Liette testifies from extensive military experience with the Peorias and Kaskaskias that their parties were typically small, except when whole villages, including women and children, moved onto the Plains to engage their western enemies. Religion was indispensable to success in war, as it was in farming and hunting, so the warriors consulted and then carried their bird skin fetishes on the warpath. Liette also describes many other features of northeastern woodland warfare: coordinated planning for attack and withdrawal, including totemic signatures on trees with readable "messages;" the greater value of adoptable prisoners than scalps; distinctive yells or "hallos" upon nearing the home village to indicate casualties and trophies; the disgrace of any war captain who lost men on more than one raid; the distribution of captives by the village council and the war captains to the families in need of replacements; the torture and death of most of the male captives who were too old to acculturate; ritual cannibalism to ingest the enemy's courage and stoutness of heart; the adoption of most of the women and children (though women were occasionally tortured); and the driving away of the dead man's spirit by beating on the village cabins.

Source: **Milo Milton Quaife, ed.,** *The Western Country in the 17th Century: The Memoirs of Lamothe Cadillac and Pierre Liette* (Chicago: R. R. Donnelley & Sons Co., The Lakeside Press, 1947), pp. 152–62.

They [the Illinois] usually prepare to go to war in the month of February. Before starting, it should be noted that in each village there are several chiefs [war captains] of the young men who control thirty, forty, and sometimes as many as fifty men. At the time I have spoken of they invite them to a feast and tell them that the time is approaching to go in search of men; so it is well to pay homage, according to their custom, to their birds [bird skin fetishes] so that these may be favorable. They all answer with a loud Ho! and after eating heartily they all go to get their mats and spread out their birds on a skin stretched in the middle of the cabin and with the *chichicoyas* [gourd rattles] they sing a whole night, saying: stone falcon, or crow, I pray to you that when I pursue the enemy I may run as fast as you fly, so that I may be admired by my comrades and feared by our enemies. At daybreak they bring back their birds.

When they wish to go to war, one of them, or the one who is their chief, offers them a feast, usually of dog. After all are in place and have observed a long silence the host says: "My comrades, you know that I have wept for a long time; I have not laughed since the time that my brother, father, or uncle died. He was your relative as well as mine, since we are all comrades. If my strength and my courage equalled yours, I believe that I would avenge a relative as brave and as good as he was, but being as feeble as I am, I cannot do better than address myself to you. It is from your arms, my brothers, that I expect vengeance for our brother. The birds that we prayed to a few days ago have assured me of victory. Their protection,

along with your courage, should induce us to undertake anything." Then he rises and, going up to each one, passes his hands over his head and over his shoulders. Then all the guests say: "Ho, ho! It is well. We are ready to die: you have only to speak." They thank him, and then depart at night and go about two leagues from the village to sleep.

It is a rule with them never to set out by day when they go in small parties, because, they say, if they went by day they would be discovered before making their attack. Their band does not ordinarily exceed twenty. The youngest, who is always the one who has shared in the fewest raids, carries the kettle and has charge of the cooking and mends the moccasins for all of them, which is no slight task. Accordingly, he hardly ever sleeps at night; but since this is the custom, they always do it amicably. They take the precaution of hiding stores of bacon and flour and some small kettles in two or three places to serve in case they should be pursued by the enemy, so as not to have to stop to hunt for food.

They also mark places for joining each other in case they are obliged to go by several different routes, and in such cases those who arrive first take a little of what they have left, if they need it, and leave their marks, which they never mistake. For this purpose they paint a picture of themselves on the nearest tree. Although several of them have heads of hair that look just alike, their totems identify them. They all have distinctive ones; one, the Buck, another the Buffalo, the Wolf, the Sun, the Earth, the Water, the Woman, the Child, the Girl, or some-

thing formed from these names as Buck-feet, Bear's Head, Woman's Breast, Buffalo Hump, the Eclipsed Moon or Sun, and so forth. So, after painting themselves as I have related, they draw a line above the head, at the end of which they draw a buffalo or its hump, a buck or its feet, the sun or a cloud above it, and so forth. When they approach an enemy, the leader of the party sends out two of the most active warriors a league ahead to reconnoiter the places through which they must pass. If they see smoke or other signs that lead them to believe the enemy is not far off, they report to the chief, who calls a halt.

I have forgotten to say that the commander carries his [colored reed] mat, into which all his men have put their birds, along with a good stock of herbs for healing the wounded. As soon as they stop, the chief takes out the birds and, after offering a short prayer to them, sends out three or four of the bravest and most active warriors to reconnoiter the enemy. If they chance to find but a man or two, they attack them without warning their comrades. If the number is very considerable they return to report, and after thoroughly examining the place where they are to attack them, they invariably wait until morning when the day is beginning to break, and they never fail to paint themselves and to look to their footgear, as a precaution in case they should be obliged to flee.

Two or three of the youngest warriors remain with the baggage in some secluded spot. At a couple of arpents' distance [c. 400 feet] from the enemy they utter the most astonishing yells in order to frighten him, rushing upon him when he takes to flight. In this

they triumph, for they know that the enemy cannot run as well as they—I speak of the Iroquois. While running in pursuit they utter the same cry as their birds. If three of them are in pursuit of one man and are in doubt which of them will lay hands on him, the first one who touches him with some missile is the one to whom the prisoner belongs, even if another should lay hands on him first. They then utter several cries to attract the attention of their comrades who are fighting elsewhere, or who are in pursuit of others, who thus learn what they have done.

When they have bound their prisoners and have reassembled, the leader makes a little harangue in which he exhorts his men to thank the spirit for having favored them, and to make every effort to retire quickly from the spot where they are. They usually march for two days and nights without stopping, resting only at their meals. If, as happens very often, their captives are women who cannot march, they break their heads or burn them on the spot. They do this only in extreme cases, as the man who brings a prisoner to the village is more esteemed than the one who kills six men among the enemy. If unhappily some of their own men have been killed, the leader of the band paints himself with mud all along the road and weeps frequently as he marches, and when he reaches the village he is obliged to take presents to the relatives of those that have been killed to pay for their death, and he is expected to go back soon to avenge the slain. If one of his followers is again killed, he has great difficulty in finding men willing to accompany him a third time, which

causes him to be hated by the kinsfolk of the dead, unless by dint of presents he finds means (to use their language) to mend their hearts.

To return to their manner of behaving when they return victorious to the village: two men go ahead, and when they are near enough to make themselves heard, they utter cries for as many persons as they have killed, and give their names. Everyone runs out to meet them, and the first to arrive appropriate everything that the warriors carry. Those who are unwilling to part with some weapon or other object which they prize, take care to hide it the day before their arrival; but they are taxed with avarice. As I have said, if some of them have been killed the leader of the party carries some broken bows and arrows in his hand, and those who precede it utter terrible cries saying: "We are dead!" whereupon the women utter terrible howls until it is learned who the dead ones are, after which only the relatives redouble their outcries.

As soon as the news has become known, a prominent man prepares to banquet the warriors, who are invited to enter. When they have arrived in the cabin which has been prepared for them, oil is immediately brought to them in dishes, with which they grease their legs. The one who gives the feast weeps and goes around passing his hands over their heads to make known to them that some of his relatives have been killed by warriors of the nation from which they bring back prisoners, and that they would give him pleasure in killing them. During this time the prisoners are outside the cabin, for it is a rule with them never to admit slaves into their cabins unless they have

been granted their lives. The prisoners sing their death song, holding in one hand a stick ten or twelve feet long, filled with feathers from all the kinds of birds the warriors have killed on the road. This is after having them sing at the doors of the cabins of all those who have most recently had relatives killed.

The old men and the leaders of war parties assemble and decide to whom the slaves shall be given. When they have settled this, they lead one of them opposite the door of the cabin of the person to whom they are giving him, and bringing along some merchandise, they enter and say that they are delighted that the young men have brought back some men to replace, if they desire it, those whom the fate of war has taken away. For this offer great thanks are returned. Soon after this the inmates of the cabin assemble and decide what they will do with the prisoner who has been given to them, and whether they wish to give him his life, a thing rarely done among the Illinois. When he is a man, they bring him in and send for the principal men of the village who have brought them the prisoners. They thank them and give them some merchandise. When they want him put to death, they bring him back to the cabin of the most considerable of those who have offered him, giving the captive to them, with a kettle and a hatchet which they have colored red to represent blood. From there he is taken to others, and according to their decision he dies or lives.

When he is condemned to die, it is always by fire. I have never seen any other kind of torment used by this nation. They plant a little tree in the

earth, which they make him clasp; they tie his wrists, and burn him with torches of straw or firebrands, sometimes for six hours. When they find his strength is almost spent they unfasten him and cut his thumbs off, after which they let him, if he wishes, run after those who are throwing stones at him, or who are trying to burn him. They even give him sticks which he holds with great difficulty. If he tries to run after anybody, they push him and he falls on his face, at which they hoot. Sometimes he furnishes a whole hour of diversion to these barbarians.

Finally he succumbs under the strain of his torments, and sometimes drops down motionless. The rabble run to get firebrands, which they poke into the most sensitive parts of his body; they drag him over hot embers, which brings him back to life, at which they renew their hooting, as if they had performed some fine exploit. When they are tired of their sport, an old scoundrel cuts his flesh from the top of the nose to the chin and leaves it hanging, which gives him a horrible appearance. In this state they play a thousand tricks on him, and finally stone him or disembowel him. Some drink his blood. Women bring their male children still at the breast and place their feet in his body and wash them with his blood. They eat his heart raw.

There are men and women who might be called cannibals, and who are called man-eaters because they never fail to eat of all those who are put to death in their villages. At nightfall everybody, big and little, knocks loudly with big sticks on the cabins and on their scaffolds in order, as they say, to drive away from their village the soul of the man they have killed.

When they go to war among the Pawnee or Quapaw, who are established on the river of the Missouri, almost all the village marches, and even many women accompany them. Thus they take along whole villages. When they are ready to start several young men go about dancing at the doors of all the cabins, one of whom has a drum on his back. They commonly use an earthen pot, which they half fill with water and cover with a buckskin, which they stretch as tight as they can, and they turn the pot upside down from time to time to moisten the skin, which gives it a better tone. A man stands behind it and beats it. Everybody dances round them and each one gives them something. When the women see that they are preparing for this dance, they lead all their dogs away for any of them that they find they kill and feast on.

They always spare the lives of the women and children unless they have lost many of their own people. In that case they sacrifice some to the manes [spirits] of their dead, throwing them suddenly into the fire to consume the bodies of their slain ones.

SIX:
Heaven and Earth

Several of the first explorers and some of their less perceptive colonial followers thought that the Indians had no religion, just as they appeared to have no laws or government *("ni foi, ni loi, ni roi")*. Shortly, however, a closer look enabled settlers and missionaries to grant the natives a modicum of religious beliefs and observances, but these were seen only as "superstitions" because of their unfamiliar, non-Christian character. But one man's superstition is another man's religion, and Indian religion, for all its novelty, was at once bona fide and culturally pervasive, capable of explaining, predicting, and controlling the world in emotionally and intellectually satisfying ways. Like all peoples known to anthropology, the various native groups of the East each possessed a religion in that they performed "a set of rituals, rationalized by myth, which mobilize[d] supernatural powers for the purpose of achieving or preventing transformations of state in man or nature" (Anthony F. C. Wallace, *Religion: An Anthropological View* [New York, 1966], 107).

When men and women seek to understand and control the unseen forces that govern their lives, their sex is less important than the efficacy of their religious beliefs and ceremonies. Sexual differences tend to diminish before the immensity of the cosmos, without, however, disappearing altogether. Consequently, we should not expect to see in Indian religion the pronounced differences between men and women that existed in other areas of Indian culture.

One facet of religion where sexual differences were significant was the creation myths, in which the various tribes sought to explain to themselves how they and their societies came to be. Since the social and political status of men and women varied from group to group, the creation myths of the various groups tended to reflect the status quo. Among the matrilineal, horticultural Iroquoians, for example, women were accorded unusual respect and formal authority. Accordingly, the creation of the earth for them begins with a woman fallen from the Sky World, who proceeds to give birth to twins, one good and the other evil, and from whose breast grows the "three sisters" who sustained the Iroquois—corn, beans, and squash. In the

patrilineal, hunting tribe of Ottawas, on the other hand, men were dominant, so their creation myth begins with men sprung from the bodies of the first animals, symbolizing the spiritual bond between hunter and hunted. Women were produced later by the Creator as helpmates to the men.

The ubiquity of creation myths suggests that behind all native religion lay a cosmology, a hierarchy of states of being, and a science of the principles of their interaction. The most populous tier consisted of supernatural beings known as "spirits" or "souls," which were continuous "selves" capable of changing form. Though they were invisible, they were audible to humans, with whom they could interact directly (such as by shaking a conjurer's tent) and by whom they were manipulable in the right circumstances. Because they were continuous, they knew the future as well as the past. Human souls, for instance, could separate temporarily from the corporeal body in sleep, travel to other realms of experience, and return to inform or instruct the person in dreams. Consequently, dreams were regarded by many missionaries as the heart of native religion, for the Indians, particularly the Iroquois, believed that the supernatural guidance of their lives came from these "secret desires of the soul," which had to be fulfilled if they were to enjoy health, happiness, and success. In death the soul left the body permanently to travel to an afterlife, which was probably vaguely conceived before the Christians began to preach of Heaven and Hell, but which seemed to be an ethereal version of the happiest life they had known on earth, replete with good hunting, abundant fruits, and fine weather.

Just as angels differed in power and character from the Christian God, so Indian spirits and souls differed from the more powerful "guardian spirits," who enjoyed the ultimate power of metamorphosis, and the "Master Spirit" or Creator. According to native belief, every plant and animal species had a "boss" or "owner" spirit whose experience encompassed all the individuals of the species. Many Indian myths were narratives of the "self" adventures of these spirits. More importantly, a young man—less commonly a young woman—who sought a supernatural talisman of success underwent a vision quest alone in the woods in hopes of receiving instruction from a guardian spirit. If he was successful, the being he saw became his personal helpmate for the rest of his life, during the course of which it would give additional counsel.

The ultimate being in the Indian pantheon, just as in the Christian, was an all-powerful, all-knowing Creator, who was the source of all good but seldom or never seen. More frequently encountered, especially after the advent of the Hell-bearing Europeans, was an evil god, a *matchemanitou* in Algonquian, who purveyed deviltry and death if not appeased. Much to the chagrin of the missionaries, most of the Indians's religious worship seemed

to center on attempts to deflect the maleficences of this deity instead of praising the benefactions of the Creator.

The Indians mobilized the supernatural in their world by a number of religious observances and rituals. Just as in the Christian churches, rituals such as personal prayer and thanksgiving could be performed by any individual, but many others could only be administered in a communal context by a specially qualified priest or shaman, known to the Europeans as a "powwow," "juggler," or "sorcerer." The native priest was usually, though not always, a male religious specialist who had acquired through apprenticeship and visions extraordinary spiritual power. Unlike his Christian counterparts, however, he possessed personal supernatural power that allowed him to manipulate the spiritual cosmology on his tribesmen's behalf; he was not a mere intermediary whose only strength lay in explanation and supplication. But because all spiritual power in the native universe was double-edged, capable of both good and evil, the shaman was as feared as he was revered. For while he could induce trances to make himself impervious to pain, influence the weather, predict the future, and interpret dreams for the villagers, he could also cause as well as cure witchcraft, the magical intrusion of a small item into the body or the capture of a soul in dream by any person with spiritual power, which caused illness and eventually death. Bewitchment was the most feared calamity in Indian life because the assailant and the cause were unknown unless discovered by a shaman whose personal power was greater than that of the witch.

56. The World on the Turtle's Back

While the Christian had his *Book of Genesis,* the Indian had his own version of Creation passed across the generations by the spoken word. In the nineteenth century, anthropologists began to collect the many versions of the creation myths of the several tribes. Among the most responsive tribes

Source: Hazel W. Hertzberg, *The Great Tree and the Longhouse: The Culture of the Iroquois* (New York: Macmillan, 1966), pp. 12–19. Reproduced by permission of the American Anthropological Association from the Anthropological Curriculum Study Project.

were the Iroquois of New York, whose cultural roots had been well preserved by their famous League of Six Nations, a number of reservations on their ancestral lands, and the revitalizing religion of Handsome Lake, a charismatic Seneca whose visions at the end of the eighteenth century saw a way to syncretize the values of traditional Iroquois religion and the offerings of Christianity. The following version is an account compiled, from several hearings of Cayuga versions, by John Witthoft, a leading modern anthropological student of the Iroquois and Delawares, and edited by Hazel Hertzberg, who drew on the whole body of published versions as well.

In it the Iroquois account for the world as they knew it—the differences between the Sky-World, Earth, and the Underworld; the complementarity of good and evil, day and night, pleasure and pain; the social ideal of balance and harmony; the sovereign obligations to kin, especially siblings; the "three sisters"—corn, beans, and squash—that sustained them and the tobacco that allowed them to raise their thoughts and thanks to heaven; the double-edged character of all spiritual power, capable of both malevolence and beneficence; the natural patterning of games and dances; and particularly the fecundity of women, whose procreative powers and horticultural skills were closely associated with the original forces of creation. To the Iroquois and many other eastern tribes who shared a similar vision of creation, the earth on which they lived was an island, a "World on the Turtle's Back," and the Sky-World from which it derived, like the afterlife to which the souls of the dead went, bore a striking resemblance to their earthly existence. The essential sameness of their anthropomorphic worlds gave them comfort and a sense of security that the natural was closely akin to the supernatural, and that neither was to be feared, only respected.

In the beginning there was no world, no land, no creatures of the kind that are around us now, and there were no men. But there was a great ocean which occupied space as far as anyone could see. Above the ocean was a great void of air. And in the air there lived the birds of the sea; in the ocean lived the fish and the creatures of the deep. Far above this unpeopled world, there was a Sky-World. Here lived gods who were like people—like Iroquois.

In the Sky-World there was a man who had a wife, and the wife was ex-pecting a child. The woman became hungry for all kinds of strange delicacies, as women do when they are with child. She kept her husband busy almost to distraction finding delicious things for her to eat.

In the middle of the Sky-World there grew a Great Tree which was not like any of the trees that we know. It was tremendous; it had grown there forever. It had enormous roots that spread out from the floor of the Sky-World. And on its branches there were many different kinds of leaves and dif-

ferent kinds of fruits and flowers. The tree was not supposed to be marked or mutilated by any of the beings who dwelt in the Sky-World. It was a sacred tree that stood at the center of the universe.

The woman decided that she wanted some bark from one of the roots of the Great Tree—perhaps as a food or as a medicine, we don't know. She told her husband this. He didn't like the idea. He knew it was wrong. But she insisted, and he gave in. So he dug a hole among the roots of this great sky tree, and he bared some of its roots. But the floor of the Sky-World wasn't very thick, and he broke a hole through it. He was terrified, for he had never expected to find empty space underneath the world.

But his wife was filled with curiosity. He wouldn't get any of the roots for her, so she set out to do it herself. She bent over and she looked down, and she saw the ocean far below. She leaned down and stuck her head through the hole and looked all around. No one knows just what happened next. Some say she slipped. Some say that her husband, fed up with all the demands she had made on him, pushed her.

So she fell through the hole. As she fell, she frantically grabbed at its edges, but her hands slipped. However, between her fingers there clung bits of things that were growing on the floor of the Sky-World and bits of the root tips of the Great Tree. And so she began to fall toward the great ocean far below.

The birds of the sea saw the woman falling, and they immediately consulted with each other as to what they could do to help her. Flying wingtip to wing-tip they made a great feathery raft in the sky to support her, and thus they broke her fall. But of course it was not possible for them to carry the woman very long. Some of the other birds of the sky flew down to the surface of the ocean and called up the ocean creatures to see what they could do to help. The great sea turtle came and agreed to receive her on his back. The birds placed her gently on the shell of the turtle, and now the turtle floated about on the huge ocean with the woman safely on his back.

The beings up in the Sky-World paid no attention to this. They knew what was happening, but they chose to ignore it.

When the woman recovered from her shock and terror, she looked around her. All that she could see were the birds and the sea creatures and the sky and the ocean.

And the woman said to herself that she would die. But the creatures of the sea came to her and said that they would try to help her and asked her what they could do. She told them that if they could find some soil, she could plant the roots stuck between her fingers, and from them plants would grow. The sea animals said perhaps there was dirt at the bottom of the ocean, but no one had ever been down there so they could not be sure.

If there was dirt at the bottom of the ocean, it was far, far below the surface in the cold deeps. But the animals said they would try to get some. One by one the diving birds and animals tried and failed. They went to the limits of their endurance, but they could not get to the bottom of the ocean. Finally, the muskrat said he would try. He dived and disappeared.

All the creatures waited, holding their breath, but he did not return. After a long time, his little body floated up to the surface of the ocean, a tiny crumb of earth clutched in his paw. He seemed to be dead. They pulled him up on the turtle's back and they sang and prayed over him and breathed air into his mouth, and finally, he stirred. Thus it was the muskrat, the Earth-Diver, who brought from the bottom of the ocean the soil from which the earth was to grow.

The woman took the tiny clod of dirt and placed it on the middle of the great sea turtle's back. Then the woman began to walk in a circle around it, moving in the direction that the sun goes. The earth began to grow. When the earth was big enough, she planted the roots she had clutched between her fingers when she fell from the Sky-World. Thus the plants grew on the earth.

To keep the earth growing, the woman walked as the sun goes, moving in the direction that the people still move in the dance rituals. She gathered roots and plants to eat and built herself a little hut. After a while, the woman's time came, and she was delivered of a daughter. The woman and her daughter kept walking in a circle around the earth, so that the earth and plants would continue to grow. They lived on the plants and roots they gathered. The girl grew up with her mother, cut off forever from the Sky-World above, knowing only the birds and the creatures of the sea, seeing no other beings like herself.

One day, when the girl had grown to womanhood, a man appeared. No one knows for sure who this man was. He had something to do with the gods above. Perhaps he was the West Wind. As the girl looked at him, she was filled with terror, and amazement, and warmth, and she fainted dead away. As she lay on the ground, the man reached into his quiver, and he took out two arrows, one sharp and one blunt, and he laid them across the body of the girl, and quietly went away.

When the girl awoke from her faint, she and her mother continued to walk around the earth. After a while, they knew that the girl was to bear a child. They did not know it, but the girl was to bear twins.

Within the girl's body, the twins began to argue and quarrel with one another. There could be no peace between them. As the time approached for them to be born, the twins fought about their birth. The right-handed twin wanted to be born in the normal way, as all children are born. But the left-handed twin said no. He said he saw light in another direction, and said he would be born that way. The right-handed twin beseeched him not to, saying that he would kill their mother. But the left-handed twin was stubborn. He went in the direction where he saw light. But he could not be born through his mother's mouth or her nose. He was born through her left armpit, and killed her. And meanwhile, the right-handed twin was born in the normal way, as all children are born.

The twins met in the world outside, and the right-handed twin accused his brother of murdering their mother. But the grandmother told them to stop their quarreling. They buried their mother. And from her grave grew the plants which the peo-

ple still use. From her head grew the corn, the beans, and the squash—"our supporters, the three sisters." And from her heart grew the sacred tobacco, which the people still use in the ceremonies and by whose upward-floating smoke they send thanks. The women call her "our mother," and they dance and sing in the rituals so that the corn, the beans, and the squash may grow to feed the people.

But the conflict of the twins did not end at the grave of their mother. And, strangely enough, the grandmother favored the left-handed twin.

The right-handed twin was angry, and he grew more angry as he thought how his brother had killed their mother. The right-handed twin was the one who did everything just as he should. He said what he meant, and he meant what he said. He always told the truth, and he always tried to accomplish what seemed to be right and reasonable. The left-handed twin never said what he meant or meant what he said. He always lied, and he always did things backward. You could never tell what he was trying to do because he always made it look as if he were doing the opposite. He was the devious one.

These two brothers, as they grew up, represented two ways of the world which are in all people. The Indians did not call these the right and the wrong. They called them the straight mind and the crooked mind, the upright man and the devious man, the right and the left.

The twins had creative powers. They took clay and modeled it into animals, and they gave these animals life. And in this they contended with one another. The right-handed twin

made the deer, and the left-handed twin made the mountain lion which kills the deer. But the right-handed twin knew there would always be more deer than mountain lions. And he made another animal. He made the ground squirrel. The left-handed twin saw that the mountain lion could not get to the ground squirrel, who digs a hole, so he made the weasel. And although the weasel can go into the ground squirrel's hole and kill him, there are lots of ground squirrels and not so many weasels. Next the right-handed twin decided he would make an animal that the weasel could not kill, so he made the porcupine. But the left-handed twin made the bear, who flips the porcupine over on his back and tears out his belly.

And the right-handed twin made berries and fruits of other kinds for his creatures to live on. The left-handed twin made briars and poison ivy, and the poisonous plants like the baneberry and the dogberry, and the suicide root with which people kill themselves when they go out of their minds. And the left-handed twin made medicines, for good and for evil, for doctoring and for witchcraft.

And finally, the right-handed twin made man. The people do not know just how much the left-handed twin had to do with making man. Man was made of clay, like pottery, and baked in the fire. [At a later time the idea was added that some men were baked too little: these were white men. Some men were baked too much: these were Negroes. But some were baked just right: these were Indians. Those who were baked too little or too much were thrown away, but the Indians were settled upon the land.]

The world the twins made was a balanced and orderly world, and this was good. The plant-eating animals created by the right-handed twin would eat up all the vegetation if their number was not kept down by the meat-eating animals which the left-handed twin created. But if these carnivorous animals ate too many other animals, then they would starve, for they would run out of meat. So the right- and the left-handed twins built balance into the world.

As the twins became men full grown, they still contested with one another. No one had won, and no one had lost. And they knew that the conflict was becoming sharper and sharper and one of them would have to vanquish the other.

And so they came to the duel. They started with gambling. They took a wooden bowl, and in it they put wild plum pits. One side of the pits was burned black, and by tossing the pits in the bowl, and betting on how these would fall, they gambled against one another, as the people still do in the New Year's rites. All through the morning they gambled at this game, and all through the afternoon, and the sun went down. And when the sun went down, the game was done, and neither one had won.

So they went on to battle one another at the lacrosse game. And they contested all day, and the sun went down, and the game was done. And neither had won.

And now they battled with clubs, and they fought all day, and the sun went down, and the fight was done. But neither had won.

And they went from one duel to another to see which one would suc-

cumb. Each one knew in his deepest mind that there was something, somewhere, that would vanquish the other. But what was it? Where to find it?

Each knew somewhere in his mind what it was that was his own weak point. They talked about this as they contested in these duels, day after day, and somehow the deep mind of each entered into the other. And the deep mind of the right-handed twin lied to his brother, and the deep mind of the left-handed twin told the truth.

On the last day of the duel, as they stood, they at last knew how the right-handed twin was to kill his brother. Each selected his weapon. The left-handed twin chose a mere stick that would do him no good. But the right-handed twin picked out the deer antler, and with one touch he destroyed his brother. And the left-handed twin died, but he died and he didn't die. The right-handed twin picked up the body and cast it off the edge of the earth. And some place below the world, the left-handed twin still lives and reigns.

When the sun rises from the east and travels in a huge arc along the sky dome, which rests like a great upside-down cup on the saucer of the earth, the people are in the daylight realm of the right-handed twin. But when the sun slips down in the west at nightfall and the dome lifts to let it escape at the western rim, the people are again in the domain of the left-handed twin—the fearful realm of night.

Having killed his brother, the right-handed twin returned home to his grandmother. And she met him in anger. She threw the food out of the cabin onto the ground, and said that

he was a murderer, for he had killed his brother. He grew angry and told her she had always helped his brother, who had killed their mother. In his anger, he grabbed her by the throat and cut her head off. Her body he threw into the ocean, and her head, into the sky. There "Our Grandmother, the Moon," still keeps watch at night over the realm of her favorite grandson.

The right-handed twin has many names. One of them is Sapling. It means smooth, young, green and fresh and innocent, straightforward, straightgrowing, soft and pliable, teachable and trainable. These are the old ways of describing him. But since he has gone away, he has other names. He is called "He Holds Up the Skies," "Master of Life," and "Great Creator."

The left-handed twin also has many names. One of them is Flint. He is called the devious one, the one covered with boils, Old Warty. He is stubborn. He is thought of as being dark in color.

These two beings rule the world and keep an eye on the affairs of men. The right-handed twin, the Master of Life, lives in the Sky-World. He is content with the world he helped to create and with his favorite creatures, the humans. The scent of sacred tobacco rising from the earth comes gloriously to his nostrils.

In the world below lives the left-handed twin. He knows the world of men, and he finds contentment in it. He hears the sounds of warfare and torture, and he finds them good.

In the daytime, the people have rituals which honor the right-handed twin. Through the daytime rituals they thank the Master of Life. In the nighttime, the people dance and sing for the left-handed twin.

57. The First Ottawas

All peoples face the challenge of explaining the origins of society as they know it. Creation myths are one satisfying means of explanation. From his long acquaintance with the Ottawas of the Great Lakes region, the French explorer Nicolas Perrot learned the following story of the creation of man and woman. The Great Hare was an anthropomorphic being of gigantic

Source: Emma Helen Blair, ed. and trans., *The Indian Tribes of the Upper Mississippi Valley and Region of the Great Lakes,* 2 vols. (Cleveland: The Arthur H. Clark Co., 1911), 1:37–40. Reprinted by permission of The Arthur H. Clark Co.

stature and spiritual force who lived on Mackinac Island. To the Ottawas he was the creator of the world; by other Algonquian tribes he was regarded as the creator's elder brother.

In a spirit of condescension toward the Indians's beliefs, Perrot relates the figurative origins of totemic clans from the fish and animals that were important to the natives. These fauna were used as cabin decorations, tree signatures in war or on journeys, and body tattoos to indicate clan membership. He also reveals that the Ottawas, a patrilineal hunting and trading society, felt a need to give men precedence not only in life but in myth as well. Thus men were created first by the Great Hare, who then made women as their helpmates.

After the creation of the earth, all the other animals withdrew into the places which each kind found most suitable for obtaining therein their pasture or their prey. When the first ones died, the Great Hare caused the birth of men from their corpses, as also from those of the fishes which were found along the shores of the rivers which he had formed in creating the land. Accordingly, some of the savages derive their origin from a bear, others from a moose, and others similarly from various kinds of animals; and before they had intercourse with the Europeans they firmly believed this, persuaded that they had their being from those kinds of creatures whose origin was as above explained. Even today [c. 1720] that notion passes among them for undoubted truth, and if there are any of them at this time who are weaned from believing this dream, it has been only by dint of laughing at them for so ridiculous a belief. You will hear them say that their villages each bear the name of the animal which has given its people their being—as that of the crane, or the bear, or of other animals. They imagine that they were created by

other divinities than those which we recognize, because we have many inventions which they do not possess, as the art of writing, shooting with a gun, making gunpowder, muskets, and other things which are used by [civilized] mankind.

Those first men who formed the human race, being scattered in different parts of the land, found out that they had minds. They beheld here and there buffaloes, elks, and deer, all kinds of birds and animals, and many rivers abounding in fish. These first men, I say, whom hunger had weakened, inspired by the Great Hare with an intuitive idea, broke off a branch from a small tree, made a cord with the fibers of the nettle, scraped the bark from a piece of a bough with a sharp stone, and armed its end with another sharp stone, to serve them as an arrow; and thus they formed a bow [and arrows] with which they killed small birds. After that, they made *viretons* [crossbow arrows], in order to attack the large beasts; they skinned these, and tried to eat the flesh. But as they found only the fat savory, they tried to make fire, in order to cook their meat; and, trying to get it, they

took for that purpose hard wood, but without success; and [finally] they used softer wood, which yielded them fire. The skins of the animals served for their covering. As hunting is not practicable in the winter on account of the deep snows, they invented a sort of racket [snowshoe], in order to walk on this with more ease; and they constructed canoes, in order to enable them to cross the rivers.

They relate also that these men, formed as I have told, while hunting found the footprints of an enormously tall man, followed by another that was smaller. They went on into his territory, following up this trail very heedfully, and saw in the distance a large cabin; when they reached it, they were astonished at seeing there the feet and legs of a man so tall that they could not descry his head; that inspired terror in them, and constrained them to retreat. This great colossus, having wakened, cast his eyes on a freshly-made track, and this induced him to step toward it; he immediately saw the man who had discovered him, whom fear had driven to hide himself in a thicket, where he was trembling with dread. The giant said to him, "My son, why art thou afraid? Reassure thyself; I am the Great Hare, he who has caused thee and many others to be born from the dead bodies of various animals. Now I will give thee a companion." Here are the words that he used in giving the man a wife: "Thou, man," said he, "shalt hunt, and make canoes, and do all things that a man must do; and thou, woman, shalt do the cooking for thy husband, make his shoes, dress the skins of animals, sew, and perform all the tasks that are proper for a woman." Such is the belief of these peoples in regard to the creation of man; it is based only upon the most ridiculous and extravagant notions—to which, however, they give credence as if they were incontestable truths, although shame hinders them from making these stories known.

58. Religion in the Native Northeast

The Europeans who worked hardest to understand native religion were the Jesuit missionaries in French Canada, who, like all missionaries, sought to replace native beliefs and practices with Christian ones. But since most of the Jesuits plied their calling in native villages, far from the security of

Source: P[ierre] de Charlevoix, *Journal of a Voyage to North-America*, 2 vols. (London, 1761), 2:141–53, 156–61.

French society, they needed a detailed knowledge of Indian religion in order to calculate the most effective and least alarming ways to insinuate Christian elements into native worship. Pierre de Charlevoix's comprehensive survey of northeastern religious observances was based on the detailed relations of his Jesuit brethren who had labored since 1611 to convert the native Canadians. Despite a predictably condescending tone, it is a remarkably full and accurate account of Indian religion in its many guises.

Although Charlevoix cannot forgive the Indians for lacking a religion similar to Catholic Christianity, with its written theology, ecclesiastical hierarchy, and dogmatic exclusivity, he clearly recognizes, as many of the early explorers and colonists did not, that they possessed a bona fide religion that spoke to their mundane and cosmic concerns. While their gods ("spirits") tended to be excessive in number and anthropomorphic, they believed in a Creator, the immortality of the soul, and an afterlife. Although they seemed to supplicate their evil gods more than the creator, they offered sacrifices, prayed, and gave thanks for success and good health. If they relied too much on dreams, guardian spirits, and conjuring "jugglers," they acknowledged— at least to the persistent missionaries—a great flood and a kind of purgatory where they expiated their "sins." For other beliefs and practices there were fewer compensations. Although they knew a form of "Heaven," they lacked a properly satanic "Hell" and a rigorous system of mortal merit. While they buried their dead with becoming respect, they "superstitiously" included the articles their souls would need on their westward journey to the afterlife, and were shocked by the French who tried to liberate the more valuable goods. And for all their religiosity, they would not usually accommodate the priests by engaging in theological debate, a reluctance (born of toleration) that created one of the toughest obstacles for the Black Robes bent on conversion. Although he had his blind spots, Charlevoix was astute enough to recognize that the Indians were not descended from the Lost Tribes of Israel, as many of his contemporaries believed well into the eighteenth century.

Nothing is more certain than that the Indians of this continent, have an idea of a supreme Being, though nothing at the same time can be more obscure. They all in general agree in looking upon him as the first spirit, and the governor and creator of the world, but when you press them a little close on this article, in order to know what they understand by the sovereign spirit, you find no more than a tissue of absurd imaginations, of fables so ill contrived, of systems so ill digested and so wild, that it is impossible to give any regular or just account of them. It is pretended that the Sioux approach much nearer than the other Indians, towards a just conception of

this first principle, but the little commerce we have hitherto had with them, does not permit me to be sufficiently informed of their traditions, to enable me to speak of them with any degree of certainty.

Almost all the nations of the Algonqui[a]n language, give this sovereign Being the appellation of the great Hare; some again call him Michabou, and others Atahocan. Most of them hold the opinion that he was born upon the waters, together with his whole court, entirely composed of four footed animals like himself; that he formed the earth of a grain of sand, which he took from the bottom of the ocean, and that he created man of the bodies of the dead animals. There are likewise some who mention a god of the waters, who opposed the designs of the great Hare, or at least refused to be assisting to him. This god is according to some, the great Tyger, but it must be observed, that the true tyger is not to be found in Canada; thus this tradition is probably of foreign extraction. Lastly, they have a third god called Matcomek, whom they invoke in the winter season, and concerning whom, I have learned nothing particular.

The Areskoui of the Hurons, and the Agreskouê of the Iroquois, is in the opinion of these nations, the Sovereign Being and the god of war. These Indians do not give the same original to mankind with the Algonquins; they do not so much as ascend so high as the first creation. According to them there were in the beginning six men in the world, and if you ask them who placed them there, they answer you, they dont know. They add, that one of these men ascended into heaven in quest of a woman, called Atahentsic [Aataentsic], of whom he had carnal knowledge, and who soon afterwards proved with child: that the master of heaven perceiving it, threw her headlong from the height of the Empyrean, and that she was received on the back of a tortoise: that she was afterwards brought to bed of two children, one of which killed the other.

There is no more said either of the five men, or even of the husband of Atahentsic, who according to some, had only one daughter, who was the mother of Thaouitsaran and Jouskeka. This latter who was the eldest, killed his brother, and in a little time after his grand-mother resigned in his favour the government of the world. They say likewise, that Atahentsic is the same with the moon, and that Jouskeka was the sun. . . .

The gods of the Indians have bodies, and live much in the same manner with us, but without any of those inconveniencies to which we are subject. The word spirit amongst them, signifies only a being of a more excellent nature than others. They have no words to express what passes the bounds of their own understanding, their conceptions being extremely limited, with respect to whatever is not the object of their senses, or to any thing besides the common occurrences of life. They however ascribe to those imaginary beings, a kind of immensity and omnipresence, for in whatever place they are, they invoke them, speak to them, believe they hear what is said to them, and act in consequence. To all the questions you put to these barbarians, in order to obtain a farther account of their belief, they answer that this is all they have been

taught or know of the matter; nay, there are only a few old men who have been initiated in their mysteries who know so much.

According to the Iroquois, the posterity of Jouskeka did not go beyond the third generation. There came on a deluge in which not a soul was saved, so that in order to repeople the earth it was necessary to change beasts into men. This notion . . . of an universal deluge is very general amongst the Americans; but there is scarce any room to doubt, that there has been another much more recent and peculiar to America. I should never have done, were I to relate all that the Indians tell us with respect to the history of their principal divinities, and the origin of the world; but besides the first being, or the great spirit, and the other Gods who are often confounded with them, there is likewise an infinite number of genii or inferior spirits, both good and evil, who have each their peculiar form of worship.

The Iroquois place Atahentsic at the head of these latter, and make Jouskeka the chief of the former; they even sometimes confound him with the god, who drove his grandmother out of heaven, for suffering herself to be seduced by a mortal. They never address themselves to the evil genii, except to beg of them to do them no hurt, but they suppose that the others are placed as so many guardians of mankind, and that every person has his own tutelary. In the Huron language these are called Okkis, and in the Algonquin Manitous: it is to them they have recourse in all perils and undertakings, as also when they would obtain some extraordinary favour; there is nothing but what they may

think they may beg of them, let it be ever so unreasonable or contrary to good morals. This protection however is not acquired at the birth of the person, he must first be expert at the management of the bow and arrow, before he can merit this favour, and much preparation must be used before he can receive it, it being looked upon as the most important affair in their whole lives. . . . There is even nothing in all nature, if we believe the Indians, which has not its genius, of which there are some of all ranks, but with different powers. When they are at a loss to conceive any thing, they attribute it to a superior genius, and their manner of expressing themselves then is, *This is a spirit.* This is said with greater justice of them, who have any singular talent, or who have performed any extraordinary action, *These are spirits,* that is they have a tutelary genius of an order superior to the common.

Some of them, and especially their jugglers [shamans], endeavour to persuade the multitude, that they are transported into extasies. This folly has been of all ages and amongst all nations, and is the parent of all false religions; the vanity natural to mankind, not being able to devise any more efficacious means of governing the weak and simple, and the multitude at last carried along with them, those who valued themselves the most on the superiority of their understandings. The American impostors, though they owe to themselves only all their address in this point, draw all the advantages from it to which they aspire. The jugglers never fail to publish that their genii give them great insight into the remotest transactions, and the most

distant futurity in their pretended ex- tasies; and as chance alone, if we would not ascribe some share of it to the devil, causes them to divine or conjecture some times pretty right, they acquire by this means great credit, and are believed to be genii of the first order. . . .

The Indians are not easily brought to confess themselves in the wrong, even to their gods themselves, and make no manner of difficulty in jus- tifying themselves at their expence: thus whenever they are under the necessity either of condemning them- selves or their tutelar [guardian spirit], the blame is always thrown upon the latter, and they apply to another with- out any ceremony, only observing the same rights as to the former: The women have also their Manitous, or Okkis, but are far from paying them the same respect with the men, per- haps from their giving them less em- ployment.

To all these genii are offered dif- ferent sorts of offerings, or if you will sacrifices. They throw into the rivers and lakes tobacco or birds, which have been strangled, in order to render the god of the waters propitious. In hon- our of the sun, and sometimes even of inferior spirits, they throw into the fire all sorts of useful things, and such as they believe they owe to them. This is sometimes done out of gratitude, but oftner from interested views, these people not being susceptible of any sentiments of affection towards their divinities. . . . We also meet with col- lars of porcelain, tobacco, maize, pease, and whole animals, especially dogs, on the sides of difficult or dan- gerous roads on rocks, or near cata- racts, which are so many offerings to the genii who preside in these places. I formerly said that the dog was the victim most commonly offered to them; these are hung up, and even some- times alive by the hind feet, and suf- fered to die mad. The war feast, which always consists of dogs, may also pass for a sacrifice. Lastly, they render nearly the same honours to the evil genii as to those which pass for pro- pitious, when they have any reason to dread their malice.

Thus . . . amongst nations who were pretended to have no idea of religion or of a deity, every thing on the contrary appears to be an object of religious worship, or least to have some relation to it. Some have imag- ined that their fasts had no other end, than to accustom them to support hunger, and I will allow that this mo- tive might be some part of the reason of this usage; but every circumstance with which they are accompanied, proves that religion has the greatest share in it; where it [is] only their ex- treme attention in observing, as I have already taken notice, what dreams they have during that time, it being certain that such dreams are looked upon as true oracles and warnings from heaven.

It is still less doubtful, that their vows are pure acts of religion, the usage being absolutely the same in this respect as with us. For example, when they happen to be without provisions, as often falls out in their voyages and huntings, they promise their genii to present in honour of them, a portion of the first beast they shall afterwards kill to some chief, and not to touch a morsel of it till they shall have ac- quitted themselves of their promise. Should this happen to be impossible by reason of the great distance of this

chief, they burn the part allotted for him, and thus make it a kind of sacrifice. . . .

Most of their festivals, songs and dances also appeared to me to have their origin in religion, and to preserve several traces of it; but one must be very sharp-sighted, or rather one must have a very strong imagination to perceive what certain travellers pretend to have discovered in them. I have known some persons, who not being able to get it out of their heads, that our Indians are descended from the ancient Hebrews, find in every thing a strong resemblance between these barbarians and the people of God. It is true there are some customs which have some appearance of this, such as not to make use of knives in certain repasts, and not to break the bones of the beasts eaten in them; and such also is the separation of the women from their husbands, during certain infirmities of the sex [menstruation]. And some have even heard, or at least have thought they heard them pronounce the word Allelujah in some of their songs: but who would ever believe their boring their ears and nostrils, to be in obedience to the law of circumcision? And besides who does not know that the rite of circumcision, is more ancient than the law which ordained the observation of it to Abraham and his posterity? The [eat-all] feast which is made on their return from hunting, and in which nothing must be left, has likewise been taken for a kind of Holocaust, or for a relique of the Jewish passover, and the rather, say they, because when any person was not able to get the better of his own portion, he was at liberty to make use of the assistance of his neighbours, as was the practice amongst the people of God, when one family were not able to eat the whole Paschal lamb.

An ancient missionary, who lived long amongst the Outaways [Ottawas], writes, that amongst these Indians an old man does the office of a priest on the festivals I have been just mentioning, that he begins by returning thanks to the genii for the success of the hunting, and that afterwards another person takes a roll of tobacco, breaks it in two and throws it into the fire. What is certain is, that those who have cited them as a proof of the possibility of atheism, properly so called, were not acquainted with them. It is true they never discourse about religion, and that their extreme indolence and indifference on this point, has always been the greatest obstacle to their conversion to Christianity, but the smallest acquaintance with them is sufficient to confute those, who say they have no idea of a deity. Indolence is their predominant passion; it even appears in their most important affairs, but in spite of this defect, and even in spite of that spirit of independance in which they are brought up, there is no nation in the world who pay a more slavish respect to the Deity, of whom their ideas are very confused, so that they never attribute any thing to chance, and derive an omen from every thing that happens, which is according to them, as I have already remarked, a declaration of the will of heaven. . . .

The best established opinion amongst our Americans is, that of the immortality of the soul. They do not however believe it to be purely spiritual more than their genii, and to tell truth, are incapable of giving any dis-

tinct definition of either. If you ask them what they think of their souls, they answer, that they are like so many shadows and living images of the body, and it is by a consequence of this principle, that they believe every thing in the universe to be animated. Thus it is only by tradition they have received this notion of the immortality of the soul. And in the different expressions they make use of, in explaining themselves on this subject, they frequently confound the soul with its faculties, and these again with their operations, though they very well know how to distinguish them, when they have a mind to speak with accuracy.

They maintain, likewise, that the soul when separated from the body, preserves the same inclinations and passions it had in its former state, and this is the reason why they bury along with the dead, the things they imagine they may stand in need of. They are even persuaded, that it remains hovering about the carcase until the festival of the dead, . . . and that afterwards it goes into the country of souls, where, according to some, it is transformed into a tortoise.

There are others who acknowledge two souls in men; to the one, they attribute every thing I have been just now speaking of, and pretend that the other never quits the body, unless it is to pass into some other, which however happens only, say they, to the souls of little children, which having enjoyed but a short term of life, obtain leave to begin a new one. It is for this reason that they bury children by the high-way sides, that the women who pass that way may collect their souls. Now these souls which are such faithful companions to their bodies

must be fed, and it is in order to discharge this duty, that eatables are laid upon their tombs; but this is of short continuance, so that the souls must begin in time to learn to fast. They [the Indians] are sometimes hard enough put to it to subsist the living, without the additional charge of feeding the dead. . . .

There is nothing in which these barbarians carry their superstition to a more extravagant length, than in what regards dreams; but they vary greatly in their manner of explaining themselves on this point. Sometimes it is the reasonable soul which ranges abroad, whilst the sensitive soul continues to animate the body. Sometimes it is the familiar genius [guardian spirit], who gives salutary council with respect to what is going to happen. Sometimes it is a visit made by the soul of the object of which he dreams. But in whatever manner the dream is conceived, it is always looked upon as a thing sacred, and as the most ordinary way in which the gods make known their will to men.

Filled with this idea, they cannot conceive how we should pay no regard to them. For the most part they look upon them either as a desire of the soul inspired by some genius, or an order from him; and in consequence of this principle, they hold it a religious duty to obey them; and an Indian having dreamed of having a finger cut off, had it really cut off as soon as he awoke, after having prepared himself for this important action by a feast. Another having dreamed of being prisoner and in the hands of his enemies, was much at a loss what to do; he consulted the jugglers, and by their advice, caused himself to be tied

to a post and burnt in several parts of the body.

There are happy and unhappy dreams. For instance, to dream of seeing a great number of elks is, say they, a sign of life; but to dream of seeing bears, denotes that the party is soon to die. I have already said, that we must except those times in which they prepare themselves for the hunting of these animals. . . .

But it is not only he who dreams that is to satisfy the obligations, he believes he is laid under by the dream: it would be a crime in any person to refuse him, what he has desired in his dream, and you may very well judge . . . with what consequences this is likely to be attended. But as the Indians are not much governed by self-interest, this principle is attended with less abuse than it would be any where else; and besides, every one may use it in his turn. If the thing desired happen to be of such a nature as not to be capable of being furnished by a private person, the public take the obligation of it upon themselves, and even should they be obliged to go in quest of it five hundred leagues, it must be found, cost what it will; and when it has once been obtained, it is inconceivable with what care it is preserved. If it happen to be any inanimate thing, they are more at ease; but if an animal, its death occasions a surprizing anxiety.

The affair becomes still more serious, should any one take it into his head to dream that he cuts the throat of another, for he will certainly accomplish it if he can; but woe to him, in his turn, should a third person dream that he revenges the dead. They may, however, easily extricate themselves from such difficulties, provided they have presence of mind immediately to oppose to such a dream another which contradicts it. "I plainly see," says the first dreamer, in that case, "that your spirit is stronger than mine, so let us mention it no more." They are not all, however, so easily brought to relinquish their purpose; but there are few who may not be satisfied, or in other words, have their genius appeased by some small present.

I do not know whether religion has any share in what is commonly called *the festival of dreams [Ononharoia]*, to which the Iroquois and some others have with more propriety, given the appellation of *the turning of the head*. This is a sort of Bacchanalian ceremony which commonly lasts fifteen days, and is celebrated towards the end of winter. There is no species of folly which is not then committed; every one running from cabbin to cabbin, disguised in a thousand different shapes, all of them equally ridiculous, breaking and destroying every thing, no one daring to oppose them. Whoever would avoid such a confusion, and not be exposed to all the outrages he must suffer on this occasion, ought to take care to absent himself. The moment any of those Bacchanalians meet with any one he gives him his dream to interpret, which if he does, it is certainly at his own cost, as he is obliged to procure whatever he has dreamed of. The festival ended, every thing is restored, a great feast is made, when they are solely intent on repairing the damages during the masquerade, which are most commonly far from being inconsiderable; for this is likewise one of those opportunities

which are waited for in silence, in order to give a hearty drubbing to those, from whom they imagine they have received any affront: but the feast being over, every thing is to be forgotten.

59. Missionaries Meet the Medicine Man in Huronia

Father Charlevoix's account of Indian religion was based largely on the writings of men such as Jean de Brébeuf and François-Joseph Le Mercier who labored together among the Hurons in the 1630s and 1640s. Their reports to Paul Le Jeune, the Jesuit superior in Quebec, describe the role of native shamans (or "jugglers") in trying to relieve their people of the dreadful diseases brought by the Europeans and in divining the future.

Brébeuf's letter of May 27, 1635, written from Ihonatiria (St. Joseph), equates native witchcraft with devil-worship, as any contemporary European would have done. Witchcraft in Indian society, however, was the personal ability to capture another's soul in dream or to magically intrude a small object—a pin, a piece of fur, a hair—into the victim's body, causing him to wither and die unless it could be found and removed. Only someone with "medicine" or spiritual power greater than the witch's could liberate the soul or remove the offending object. Since every adult Indian possessed some degree of spiritual power and was therefore capable of bewitching an enemy, only a shaman or "sorcerer" was qualified to counteract the spell, usually for a fee or gift. It paid to be generous in rewarding the shaman because his or her power (there were female conjurers in many native groups), like all spiritual power, was double-edged, capable of both good and evil.

In a report from the same Huron town dated June 21, 1637, Father Le Mercier describes the efforts, seemingly successful, of a peripatetic shaman to cure the people of smallpox. His method consisted of feasts, which were forms of prayer and offering, and the external and internal application of a liquid potion, similar—probably designedly—to Christian baptism and com-

Source: Reuben Gold Thwaites, ed., *The Jesuit Relations and Allied Documents*, 73 vols. (Cleveland, 1896–1901), 8:123, 125; 13:237–41.

munion. The priest also notes the typical exclusion of the women from the initial feast but their ultimate incorporation in the ceremony. The European belief that native shamanism was largely devil-worship is not accurate because shamans wielded *personal* supernatural power, unlike their Christian counterparts whose only strength lay in explanation and supplication. So individual was a shaman's power that it could be transferred or lent to an assistant, who would apply it on his master's behalf.

[The Hurons] say that the Sorcerers ruin them; for if any one has succeeded in an enterprise, if his trading or hunting is successful, immediately these wicked men bewitch him, or some member of his family, so that they have to spend it all in Doctors and Medicines. Hence, to cure these and other diseases, there are a large number of Doctors whom they call *Arendiouane*. These persons, in my opinion, are true Sorcerers, who have access to the Devil. Some only judge of the evil, and that in divers ways, namely, by Pyromancy, by Hydromancy, Necromancy, by feasts, dances, and songs; the others endeavor to cure the disease by blowing, by potions, and by other ridiculous tricks, which have neither any virtue nor natural efficacy. But neither class do anything without generous presents and good pay.

There are here some Soothsayers [conjurers], whom they call also *Arendiouane* and who undertake to cause the rain to fall or to cease, and to predict future events. The Devil reveals to them some secrets, but with so much obscurity that one is unable to accuse them of falsehood; witness one of the village of *Scanonaenrat* [called by the Jesuits St. Michael] who, a little while before the [accidental] burning of the villages before mentioned, had seen in a dream three flames falling from the

Sky on those villages. But the Devil had not declared to him the meaning of this enigma; for, having obtained from the village a white dog, to make a feast with it and to seek information by it, he remained as ignorant afterward as before.

Lastly, when I was in the house of Louys de sainete Foy [Amantacha, a Huron convert], an old woman, a sorceress, or female soothsayer of that village, said she had seen those who had gone to the war, and that they were bringing back a prisoner. We shall see if she has spoken the truth. Her method is by pyromancy. She draws for you in her hut the lake of the Hiroquois; then on one side she makes as many fires as there are persons who have gone on the expedition, and on the other as many fires as they have enemies to fight. Then, if her spell succeeds, she lets it be understood that the fires from this side have run over, and that signifies that the warriors have already crossed the lake. One fire extinguishing another marks an enemy defeated; but if it attracts it to itself without extinguishing it, that is a prisoner taken at mercy. It is thus . . . that the Devil amuses this poor people, substituting his impieties and superstitions in place of the compliance they ought to have with the providence of God, and the worship they ought to render him.

The Father Superior [Le Mercier] continued his journey thence and stopped at *Angoutenc*, where he baptized two little children. The next day, the 28th [of January 1637], he arrived at *Ossossané*, where he found the demons let loose, and a poor people in deeper affliction than ever, giving their attention to the follies of a certain *Tehorenhaegnon*, who boasted of having a secret remedy for this kind of malady [smallpox], which he had learned from the demons themselves, after a fast of 12 or 13 days in a little cabin which he had made for this purpose on the shore of the lake. Accordingly, the inhabitants of *Ossossané*, hearing of what he could do, and seeing that presents were offered to him on all sides in order to gain his good will, and to get from him some relief, sent to him some of their chief men to entreat him very humbly to have pity upon their misery, and to proceed to their village to see the sick and to give them some remedies. *Tehorenhaegnon* evinced a willingness to comply with their request; and not being able, or rather not deigning to go thither in person, sent one of his associates, named *Saossarinon*, to whom he communicated all his power, in proof of which he gave him his bow and arrows, which would represent his person. As soon as he had arrived, one of the Captains proclaimed in a loud voice, throughout the village, that all the sick should take courage, that *Tehorenhaegnon* promised to drive the disease away very soon; that, not being able to come in person, *Saossarinon* had been sent by him, with power to give them all manner of satisfaction; that he ordained that for three consecutive days three feasts should be made, promising that all those who should be present there, and should observe all the ceremonies, should be protected from disease. Towards evening, the people assembled in the very cabin of our host, which is one of the largest in the village. Our [Jesuit] Fathers stayed there, in order to see all that might happen. The company was composed only of men,—the women were to have their turn afterwards; there were some present from all the families. Before beginning the ceremony, one of the Captains climbed to the top of the cabin and cried aloud in this manner: "Come now, see us here assembled. Listen, you demons whom *Tehorenhaegnon* invokes, behold us about to make a feast and have a dance in your honor. Come, let the contagion cease and leave this town; but, if you still have a desire to eat human flesh, repair to the country of our enemies; we now associate ourselves with you, to carry the sickness to them and to ruin them." This harangue ended, they begin to sing. Meanwhile, *Saossarinon* goes to visit the sick and makes the round of all the cabins. But the feast did not take place until daybreak; the entire night was passed in a continual uproar; now they sang, and at the same time beat violently, keeping time, upon pieces of bark; now they arose and began to dance; each one strove to do well, as if supposing that his life depended upon it. The substitute of *Tehorenhaegnon*, after having seen the sick, was to have put in an appearance at this cabin, but he found so much practice that daylight overtook him in his progress. Meanwhile, he was awaited with great impatience; and as they were singing, one after another, there was one of them who began in these words,

"Come, great *Arendiouane,* come, behold the day beginning to dawn." Not to keep them waiting longer, he passed by some of the remaining cabins. At his arrival a profound silence prevailed; a Captain marched before him holding in one hand the bow of *Tehorenhaegnon* as a sign of the power possessed by this substitute, and in the other a kettle filled with a mysterious water with which he sprinkled the sick. As for him, he carried a Turkey's wing, with which he fanned them gravely and at a distance, after having given them something to drink. He performed the same ceremonies for the sick of this cabin; then, having inspired the whole company with courage and strong hope, he withdrew. The feast took place, and afterwards the men left the place to the women, who also came singing and dancing in their turn; as for a feast, they had none.

On this 20th, *Saossarinon* himself made the second feast. There the aid of the demons was invoked in the same words as upon the preceding day, and, after having eaten, some one said that the Physician had already cured twelve of them. This news caused great rejoicing among the company; the Captain *Andahiach* thanked him and his master *Tehorenhaegnon,* with all the Captains of the village of *Andiataé,* declaring that the whole village would be under obligation to them, and begged them to continue their favors. The 3rd feast did not take place for lack of fish.

60. The Woman Who Would Be Priest

The Christian missionaries made a considerable impact on the native religions of the New World, sometimes altering their practices, sometimes modifying their beliefs, but often only confirming their traditionalism. Chrestien Le Clercq, the Recollect priest who worked among the Micmacs of the Gaspé, witnessed one apparent change in the late seventeenth century. The Micmac usurpation of the priestly function as "Patriarchs" proceeded less from a desire to convert to Christianity than a need to revitalize or shore up their own religion by adding Christian elements that seemed to be useful. Since many of the Indians's intellectual problems in the colonial

Source: Father Chrestien Le Clercq, *New Relation of Gaspesia With the Customs and Religion of the Gaspesian Indians,* ed. and trans. William F. Ganong (Toronto: The Champlain Society, 1910), pp. 229–30.

period derived from the European presence (diseases and aggressive missionaries, especially), they logically assumed that European "medicine"—in small doses—could help provide solutions. It was therefore typical of the natives to incorporate Christian beliefs, deities, or ceremonies into their own religious corpus when looking for ways to remain traditionally Indian, just as the ancient female patriarch used unstrung rosary beads. Understandably, such syncretism confounded and disappointed the missionaries.

As our Indians perceive that much honour is accorded to the missionaries, and that they have given themselves in respect and reverence the title of Patriarch, some of these barbarians have often been seen meddling with, and affecting to perform, the office and functions of missionary, even to hearing confession, like us, from their fellow-countrymen. So therefore, when persons of this kind wish to give authority to that which they say, and to set themselves up as patriarchs, they make our Gaspesians [Micmacs] believe that they have received some particular gift from heaven, as in the case of one from Kenebec [Maine], who said that he had received an image from heaven. This was, however, only a picture which had been given him when he was trading with our French.

It is a surprising fact that this ambition to act the patriarch does not only prevail among the men, but even the women meddle therewith. These, in usurping the quality and the name of *religieuses,* say certain prayers in their own fashion, and affect a manner of living more reserved than that of the commonalty of Indians, who allow themselves to be dazzled by the glamour of a false and ridiculous devotion. They look upon these women as extraordinary persons, whom they believe to hold converse, to speak familiarly, and to hold communication with the sun, which they have all adored as their divinity. Not long ago, we had a famous one of them who, by her extravagant superstitions, encouraged the same in these poor Indians. I had an extreme desire to see her, but she died in the woods without the baptism that I had the intention to give her if I had been so happy as to render her worthy of it. This aged woman, who counted more than a hundred and fourteen [probably exaggerated] years since her birth, had as the basis for all her ridiculous and superstitious devotions, some beads of jet, which were the remains of an unthreaded rosary. These she carefully preserved, and gave them only to those who were her friends, protesting to them, meanwhile, that the gift which she gave them had come originally from heaven, which was always continuing to give her the same favour just so many times as she, in order to worship the sun, went out from her wigwam and rendered it her homage and adoration. "I have only, then," said she to them, "to hold up my hand and to open it, in order to bring down from heaven these mysterious beads, which have the power and the property not only of succouring the Indians in their sicknesses and all their most pressing necessities, but also of preserving them

from surprise, from persecution, and from the fury of their enemies." It can truly be said that if some one of these people would devote himself wholly to goodness, and would take care to instruct the others, he could accomplish prodigies among them, since they would easily believe everything that a man of their nation would tell them. This imposture, then, that these rosary beads came from heaven, was so well received by those who gloried in possessing some of them, that such persons preserved them as they did the things which they held most dear in the world; and it angered these persons beyond endurance to contradict them in a foolishness which passed in their esteem for something divine and sacred.

61. Idols, Priests, and Rainmakers in Virginia

The durability of native religion in the face of powerful forces for change is nowhere better documented than in Robert Beverley's 1705 description of his personal search for the religion of the native Virginians. Displaying at once an ethnographic curiosity and a daring irreverence toward his subject, he tells how he plunged into a dark Indian temple in search of their "idol," an effigy that he, as a Protestant Christian, found as useless and as sacrilegious as a Catholic crucifix. He also holds up for ridicule the conjurations of a native rainmaker, but, like his friend Colonel Byrd, he ends without a clear explanation of the Indian's ability—or fortune—to limit his shower to Byrd's fields.

Despite his skeptical attitude, Beverley managed to elicit some intriguing details from native informants. Long after the once-mighty Powhatan confederacy had been beaten into fragments and their culture relegated to small reservations surrounded by English farms and plantations, the native Virginians worshipped an idol far older than the English presence, a creator made in their image as the perfect loafer, and a mischievous deity who needed to be placated. They still entertained a vision of a sensual afterlife and an innate thankfulness for the fruits of the earth, the first of which they always celebrated, whether it be green corn or a boy's first deer. Even the power of the traditional priests could silence a loquacious informant be-

Source: [Robert Beverley,] *The History and Present State of Virginia* (London, 1705), bk. 3, pp. 28–31, 32–34, 36–37.

cause he realized that their political and religious conservatism was the only thing binding a fragmented people of increasingly divided loyalties. When native lakes began to burn eternally to torment the souls of the wicked, the Indians were slipping toward the white man's Hell on a road slick with firewater.

I have been at several of the *Indian* Towns, and conversed with some of the most sensible of them in that Country; but I cou'd learn little from them, it being reckon'd Sacriledge, to divulge the Principles of their Religion. However, the following Adventure discover'd something of it. As I was ranging the Woods, with some other Friends, we fell upon their *Quioccosan* (which is their House of Religious Worship) at a time, when the whole Town were gathered together in another place, to consult about the bounds of the Land given them by the *English*.

Thus finding our selves Masters of so fair an opportunity, (because we knew the *Indians* were engaged,) we resolved to make use of it, and to examine their *Quioccasan*, the inside of which, they never suffer any *English* Man to see; and having removed about fourteen Loggs from the Door, with which it was barricado'd, we went in, and at first found nothing but naked Walls, and a Fire place in the middle. This House was about eighteen foot wide, and thirty foot long, built after the manner of their other Cabbins, but larger, with a Hole in the middle of the Roof, to vent the Smoke, the Door being at one end: Round about the House, at some distance from it, were set up Posts, with Faces carved on them, and painted. We did not observe any Window, or passage for the Light, except the Door, and the vent of the Chimney. At last, we observ'd, that at the farther end,

about ten foot of the Room, was cut off by a Partition of very close Mats; and it was dismal dark behind that Partition. We were at first scrupulous to enter this obscure place, but at last we ventur'd, and groping about, we felt some Posts in the middle; then reaching our hands up those Posts, we found large Shelves, and upon these Shelves three Mats, each of which was roll'd up, and sow'd fast. These we handed down to the light, and to save time in unlacing the Seams, we made use of a Knife, and ripp'd them, without doing any damage to the Mats. In one of these we found some vast Bones, which we judg'd to be the Bones of Men, particularly we measur'd one Thigh-bone, and found it two foot nine inches long: In another Mat, we found some *Indian Tomahawks* finely grav'd, and painted. These resembl'd the wooden Faulchion [a curved broad sword] us'd by the Prize fighters in *England,* except that they have no guard to save the Fingers. They were made of a rough heavy Wood. . . . Among these *Tomahawks* was the largest that ever I saw; there was fasten'd to it a Wild Turky's Beard painted red, and two of the longest Feathers of his Wings hung dangling at it, by a string of about 6 Inches long, ty'd to the end of the *Tomahawk.* In the third Mat there was something, which we took to be their Idol, tho of an underling sort, and wanted putting together. The pieces were these, first a Board three foot and a half long, with one

indenture at the upper end, like a Fork, to fasten the Head upon, from thence half way down, were Half hoops nail'd to the edges of the Board, at about four Inches distance, which were bow'd out, to represent the Breast and Belly; on the lower half was another Board of half the length of the other, fasten'd to it by Joynts or pieces of Wood, which being set on each side, stood out about 14 inches from the Body, and half as high; we suppos'd the use of these to be for the bowing out of the Knees, when the Image was set up. There were packt up with these things, red and blue pieces of Cotton Cloath, and Rolls made up for Arms, Thighs and Legs, bent to at the Knees, as is represented in the Figure of their Idol, which was taken by an exact Drawer in the Country. It wou'd be difficult to see one of these Images at this day, because the *Indians* are extreme shy of exposing them. We put the Cloaths upon the Hoops for the Body, and fasten'd on the Arms and Legs, to have a view of the representation: But the Head and rich Bracelets, which it is usually adorn'd with, were not there, or at least we did not find them. We had not leisure to make a very narrow search; for having spent about an hour in this enquiry, we fear'd the business of the *Indians* might be near over; and that if we staid longer, we might be caught offering an affront to their Superstition; for this reason we wrapt up these Holy materials in their several Mats again, and laid them on the Shelf, where we found them. This Image when drest up, might look very venerable in that dark place; where 'tis not possible to see it, but by the glimmering light, that is let in, by lifting up a piece of the Matting, which

we observ'd to be conveniently hung for that purpose; for when the light of the Door and Chimney, glance in several directions, upon the Image thro that little passage, it must needs make a strange representation, which those poor people are taught to worship with a devout Ignorance. There are other things that contribute towards carrying on this Imposture; first the chief Conjurer enters within the Partition in the dark, and may undiscern'd move the Image as he pleases: Secondly, a Priest of Authority stands in the room with the people, to keep them from being too inquisitive, under the penalty of the Deity's displeasure, and his own censure.

Their Idol bears a several name in every Nation, as *Okee, Quioccos, Kiwasa*. They do not look upon it, as one single Being, but reckon there are many of them of the same nature; they likewise believe, that there are tutelar Deities in every Town. . . .

Once in my Travels, in very cold Weather, I met at an *English* man's House with an *Indian*, of whom an extraordinary Character had been given me, for his Ingenuity and Understanding. When I see he had no other *Indian* with him, I thought I might be the more free; and therefore I made much of him, seating him close by a large Fire, and giving him plenty of strong Cyder, which I hop'd wou'd make him good Company, and openhearted. After I found him well warm'd (for unless they be surprized some way or other, they will not talk freely of their Religion) I asked him concerning their God, and what their Notions of Him were? He freely told me, they believ'd God was universally beneficent, that his Dwelling was in the Heavens above, and that the Influ-

ences of his Goodness reach'd to the Earth beneath. That he was incomprehensible in his Excellence, and enjoy'd all possible Felicity: That his Duration was Eternal, his Perfection boundless, and that he possesses everlasting Indolence and Ease. I told him, I had heard that they Worshipped the Devil, and asked why they did not rather Worship God, whom they had so high an opinion of, and who wou'd give them all good things, and protect them from any Mischief that the Devil could do them? To this his answer was, That, 'tis true, God is the giver of all good things, but they flow naturally and promiscuously from him; that they are showr'd down upon all Men indifferently without distinction; that God do's not trouble himself, with the impertinent affairs of Men, nor is concern'd at what they do: but leaves them to make the most of their Free Will, and to secure as many as they can, of the good things that flow from him. That therefore it was to no purpose either to fear, or Worship him: But on the contrary, if they did not pacify the Evil Spirit, and make him propitious, he wou'd take away, or spoil all those good things that God had given, and ruine their Health, their Peace and their Plenty, by sending War, Plague and Famine among them; for, said he, this Evil Spirit, is always busying himself with our affairs, and frequently visiting us, being present in the Air, in the Thunder, and in the Storms. He told me farther, That he expected Adoration and Sacrifice from them, on pain of his displeasure; and that therefore they thought it convenient to make their Court to him. I then asked him concerning the Image, which they Worship in their *Quioccasan;* and assur'd

him, that it was a dead insensible Log, equipt with a bundle of Clouts, a meer helpless thing made by Men, that could neither hear, see, nor speak; and that such a stupid thing could no ways hurt, or help them. To this he answer'd very unwillingly, and with much hesitation; However, he at last deliver'd himself in these broken and imperfect sentences; *It is the Priests— they make the people believe, and——* Here he paus'd a little, and then repeated to me, that *it was the Priests* ——and then gave me hopes that he wou'd have said something more, but a qualm crost his Conscience, and hinder'd him from making any farther Confession.

The Priests and Conjurers have a great sway in every Nation. Their words are looked upon as Oracles, and consequently are of great weight among the common people. They perform their Adorations and Conjurations, in the general Language before spoken of, as the Catholicks of all Nations do their Mass in the *Latin*. They teach, that the Souls of Men survive their Bodies, and that those who have done well here, enjoy most transporting Pleasures in their *Elizium* [Heaven] hereafter; that this *Elizium* is stor'd with the highest perfection of all their Earthly Pleasures; namely, with plenty of all sorts of Game, for Hunting, Fishing and Fowling; that it is blest with the most charming Women, which enjoy an eternal bloom, and have an Universal desire to please. That it is deliver'd from excesses of Cold or Heat, and flourishes with an everlasting Spring. But that, on the contrary, those who are wicked, and live scandalously here, are condemn'd to a filthy stinking Lake after Death, that

continually burns with Flames, that never extinguish; where they are persecuted and tormented day and night, with Furies in the Shape of Old Women.

They use many Divinations and Inchantments, and frequently offer Burnt Sacrifice to the Evil Spirit. The people annually present their first Fruits of every Season and Kind, namely, of Birds, Beasts, Fish, Fruits, Plants, Roots, and of all other things, which they esteem either of Profit or Pleasure to themselves. They repeat their Offerings, as frequently as they have great successes in their Wars, or their Fishing, Fowling or Hunting. . . .

Some few years ago, there happen'd a very dry time, towards the heads of the Rivers, and especially on the upper parts of *James River,* where Collonel [William] *Byrd* [an Indian trader as well as planter] had several Quarters of Negroes. This Gentleman has for a long time been extreamly respected, and fear'd by all the *Indians* round about, who, without knowing the Name of any Governour, have ever been kept in order by Him. During this drowth [drought], an *Indian,* well known to one of the Collonel's Overseers, came to him, and ask'd if his Tobacco was not like to be spoyl'd? The Overseer answer'd Yes, if they had not Rain very suddenly: The *Indian,* who pretended great kindness for his Master, told the Overseer, if he would promise to give him two Bottles of Rum, he would bring him Rain enough: The Overseer did not believe any thing of the matter, not seeing at that time the least appearance of Rain, nor so much as a Cloud in the Sky; however, he promis'd to give him the Rum, when his Master came thither,

if he wou'd be as good as his word: Upon this the *Indian* went immediately a *Pauwawing,* as they call it; and in about half an hour, there came up a black Cloud into the Sky, that shower'd down Rain enough upon this Gentlemans Corn and Tobacco, but none at all upon any of the Neighbours, except a few drops of the Skirt of the Shower. The *Indian* for that time went away, without returning to the Overseer again, till he heard of his Masters arrival at the *Falls,* and then he came to him, and demanded the two Bottles of Rum. The Collonel at first seem'd to know nothing of the matter, and ask'd the *Indian,* for what reason he made that demand? (altho his Overseer had been so overjoy'd at what had happen'd that he could not rest till he had taken a Horse and rid near forty Miles to tell his Master the story.) The *Indian* answer'd with some concern, that he hop'd the Overseer had let him know the service he had done him, by bringing a Shower of Rain to save his Crop. At this the Collonel, not being apt to believe such Stories, smil'd, and told him, he was a Cheat, and had seen the Cloud a coming, otherwise he could neither have brought the Rain, nor so much as foretold it. The *Indian* at this seeming much troubl'd, reply'd, Why then had not such a one, and such a one, (naming the next Neighbours) Rain as well as your Overseer, for they lost their Crops; but I lov'd you, and therefore I sav'd yours? The Collonel made sport with him a little while, but in the end order'd him the two Bottles of Rum, letting him understand however, that it was a free Gift, and not the consequence of any Bargain with his Overseer.

SEVEN:
Death

The final rite of passage in the human life-cycle commemorates the irreversible transition from life to death. This is not a simple passage because both the living and the dead undergo rites of separation, transition, and incorporation. In the native cultures of the East, the dead were separated from the society of the living only gradually. After being dressed and painted to best advantage, they remained for a time in the lodge where they had died to allow the survivors to bid farewell, sing their praises, and lament their passing. Other ceremonies at graveside prolonged the process of separation until the deceased were interred in various ways depending on their age, sex, and social standing and the circumstances of their death. But even burial—in the ground or on scaffolds—did not signal their complete separation. Some native groups apparently believed that the souls of the dead did not make the final journey to the afterlife until their bones had lost all flesh, either through natural putrefaction or scraping. Thus the obligations of the living to the dead were not finally met until these clean bones had been reinterred in new ceremonies, such as the Huron "feast of the dead." Then, if the dead had been properly buried with the articles and food they would need for their long journey, their souls could take their final departure. Having successfully made the journey, the souls could then be incorporated into the villages of the dead, which closely resembled in appearance and social structure the societies from which they had come.

Rites similar in character marked the painful passage of the survivors from grief to acceptance. The living underwent separation both from the deceased and from the larger society. According to their closeness of kinship to the deceased, survivors were regarded as "impure" by virtue of their contact with the dead and were therefore required to separate themselves for a prescribed period from normal social relations. Close relatives, such as spouses or siblings, mourned for the longest period in disheveled hair, no make-up, and ragged clothes. The higher the social standing of the deceased, the longer the suspension of social life and the more people involved. The death of an important chief might cause general mourning among a whole tribe and several of its closest neighbors and allies. Shortly, however, the

survivors would be reunited with each other by feasts and other celebrations, some of which occurred at graveside. Spouses particularly were reintegrated into society by their in-laws, who lifted the obligations of mourning, dressed them in new clothes, and gave them permission to remarry. When life returned to normal for the living and the souls of the dead had reached their destination, the final rites of passage for the eastern Indians had come to a close.

62. Huron Feasts of the Dead

Two superiors of the Jesuit mission to the Hurons, Jean de Brébeuf and Jérôme Lalement, provided the following descriptions of the beliefs and ceremonies of that tribe concerning death. In his report of 1636, Brébeuf notes that the Hurons, like most native groups, had no fear of death because their afterlife closely resembled their earthly existence. He might have added that their ignorance of the Christian concepts of sin and eternal damnation spared them considerable anxiety. When the deceased was prepared for burial by clan members of the opposite moiety (the clans of each village or tribe were divided into two moieties or halves to foster reciprocity and mutual obligations), a headman consoled the family and a feast was given to close the ranks of the living as well as to feed the person's soul about to begin its long journey to the land of the dead. The mourners brought presents for the relatives and the sponsors of the funeral, while the corpse received articles appropriate to his or her sex and social station. The form of burial, scaffold or interment, depended on the circumstances of death, but the body was almost always flexed in a fetal position, suggesting, perhaps, that death was regarded as a kind of spiritual rebirth. Out of respect, the deceased's spouse did not remarry during a prescribed period of mourning. A similar though perhaps longer moratorium was placed on the use of the deceased's name, which was then "raised" by a kinsman whose display of martial courage entitled him to a new name.

Source: Reuben Gold Thwaites, ed., *The Jesuit Relations and Allied Documents*, 73 vols. (Cleveland, 1896–1901), 10:265–77; 23:209–23.

Brébeuf's mention of the Hurons's "feast of the dead" introduces Father Lalement's detailed account of that ceremony, which occurred about every ten to fifteen years when a major village changed location. Since they did not wish to leave their ancestors behind in the village cemetery, the climax of the ten days' solemnities was the reburial of the bones of all the Hurons who had died since the last such feast, whether at home or among other nations. The place of burial was a large pit about ten feet deep and fifteen feet across, lined with rich beaver robes and surrounded by an extensive platform for the display of each clan's offerings to the dead. When the disarticulated bones of their relatives and allies were mingled in this ossuary, valuable grave offerings were laid amongst them and the whole covered with beaver robes, dirt, and the logs from the platform. Often a special bark lodge was built on the site to commemorate the affair.

Lalement describes the long prelude to this finale in which the Hurons and their closest allies, despite their linguistic differences, joined their living in feasts, gift-giving, mock wars, and dances as they prepared to mingle their dead. The Nipissings, the northern neighbors of the Hurons, even held a civil election and announced the results to the 2000 participants. The feast was also the occasion for resurrecting the clan-owned names of the dead by bestowing them on worthy kinsmen. Untypically, the women played a special role in this feast. In a special cabin, they superintended the bones of their dead, which they had placed in richly bedecked bark baskets. The headmen honored their deep mourning with an exclusive feast. The whole ceremony served as an elaborate redistribution of wealth and an occasion for the fulfillment of reciprocal obligations between friends, relatives, and allies.

Our Indians are not Savages as regards the duties that Nature itself constrains us to render to the dead; they do not yield in this respect to many Nations much more civilized. You might say that all their exertions, their labors, and their trading, concern almost entirely the amassing of something with which to honor the Dead. They have nothing sufficiently precious for this purpose; they lavish [fur] robes, axes, and Porcelain [wampum] in such quantities that, to see them on such occasions, you would judge that they place no value upon them; and yet these are the whole riches of the Country. You will see them often, in the depth of winter, almost entirely naked, while they have handsome and valuable robes in store, that they keep in reserve for the Dead; for this is their point of honor. It is on such occasions they wish above all to appear magnificent. But I am speaking here only of their private funerals. These simple people are not like so many Christians, who cannot endure that any one should speak to them about death, and who

in a mortal sickness put a whole house to trouble to find means of breaking the news to the sick man without hastening his death. Here when any one's health is despaired of, not only do they make no difficult in telling him that his life is near its close, but they even prepare in his presence all that is needed for his burial; they often show him the robe, the stockings, the shoes, and the belt which he is to wear. Frequently they are prepared after their fashion for burial, before they have expired; they make their farewell feast to their friends, at which they sometimes sing without showing any dread of death, which they regard with very little concern, considering it only as the passage to a life differing very little from this. As soon as the sick man has drawn his last breath, they place him in the position in which he is to be in the grave; they do not stretch him at length as we do, but place him in a crouching posture, almost the same that a child has in its mother's womb. Thus far, they restrain their tears. After having performed these duties the whole Cabin begins to resound with cries, groans, and wails; the children cry *Aistan,* if it be their father; and the mother, *Aien, Aien,* "My son, my son." Any one who did not see them, quite bathed in their tears, would judge, to hear them, that these are only ceremonial tears; they make their voices tremble all with one accord, and in a lugubrious tone, until some person of authority makes them stop. As soon as they cease, the Captain goes promptly through the Cabins, making known that such and such a one is dead. On the arrival of friends, they begin anew to weep and complain. Frequently some one of im-

portance begins to speak, and consoles the mother and the children,—at times launching into praises of the deceased, lauding his patience, his good-nature, his liberality, his magnificence, and, if he were a warrior, the greatness of his courage; at times he will say, "What would you have? there was no longer any remedy, he must indeed die, we are all subject to death, and then he dragged on too long," etc. It is true that, on such occasions, they are never lacking in speech. I have sometimes been surprised to see them dwelling a long time on this subject, and bringing forward, with much discretion, every consideration that might give consolation to the relatives of the deceased.

Word of the death is also sent to the friends who live in the other Villages; and, as each family has some one who takes care of its Dead, these latter come as soon as possible to take charge of everything, and determine the day of the funeral. Usually they inter the Dead on the third day; as soon as it is light, the Captain gives orders that throughout the whole Village a feast be made for the dead. No one spares what he has of the best. They do this, in my opinion, for three reasons: First, to console one another, for they exchange dishes, and hardly any one eats any of the feast he has prepared; secondly, on account of those of other Villages, who often come in great numbers. Thirdly, and principally, to serve the soul of the deceased, which they believe takes pleasure in the feast, and in eating its share. All the kettles being emptied, or at least distributed, the Captain publishes throughout the Village that the body is about to be borne to the Cemetery. The whole Village assem-

bles in the Cabin; the weeping is re-
newed; and those who have charge of
the ceremonies get ready a litter on
which the corpse is placed on a mat
and enveloped in a Beaver robe, and
then four lift and carry it away; the
whole Village follows in silence to the
Cemetery. A Tomb is there, made of
bark and supported on four stakes,
eight to ten feet high. However, before
the corpse is put into it, and before
they arrange the bark, the Captain
makes known the presents that have
been given by the friends. In this
Country, as well as elsewhere, the most
agreeable consolations for the loss of
friends are always accompanied by
presents, such as kettles, axes, Beaver
robes, and Porcelain collars [necklaces].
If the deceased was a person of impor-
tance in the Country, not only the
friends and neighbors, but even the
Captains of other Villages, will come
in person and bring their presents.
Now all the presents do not follow the
dead man into the grave; sometimes a
Porcelain collar is put around his
neck, and near by a comb, a gourd
full of oil, and two or three little
loaves of bread; and that is all. A large
share goes to the relatives, to dry their
tears; the other share goes to those
who have directed the funeral ceremo-
nies, as a reward for their trouble.
Some robes, also, are frequently laid
aside, or some hatchets, as a gift for
the Youth. The Chief puts into the
hand of some one of the latter a stick
about a foot long, offering a prize to
the one who will take it away from
him. They throw themselves upon him
in a body, with might and main, and
remain sometimes a whole hour strug-
gling. This over, each one returns
quietly to his Cabin.

I had forgotten to say that usually,
during this whole ceremony, the
mother or the wife will be at the foot
of the grave calling to the deceased
with singing, or more frequently com-
plaining in a lugubrious voice.

Now all these ceremonies do not
always take place; as for those killed
in war, they inter them, and the rela-
tives make presents to their patrons
[the father's kinsmen], if they had any,
which is rather common in this Coun-
try, in order to encourage them to raise
a force of soldiers, and avenge the death
of the deceased. As to the drowned,
they are interred also, after the most
fleshy parts of the body have been
taken off, piece by piece. . . . Double
the presents are given on such an occa-
sion, and people from the whole Coun-
try often gather there, and contribute
of their property; and this is done,
they say, to appease the Sky, or the
Lake.

There are even special ceremonies
for little children who die less than a
month or two old; they do not put
them like the others into bark tombs
set up on posts, but inter them on the
road,—in order that, they say, if some
woman passes that way, they may se-
cretly enter her womb, and that she
may give them life again, and bring
them forth. . . . This fine ceremony
took place this Winter in the person
of one of our little Christians, who had
been named Joseph at baptism. I
learned it on this occasion from the
lips of the child's father himself.

The funeral ceremonies over, the
mourning does not cease, the wife con-
tinues it the whole year for the hus-
band, and the husband for the wife;
but the great mourning properly lasts
only ten days. During this time they

remain lying on mats and enveloped in furs, their faces against the ground, without speaking or answering anything except *Cway*, to those who come to visit them. They do not warm themselves even in Winter, they eat cold food, they do not go to the feasts, they go out only at night for their necessities; they cause a handful of hair to be cut from the back of the head; they say this is done only when the grief is profound,—the husband practicing this ceremony generally on the death of his wife, or the wife on the death of her husband. This is what there is of their great mourning.

The lesser mourning lasts all the year. When they go visiting they do not make any salutation, not even saying *Cway*, nor do they grease their hair; the women do it, however, when their mothers command them, as the latter have at their disposal their hair, and even their persons; it is their privilege to send the daughters to feasts, for without the command many would not go. What I find remarkable is that, during the whole year, neither the husband nor the wife remarries; if they did, they would be talked about throughout the Country.

The graves are not permanent; as their Villages are stationary only during a few years, while the supplies of the forest last, the bodies only remain in the Cemeteries until the feast of the Dead, which usually takes place every twelve years. Within this time they do not cease to honor the dead frequently; from time to time, they make a feast for their souls throughout the whole Village, as they did on the day of the funeral, and revive their names as often as they can. For this purpose they make presents to the Captains, to give to him who will be content to take the name of the deceased; and, if he was held in consideration and esteem in the Country while alive, the one who resuscitates him,—after a magnificent feast to the whole Country, that he may make himself known under this name,—makes a levy of the resolute young men and goes away on a war expedition, to perform some daring exploit that shall make it evident to the whole Country that he has inherited not only the name, but also the virtues and courage of the deceased.

Toward the end of the Summer [1642], these Peoples turned their thoughts to the celebration of their feast of the dead,—that is, to collect the bones of their deceased relatives, and, by way of honor to their memory, to procure for them a more honorable sepulchre than that which had enclosed them since their death. This solemnity, among the Nomad [hunting] Tribes up here, is accompanied by rites of some importance, differing much from those of our Hurons . . . and it may perhaps be interesting to learn some further particulars about them, which I shall set down here.

The day was appointed, at the beginning of September, for all the confederated Nations, who were invited thereto by Envoys expressly sent. The spot selected for the purpose was at a Bay of the great Lake [Huron], distant about twenty leagues from the country of the Hurons. Having been invited to attend, I thought that I ought to take advantage of the opportunity that G o d gave me to establish closer relations with these Barbarians, so as to secure, in the future, better means for

the advancement of his Glory among them. The number of persons present was about two thousand.

Those of each Nation, before landing, in order to make their entry more imposing, form their Canoes in line, and wait until others come to meet them. When the People are assembled, the Chief stands up in the middle of his Canoe, and states the object that has brought him hither. Thereupon each one throws away some portion of his goods to be scrambled for. Some articles float on the water, while others sink to the bottom. The young men hasten to the spot. One will seize a mat, wrought as tapestries are in France; another a Beaver skin; others get a hatchet, or a dish, or some Porcelain beads, or other article,—each according to his skill and the good fortune he may have. There is nothing but joy, cries, and public acclamations, to which the Rocks surrounding the great Lake return an Echo that drowns all their voices.

When the Nations are assembled, and divided, each in their own seats, Beaver Robes, skins of Otter, of Caribou, of wild Cats, and of Moose; Hatchets, Kettles, Porcelain Beads, and all things that are precious in this Country, are exhibited. Each Chief of a Nation presents his own gift to those who hold the Feast, giving to each present some name that seems best suited to it. As for us, the presents that we gave were not for the purpose of drying their tears, or consoling them for the death of the deceased; but that we might wish to the living the same happiness that we hope to enjoy in Heaven when they shall have acknowledged the same G o d whom we serve on Earth. This kind of present aston-

ished them at first, as not being according to their usages. But we gave them to understand that only the hope that we had of seeing them become Christians led us to desire their friendship.

After that, it was a pleasure characterized by nothing of savagery, to witness in the midst of this Barbarism a Ballet danced by forty persons, to the sound of voices and of a sort of drum, in such harmonious accord that they rendered all the tones that are most agreeable in Music.

The dance consisted of three parts. The first represented various encounters of enemies in single combat,—one pursuing his foe, hatchet in hand, to give him the deathblow, while at the same time he seems to receive it himself, by losing his advantage; he regains it, and after a great many feints, all performed in time with the music, he finally overcomes his antagonist, and returns victorious. Another, with different movements, fences, javelin in hand; this one is armed with arrows; his enemy provides himself with a buckler that covers him, and strikes a blow at him with a club. They are three different personages, not one of whom is armed like the others; their gestures, their movements, their steps, their glances,—in a word, everything that can be seen, is different in each one; and yet in so complete accord with one another that it seems as if but one mind governed these irregular movements.

Hardly was this combat ended than the Musicians arose; and we witnessed, as the Second Part, a dance on a large scale,—first by eight persons, then by twelve, then by sixteen, ever increasing in proportion, who quickened or

checked their steps according to the voices that gave the measure.

The Women then suddenly appeared, and danced the Third Part of this Ball, which was as agreeable as the others, and in no wise offensive to modesty. The [Ojibwa] inhabitants of the Saut [Sault Ste. Marie], who came to this Feast from a distance of a hundred or a hundred and twenty leagues, were Actors in this Ballet.

A Pole of considerable height had been set in the ground. A Nipissirinien [Nipissing] climbed to the top of it, and tied there two prizes,—a Kettle, and the skin of a Deer,—and called upon the young men to display their agility. Although the bark had been stripped from the Pole, and it was quite smooth, he greased it, to make it more difficult to grasp. No sooner had he descended, than several pressed forward to climb it. Some lost courage at the beginning, others at a greater or lesser height; and one, who almost reached the top, suddenly found himself at the bottom. No one could attain the top; but there was a Huron who provided himself with a knife and some cord, and, after having made reasonable efforts until he reached the middle of the Pole, he had recourse to cunning. He drew his knife, and cut notches in the tree, in which he placed his cord; then making a stirrup of it, he supported and raised himself higher, and continued to do so until he attained the prizes suspended there, in spite of the hooting and shouting of the Audience. Having grasped these, he slid to the ground, and reëmbarked to go to Kebec [Quebec], whither his journey led him.

This unfair conduct led the Algonquin Captains to make a Public complaint, which was deemed reasonable; and the Hurons taxed themselves for a present of Porcelain Beads to repair this injustice, which caused the Souls of the deceased to weep.

After this, the election of the Nipissirinien Chiefs took place. When the votes were taken, the chief Captain arose, and called them each by name. They made their appearance, clothed in their finest robes.

When they had received their Commissions, they gave largess of a quantity of Beaver skins and Moose hides, in order to make themselves known, and that they might be received with applause in their Offices.

This Election was followed by the Resurrection of those Persons of importance who had died since the last Feast; which means that, in accordance with the custom of the Country, their names were transferred to some of their relatives, so as to perpetuate their memory.

On the following day, the Women were occupied in fitting up, in a superb manner, a Cabin with an arched roof, about a hundred paces long, the width and height of which were in proportion.

Although the Riches of this Country are not sought for in the bowels of the Earth, and although most of them consist only in the spoils of Animals,— nevertheless, if they were transported to Europe, they would have their value. The presents that the Nipissiriniens gave to the other Nations alone would have cost in France forty or even fifty thousand francs.

After that, the same Women carried the bones of their Dead into this magnificent Room. These bones were enclosed in caskets of bark, covered

with new robes of Beaver skins, and enriched with collars and scarfs of Porcelain Beads.

Near each Dead body sat the women, in two lines, facing each other. Then entered the Captains, who acted as Stewards, and carried the dishes containing food. This Feast is for the Women only, because they evince a deeper feeling of mourning.

Afterward, about a dozen Men with carefully selected voices entered the middle of the Cabin, and began to sing a most lugubrious chant, which, being seconded by the Women in the refrains, was very sweet and sad.

The gloom of the night conduced not a little to this Mourning; and the darkness, lighted only by the flickering flames of two fires which had been kindled at each end of the Cabin, received their wailings and their sighs. The theme of the song consisted in a sort of homage paid to the Demon whom they invoked, and to whom their lamentations were addressed. This chant continued through the night, amid deep silence on the part of the Audience, who seemed to have only respect and admiration for so sacred a ceremony.

On the following morning, these Women distributed corn, moccasins, and other small articles that are within their means, or the products of their industry. Their chant—ever plaintive, and interspersed with sobs—seemed to be addressed to the Souls of the deceased, whom they sped on their way— as it appeared, with deep regret—by continually waving branches that they held in their hands, for fear that these poor Souls might be surprised by the dread of war and the terror of arms, and that their rest might thus be dis-

turbed. For, at the same time, the body of an Army could be observed descending a neighboring Mountain with frightful cries and yells, running around at first in a circle, then in an oval; and, at last, after a thousand other figures they rushed upon the Cabin, of which they became Masters, —the Women having yielded the place, as if to an Enemy.

These Warriors became Dancers after this Victory. Each Nation, in turn, occupied the Ballroom, for the purpose of displaying their agility, until the Algonquin Captains, who acted as Masters of Ceremonies, entered ten or twelve in line, bearing flour, beavers, and some dogs still alive, with which they prepared a splendid Feast for the Hurons. The Algonquin Nations were served apart, as their Language is entirely different from the Huron.

Afterward, two Meetings were held; one consisted of the Algonquins who had been invited to this Solemnity, to whom various presents were given, according to the extent of the Alliance that existed between the Nipissiriniens and them. The bones of the Dead were borne between the presents given to the most intimate Friends, and were accompanied by the most precious robes and by collars of porcelain beads, which are the gold, the pearls, and the diamonds of this Country.

The second Assembly was that of the Huron Nations, at which the Nipissiriniens gave us the highest Seat, the first titles of honor, and marks of affection above all their Confederates. Here new presents were given, and so lavishly that not a single Captain withdrew empty-handed.

The Feast concluded with prizes given for physical strength, for bodily skill, and for agility. Even the Women took part in this contest, and everything was done with such moderation and reserve that—at least, in watching them—one would never have thought that he was in the midst of an assemblage of Barbarians,—so much respect did they pay to one another, even while contending for the victory.

63. The Algonquian Way of Death

The broad similarity of cultural treatments of the dead in the eastern woodlands is suggested by Nicolas Perrot's lucid description of the Great Lakes tribes, particularly the Ottawas. Although their ceremonies were shorter (three days instead of ten) and held annually (instead of once every ten or fifteen years), they exchanged feasts of the dead with their Algonquian and Huron neighbors in order to cement alliances, foster close tribal relations, and redistribute wealth. Their general pattern of funerals and mourning differed little more. The sexes maintained different mourning styles, the deceased's family feasted nonrelatives and gift-givers, and fathers and younger brothers took the death of sons and older brothers especially hard in those patrilineal societies. Spouses were required to subject themselves to two years of self-abnegation and then marry either their spouse's sibling or a person chosen by their in-laws. Chiefs were mourned for one year by their adult tribesmen and then replaced. A dying man was placed in a flexed position before rigor mortis could set in, which required digging—with only sharp sticks and crude hoes—the smallest possible grave, often in frozen soil. With frequent reburials during feasts of the dead, these graves were generally shallow as well.

Source: **Emma Helen Blair**, ed. and trans., *The Indian Tribes of the Upper Mississippi Valley and Region of the Great Lakes,* 2 vols. (Cleveland: The Arthur H. Clark Co., 1911), 1:70–73, 78–83, 85–88. Reprinted by permission of The Arthur H. Clark Co.

When an Outaoüas [Ottawa], or other savage [of the Great Lakes] is at the point of death, he is decked with all the ornaments owned by the family—I mean, among his kindred and his connections by marriage. They dress his hair with red paint mixed with grease, and paint his body and his face red with vermilion; they put on him one of his handsomest shirts, if he has such, and he is clad with a jacket and a blanket, as richly as possible; he is, in a word, as properly garbed as if he had to conduct the most solemn ceremony. They take care to adorn the place where he is [lying] with necklaces of porcelain and glass beads (both round and long), or other trinkets. His weapons lie beside him, and at his feet generally all articles that he has used in war during his life. All his relatives—and, above all, the jugglers [shamans]—are near him. When the sick man seems to be in agony, and struggles to yield up his last breath, the women and girls among his relations, with others who are hired [for this purpose], betake themselves to mourning, and begin to sing doleful songs, in which mention is made of the degrees of relationship which they have with the sufferer. But if he seems to be recovering, and to regain consciousness, the women cease their weeping; but they recommence their cries and lamentations whenever the patient relapses into convulsions or faintness. When he is dead (or a moment before he expires), they raise him to a sitting position, his back supported, [to look] as if he were alive. I will say here, in passing, that I have seen some savages whose death-agonies lasted more than twenty-four hours, the sick man making fearful grimaces

and contortions, and rolling his eyes in the most frightful manner; you would have believed that the soul of the dying man beheld and dreaded some enemy, although he was lying there without recognizing us, and almost dead. The corpse remains thus sitting until the next day, and is kept in this position both day and night by the relatives and friends who go to visit the family; they are also assisted from time to time by some old man, who takes his place near the women who are relatives of the dead man. [One of them] begins her mournful song, while she weeps hot tears; all the others join her therein, but they cease to sing at the same time when she does; and then a present is given to her—a piece of meat, a dish of corn, or some other article.

As for the men, they do not weep, for that would be unworthy of them; the father alone makes it evident, by a doleful song, that there is no longer anything in the world which can console him for the death of his son. A brother follows the same practice for his elder brother, when he has received from the latter during his life visible marks of tenderness and affection. In such case, the brother takes his place naked, his face smeared with charcoal, mingled with a few red lines. He holds in his hands his bow and arrows, as if he intended at the start to go against some enemy; and, singing a song in a most furious tone, he runs like a lunatic through the open places, the streets, and the cabins of the village, without shedding a tear. By this extraordinary performance he makes known to all who see him how great is his sorrow for the death of his brother; this softens the hearts of his neighbors, and

obliges them to provide among themselves a present, which they come to offer to the dead. In the speech with which they accompany this gift they declare that it is made in order to wipe away the tears of his relatives; and that the mat which they give him is for him to lie on, or [that they give] a piece of bark to shelter his corpse from the injurious effects of the weather.

When the time comes for burying the corpse, they go to find the persons designated for this office; and a scaffold is erected seven or eight feet high, which serves the dead in place of a grave—or, if he is placed in the ground, they dig for him a grave only four or five feet deep. During all this time, the family of him whose funeral is solemnized exert all their energies to bring him grain, or peltries, or other goods, [which they place] either on the scaffold or near the grave; and when one or the other is completed they carry thither the corpse, in the same position which it had at death, and clothed with the same fine apparel. Near him are his weapons, and at his feet all the articles which had been placed there before his death. When the funeral ceremonies have been performed and the body buried, the family make liberal payment to those who took part therein, by giving them a kettle or some porcelain necklaces for their trouble.

All the people in the village are obliged to attend the funeral procession; and, when all is over, one man among them all steps forward, who holds in his hand a little wooden rod, as large as one's finger and some five inches long, which he throws into the midst of the crowd, for him who can

catch it. When it has fallen into some person's hand the rest try to snatch it from him; if it falls on the ground every one tries to reach it to pick it up, pulling and pushing each other so violently that in less than half an hour it has passed through the hands of all those who are present. If at last any one of the crowd can get possession of it, and display it to them without any one taking it from him, he sells it for a fixed price to the first person who desires to buy it; this price will be very often a kettle, a gun, or a blanket. The bystanders are then notified to be present again, on some day appointed, for a similar ceremony; and this is done, sometimes quite often, as I have just related.

After this diversion, public notice is given that there is another prize, to be given to the best runner among the young men. The goal of this race is indicated, [and the course is marked out] from the place where the runners must start to that which they are to reach. All the young men adorn themselves, and form in a long row on the open plain. At the first call of the man who is to give the signal, they commence to run, at some distance from the village, and the first one who arrives there carries away the prize.

A few days afterward the relatives of the dead man give a feast of meat and corn, to which are invited all the villagers who are not connected with them by marriage and who are descended from other families than their own—and especially those persons who have made presents to the dead. They also invite, if any such are found, strangers who have come from other villages; and they inform all the guests that it is the dead man who gives them

this feast. If it is one of meat, they take a piece of this, as well as of other kinds of food, which they must place upon the grave; and the women, girls, and children are permitted to eat these morsels, but not the grown men, for these must regard such act as unworthy of them. At this feast each is free to eat what he wishes, and to carry the rest [of his portion] home with him. Considerable presents in goods are given to all those strangers who have previously made presents to the dead person; but these are not given to his own tribesmen. The guests are then thanked for having remembered the dead, and congratulated on their charitable dispositions.

When either the man or his wife dies, the members of the family [clan] to which the dead person belongs exhaust their means, and contribute among the relatives, to furnish peltries, merchandise, and provisions to be carried to the parents of the departed, so as to aid the latter in meeting the great expenses which they necessarily incur on that occasion.

If the husband dies, the wife cannot marry again unless the man is one to the liking of the mother-in-law, and after two years of mourning. This period the widow observes by cutting off her hair, and not using any grease on it; she combs it as seldom as she possibly can, and it is always bristling; she also goes without vermilion [red paint], which she can no longer use on her face. Her clothing is but a wretched rag, sometimes a worn-out old blanket, sometimes a hide black with dirt, so wretched that it cannot be used for anything else. She is interdicted from visiting her friends, unless they have previously visited her or she

meets them when she goes out to search for firewood. In the cabin she usually occupies the place which her husband had while living. In whatever place she may be, she must not show any indication of pleasure, and it is not without having to suffer pain that she must thus restrain herself; because the savages, when they see the women weeping for their departed husbands, mock them and say a thousand insulting things to them. She continues to render the same services to the parents of her husband, and yields as entire submission to all that they command her to do, as she did when he was alive. Those about her show, it is true, much consideration for her modesty and for the line of conduct which she is obliged to follow; for they take special pains not to give in the least thing any occasion for grief—either giving her food, or sending to the house of her parents, out of respect to her, the best of what they have, without either herself or her family being expected to reciprocate the gift through politeness.

When her two years of widowhood have expired, if she has strictly observed [the requirements of] her mourning, they take off her rags, and she again puts on handsome garments; she rubs vermilion on her hair and her face, and wears her earrings, her collar of glass and porcelain beads, and other trinkets which the savages consider most valuable. If one of the brothers or near relatives of her late husband loves her, he marries her; if not, she accepts [as husband] some man whom she is obliged to marry, without the power to refuse him—for the parents of the deceased are masters of her body. But if they do not provide a husband for her she cannot be

hindered from marrying some other man after the period of her widowhood is ended; and in leaving to her this liberty they are obliged to recognize her fidelity by presents. . . .

When the wife dies, the husband in like manner observes his mourning. He does not weep, but he refrains entirely from painting his face with vermilion, and puts only a very little grease on his hair. He makes presents to the parents of the deceased wife; if he does not lodge with them he sends them the best part of his game or fish, or of any other gains. It is not permitted to him to marry again until after his two years of mourning, and when he has spent them in the manner required. If he is a good hunter, or has some other accomplishment, his sister-in-law or one of her cousins is given to him in marriage; but if there are none of these he accepts a girl who is regarded as suitable, whom he is obliged to take for his wife, without the power of refusal; for he is prohibited from marrying again save with the knowledge and consent of his mother-in-law, in case she is alive, or at the will of her relatives if she is dead. If he disobeyed this rule all the relatives of his deceased wife would heap a thousand indignities on the woman whom he had taken without such consent; and if he had two wives, they would do the same to the other one. The relatives would carry their animosity so far that the brothers or the cousins of the deceased woman would league themselves with their comrades to carry away his new wife and violate her; and this act would be considered by disinterested persons as having been legitimately perpetrated. This is the reason why very few men are known to make such a mistake when they marry again, since this is the law among them, although it is not universal.

If the savages intend to celebrate the feast of their dead, they take care to make the necessary provision for it beforehand. When they return from their trade with the Europeans, they carry back with them the articles which suit them for this purpose; and in their houses they lay in a store of meat, corn, peltries, and other goods. When they return from their hunting [in late spring], all those of the village come together to solemnize this feast. After resolving to do so, they send deputies from their own people into all the neighboring villages that are allied with them, and even as far away as a hundred leagues or more, to invite those people to attend this feast. In entreating them to be present at it, they designate the time which had been fixed for its solemnization. The greater part of the men in those villages who are invited to this feast set out, a number in each canoe, and these together provide a small fund with which to offer a common present to the village which has invited them, on their arrival there. Those who have invited them make ready for their coming a large cabin, stoutly built and well covered, for lodging and entertaining all those whom they expect. As soon as all the people have arrived, they take their places, each nation separately from the others, at the ends and in the middle of the cabin, and, thus assembled, they offer their presents and lay aside their [outer] garments, saying that messengers have come to invite them to pay their re-

spects to the shades and the memory of the departed in that village; and immediately they begin to dance to the noise of a drum and of a gourd which contains some small pebbles, both keeping the same time. They dance from one end to the other of the cabin, returning after one another, in single file, around three spruce-trees or three cornstalks which are set up there. During these dances, people are at work preparing the meal; they kill dogs, and have these cooked with other viands which are speedily prepared. When all is ready, they make the guests rest a little while, and after all the dances are ended the repast is served.

I omitted to state that as soon as the hosts call for the dances to stop they take from their guests the presents which they have made, and all their garments; and in exchange for these the visitors are given, by those who invited them, other articles of clothing which are more valuable. If the hosts have just returned [from the trading], these are shirts, coats, jackets, stockings, new blankets, or [packages of] paints and vermilion, even though the guests have brought only old garments—perhaps greasy skins, or robes [made from the skins] of beavers, wild-cats, bears, and other animals.

When those who are invited from the other villages have all arrived, the same entry and the same reception are provided for the people of each village. When all are assembled, they are expected to dance all at the same time during three consecutive days; and during this period one of the hosts invites to a feast at his own house about twenty persons, who are chosen and sent out by their own people. But in-stead of serving food at this feast, it is presents which are offered to the guests, such as kettles, hatchets, and other articles from the trade; there is, however, nothing to eat. The presents which they have received belong in common to the tribesmen; if these were articles of food, they can eat them, which accordingly they do very punctually, for their appetites never fail them. Another of the hosts will do the same for other dancers, who will be invited to come to his house, and see how his people treat [their guests]—until all those of the [entertaining] village have in turn given feasts of this sort. During [these] three days they lavish all that they possess in trade-goods or other articles; and they reduce themselves to such an extreme of poverty that they do not even re-serve for themselves a single hatchet or knife. Very often they keep back for their own use only one old kettle; and the sole object for which they incur all this expenditure is, that they may render the souls of the departed more happy and more highly respected in the country of the dead. For the savages believe that they are under the strictest obligation to perform, in the honors which they pay to their dead, all that I have related, and that it is only this sort of lavish spending which can fully secure rest for the departed souls; for it is the custom among those people to give whatever they possess, without reservation, in the ceremonies of funerals or of other superstitions. There are still some of those savages who have sucked the milk of [the Christian] religion, who nevertheless have not wholly laid aside ideas of this sort, and who bury with the corpse whatever belonged to the person dur-

ing his life. Solemnities of this kind for the dead were formerly celebrated every year, each tribe being alternately hosts and guests; but for several years past this has been no longer the custom, except among some few [villages].

The Frenchmen who have gone among them have made them realize that these useless extravagances of theirs were ruining their families, and reducing them to a lack of even the necessities of life.

64. Micmac Suicide

In native society, as in European, there were many roads to death. War and pestilence, starvation and exposure claimed many, but not a few took their own lives, as Chrestien Le Clercq reveals in his description of the Micmacs in 1691. All over the East, Indians of both sexes and all ages committed suicide by eating the roots of the may apple and water hemlock, by hanging, stabbing, shooting or drowning themselves. Their motives were equally various: unrequited love, jealousy, the death of a loved one, forced marriage, sickness (especially disfigurement by smallpox), the avoidance of martyrdom or torture, melancholy, shame, gambling losses, revenge for personal dishonor, or even parental punishment. Under the impress of Christian teaching, the Indians moved from an aboriginal ambivalence toward strong disapproval of suicide, believing that the souls of suicides were forever earthbound and excluded from the village of the dead. Only self-deaths for love continued to draw sympathy (William N. Fenton, "Iroquois Suicide: A Study in the Stability of a Culture Pattern," Bureau of American Ethnology, Bulletin 128, *Anthropological Papers*, nos. 13–18 [Washington, D.C., 1941], 79–137).

The Gaspesians [Micmacs], however, are so sensitive to affronts which are offered them that they sometimes

abandon themselves to despair, and even make attempts upon their lives, in the belief that the insult which has

Source: Father Chrestien Le Clercq, *New Relation of Gaspesia With the Customs and Religion of the Gaspesian Indians,* ed. and trans. William F. Ganong (Toronto: The Champlain Society, 1910), pp. 247–50.

been done them tarnishes the honour and the reputation which they have acquired, whether in war or in hunting.

Such were the feelings of a young Indian who, on account of having received by inadvertence a blow from a broom, given by a [French] servant who was sweeping the house, imagined that he ought not to survive this imaginary insult which waxed greater in his imagination in proportion as he reflected upon it. "What," said he to himself, "to have been turned out in a manner so shameful, and in presence of so great a number of Indians, my fellow-countrymen, and after that to appear again before their eyes? Ah, I prefer to die! What shall I look like, in the future, when I find myself in the public assemblies of my nation? And what esteem will there be for my courage and my valour when there is a question of going to war, after having been beaten and chased in confusion by a maid-servant from the establishment of the captain of the French. It were much better, once more, that I die." In fact he entered into the woods singing certain mournful songs which expressed the bitterness of his heart. He took and tied to a tree the strap which served him as girdle, and began to hang and to strangle himself in earnest. He soon lost consciousness, and he would even infallibly have lost his life if his own sister had not happened to come by chance, but by special good fortune, to the very place where her miserable brother was hanging. She cut the strap promptly, and after having lamented as dead this man in whom she could not see any sign of life, she came to announce this sad news to the Indians who were with Monsieur [Pierre]

Denys. They went into the woods and brought to the habitation this unhappy Gaspesian, who was still breathing though but little. I forced open his teeth, and, having made him swallow some spoonfuls of brandy, he came to himself, and a little later he recovered his original health.

His brother had formerly hung and strangled himself completely, in the Bay of Gaspé, because he was refused by a girl whom he loved tenderly, and whom he sought in marriage. For, in fact, although our Gaspesians, as we have said, live joyously and contentedly, and although they sedulously put off, so far as they can, everything which can trouble them, nevertheless some among them fall occasionally into a melancholy so black and so profound that they become immersed wholly in a cruel despair, and even make attempts upon their own lives.

The women and the girls are no more exempt than the men from this frenzy, and, abandoning themselves wholly to grief and sadness caused either by some displeasure they may have received, or by the recollection of the death of their relatives and friends, they hang and strangle themselves, as formerly did the wives and daughters of the Milesians, whom only the apprehension of being exposed wholly nude in the public places, according to the law that was made expressly for this purpose, kept from committing like cruelties. Nothing, however, has been effective up to the present in checking the mania of our Gaspesian women, of whom a number would miserably end their lives, if, at the time when their melancholy and despair becomes known through the sad and gloomy songs which they sing,

and which they make resound through the woods in a wholly dolorous manner, some one did not follow them everywhere in order to prevent and to anticipate the sad effects of their rage and their fury. It is, however, surprising to see that this melancholy and despair become dissipated almost in a moment, and that these people, however afflicted they seem, instantly check their tears, stop their sighs, and recover their usual tranquillity, protesting to all those who accompany them, that they have no more bitterness in their hearts. "*Ndegouche,*" say they, "*apche mou, adadaseou, apche mou oüahga-hi, apche mou kedoukichtone-bilchi.*" "There is my melancholy gone by; I assure thee that I shall lament no more, and that I have lost any intention to hang and strangle myself."

65. Painted Posts and Funeral Change among the Delawares

By 1780, when David Zeisberger penned his account of Delaware culture, native funeral customs had changed, if only externally, due to contact with Christian missionaries and colonists. Most of the changes occurred around the burial itself, the most visible—and therefore most superficial—aspect of death. Bark coverings had given way in some hatchet-wielding groups to loose planks and full coffins (or hollowed log imitations). In a few Moravian communities, perhaps, but not in most, grave goods were reduced or foregone altogether. And earth was thrown directly on the coffin, whereas traditionally a bark and log compartment sheltered the corpse. But other customs were unaltered: the redistribution of wealth at death to prevent hoarding and inequality, which required separate household possessions for husband and wife; the levirate and sororate in which a survivor married his or her spouse's sibling; painted posts to distinguish graves by social status and sex (articles appropriate to the deceased's economic role were either hung or painted on the post) and to commemorate the living deeds and qualities of the deceased; prescribed periods of mourning; and elaborate condolence councils and protocol for chiefs to cement tribal alliances and clan relations.

Source: David Zeisberger's History of the Northern American Indians, ed. Archer Butler Hulbert and William Nathaniel Schwarze (Columbus: Ohio Archaeological and Historical Society, 1910), pp. 87–90, 150–51.

Most important was the continuity of beliefs in an afterlife populated by anthropomorphic souls and the need to send them thither with ancient regard and the articles and food required for such an important journey.

Of inheritances they know nothing. Every Indian knows that whatever he leaves at his death is divided among his friends. If a woman becomes a widow, no matter how long she may have lived with her husband, friends come, take everything that belonged to the man, and bring it to one place. The friends do not keep a single article, for they wish to forget the dead and are afraid lest the smallest part of the property of the deceased should remind them of him. They give what the deceased has left to their friends and no one of his friends receives anything; even though he should wish to take something he will not do it through fear of the others. If a dying Indian leaves his gun or any other trifle to a particular friend the legatee is immediately put in possession and no one disputes his right. The widow gets nothing, yet whatever the husband has given to his wife during his life-time remains her property. Therefore we need not wonder that a married Indian pair should not have their goods in common, for otherwise the wife would be left wholly destitute after her husband's death. In like manner the husband inherits nothing when his wife dies.

According to ancient custom a widow should not marry again within a year after the death of her husband, for the Indians say that he does not forsake her before that time. At the end of this period, however, they believe that his soul goes to its place. A widow must endeavor to live by her own industry. She is not permitted to purchase any meat, for the Indians are superstitiously persuaded that their guns fail if a widow should eat of the game they have killed. Now and then a kind friend will venture to transgress the rule and give her some meat secretly. As soon as the first year of her widowhood is passed, the friends of the deceased husband clothe and provide for her and her children. They also propose another husband if they know of a desirable party, or, at least, tell her that she is now at liberty to choose for herself. If, however, she has not attended to the prescribed rule but married within the year, they never trouble themselves about her again except, perhaps, to speak evil of her.

If a man's wife die, her relatives pretend to have some claim upon him until a year has passed. If he has remained a widower during that time they generally secure him a wife, preferring a sister of the departed, if one be living.

The burying places are at some distance from the towns. Before they had hatchets and other tools they used to line the inside of a grave with the bark of trees and when the corpse was let down they placed some pieces of wood across, which were again covered with bark and then the earth thrown in. When they were able to split boards they placed them, not, however, joined in any way, in the grave

in such a manner that the corpse might be between them. A fourth board was laid over it as a cover. Now they have learned to make proper coffins. The graves are generally dug by old women as the young people abhor this kind of work. The coffin is made by men and placed in the grave. Then the corpse is brought, dressed in new clothing and a white shirt, with the face and shirt painted red, laid upon a new mat and let down into the grave. They cover the body with the strowd and nail up the coffin. Formerly it was the custom to place the pouch, tobacco, pipe, knife, fire material, kettle and hatchet in the grave but this is no longer done. They also fill up the grave with earth, which was not done in former times. The graves are all arranged in such a manner that the head was turned to the east and the feet to the west. At the head of the corpse a tall post is erected, pointing out who is buried. If the deceased was a chief this post is neatly carved but not otherwise decorated. If it was a [war] Captain the post is painted red and his head and glorious deeds are portrayed upon it. The burial post of a physician [shaman] is hung with a small tortoise shell which he used in his juggling practice. In honor of a great warrior his warlike deeds are exhibited in red color on the burial post.

In the evening soon after sunset and in the morning before daybreak the female relations and friends assemble in the house of the deceased and mourn over the body. This is done until he is buried. All the effects of the deceased are piled up near the body. These are taken to the place of burial and the greater part is dis-tributed among those who assisted in burying the dead. The rest is given to the friends present, each receiving a share. During the letting down of the corpse into the grave the women set up a deafening howl. Men deem it a shame to weep, yet in silence and un-observed they often cannot refrain from tears. After the ceremony is over the mother, grandmother or other near female relative of the deceased goes evening and morning to the grave and weeps over it. This is repeated daily for some time but gradually less and less till the mourning period is over. Sometimes they place victuals on the grave that the deceased may not suffer hunger. The food thus left is generally consumed by dogs.

Concerning mourning for the dead it might be added that a widow is ex-pected to observe in externals the fol-lowing rules during the period of mourning which lasts a year. She must lay aside all ornaments, wash but lit-tle, for as soon as she makes preten-sions at cleanliness, combs and dresses her hair, it is reported that she is anx-ious to marry. Men who are in mourn-ing have no such regulations to ob-serve.

Should a chief have lost a child or near relative, no complaint may be brought before him, nor may his ad-vice be asked on any affairs of state. Even important embassies from other nations cannot be attended to by him until comfort has been formally of-fered. This is commonly done by de-livering a string or fathom of wampum and addressing to him a speech, in which figuratively the remains of the deceased are buried, the grave covered with bark that neither dew of heaven

nor rain may fall upon it, the tears are wiped from the chief's eyes, the sorrow of burial taken from his heart and his heart made cheerful. This done, it is possible to confer with him on the matters of state that need consideration.

When Europeans, who are in more comfortable circumstances than the Indians, wish to comfort a chief, they not only give a string of wampum but wrap the corpse of the deceased in a large piece of fine linen, laying another piece on the grave and wipe the tears from his eyes with silk handkerchiefs. Both the linen and the silks are given him as a present.

When a chief dies sympathy is expressed with the whole nation. I will give a brief description of the ceremonies observed when the Cherokees sent a formal and numerous embassy to the Delawares in Goschachgünk to renew their alliance with them after their Chief Netawatwes had died. The ambassadors halted several miles below the town and sent word that they had arrived. The day after some Delaware Captains went down to welcome them and delivered a speech, in which they expressed joy on their arrival, extracted the thorns they had gotten on the journey from their feet, took the sand and gravel from between their toes, and anointed the wounds and bruises made by the briars and brushwood with oil, wiped the perspiration from their faces and the dust from their eyes, cleansed their ears, throats and hearts of all evil they had seen, heard or which had entered their hearts. A string of wampum was delivered in confirmation of this speech and then the Captains, accompanied by a large number of Indians, conducted the embassadors to the town. On entering the Cherokees saluted the inhabitants by firing their pieces, which was answered in the same manner by the Delawares. Next, the Captain of the Cherokees began a song, during which they proceeded to the Council-house, where everything had been prepared for the reception of the visitors. All having been seated, the Cherokee Captain comforted the grandfather, the Delaware nation, over the loss of the Chief. Continuing he wrapped the remains in a cloth, buried them, covered the grave with bark, wiped the tears from the eyes of the weeping nation, cleansed their ears and throats and took away all the sorrow from their hearts. He confirmed his speech by delivering a string of wampum. Then the peace-pipe was stuffed, lighted and in turn smoked by several Captains of the Delawares and Cherokees.

66. Taking Leave of the Dead in the Carolinas

Native funeral customs were generally consistent throughout the East and within the northern and southern culture areas. John Lawson's journey through the Carolinas in 1700–1701 enabled him to observe the death customs of many southeastern groups, which he found to form a coherent pattern. One characteristic shared by most eastern tribes was that the dead were differentiated as they had been in life by sex, office, and social status. Women, accordingly, seldom received expensive or ostentatious funerals. Indeed, among the men, only headmen, renowned warriors, and shamans were honored in the manner Lawson and most southern observers describe. This consisted of the placement of their cleansed bones in a dressed deerskin pouch or, in Virginia, their embalmed skins, and then in an elevated sepulcher reserved for "grandees." Hired female mourners sang their doleful tunes and the surviving headmen renewed tribal alliances and histories at funeral orations and feasts. Other characteristics shared by the Carolinians with their northern neighbors were sensual visions of "heaven" and "hell," and mat and wood burial vaults to keep the earth from touching the corpse. Only an unusually short period of mourning before women could remarry— if Lawson was correct—seems to have separated Carolina customs from the eastern pattern. More typical were the Creeks, who permitted spouses to remarry only after four annual Green Corn ceremonies had been held, by marrying a sibling of the deceased, or with the consent of the deceased's family.

The Burial of their Dead is perform'd with a great deal of Ceremony, in which one Nation differs, in some few Circumstances, from another, yet not so much but we may, by a general Relation, pretty nearly account for them all.

When an *Indian* is dead, the greater Person he was, the more expensive is his Funeral. The first thing which is done, is, to place the nearest Relations near the Corps, who mourn and weep very much, having their Hair hanging down their Shoulders, in a very forlorn manner. After the dead Person has lain a Day and a Night, in one of their Hurdles of Canes, commonly in some Out-House made for that purpose, those that officiate about the Funeral, go into the Town, and the first young Men they meet withal, that have Blankets or Match Coats on,

Source: John Lawson, *A New Voyage to Carolina* (London, 1709), pp. 179–83.

whom they think fit for their Turn, they strip them from their Backs, who suffer them so to do, without any Resistance. In these they wrap the dead Bodies, and cover them with two or three Mats, which the *Indians* make of Rushes or Cane; and last of all, they have a long Web of woven Reeds, or hollow Canes, which is the Coffin of the *Indians,* and is brought round several times, and tied fast at both ends, which indeed, looks very decent and well. Then the Corps is brought out of the House, into the Orchard of Peach-Trees, where another Hurdle is made to receive it, about which comes all the relations and Nation that the dead Person belong'd to, besides several from other Nations in Alliance with them; all which sit down on the Ground, upon Mats spread there, for that purpose; where the Doctor or Conjurer appears; and, after some time, makes a Sort of *O-yes,* at which all are very silent; then he begins to give an Account, who the dead Person was, and how stout a Man he approv'd himself; how many Enemies and Captives he had kill'd and taken; how strong, tall, and nimble he was; that he was a great Hunter, a Lover of his Country, and possess'd of a great many beautiful Wives and Children, esteem'd the greatest of Blessings among these Savages, in which they have a true Notion. Thus this Orator runs on, highly extolling the dead Man, for his Valour, Conduct, Strength, Riches, and Good-Humour; and enumerating his Guns, Slaves and almost every thing he was possess'd of, when living. After which, he addresses himself to the People of that Town or Nation, and bids them supply the dead Man's Place, by following his steps, who, he assures

them, is gone into the Country of Souls, (which they think lies a great way off, in this World, which the Sun visits, in his ordinary Course) and that he will have the Enjoyment of handsome young Women, great Store of Deer to hunt, never meet with Hunger, Cold or Fatigue, but every thing to answer his Expectation and Desire. This is the Heaven they propose to themselves; but, on the contrary, for those *Indians* that are lazy, thievish amongst themselves, bad Hunters, and no Warriours, nor of much Use to the Nation, to such they allot, in the next World, Hunger, Cold, Troubles, old ugly Women for their Companions, with Snakes, and all sorts of nasty Victuals to feed on. Thus is mark'd out their Heaven and Hell. After all this Harangue, he diverts the People with some of their Traditions, as when there was a violent hot Summer, or very hard Winter; when any notable Distempers rag'd amongst them; when they were at War with such and such Nations; how victorious they were; and what were the Names of their War-Captains. To prove the times more exactly, he produces the Records of the Country, which are a Parcel of Reeds, of different Lengths, with several distinct Marks, known to none but themselves; by which they seem to guess, very exactly, at Accidents that happen'd many Years ago; nay two or three Ages or more. The Reason I have to believe what they tell me, on this Account, is, because I have been at the Meetings of several *Indian* Nations; and they agreed, in relating the same Circumstances, as to Time, very exactly; as, for Example, they say, there was so hard a Winter in *Carolina,* 105 years ago, that the great

Sound was frozen over, and the Wild Geese came into the Woods to eat Acorns, and that they were so tame, (I suppose, through Want) that they kill'd abundance in the Woods, by knocking them on the Head with Sticks.

But, to return to the dead Man. When this long Tale is ended, by him that spoke first; perhaps a second begins another long Story; so a third, and fourth, if there be so many Doctors present; which all tell one and the same thing. At last, the Corps is brought away from that Hurdle to the Grave, by four young Men, attended by the Relations, the King, old Men, and all the Nation. When they come to the Sepulcre, which is about six Foot deep, and eight Foot long, having at each end (that is, at the Head and Foot) a Light-Wood, or Pitch-Pine Fork driven close down the sides of the Grave, firmly into the Ground; (these two Forks are to contain a Ridge-Pole, as you shall understand presently) before they lay the Corps into the Grave, they cover the bottom two or three times over with Bark of Trees, then they let down the Corps (with two Belts, that the *Indians* carry their Burdens withal) very leisurely, upon the said Barks; then they lay over a Pole of the same Wood, in the two Forks, and having a great many Pieces of Pitch-Pine Logs, about two Foot and a half long, they stick them in the sides of the Grave down each End, and near the Top thereof, where the other Ends lie on the Ridge-Pole, so that they are declining like the Roof of a House. These being very thick plac'd, they cover them (many times double) with Bark; then they throw the Earth thereon, that came

out of the Grave, and beat it down very firm; by this Means, the dead Body lies in a Vault, nothing touching him; so that when I saw this way of Burial, I was mightily pleas'd with it, esteeming it very decent and pretty, as having seen a great many Christians buried without the tenth Part of that Ceremony and Decency. Now, when the Flesh is rotted and moulder'd from the Bone, they take up the Carcass, and clean the Bones, and joint them together; afterwards, they dress them up in pure white dress'd Deer-Skins, and lay them amongst their Grandees and Kings in the *Quiogozon*, which is their Royal Tomb or Burial-Place of their Kings and War-Captains. This is a very large magnificent Cabin, (according to their Building) which is rais'd at the Publick Charge of the Nation, and maintain'd in a great deal of Form and Neatness. About seven foot high, is a Floor or Loft made, on which lie all their Princes, and Great Men, that have died for several hundred Years, all attir'd in the Dress I before told you of. No Person is to have his Bones lie here, and to be thus dress'd, unless he gives a round Sum of their Money to the Rulers, for Admittance. If they remove never so far, to live in a Foreign Country, they never fail to take all these dead Bones along with them, though the Tediousness of their short daily Marches keeps them never so long on their Journey. They reverence and adore this *Quiogozon*, with all the Veneration and Respect that is possible for such a People to discharge, and had rather lose all, than have any Violence or Injury offer'd thereto. These Savages differ some small matter in their Burials; some burying right upwards, and

otherwise. . . . Yet they all agree in their Mourning, which is, to appear every Night, at the Sepulcre, and howl and weep in a very dismal manner, having their Faces dawb'd over with Light-wood Soot, (which is the same as Lampblack) and Bears Oil. This renders them as black as it is possible to make themselves, so that theirs very much resemble the Faces of Executed Men boil'd in Tar. If the dead Person was a Grandee, to carry on the Funeral Ceremonies, they hire People to cry and lament over the dead Man. Of this sort there are several, that practise it for a Livelihood, and are very expert at Shedding abundance of Tears, and howling like Wolves, and so discharging their Office with abundance of Hypocrisy and Art. The Women are never accompanied with these Ceremonies after Death; and to what World they allot that Sex, I never understood, unless, to wait on their dead Husbands; but they have more Wit, than some of the Eastern [Asian] Nations, who sacrifice themselves to accompany their Husbands into the next World. It is the dead Man's Relations, by Blood, as his Uncles, Brothers, Sisters, Cousins, Sons, and Daughters, that mourn in good earnest, the Wives thinking their Duty is discharg'd, and that they are become free, when their Husband is dead; so, as fast as they can, look out for another, to supply his Place.

67. Full Circle among the Fox

Most of the accounts we have of Indian attitudes toward death come from the pens of white observers who, as sympathetic as they might be, could not know what it was like to be an Indian and to lose a loved one. Fortunately, a Fox woman left for us a moving account of her experiences with death early in our own century, experiences molded by cultural patterns hundreds of years old. Like her ancestors, she divided her husband's belongings among her male relatives, fasted, and wore mourning clothes provided by her husband's family. But because her mother was dead, she received no

Source: "The Autobiography of a Fox Indian Woman," ed. and trans. Truman Michelson, U.S. Bureau of American Ethnology, *Annual Report,* no. 40 (Washington, D.C., 1925), pp. 329–37.

instruction in the etiquette of mourning until her maternal uncle took her under his tutelage, as he had done at her divorce. He counselled her to put aside her excessive grief, to look to the future rather than dwelling morbidly on the past. If she had obeyed the tribal custom of walking far into the bush away from her husband's grave without looking back, she could have successfully hidden from his departing soul. By staying in their wickiup, she could not escape the constant visitations of his spirit in dreams. Her uncle's injunctions freed her to resume normal relations with her husband's memory by feeding his soul with food thrown into the fire and by remembering his qualities for four years, like the Creeks, before remarrying. When his family held an adoption feast to reintegrate her into society, she was released from her obligatory period of mourning. Courtship ensued, then marriage to her husband's "brother" (close friend), and finally children, thus completing the full circle of life.

Soon he [her second husband] fell ill. I felt very sorry for him. I felt terribly. Soon he became sicker and sicker. I cried in vain, as I felt so badly about him. And he died. Soon it was terrible for me. I undid my hair and loosened it. For several nights I could not sleep as I was sorrowful. On the fourth day I called the men. "You are to divide all these possessions of ours among you," I said to my male relatives. And then the female relatives of my dead husband came to comb my hair. And they brought other garments for me to wear. I wore black clothing. And soon those male relatives of mine to whom I had given our possessions brought food of every kind. The women brought all things which women raise. I went over to those (women) who had combed my hair and told them to take that food. I felt as wretched as possible. I was fasting. Soon I would walk far off to cry, it was far off so that it would not be known, (and) so that it should not be said about me, "Heavens! she must be very sorry, even as if

she were related to him." And I became lazy. I only wanted to lie down. I kept on sleeping as I was lonely.

That uncle (mother's brother) mentioned before probably heard about it. "She is very poorly since her husband died. She acts differently (from what she did formerly). To-day she is as if sick," is what he heard. He came to me. "I have come to see, my niece (sister's daughter), whether you are sick. You are losing much weight," he said to me. "No," I said to him. "I have come to instruct you as to what you should do. I know that you listened to what I told you when you were divorced. As you believed me you did exactly as I told you. You have made me very happy. Now this is what you are to do, my niece. Do not think so very much of him all the time, for it is dangerous to do that. That will happen to you if you dream that you are sleeping with him. You will cease to live very soon. That is why it is forbidden to do that. If you are sorry for your husband while still

bound by death ceremonies, you would not go where something is going on," he said to me. "And do not talk much, and do not laugh as long as you are bound by death ceremonies. You must be merely always quietly making something. Nor must you look around too much. Perhaps it was because you were not careful that no one straightway instructed you what you should do when your husband first died. I myself was busy at the time; that is why I did not come and instruct you what you should do. This is what is (supposed to be) done when one's husbands (wives) die. When they are taken to be buried (those surviving) accompany them when the (dead) are brought there. After they are placed on top of the hole, they begin to speak to those ghosts. After they have spoken to them, first the relatives (of the dead) begin to throw tobacco for them, then others afterwards. After all have offered tobacco to them, then last of all the husbands (wives) offer tobacco to them. They walk around in a circle where the (dead) is. Then they walk toward the East. They continue to go any place in the brush. They go through very thick brush. They are never to look backward. If they were to look backward they would die soon. It is far off where they are to go, and turn to go back. That is what they (are supposed to) do. Perhaps you did not do that, so I have heard," my uncle said to me.

"I did not know that that was the way. For I did not hear my mother, when she was alive, speak of how those unreleased from death-ceremonies should act. That is why I did not know what should be done. I did not go there when (my husband) was bur-

ied. I stayed here in the wickiup," I told my uncle.

"This is why they do that, so they may run and hide from that soul, and why they wander around in thick brush," he said to me. "So that is why you feel so badly. If you had done as I now tell you, you would not be that way. And when you eat always put some on the fire for him. Do not forget (to do this) as long as an adoption-feast has not been held and as long as you are not freed from death-ceremonies. That is what you must do," my uncle said to me. "Well, that is all. I shall soon come again to give you instructions," he said to me. And he departed.

And then always when I ate I put (food) on the fire for my husband. And I tried to cease to think of him all the time as I was afraid to die early.

Later on when I heard that an adoption-feast was about to take place, sure enough they soon came to summon me. When I came there, there were many Indians. When I went in there, the ones who were adopted were eating there. When they fed me it was as if we were eating with my husband for the last time, in order that he might be released. After I had eaten, I was told, "Take off your clothing." Then they began to clothe me in fresh clothes, and my hair was combed and my face was washed. And then I was told, "Well, do not take off your (clothing). For (now) you are to be clad like this. You may begin to wear finery. You may go and do whatever you please. If you are desirous of marrying anyone, you may marry him. Some one will take care of you if you marry him. Do not be afraid of us. You have pleased us by treating our

relative well while he was alive. So why should we be against you? So you must believe what we say to you this day." And then I departed.

For the first time I began to wear fresh clothing. And I began to be careful again. And that uncle of mine came again. "At last I have come to give you instructions again, my niece. This day you have ceased to be restricted by death-ceremonies. You know how hard it was to find a good man who treated you well. So you must feel very badly. Do not stop thinking of him (in a little while). A good man is hard to find. You know how your first husband treated you in the past. He abused you badly. So you should not forget your last husband for a long time. The men will begin to court you. Do not think of beginning to respond to them right away. For four years try not to forget your husband of whom you have sight. For you are still young. It will be nothing if you do not marry any one for a long time. Your next husband will not be as good. That is why I have come to tell you how sorry I am for your husband. So you must try to do that. And I am very proud that you believed me when I told you to do what was right. Some (women) become immoral when their mothers die, as they cease to be guided by any one. And they do not listen to others when they are instructed. That is also why I think my niece will watch out for herself. Well, my niece, I have finished instructing you. If you do that, you will lead a straight life."

I did as he told me. None of the men who were courting me was able to get my consent. I sharply scolded any one who courted me. For four

years I remained (single), (showing) how sorry I was for my husband. If I had had a child I should have never married again. As it was, I was too much alone all the time. "That is why," I thought, "I am always lonely." When more than four years were up, I again began to be kind to one man. Soon he asked that we should marry. "Now I began to be kind to you so that we should be married. Your husband was my friend. We used to talk together a great deal. He said to me, 'if I die first, you must court the one with whom I live, so as to marry her. She behaves very well. She is your sister-in-law as we are friends. It is because I do not want other men to marry her as she is too good. That really is why I say it to you. It might happen that I should die first, for we do not know when we are to die,' he said to me, 'and you must treat her nicely as I love her dearly as she is good,' he said to me. So I am trying to get you (to agree) for us to do so. As I was told, 'you must treat her well,' I could not begin to treat you meanly. I should try (to treat you) as my friend treated you," he said to me. Then I consented.

Oh, he never became angry, but he was rather lazy. He was slow in making anything. And he was a gambler. I did not love him as much as I did the one who was dead.

And I began to wish to have a child again. "If I had a child I should have it do things for me. Surely they will not all die," I thought. Soon I asked an old woman who knew about medicine. "Is there perhaps a medicine whereby one might be able to have a child if one drank it?" I said to her. "Surely I know one," she said to me,

"you might have a child if you drink it, for you already have had children," she said to me. "It was because I drank a medicine that I ceased having children," I said to her. "That is nothing. You might easily have a child," she said to me. "You might have relatives if you had children," she said to me.

She gave me (medicine) to drink. Sure enough, I began to have children.

After we had many children then my husband died. "Well, I shall never marry again," I thought, "for now these children of mine will help me (get a living)," I thought.

Suggested Readings

Tribal Ethnographies

Harrington, M. R. *The Indians of New Jersey: Dickon among the Lenapes.* New Brunswick, N.J.: Rutgers University Press, 1963. The fictionalized but historically accurate experiences of a colonial English boy among the Delawares, a vehicle for describing their society and culture.

Harrington, M. R. *Iroquois Trail: Dickon among the Onondagas and Senecas.* New Brunswick, N.J.: Rutgers University Press, 1965. The same boy among the Iroquois.

Hertzberg, Hazel W. *The Great Tree and the Longhouse: The Culture of the Iroquois.* New York: Macmillan, 1966. A clearly written but sophisticated text for seventh graders that includes some of the best and latest analysis of Iroquois culture.

Hudson, Charles. *The Southeastern Indians.* Knoxville: University of Tennessee Press, 1976. A richly illustrated, detailed survey of southern culture, notable for its comprehensiveness and lucidity.

Kinietz, W. Vernon. *The Indians of the Western Great Lakes, 1615–1760.* Ann Arbor: University of Michigan Press, 1940. A historical description of Great Lakes cultures taken from contemporary French and English sources.

Marten, Catherine. "The Wampanoags in the Seventeenth Century: An Ethnohistorical Survey." *Occasional Papers in Old Colony Studies* [Plimoth Plantation], no. 2 (Dec. 1970):1–40. A brief but thorough survey of the historical materials on this important Massachusetts tribe.

McCary, Ben C. *Indians in Seventeenth-Century Virginia.* Williamsburg: Virginia 350th Anniversary Celebration Corp., 1957. A pamphlet-length ethnography of Powhatan culture based on contemporary English sources and archaeology.

Newcomb, William W., Jr. *The Culture and Acculturation of the Delaware Indians.* University of Michigan, Museum of Anthropology, Anthropological Papers, no. 10. Ann Arbor, 1956. A historical ethnography following the tribe from the mid-Atlantic coast to Oklahoma.

Ritzenthaler, Robert E., and Ritzenthaler, Pat. *The Woodland Indians of the Western Great Lakes.* Garden City, N.Y.: American Museum of Natural History, 1970. A popular ethnographic treatment.

Speck, Frank G. *Penobscot Man: The Life History of a Forest Tribe in Maine.* New York: Octagon Books, 1970. A traditional ethnography based largely on field work among the Old Town Penobscots between 1907 and 1918.

Tooker, Elisabeth. *An Ethnography of the Huron Indians, 1615–1649.* Midland, Ontario: The Huronia Historical Development Council, 1967. A comprehen-

sive inventory of all facets of Huron culture, largely from the writings of the Jesuit missionaries who worked among them.

Trigger, Bruce G. *The Huron: Farmers of the North*. New York: Holt, Rinehart and Winston, 1969. A brief but masterly analysis of Huron culture by the acknowledged authority on the tribe.

Trigger, Bruce G. *The Children of Aataentsic: A History of the Huron People to 1660*. 2 vols. Montreal and London: McGill-Queen's University Press, 1976. A superbly objective and definitive ethnohistory of a pivotal tribe.

Trigger, Bruce G., ed. *Northeast*. Washington, D.C.: Smithsonian Institution, 1978. Vol. 15. *Handbook of North American Indians*. Gen. ed. William C. Sturtevant. 20 vols. The new Bible of northeastern Algonquian and Iroquoian studies, a comprehensive historical and ethnographic survey, richly illustrated.

Wallace, Anthony F. C. *The Death and Rebirth of the Seneca*. New York: Alfred A. Knopf, 1970. Perhaps the best ethnohistory of an eastern tribe, filled with cultural and psychological insights by a trained psychiatrist-anthropologist-ethnohistorian.

Wallace, Paul A. W. *Indians in Pennsylvania*. Harrisburg: Pennsylvania Historical and Museum Commission, 1961. A lightly documented but authoritative popular account of Delaware culture and history in the colonial period.

Wallis, Wilson D., and Wallis, Ruth S. *The Micmac Indians of Eastern Canada*. Minneapolis: University of Minnesota Press, 1955. An ethnographic and historical survey based on field work and contemporary sources.

SPECIALIZED STUDIES

Barbour, Philip L. *Pocahontas and Her World*. Boston: Houghton Mifflin, 1970. The best biography of the girl and her culture.

Beauchamp, William M. "Iroquois Women." *Journal of American Folklore* 13 (1900):81–91. An informal but informed essay on the colonial tribe, which lacks a sense of historical change.

Brown, Judith K. "Economic Organization and the Position of Women among the Iroquois." *Ethnohistory* 17 (1971):151–67. Argues that the women's high status was due to their control of the economic organization of Iroquois society.

Carr, Lucien. "On the Social and Political Position of Women among the Huron-Iroquois Tribes." Peabody Museum of American Archaeology and Ethnology, *Annual Report* 3 (1884):207–32. The earliest specialized study on the subject but still valuable.

Driver, Harold E. "Girls' Puberty Rites and Matrilocal Residence." *American Anthropologist*, n.s. 71 (1969):905–8. A western focus, but proves that matrilocality is not statistically related to the social importance of puberty rites, which are nearly universal in North America.

Foreman, Carolyn Thomas. *Indian Women Chiefs*. Reprint. Washington, D.C.: Zenger Publishing Co., 1976. Contains a chapter on Nancy Ward, the "Beloved Woman" of the eighteenth-century Cherokees.

Goldenweiser, A. A. "Functions of Women in Iroquois Society." *American Anthropologist*, n.s. 17 (1915):376–77. A brief summary of a larger paper arguing that the relatively high status of Iroquois women was due to the matrilocal residence patterns and to their economic role as farmers.

Grumet, Robert Steven. "Sunksquaws, Shamans, and Tradeswomen: Middle Atlantic Coastal Algonkian Women During the 17th and 18th Centuries." In *Women and Colonization: Anthropological Perspectives.* Edited by Mona Etienne and Eleanor Leacock. New York: Praeger, 1980. Argues that the traditional roles of native women—which included political, religious, and economic leadership—were not seriously eroded by European contact, and that adaptations were selective and creative.

Hewitt, J. N. B. "Status of Woman in Iroquois Polity before 1784." Smithsonian Institution, *Annual Report 1932* (Washington, D.C., 1933):475–88. A somewhat eccentric, technical, and unsubstantiated argument for the political supremacy of Iroquois women in the colonial period, by a Tuscarora anthropologist.

Hilger, Sister M. Inez. *Chippewa Child Life and Its Cultural Background.* Bureau of American Ethnology, *Bulletin* 146 (Washington, D.C., 1951). A detailed ethnographic account based on field work in the 1930s on reservations in Minnesota, Wisconsin, and Michigan.

Kidwell, Clara Sue. "The Power of Women in Three American Indian Societies." *Journal of Ethnic Studies* 6 (1978):113–21. An interpretative essay based on the works of Landes (1938), Lurie (1961), and Spindler (1962).

Landes, Ruth. *The Ojibwa Woman.* New York: Columbia University Press, 1938. A detailed pioneering study based on field work among the Ojibwa of western Ontario in the early 1930s.

Leacock, Eleanor B. "Matrilocality in a Simple Hunting Economy (Montagnais-Naskapi)." *Southwestern Journal of Anthropology* 11 (1955):31–47. Argues from historical sources and field work that with the shift from big game hunting to the fur trade, these largely matrilocal bands became increasingly patrilocal and patrilineal.

Leacock, Eleanor, and Goodman, Jacqueline. "Montagnais Marriage and the Jesuits in the Seventeenth Century: Incidents from the Relations of Paul Le Jeune." *Western Canadian Journal of Anthropology* 6 (1976):77–91. Extensive excerpts from the *Jesuit Relations* show that the missionaries sought to intrude hierarchical principles upon the ordering of interpersonal relations in Indian societies by reducing female independence, punishing injustice and disciplining children corporally, supporting monogamy, prohibiting divorce, and encouraging the private family ownership of hunting territories.

[Lurie,] Nancy Oestreich. "Trends of Change in Patterns of Child Care and Training among the Wisconsin Winnebago." *The Wisconsin Archaeologist,* n.s. 29 (1948):40–140. A historical Master's thesis in anthropology on a woodland Siouan tribe.

Lurie, Nancy Oestreich, ed. *Mountain Wolf Woman, Sister of Crashing Thunder: The Autobiography of a Winnebago Indian.* Ann Arbor: University of Michigan Press, 1961. The life story of a charming Indian matron told to her adopted niece, who provides valuable cultural notes and background.

Lurie, Nancy Oestreich. "Indian Women: A Legacy of Freedom." In *Look to the Mountain Top.* Edited by Charles Jones. San Jose: H. M. Gousha, 1972. A popular essay by one of the best students of Indian life.

McClary, Ben Harris. "Nancy Ward: The Last Beloved Woman of the Cherokees." *Tennessee Historical Quarterly* 21 (1962):352–64. An uncritical but useful study of an unusual woman who helped persuade the Cherokees to side with the Americans in the Revolution.

Olbrechts, Frans M. "Cherokee Belief and Practice with Regard to Childbirth." *Anthropos* 26 (1931):17–33. A penetrating glimpse into the traditional mental world of a southeastern tribe.

Parker, Arthur C. *Parker on the Iroquois*. Edited by William N. Fenton. Syracuse: Syracuse University Press, 1968. Contains Parker's informed study of *Iroquois Uses of Maize*, which describes the economic roles of men and women from historical accounts and the personal experience of the author, a Seneca Indian raised on the Cattaraugus reservation.

Parsons, Elsie Clews, ed. *American Indian Life*. Reprint. Lincoln, Neb., 1967. Twenty-seven fictionalized but ethnographically accurate biographies of Indian men and women from eight North American culture areas by leading anthropological authorities.

Pettitt, George A. *Primitive Education in North America*. University of California Publications in American Archaeology and Ethnology 43, no. 1. Berkeley and Los Angeles, 1946. A scholarly analysis of Indian education through uncles, masks, imitation, personal names, first-fruits rites, myths, and religion.

Randle, Martha C. "Iroquois Women, Then and Now." In *Symposium on Local Diversity in Iroquois Culture*. Edited by William N. Fenton. Bureau of American Ethnology, *Bulletin* 149 (Washington, D.C., 1951):169–80. Argues that acculturation was felt less by Iroquois women whose economic and domestic roles were not altered as drastically as were the men's.

Richards, Cara E. "Matriarchy or Mistake: The Role of Iroquois Women through Time." In *Cultural Stability and Cultural Change: Proceedings of the 1957 Annual Spring Meeting of the American Ethnological Society*. Edited by Verne F. Ray. Seattle, 1957. Argues that before 1784 the Iroquois woman's status rose as a result of enhanced authority in decisions about the fate of captives and marriage.

Rogers, Edward S., and Rogers, Jean H. "The Individual in Mistassini Society from Birth to Death." National Museum of Canada, *Bulletin* 190, Anthropological Series, no. 60 (Ottawa, 1963):14–36. The Cree life cycle, based on field work among the Cree of south-central Quebec in 1953–1954.

Rothenberg, Diane. "Erosion of Power: An Economic Basis for the Selective Conservatism of Seneca Women in the Nineteenth Century." *Western Canadian Journal of Anthropology* 6 (1976):106–22. Argues that the Allegany women resisted certain aspects of Quaker-inspired change in order to maintain the flexible, complementary nature of their economy.

Spindler, Louise S., and Spindler, George D. "Male and Female Adaptations in Culture Change." *American Anthropologist*, n.s. 60 (1958):217–33. A preview of Spindler (1962).

Spindler, Louise S. *Menomini Women and Culture Change*. American Anthropological Association, *Memoir* 91 (Menasha, Wisc., 1962). Argues that women, by virtue of their domestic-educative roles, are more conservative of traditional values and less affected by acculturation.

Thériault, Yves. *Ashini*. Montreal: Harvest House, 1972. A fictionalized autobiography of a modern Montagnais hunter sensitive to nature and to the white man's challenge.

Thériault, Yves. *N'Tsuk*. Montreal: Harvest House, 1972. A companion to *Ashini*, about a Montagnais woman whose life stands in stark contrast to that of an "emancipated" white urban woman.

Trigger, Bruce G. "Iroquoian Matriliny." *Pennsylvania Archaeologist* 48 (1978): 55–63. Argues that matrilocality and prolonged male absence led to sexual separatism and parity between male and female authority in politics and the economy.

Wallace, Anthony F. C. "Women, Land, and Society: Three Aspects of Aboriginal Delaware Life." *Pennsylvania Archaeologist* 17 (1947):1–35. Written by a college senior, but one of the best studies of the Delawares by an ethnohistorian.

Wallace, Anthony F. C. "Handsome Lake and the Decline of the Iroquoian Matriarchate." In *Kinship and Culture*. Edited by Francis L. K. Hsu. Chicago: Aldine, 1971. An analysis of how the new "Longhouse" religion diminished the "matriarchal" nature of Iroquois society after 1800.

Willis, Jane. *Geniesh: An Indian Girlhood.* Toronto: New Press, 1973. The autobiography of a James Bay Cree woman born in 1940 and her experiences in government and church schools for Indians.

Willis, William S., Jr. "Patrilineal Institutions in Southeastern North America." *Ethnohistory* 10 (1963):250–69. Argues that European contact introduced elements of patriliny to the matrilineal Southeast.

Woodward, Grace Steele. *Pocahontas.* Norman: University of Oklahoma Press, 1969. A graceful but sometimes romantic biography, not particularly strong on Powhatan culture.

Young, Philip. "The Mother of Us All." *The Kenyon Review* 24 (1962):391–415. An insightful study of what Pocahontas has meant to American literary culture and ideology.